PLEASANT PLACES

AHMANSON · MURPHY
FINE ARTS IMPRINT

Pleasant Places

THE RUSTIC LANDSCAPE FROM BRUEGEL TO RUISDAEL

Walter S. Gibson

UNIVERSITY OF CALIFORNIA PRESS

Berkeley / Los Angeles / London

*The publisher gratefully
acknowledges the generous
contribution to this book provided
by Sharon and Barclay Simpson
and by the Art Book Endowment
of the Associates of the University
of California Press, which is
supported by a major gift from
the Ahmanson Foundation.*

University of California Press
Berkeley and Los Angeles, California

University of California Press, Ltd.
London, England

Library of Congress Cataloging-in-Publication Data

Gibson, Walter S.
 Pleasant places : the rustic landscape from Bruegel to
Ruisdael / Walter S. Gibson.
 p. cm.
 Includes bibliographical references and index.
 ISBN 0-520-21698-9 (alk. paper)
 1. Landscape prints, Dutch—Netherlands—Haarlem.
2. Landscape prints—17th century—Netherlands—
Haarlem. 3. Netherlands—In art.
 I. Title.
 NE954.3.N4G53 2000
 769'.436492'09492—DC21 99-29336
 CIP
Printed in the United States of America
9 8 7 6 5 4 3 2 1

This book is printed on acid-free paper.

For Katharine Fremantle,
Charity Cannon Willard,
and my wife, Sally

Contents

Illustrations

Figures

Acknowledgments

This book owes its origin to an invitation by Molly Faries to give the Burke Lecture in the History of Art at Indiana University in 1992. My intention at that time was to enlarge on some observations I had made in the last chapter of a previous book (*"Mirror of the Earth,"* 1989), with the view of publishing them in an article. But it soon became evident that the subject deserved a more extended treatment. The present book was substantially completed during my appointment as a fellow-in-residence at the Netherlands Institute for Advanced Study in 1995–96. I am very grateful to the institute for providing me with the necessary time and facilities for research and writing, with a particular thanks to the librarian Dinny Young, who worked efficiently to obtain books and articles for me from other collections. I should add that the institute's location in Wassenaar also gave me an unexpected intimate access to a typically Dutch landscape, the dunes of the North Sea.

My research was facilitated at every stage by colleagues in Holland, above all Boudewijn Bakker, Reindert Falkenburg, Manfred Sellink, Edwin Buijsen, and Huigen Leeflang, who generously discussed with me their own work in progress and supplied me with references and answers to my many questions. I owe a very special debt to Eddy de Jongh for his advice and friendly assistance on many occasions, and particularly for a memorable afternoon that we spent at Hofwijk, Constantijn Huygens's country house that still exists. Its gardens, however, are sadly diminished, and its rustic felicity, celebrated in Huygens's great poem, has been completely destroyed by urban traffic.

This book has also benefited from the reading of various chapters by Katharine Fremantle, Nadine Orenstein, and Laurinda Dixon; and of late drafts of the book by both Laurinda and my wife, Sally. They have my heartfelt thanks, as do Deborah Kirshman and Kimberly Darwin, respectively Fine Arts Editor and Editoral Assistant at the University of California Press, as well as Stephanie Fay, who have worked patiently with me to transform the manuscript into a book. I am immensely grateful to Fronia W. Simpson, who edited the final text with a rare intelligence and tact.

As in the past, much of my work was done in the libraries of the Cleveland Museum of Art and the Sterling and Francine Clark Art Institute of Williamstown, Massachusetts; in the latter, Nancy Spiegel was especially helpful in obtaining material through interlibrary loan. Sabine Kretzschmar, formerly Assistant Curator of Prints, The Cleveland Museum of Art, was of great assistance, both in selecting prints and in giving me her expert advice on various prints. I was also helped by numerous institutions and individuals in Europe, many of whose contributions are acknowledged in the following pages: Gebrand Kotting and the staff of the Rijksbureau voor Kunsthistorische Documentatie, in The Hague; the print rooms in the Rijksmuseum, Amsterdam (where I spent many fruitful hours); and the Museum Boijmans Van Beuningen, Rotterdam. C. P. van Eeghen kindly let me see his fine collection of Dutch drawings in The Hague. Wim van Aanrooij and Peter Lautner provided invaluable assistance in translating several texts, while Mark Lindholm faxed me from Europe an urgently needed document. Two art dealers, Galerie Sanct Lucas (Vienna) and Johnny van Haeften (London) were especially helpful in obtaining permission for me to publish a photograph. Others who have assisted me in various ways include Holm Bevers, Elisabeth de Bièvre, Albert Blankert, Celeste Brusati, Truus van Bueren, Diane Cearfoss, Pierre Coleman, Jan Piet Filedt Kok, Lawrence O. Goedde, Peter Hecht, E. J. Johnson, Walter A. Liedtke, Ger Luijten, A. Monballieu, Colin Painter, Conrad Rawski, Diane Scillia, Seymour Slive, Frans Tames, William Robinson, Ilja Veldman, and Robert Volz. Gregory Jecmen assisted me on several occasions and was especially invaluable in helping me obtain some long-sought photographs. Lyckle de Vries and Dirk Uythof provided opportunities for me to discuss my work before interested audiences, as did the art history graduate students at the University of Toronto and Williams College, and especially Christopher Brown, who listened critically but sympathetically to my ideas on a subject that has long occupied us both. They all have my warmest thanks.

The dedication expresses my gratitude to three who have long sustained me in ways that go far beyond the confines of this book. They have also, in various ways, been faithful and wise companions on my *wandelingen* through many of the landscapes described in the following pages, both in nature and in their surrogates in art.

Walter S. Gibson
Pownal, Vermont
March 1999

Introduction

He who thinks to expect any good from living in a land that lies lower than the sea, that in the winter is an immense layer of ice and in the summer an endless swamp, which makes every [sort of] vegetation impossible, [he] must go to Holland. I am certain that he will find there all that he longs for. — Henri, count of Rohan, 1600

Some of the greatest masterpieces of seventeenth-century Dutch painting show quite prosaic scenery: a patch of dunes with a church spire or two rising in the distance, some cottages beside a road, a farm nestled among trees by a stretch of water. In a painting of 1631, Jan van Goyen depicts several weather-beaten old cottages and a dovecote in the dunes (Fig. 1). Even simpler is a landscape that Van Goyen painted in 1641, dominated by two ancient oaks silhouetted against a wide expanse of dune and sky (see Plate 5). A clump of trees and a tumbledown fence are the major elements in a painting by Pieter de Molijn, executed in 1626 (Plate 1). Such humble scenes were the stock-in-trade of many Dutch artists; and even Rembrandt, for all his interest in grand history subjects with expressive human figures, took great delight in depicting similar views, especially in his drawings and prints. A good example occurs in his *Landscape with Three Gabled Cottages*, an etching of 1650 (Fig. 2), showing a row of simple thatch-roofed cottages sheltered among the trees by the roadside.

The unpretentious quality of these images, their striking ordinariness, in fact, perhaps becomes clearer when they are compared with the landscape types that flourished during the sixteenth century, when landscape emerged as an independent subject in the art of Western Europe. In its restricted viewpoint and limited selection of motifs, the rustic view is at the opposite pole from the far-flung

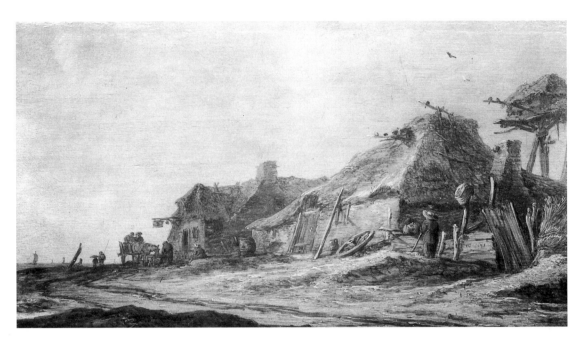

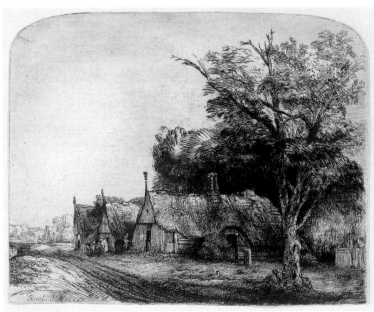

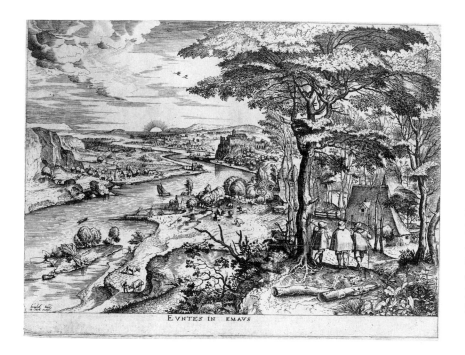

vistas painted by Joachim Patinir and a host of followers, including Herri Bles and above all Pieter Bruegel the Elder (Fig. 3). The sixteenth-century landscapes enchant the eye with their often map-like profusion of "realms, cities, seas, rivers and mountains," as Thomas Elyot said of maps themselves, "that uneth [scarcely] in an old man's lifetime cannot be journeyed and pursued," and show "everything that within all the world is contained."[1] Nor can the rustic landscape compete with the spectacular mountain scenery favored by Albrecht Altdorfer and other Danube artists (who had been inspired by local topography long before the Dutch but with quite different results), as well as such Flemish artists as Pieter Bruegel and Joos de Momper. Their landscapes captured the rugged Alpine peaks that had ravished Conrad Gesner's soul, caused Montaigne to say that he could not look into a mountain gorge without feeling a "shudder and a trembling in my hams and thighs,"[2] and led Samuel van Hoogstraeten to recommend them as the sort of view artists should paint if they wanted to "make the eye stare and admire."[3] But if the rustic landscape is hardly calculated to inspire fear or wonder, it is equally remote from the idealized arcadian landscape Virgil described, with its "whispering ilex" and "tender myrtles,"[4] that was invented by Giorgione and repeated endlessly by later artists, both Italian and transalpine. When we contemplate the windswept dunes of Van Goyen and the woods and marshes of Jacob van Ruisdael, for example, it is difficult to imagine them inhabited by scantily clad shepherds and shepherdesses, or nymphs and satyrs, or the other fictional creatures that have inspired the pastoral poets of every age.

In his biography of Jacob van Ruisdael of 1721, Arnold van Houbraken distinguished Ruisdael's

inlandsche, or domestic, landscapes from his *buitenlandsche*, or foreign, views.[5] By his criteria the rustic landscape is very much *inlandsche*, but that characterization must be further qualified. Although the rustic scene may show well-tended fields or expanses of neglected farmland reclaimed by weeds and second-growth trees, it lies somewhere between the carefully wrought order of the formal garden and the forest or other wilderness untouched by human presence. "Too tame would be all too formal; too wild would be all too rough," Constantijn Huygens wrote in his poem *Hofwijck* of 1646.[6] The rustic landscape, as I define it, avoids both of these extremes. Rather, it shows the Dutch countryside as it could be seen near the towns and cities of the seventeenth century, an unheroic, comfortable scenery with its familiar windmills and waterways, its pollarded willows, thatch-roofed cottages, cultivated fields, and cows; it can also include woods sheltering perhaps some cottages or a hut. It is, moreover, a physical landscape that was beginning to disappear even in the seventeenth century and now has largely vanished in many places under the relentless pressures of urbanization. A major victim of these changes was the Haarlemmermeer, the great inland sea whose waters occupied a large part of the province of Holland until it was drained in the nineteenth century.[7]

This is not to say that the rustic landscape in art was necessarily topographic in character or intention. Indeed, it is difficult to determine how many of these views were faithful renderings of particular places. Some represent specific places, as we can gather from inscriptions on drawings or prints. Others we may identify from the city views, buildings, or other landmarks included by the artist, as in many of Van Goyen's drawings or in various landscape prints and drawings of Rembrandt.[8] The so-called *Haarlempjes*, or views of Haarlem, produced by Jacob van Ruisdael are readily identified by the distinctive city skyline in the distance.[9] Except in special circumstances, however, it is doubtful that the Dutch artists were committed to topographic accuracy. In his *Hofwijck*, Huygens warns us against seeing this poem as a literal description of his country estate: the poet's pen tells lies, he says, partly from habit, partly from the demands of art, and people who seek the truth in well-rhymed books stray as far from the path as those who would use a landscape painting like a map.[10] Artists took similar liberties. Jan van Goyen, for example, often used his sketches done on the spot as motifs in quite imaginary scenes, and many landscapists, including Ruisdael in his *Haarlempjes*, were fond of transposing buildings and other landmarks to create more effective compositions.[11] Nevertheless, their landscapes do not constitute the sort of "lies in art" (*leugens in de konst*) that Hoogstraeten condemned in those pictures that show a hilly Britain with Alpine peaks, or mountainous Palestine, with its many caves, featuring Dutch meadows.[12] Despite their topographic liberties, the Dutch landscapists were concerned with the evocation of the Dutch scene, offering ever-new variations of a landscape already well known to their public. And we are still fascinated by the many ways they devised to celebrate the utterly commonplace.

Although the rustic landscape as a type was not invented by Jan van Goyen and his compatriots but first emerged a half century earlier at Antwerp, in the circle of Hieronymus Cock and Pieter

Bruegel the Elder, it received its definitive formulation in Holland. And it was in the hands of Dutch artists that the rustic scene had its richest proliferation of motifs and compositional types.[13] The earliest artists of the rustic scene began working in the second and third decades of the seventeenth century, among them Esaias van de Velde, soon followed by his pupil Jan van Goyen, Pieter de Molijn, and Salomon van Ruysdael. These artists favored broad expanses of water and sky and diffuse, atmospheric tonalities achieved by a limited, at times almost monochromatic, palette and rapid brushwork. Elements of this "tonal" style also appear in Rembrandt's landscapes paintings, as well as those of Aert van der Neer, known for his nocturnal scenes, and the somewhat younger Philips Koninck, specializing in panoramic views of the Dutch countryside. But by midcentury, a younger generation of landscapists had moved toward more monumental compositions and brighter, more contrasting colors; the chief exponents of this "classic" phase were Jacob van Ruisdael and his pupil Meindert Hobbema. Their subjects included forest interiors and farmland scenes, although Ruisdael, as I have noted, also produced panoramic views of Haarlem and its surrounding dunes.

The Dutch public had access to other kinds of landscapes, of course, landscapes that transported them imaginatively to distant foreign parts. Aelbert Cuyp, Nicolaes Berchem, and Adam Pynacker, among others, offered Italianate scenes inspired by the Roman Campagna or the Apennines, infused by a warm golden light so different from the dull light of native skies. Allart van Everdingen painted the forested mountain slopes and waterfalls of Scandinavia (which Ruisdael occasionally painted too), and Herman Saftleven specialized in views inspired by the Rhine Valley.[14] Even distant Brazil, a Dutch colony between 1630 and 1654, was brought to the United Provinces in the paintings of Frans Post. Nevertheless, the return of the Dutch art-buying public again and again to images of its own familiar countryside is abundantly evident in the great numbers of domestic views produced in paintings, prints, and drawings during the century. The Dutch rustic scene also profoundly influenced later artists in many countries into the nineteenth century and even later.

To earlier generations, scholars and museum visitors alike, the rustic scene was simply a natural expression of the Dutch "temperament," hardly worthy of special remark. The old Dutch painters were realists, perhaps the supreme realists of all time, concerned, as Eugène Fromentin said in 1876, with making "a portrait" of Holland.[15] Since the Dutch countryside was part of their environment, there seemed no need to speculate why they recorded it so repeatedly and with such apparently inexhaustible enthusiasm for its homely scenery. In the last quarter century or so, however, we have come to realize that Dutch art of the seventeenth century was not simply a mirror of nature, but was conditioned by, and expressed in various ways, the *mentalité* of the Dutch people, more precisely, their concept of the world and their attitudes and unspoken, even unconscious, assumptions about it and their place in it. A number of scholars have explored these attitudes and assumptions in Dutch genre scenes, still lifes, and portraiture. In particular, they have demonstrated that the Dutch artists were not averse to introducing disguised symbolism into their apparently straightforward "mirrors

of life,"[16] most often as moralizing commentaries on the subject matter depicted. The recovery of these symbolic details and their literary sources has illuminated the significance of tavern scenes, "merry companies," still lifes, and even portraiture.

Dutch landscape images have been subjected to similar readings. Especially pervasive is the claim that the landscape paintings of Van Goyen, Ruisdael, and others were created to function as elaborate moral allegories specifically intended to inspire in the beholder pious reflections on the proper conduct of his or her life and on the prospects for salvation. The audience for these landscapes, we are often told, consisted mainly of Calvinists; the modern viewer can penetrate these moral allegories only through what one scholar has called the "scriptural reading" of various symbolic details, including trees, mountains, and figures, in the landscape image, with the help of Calvinist sermons, religious tracts, and the like.[17] This approach has yielded valuable insights into seventeenth-century viewers' perceptions of both real landscapes in nature and their surrogates in art. Nevertheless, many scholars have received the interpretations of the "scriptural readers," as we may conveniently call them, with considerable skepticism, and indeed, their more extreme claims can be rejected on numerous grounds.

In reaction to the scriptural readers, other scholars have advanced more positive interpretations. Some writers have proposed that the Dutch artists and their public saw their native landscape as a source of wonder and delight, and as a reflection of divine beneficence. It has also been argued that the rustic view embodies the intense patriotism and pride that the Dutch people had in a land they had but lately wrested from Spanish overlords and still had to fight to preserve. For other scholars, the rustic landscape points to both the increasing urbanization of the country, especially in the province of Holland, and the reclamation of land from the water by means of polderization and dikes. Still others have also seen the rustic landscape as a parallel to the scientific interests of the period. These claims have varying degrees of validity,[18] but there is one claim that deserves particular attention: it is that the rustic landscape commemorated the ways in which people interacted with the countryside itself. Indeed, it is precisely this interaction that informs one of the earliest cycles of rustic landscapes produced in Holland.

The cycle in question is a set of views of various places in the countryside around Haarlem etched by the Amsterdam printmaker and publisher Claes Jansz Visscher, who issued them about 1611–12 (see Figs. 58–69). On the title print, Visscher informs us that these are *Plaisante Plaetsen*, or "pleasant places," for those who do not have time to travel far, and he invites "those who enjoy the varied views of country houses and the surprising turns in ever delightful roads: come let your eager eye roam these open vistas offered by the sylvan surroundings of Haarlem." The places shown in Visscher's prints are identified by a table of contents. One landscape, for example, is titled "A pleasant spot near the dunes," while another depicts the road to Leiden. Other prints show particular buildings, and in all of them we can see people walking or riding along the road, pausing to pass the time

of day, or simply lounging against a fence. It is evident that Visscher intended to show the favorite spots that people visited in the vicinity of Haarlem. As an entrepreneur, Visscher must have been confident that his *Pleasant Places* contained subjects that would appeal to a wide market, that is, the townspeople who ventured into the countryside on Sundays and holidays.

Indeed, it is as "pleasant places" that we might characterize all Dutch rustic landscapes, whether in paintings or in prints, for they evoke memories of excursions enjoyed in the countryside near some Dutch town or a promenade in the vicinity of some country house, such as we can perhaps see in Jan van Goyen's *Village Landscape* of 1626 (see Plate 10), or in Philips Koninck's panorama done some years later (see Fig. 85). The kinds of amenities that people enjoyed on their excursions out of the city, their pleasures and pastimes, define what may be called the urban experience of the countryside. But the Dutch countryside was not only a transitory urban playground, it was also the locus of the perennial human longing for peace and tranquility, for a more elevated mode of life removed from daily cares. This is not a new proposal; it has been advanced a number of times previously, but it merits further investigation. In particular, it can be shown how this urban experience in its diverse aspects crucially determined the various forms that the rustic landscape took at the hands of Dutch draftsmen and painters during the seventeenth century. The landscape prints, and probably a majority of the landscape paintings as well, were produced for an open market consisting mostly of town dwellers, and it was precisely their experience that was reflected in the particular motifs that artists included in their depictions of the Dutch countryside and, perhaps even more significant, what they omitted.

The present study has been prompted by two considerations: the belief that the origins, development, and significance of the Dutch rustic landscape can properly be understood only after a close scrutiny of its sixteenth-century Flemish sources;[19] and the conviction that the current preoccupation with the "scriptural reading" of landscapes as moral allegories precludes any clear appreciation of how the rustic view might have functioned in its own time. Pleasure, not preaching, I believe, constituted the chief appeal of rural landscapes for viewers of the seventeenth century, and the varieties of pleasure and the way in which they were expressed in landscape images are recurring themes in this study. The focus is on Haarlem between 1600 and 1635, the place and time that were so decisive for the development of the Dutch rustic landscape. The emphasis is on prints, the medium in which the rustic view was first disseminated to the general art-buying public. These various aspects of the Dutch "pleasant places" form the substance of the seven chapters in this book. The first two treat the origins of the rustic landscape in the sixteenth century and its definitive reformulation in the following century at the hands of the Dutch artists who created a heritage of images still potent today. The third chapter presents a critical review of "scriptural reading" as a mode of interpreting the Dutch rustic landscape, while the fourth is an excursus: it explores at length traditional ideas concerning recreation, providing the proper context in which to understand the function of landscape images,

including rustic views, as sources of pleasure and mental relaxation. Using Visscher's *Plaisante Plaet-sen* and contemporary descriptions of Haarlem's environs as points of departure, the fifth chapter examines the various ways in which townspeople, both the day-trippers and the owners of country houses, experienced the Dutch countryside. The sixth addresses the role of staffage in Dutch rustic scenes, suggesting how the typical poses and activities of these generally anonymous figures, particularly the peasants, might have conditioned the responses of contemporary viewers to images of the local countryside. The seventh and final chapter approaches the rustic landscape from a somewhat different standpoint, considering the dilapidated farm buildings, dead trees, and other evidences of material decay that occur in so many scenes of the Dutch countryside. Such ruins may in part reflect traditional ideas concerning rustic life as imagined by the townsperson, but they also involve another way in which the artist engaged his audience and manifest still another lasting contribution made by the Dutch rustic view to the history of landscape painting. The various readings of the Dutch rustic landscapes offered in these chapters, it must be emphasized, are intended, not to exclude other interpretations, but to augment them in a way that will enhance our understanding of these memorials of a countryside now largely lost to us and, I venture to hope, enhance our enjoyment of them as well.

1

Prologue

ANTWERP AND THE *SMALL LANDSCAPES* OF HIERONYMUS COCK

Then hurry
On Sundays and holidays around one o'clock
To Borgerhout, to Berchem and Dueren,
To Mercxem, to Wulrijck and to the Kiel also,
To the *Plucke* and to the *Cow-kettle* [inns] in the town of Hoboken,
And all throughout this region, without fail.
The drunkards quickly troop back
Disorderly to the city of Antwerp . . .
— *Pronstelcatie . . . van Meester Malfus Knollebol*

Claes Jansz Visscher's etchings of pleasant places of about 1611–12 were produced by an Amsterdam printmaker to commemorate the countryside around the nearby city of Haarlem. Although this suite of landscape etchings played a vital role in inaugurating the rustic landscape in Holland, as we shall see, the birthplace of the rustic scene was neither Amsterdam nor Haarlem, but Antwerp in the previous century, more precisely in the two series of prints that Hieronymus Cock published in 1559 and 1561. Generally known today as the *Small Landscapes*, their importance for the later Dutch landscape has long been acknowledged, but this phenomenon has never been studied in detail. Cock's publication of the *Small Landscapes* and their transmission from Antwerp to Haarlem and Amsterdam in the early years of the seventeenth century constitute a fascinating story of how several generations of enterprising print publishers played a crucial role in the early development of the Dutch landscape school.

Hieronymus Cock was the first major print publisher of Northern Europe.[1] Working in Antwerp between 1550 and his death in 1570, he issued almost a thousand prints after the leading Dutch, Flemish, and Italian artists of the day, and close to a tenth of his total production was landscapes, many published in series of four, eight, and ten sheets, and even more.[2] By far his most extensive landscape

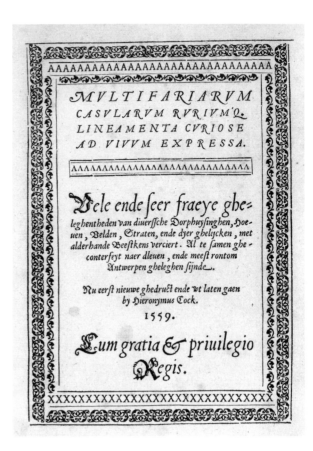

cycle was the *Small Landscapes*, the first set of which he issued in 1559 (Figs. 4–8).[3] It consists of a title print and fourteen landscape views. Two years later he issued a second series of the *Small Landscapes*, this time with a title plate accompanied by at least twenty-seven plates (Figs. 9–16).[4] The title print of the first series (see Fig. 4) is inscribed in Latin and Dutch, the latter text informing us that these landscapes depict "the many and very attractive places of various cottages, farms, fields, roads, and the like ornamented with animals of all sorts. All portrayed from life, and mostly situated in the country near Antwerp."[5] In contrast to this first series of 1559, the inscription on the title print of the second series of 1561 (see Fig. 9) is both shorter and entirely in Latin: "Pictures of farms, country houses, and rustic villages engraved in a most elegant and lifelike manner."[6] Although the second title also assures us that these images are done in a lifelike manner (*ad vivum*), we are not informed if they depict specific places around Antwerp. At least one print did not; a scene in the second series (Bastelaer 38)[7] represents the castle Oud-Alkemade near Warmond, on the road between Haarlem and Leiden.[8] We do not know if Cock included any other "foreign" views in these series.

Taken together, the two sets of the *Small Landscapes* include some views of impressive castles and manor houses, as well as one of the gates of Antwerp, the so-called Roode Poort, or Red Gate, and

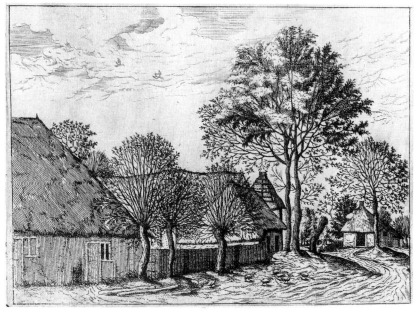

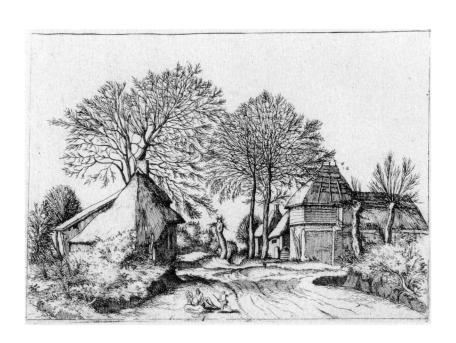

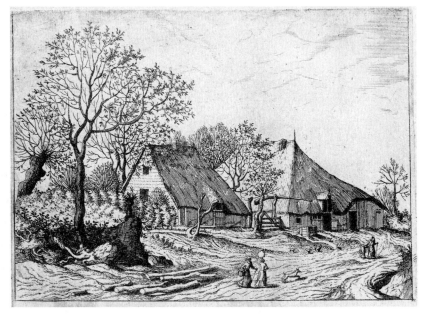

FIGURE 7
After Joos van Liere (?),
landscape, from the *Small
Landscapes*, first series, 1559,
engraving and etching.
Washington, National Gallery
of Art, Rosenwald Collection.

FIGURE 8
After Joos van Liere (?),
landscape, from the *Small
Landscapes*, first series, 1559,
engraving and etching.
Amsterdam, Rijksmuseum.

PRAEDIORVM VILLARVM ET
RVSTICARVM CASVLARVM
ICONES ELENGANTISSI⸗
MÆ AD VIVVM IN AERE
DEFORMATAE⁓

LIBRO SECVNDO 1561
HIERONYMVS COCK EXCVDEBAT CVM GRATIA ET PRIVILEGIO

FIGURE 9
Flemish, title print, from
the *Small Landscapes*, second
series, 1561, engraving and
etching. Washington,
National Gallery of Art,
Rosenwald Collection.

FIGURE 10
After Joos van Liere (?),
landscape, from the *Small
Landscapes*, second series,
1561, engraving and etching.
Washington, National
Gallery of Art, Rosenwald
Collection.

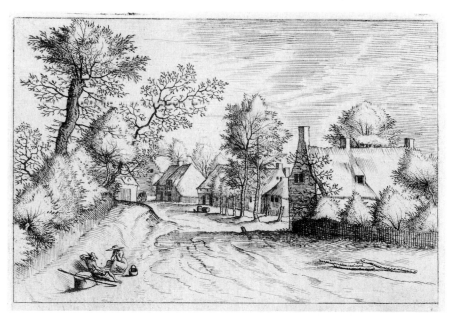

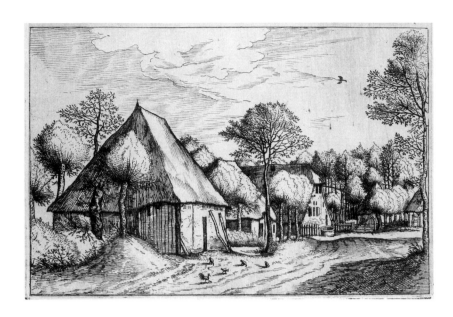

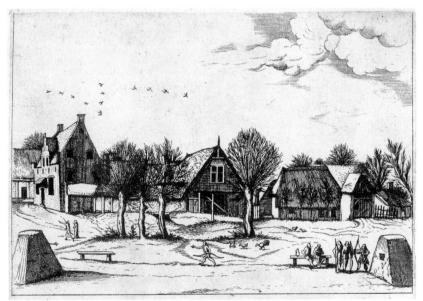

FIGURE 11
After Joos van Liere (?),
landscape, from the *Small
Landscapes*, second series, 1561,
engraving and etching.
Washington, National Gallery
of Art, Rosenwald Collection.

FIGURE 12
After Joos van Liere (?),
landscape, from the *Small
Landscapes*, second series, 1561,
engraving and etching.
Amsterdam, Rijksmuseum.

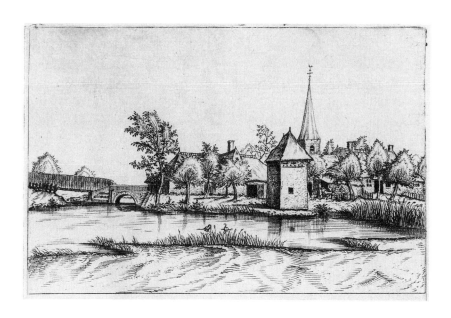

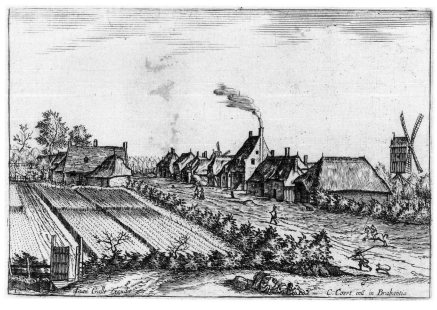

FIGURE 13
After Joos van Liere (?),
landscape, from the *Small
Landscapes*, second series,
1561, engraving and etching.
Washington, National Gallery
of Art, Rosenwald Collection.

FIGURE 14
After Joos van Liere (?),
landscape, from the *Small
Landscapes*, second series,
1561, engraving and etching.
Amsterdam, Rijksmuseum.

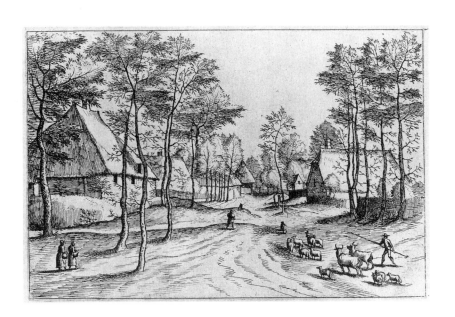

FIGURE 15
After Joos van Liere (?),
landscape, from the *Small
Landscapes*, second series,
1561, engraving and etching.
New York, The Metropolitan
Museum of Art.

FIGURE 16
After Joos van Liere (?),
landscape, from the *Small
Landscapes*, second series,
1561, engraving and etching.
Amsterdam, Rijksmuseum.

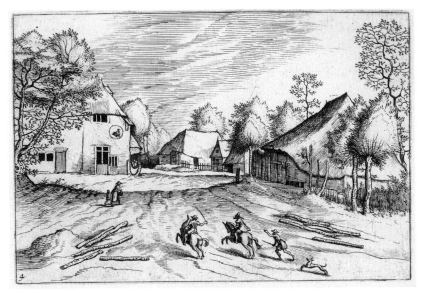

FIGURE 17
After Hans Vredeman de Vries,
Imaginary City View, engraving.
Amsterdam, Rijksmuseum.

some houses just beyond the wall (B. 40),[9] but for the most part they depict modest subjects: a cluster of peasant cottages, a road, and other stretches of local countryside. The human figures in these scenes are relatively few and inconsequential; like the farm animals, they are drawn with rather less care than the buildings and trees, and they often seem oddly undersized for their surroundings, as if they had been added as afterthoughts, but their activities contribute significantly to the peaceful mood of these landscapes. Only one scene shows real labor, in this case some lumbermen hard at work in an open area before a farmstead (see Fig. 5), and occasionally a countryman conducts a herd of sheep or cattle down a road (see Fig. 15; see also B. 27, B. 29). Otherwise, the plowed fields stand empty of laborers (see Fig. 14) or at most contain a lone sower (B. 63); chickens and ducks scratch for food, cows rest, people stop to gossip or to drink before an inn, At the Sign of the Swan (see Fig. 16), which is one of two inns shown; the other inn is signless, but its function is suggested by the trestle table and benches before its entrance (B. 23).[10] This is not the workaday world of agricultural drudgery. Instead, it is the Sunday and holiday world of bucolic tranquility, where nothing much ever happens, and people have the leisure to stroll about, to enjoy the fresh air and other natural amenities, and, in one print, to participate in an archery contest (see Fig. 12) or even to make love hidden in a grainfield (B. 46). The Sign of the Swan appropriately terminates the second series with its promise of refreshment after such rural pastimes. In one respect, the *Small Landscapes* find their counterparts in the imaginary city views of Hans Vredeman de Vries, which Cock had begun issuing in the very same years (Fig. 17). Much grander in concept, De Vries's prints epitomize the ideal city, purged of

all the dirt, noise, and commotion of the marketplace, purged, indeed, of most of its inhabitants, an Antwerp, perhaps, transformed into a Renaissance dream city of palaces, temples, colonnades, and terraces. Although more firmly anchored in reality, Cock's *Small Landscapes* in their more modest way also reflect an ideal vision.

Despite their seemingly artless arrangements, these landscapes display two basic compositional types. In some views, the terrain, trees, and buildings are arranged roughly parallel to the picture plane; others are dominated by a foreshortened perspective movement into depth (compare, for example, Figs. 5 and 15).[11] Yet, within these two types, there is considerable variation as we move from scene to scene. The execution of the prints is generally attributed to one of the Van Deutecum brothers, either Jan or Lucas, working from preparatory drawings, eleven of which are known to have survived.[12] One drawing, now in Cleveland (Fig. 18),[13] was the preliminary design for a print in the first series (see Fig. 13); the printmaker reversed the composition but followed it fairly closely, altering only a few details, especially the bridge and fencelike structure seen at the left in the print. He also eliminated the man walking on the bridge but retained the two ducks in the water and articulated the foreground more fully. Another drawing (Fig. 19) served as the model for a second landscape in the first series (see Fig. 8), and once more the printmaker added details of his own.[14] As we find with so many of the landscapes issued by Cock, the sketchy, atmospheric lines in the preliminary drawings became harder and more rigid under the printmaker's burin and etching needle.[15]

All these drawings appear to be by the same artist. Figures and other details were occasionally added by another hand, but most likely not the printmaker, whose own figure style was rather less elegant.[16] None of the sheets, however, bears the signature of the original draftsman, and Cock did not see fit to indicate the name of their "inventor," as he generally did on his other prints. Peter Parshall has connected this lack of an artist's name with Cock's claim on the title print of the first series that the scenes were done "from life," suggesting in effect that they were not the "inventions" of a particular artist but were done directly *naer het leven*, or "after life."[17] Nonetheless, several artists have been proposed as the designer of the *Small Landscapes*. They include Cornelis Cort, a printmaker then in the employ of Hieronymus Cock, and Pieter Bruegel the Elder,[18] but the style of the two series does not support an attribution to either artist. More convincing is the suggestion advanced some years ago by Egbert Haverkamp Begemann, who attributed them to one Joos van Liere, an artist described by Van Mander as an "artful" (*constigh*) landscape painter in oils and watercolors and an excellent tapestry designer who was born in Brussels.[19] He worked at Antwerp and in the 1570s is recorded in Brussels and Frankenthal before becoming a Calvinist preacher in Zwijndrecht, near Antwerp, where he died in 1583. Little is known about his artistic activity, but in the following century, Hendrick Hondius, a printmaker and publisher in The Hague, issued five landscape prints bearing Van Liere's name as "inventor," several after drawings that have survived. Four show forest scenes, but one depicts a village very much in the spirit of the *Small Landscapes*.[20]

FIGURE 18
Joos van Liere (?), *Landscape with Moated Village*, drawing. Cleveland, The Cleveland Museum of Art.

FIGURE 19
Joos van Liere (?), *Village Landscape*, drawing. Darmstadt, Hessisches Landesmuseum.

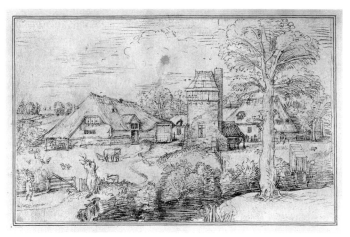

FIGURE 20
Flemish, *Village with Farmhouses*, page
from the *Antwerp Sketchbook*, 1540s.
Berlin, Staatliche Museen Preussischer
Kulturbesitz, Kupferstichkabinett.

FIGURE 21
Flemish, *Farmhouse and Outbuildings*,
from the *Errera Sketchbook*, drawing,
1530–35. Brussels, Musées Royaux des
Beaux-Arts de Belgique.

FIGURE 22
Workshop of Herri Bles, *Farmhouse
and Outbuildings*. Brussels, Musées
Royaux des Beaux-Arts de Belgique.

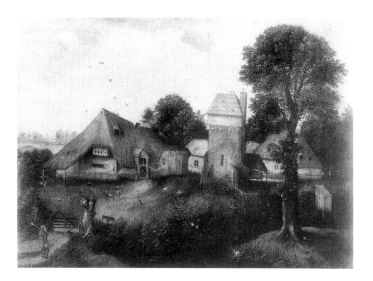

But whether he was Joos van Liere or some other artist, the designer of the *Small Landscapes* was remarkably inventive, for these peaceful country views are almost without precedent in earlier Flemish art. Their essential novelty is evident when we compare them with the so-called *Large Landscapes* that Cock had published after Pieter Bruegel the Elder just a few years before, about 1555 (see Fig. 3).[21] With their bird's-eye viewpoints and panoramic vistas sweeping grandly to distant horizons, most of the *Large Landscapes* are very much in the tradition of the Flemish world landscape. Cock issued many other landscape prints of this type, although seldom as dramatic, including a group of five prints after the Brussels landscape painter Lucas Gassel, and a suite of thirteen prints, dated 1558, etched by Cock himself after drawings by his brother Matthys.[22]

In contrast to Bruegel's *Large Landscapes* and other world landscapes issued by Cock, the *Small Landscapes* have only a few forerunners in Flemish art. Rustic scenes, of course, can be found much earlier. They often appear in books of hours as settings for such subjects as the Massacre of the Innocents and for calendar scenes, or in depictions of village festivities, such as the woodcuts issued by the Beham brothers and other Nuremberg artists in the 1520s and 1530s.[23] Farm buildings and villages can also be found in Albrecht Dürer's *Prodigal Son among the Swine* engraving of about 1498, and in the right background of Lucas van Leyden's *Return of the Prodigal Son* engraved about 1510.[24] From the early sixteenth century on, the Flemish painters often included farmsteads and villages in their figure compositions, and we encounter similar details in the expansive landscapes of Patinir and his followers. A particularly fine view of a Flemish hamlet appears in the background of the *Rest on the Flight to Egypt* by Bruegel's teacher, Pieter Coecke van Aelst.[25]

But the real ancestors of the *Small Landscapes* are perhaps to be found in various artists' sketchbooks, such as the *Antwerp Sketchbook*, an anonymous collection dating from the 1540s.[26] A number of pages show views outside Antwerp's walls and in the countryside, some of them remarkable anticipations of the *Small Landscapes* in format and choice of motif (Fig. 20).[27] Another collection is the *Errera Sketchbook*, compiled by one or more anonymous Antwerp artists between 1530 and 1535.[28] One sheet depicts a simple farmhouse with a dovecote and other outbuildings, as well as some trees (Fig. 21); this sketch, however, was intended, not as an independent work of art, but as part of a repertoire of various landscape motifs, presumably to be used in larger compositions. Several structures from this sheet, in fact, recur in paintings from the workshop of the Antwerp artist Herri Bles, including a *Christ Carrying the Cross*.[29] But the farmstead must have appealed to at least several art patrons for its own sake, because Bles and his workshop made it the subject of an independent composition that exists in two paintings: one formerly in a Berlin private collection; the other in Brussels (Fig. 22). Because the panel formerly in Berlin is dated precisely *1546.19.April*, it has been suggested that the composition records an actual farm.[30] Both pictures closely follow the drawing, with only a few details added to complete the composition. It was just about the same time, in 1543, that Cornelis

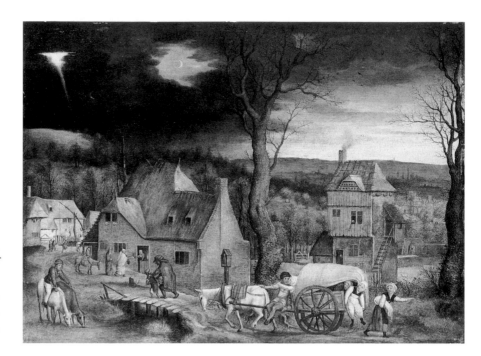

FIGURE 23
Cornelis Massys, *Arrival of
Mary and Joseph in Bethlehem*,
1543. Berlin, Staatliche Museen
Preussischer Kulturbesitz,
Gemäldegalerie.

Massys, another Antwerp artist, painted the *Arrival of Mary and Joseph in Bethlehem* (Fig. 23).[31] The biblical story has been placed in a small Flemish village in winter, the dark clouds above heralding an approaching storm. In the following decade, Pieter Bruegel included a rustic view in his *Large Landscapes* of about 1555 (Fig. 24); it depicts a church and some cottages half concealed among the trees and a road rendered almost impassable by what may be the largest mud puddle ever depicted in art.

The interest in the countryside and its inhabitants culminated in the years just after 1550. This is when we see the earliest scenes of peasant festivities in Antwerp, among them the depiction of kermises, or church fairs, in prints by Pieter van der Borcht and the two famous prints after Pieter Bruegel the Elder, the *Hoboken Kermis* and the *St. Joris Kermis*. Pieter Aertsen's earliest surviving *Peasant Festival* dates from 1550; soon afterward, he painted scenes of country people offering their produce in town markets. While this phenomenon has received considerable attention,[32] less familiar is the development of another kind of image, one that places the rural landscape in close conjunction with the city. This is a venerable tradition. In his *Allegory of Good Government* frescoes painted in 1338–40 in the town hall of Siena, Ambrogio Lorenzetti showed the Sienese countryside secure and prosperous under the city's wise administration.[33] German city views of the fifteenth century, as in the *Nuremberg Chronicles*, frequently include the rural environs, and a picture-map of 1516 by Erhard Ertzlaub shows Nuremberg firmly ensconced within its territorial holdings and the imperial forests.[34] Such images may be compared to the tradition of laudatory poems and prose texts that not only described a particular city—including the beauty of its buildings, the virtues of its inhabitants, and the

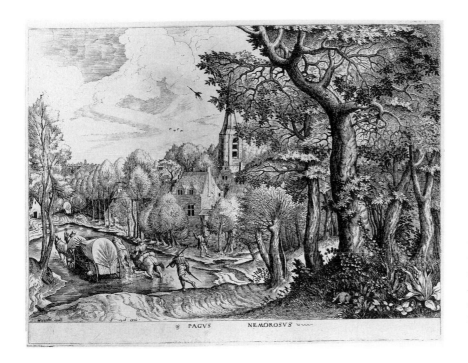

FIGURE 24
After Pieter Bruegel the Elder,
Pagus Nemorosus, from the
Large Landscapes, etching and
engraving. New York, The
Metropolitan Museum of Art.

like—but also celebrated the amenities offered by the surrounding countryside.[35] In a poem prais-
ing Ghent published in 1574, Marcus van Vaernewyck devoted a number of verses to the country
around it, its meadows and waterways, as well as the inns where people go to enjoy an afternoon in
the open air.[36]

While such laudatory descriptions of Netherlandish cities came into their own only in the seven-
teenth century, a similar country-city relationship had long informed the visual depictions of
Antwerp. A good example is the double view of Antwerp engraved by Melchisedek van Hoorn in
1550 (Fig. 25). In both views, the foreground is given over to the adjacent countryside, dotted with
windmills, fields, and villages. In the bottom view, we see Antwerp from the land side, including the
Renaissance gate of St. George, which was immortalized in a drawing by Bruegel of 1559.[37] The top
image shows the busy harbor of Antwerp along the Schelde river; the bank of the river closest to us
lies in the county of Flanders; toward the right is the little village of Ste. Anneken, whose main street
features an inn. Antwerp's river side was a favorite view, it seems, appearing in the earliest preserved
depiction of the city, a long woodcut of 1515.[38] Later views of Antwerp increasingly emphasized the
countryside across the river, and its attraction for Antwerp's citizens is suggested by an inscription
on the upper view in Van Hoorn's print, which assures us that "here one may see Antwerp lying pleas-
antly on the Schelde with the Flemish fields."[39] The term *Flemish fields*, or "Vlaemsche Landouwe,"
seems to have been a common name for Flanders. Karel van Mander, a native of Flanders, in a poem
composed in the autumn of 1573, takes leave of his friends and family to travel to foreign parts, and

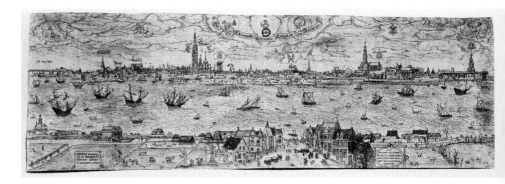

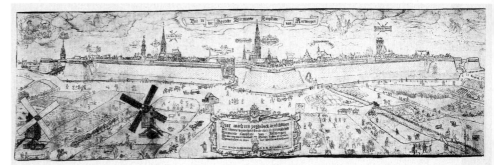

FIGURE 25
Melchisedek van Hoorn,
Two Views of Antwerp, 1550,
etching. Nuremberg,
Germanisches Museum.

he regrets that he must go "[w]t dees Vlaemsche Landouwe," that is, "out of these Flemish fields."[40] This and other "portraits" of Antwerp and its countryside are among the earliest manifestations of a form of rustic landscape that we may call the "town-and-country" tradition; it persisted far into the seventeenth century, not only in views of Antwerp[41] but in depictions of other cities as well. The printmaker Pieter Bast, for example, employed this format in his views of Dutch cities, beginning in 1598 with a profile of Franeker that serves as the distant backdrop for the elegantly dressed young people who promenade in the fields lying to the northeast.[42]

In spite of these precedents, however, it was left to Hieronymus Cock to take the decisive step of removing the rustic scene from the urban context and establishing it as an independent landscape type. He still refers to Antwerp in the title print of the 1559 series; this may be compared to what Claes Jansz Visscher would put on the title print of his views of the Haarlem countryside some fifty years later. But unlike Visscher, Cock did not identify the particular "pleasant places" that he selected for depiction; some may have been situated across the Schelde in the "Vlaemsche Landouwe." Although we do not know if the scenic views published by Cock matched in beauty those in the vicinity of Haarlem, it is a matter of record that the citizens of Antwerp pursued country pleasures according to their circumstances and purses. Wealthier citizens often had *hofjes van plaisance,* or summerhouses, outside the city walls, where they could retreat from city cares.[43] One such suburban estate, including an extensive garden, was owned by Nicolaas Jonghelinck, a royal official and a major patron of Pieter Bruegel the Elder.[44] Other country houses were owned by the English factor

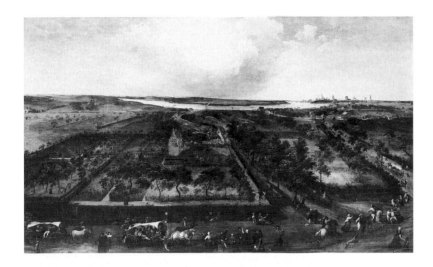

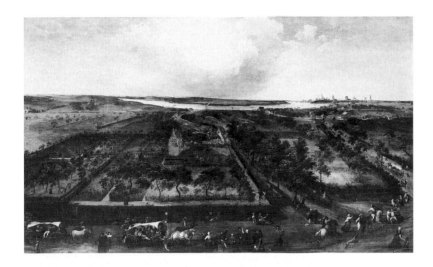

FIGURE 26
Jacob Grimmer, *A View of the Kiel near Antwerp*, 1578. Antwerp, Koninklijk Museum voor Schone Kunsten.

FIGURE 27
Detail of Figure 26.

Richard Clough and the Italian historian Lodovico Guicciardini.[15] A *hof van plaisance* can be seen in a painting of 1578 by Jacob Grimmer (Fig. 26), an Antwerp artist about whom we shall hear more later. A variation of the "town-and-country" landscape, Grimmer's picture may well show the estate of Cornelis de Schot, a member of a prominent Antwerp family, within easy riding distance of the city, and Antwerp itself can be seen in the distance at the upper right. The foreground is occupied by the house and garden with an orchard and vineyard beyond (Fig. 27). Here can be discerned members of the owner's family, and perhaps his friends, taking the air in the garden and orchard. The estate is protected by a wall below which a line of people follows a road, some on foot, merrymakers returning from some outlying spot in the country, perhaps a kermis or other village festival.

The people on this road probably include the less affluent inhabitants of Antwerp, who were generally limited to day excursions, especially in the spring and summer. According to a *pronstelcatie*, or mock New Year's astrological prediction, published at Antwerp about 1560, the townsmen on Sun-

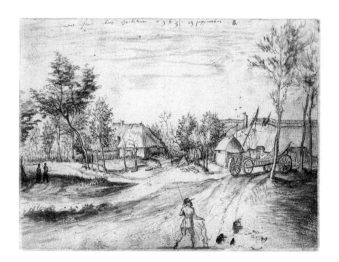

FIGURE 28
Flemish, *Village near
Hoboken*, 1563, drawing.
Amsterdam, Rijksmuseum.

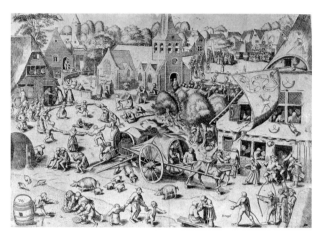

FIGURE 29
After Pieter Bruegel the Elder,
Hoboken Kermis, etching and
engraving. New York, The
Metropolitan Museum of Art.

days and holidays rush out to Borgerhout, Berchem, Deueren, and other villages and hamlets in the nearby countryside, where they attend various rustic celebrations.[46] As the *pronstelcatie* also suggests, their pastimes included drinking in the rural taverns, for the taxes on beer were much less in the country than in the city, a circumstance perhaps commemorated in at least one print from the *Small Landscapes*, depicting the village inn At the Sign of the Swan (see Fig. 16). One of the most popular places of resort was Hoboken, now a part of Antwerp, but then lying not far from the city walls.[47] As it happens, none of the prints in Cock's two series of the *Small Landscapes* can be identified directly with Hoboken, but a view of one or more localities nearby can be seen on a drawing in Amsterdam (Fig. 28). On the recto, we see a hamlet divided by a country road, with a man and his dog standing in the foreground; the verso shows some farmhouses with the towers of Antwerp in the distance. Both are identified by inscriptions, presumably by the artist himself, the recto informing us that "this is near Hoboken 1563/19 September." These two scenes are much in the same format as the *Small Landscapes* and, in fact, have been attributed to an artist in the circle of Joos van Liere.[48]

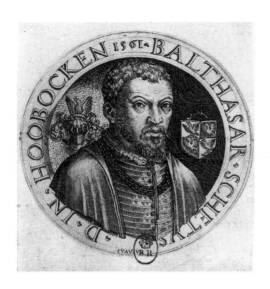

Hoboken was famous for its three annual festivals, one of which, the Feast of St. Sebastian, was commemorated by Pieter Bruegel the Elder in a print published by Hieronymus Cock about 1559–60 (Fig. 29).[49] The various events of the day are shown simultaneously, from the church procession in the morning to the games, dancing, and drinking in the afternoon. Originally a manor in the possession of the prince of Orange, later to be known as William the Silent, Hoboken had long enjoyed a certain notoriety as a place for lovers and ladies of easy virtue. According to a mock New Year's "prognostication" of about 1561, in May many people would go to Hoboken, where many babies would be made.[50] This unsavory reputation, incidentally, seems to have survived into the following century: in *The Spanish Brabanter*, a famous play written by Gerbrandt Adriaensz Bredero in 1618, the swindler Jerolimo claims that he was born near Hoboken of noble blood and great lineage; elsewhere we are told that it was near Hoboken that he owned a great estate with its own dovecote.[51] Bredero's audience would probably have understood these two references to Hoboken as casting grave doubt on Jerolimo's pretensions to an illustrious pedigree. Hoboken's dubious reputation, however, does not seem to have affected its fortunes adversely in Bruegel's day. In 1559, the year that saw the publication of Bruegel's *Hoboken Kermis*, Hoboken was acquired from William of Orange by a wealthy Antwerp banker, Melchior Schetz. With the manor came the title which both Melchior and his brother Balthasar seem to have coveted. An etching of 1561 by Lambert Sauvius portrays Balthasar Schetz as "Lord of Hoboken" (Fig. 30), and a painting by Gillis Mostaert, now lost but described by Van Mander, depicted the Schetz brothers' being "received very ceremoniously by the peasants of Hoboken."[52] A third brother, Gaspar Schetz, enjoyed similar honors; he inherited the lordship of Grobendonck from his father and bought several other manors, including Wezenmael, the last-named making him the hereditary marshal of Brabant.[53] How Gaspar's manors flourished under his aegis is not known, but his brothers Melchior and Balthasar seem to have taken their seignorial responsibilities

very seriously. They returned the local taxes on beer and wine to the village, patronized the local kermises, and sought in various ways to promote the local tourist trade.

Both the country-house owners and the day-trippers would have appreciated the "pleasant places" offered them in the two series of the *Small Landscapes*. That the *Small Landscapes* proved a commercial success is suggested by the fact that in the same year that the second series was published, 1561, Cock apparently combined both sets to create a single series augmented by the addition of perhaps as many as ten new views, although this is uncertain.[54] In any case, each print in this new edition is inscribed with a number in the lower border. We may assume that it was this combined and enlarged series that Cock consigned to the book publisher Christophe Plantin for shipment all over Europe; Plantin's records list them as *dorpshuysboecken, livres de maisons de villages,* and *livres de fermes.*[55] This designation of the *Small Landscapes* as "books of village houses" or "books of farms" is significant, for it indicates that while they also included occasional views of castles and sumptuous country houses, as we have seen, the simple rustic scenes seem to have appealed more to the print-buying public.

Despite the success that Cock enjoyed with his *Small Landscapes,* it is difficult to assess their impact on the development of Flemish landscape painting during the remainder of the sixteenth century. This is partly because the decades after 1560 witnessed a phenomenally rapid growth of rustic scenery in paintings and prints, in which various pictorial traditions jostled each other and occasionally intermingled. Many rustic views adhere to the "town-and-country" format exemplified in Van Hoorn's double view of Antwerp. A good example is in Jacob Grimmer's panoramic *View of the Kiel near Antwerp* of 1578 (see Fig. 26), where the city has been relegated to the far-right distance. It also governs a later picture of 1587, *View of the Schelde near Antwerp* (Fig. 31), in which Grimmer shows a somewhat different aspect of country pastimes. The middle terrain is occupied by a village and a large manor house whose inhabitants, it seems, disport themselves in the foreground: a fashionable picnic is in progress in the meadow at lower left; at the right, some travelers in a wagon watch a boy standing on his head. One imagines the guests of the Schetz brothers being entertained in a similar manner in Hoboken. On the distant horizon we can see the towers of Antwerp, an inconspicuous but significant reminder of her political jurisdiction over the local countryside. Only two years before this landscape was painted, the city had made her final capitulation to Spanish control, and it may well be that this picture somehow expresses a hope for a peaceful future under Antwerp's restored prosperity. In their deep background vistas, Grimmer's two landscapes also conform to the world-landscape tradition.[56] But they may also owe something to the *Civitates orbis terrarum*, a collection of city views by Georg Braun and Frans Hogenberg, the first volume of which appeared in 1572: a number of views show the city in profile or in bird's-eye perspective lying beyond an extensive stretch of the adjacent countryside.[57]

Other types of village landscapes emerged in the half century after Pieter Bruegel and deserve

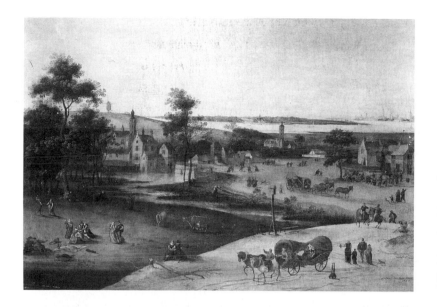

FIGURE 31
Jacob Grimmer, *View of the Schelde near Antwerp*, 1587. Antwerp, Koninklijk Museum voor Schone Kunsten.

FIGURE 32
Jan Brueghel the Elder, *Village Kermis*. Munich, Bayerische Staats-gemäldesammlungen.

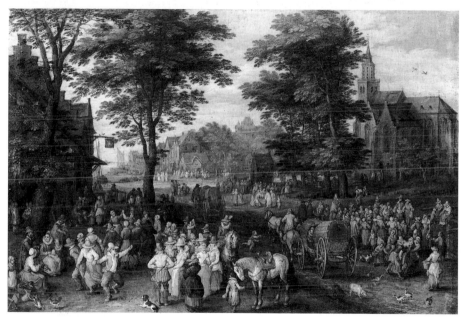

more attention than can be given here. Much in the tradition of Bruegel's *Labors of the Months* of 1565, homely Flemish hamlets and farms were frequently placed against exotic prospects of mountains and river valleys, as in the prints of Hans Bol and the paintings of Gillis Mostaert.[58] A second variant was favored by Joos de Momper the Younger and Jan Brueghel the Elder.[59] Especially in the case of Jan Brueghel (Fig. 32), these landscapes are often hardly more than stage settings for the crowds of anecdotal, colorfully dressed peasants who surge through the village marketplace, throng the coun-

FIGURE 33
Copy after Pieter Bruegel
the Elder, *Parable of the
Unfaithful Shepherd.*
Philadelphia, Philadelphia
Museum of Art, John G.
Johnson Collection.

try lanes and roads, and celebrate their rowdy kermises, often under the watchful eye of some well-dressed gentlefolk from the city or neighboring manor house. Such rural delights may seem remote from the urban world, but the presence of this world is frequently manifested in the spires and towers visible on the horizon, often recognizable as those of Antwerp. These crowded rustic scenes could not differ more from the distinctively quiet intimacy of the *Small Landscapes.*

Amid this proliferation of rustic subjects, the *Small Landscapes* exerted a persistent if diffused influence in Flemish art during the second half of the sixteenth century. Pieter Bruegel's contribution to the development of this landscape type is less clear than it formerly seemed, now that the so-called Small Landscape drawings, most of them signed *Bruegel* and dated between 1560 and 1562, have been demonstrated to be, not by him, but by an artist of a generation later (see chapter 2). Nevertheless, Bruegel too seems to have responded to the *Small Landscapes,* especially in the last years of his life, when he abandoned the Olympian perspectives of his earlier landscapes to look more closely at his own homeland. In his *Peasant and the Birdnester* of 1568, for example, the farmstead and horses in the right distance are very close in spirit to similar features in some of the *Small Landscapes.*[60] But if Bruegel learned from the *Small Landscapes,* he soon surpassed his models, as he did in the *Misanthrope* done in the same year, 1568, and the *Parable of the Unfaithful Shepherd,* known to us in a good copy now in Philadelphia (Fig. 33), in which he evoked the flat, damp terrain of the Flemish countryside, including a heavily rutted dirt road stretching into the distance, with a vividness that even the *Small Landscapes* could not match.[61]

FIGURE 34
Julius Goltzius, after Gillis
Mostaert, *June*, engraving.
Amsterdam, Rijksmuseum.

Other possible but isolated examples of Cock's influence could be cited, such as a pair of anony-
mous drawings, dated 1571, depicting hamlets,[62] a farm scene painted in 1581 by Pieter Baltens, his
only signed and dated work,[63] and a remarkable set of the *Labors of the Months* engraved by Julius
Goltzius (Fig. 34).[64] These prints were done after designs by Gillis Mostaert, as we are informed by
an inscription on the first plate, and while they show a somewhat convoluted terrain, they have little
in common with his painted landscapes; rather, these quiet, simply composed views of the country-
side suggest that the artist had turned to the *dorpshuysboecken* for inspiration. Views of local scenery
seem to have been a specialty of Jacob Grimmer; in his *Schilder-boeck* of 1604, Karel van Mander
tells us that Grimmer did many views of landscapes *naer het leven* around Antwerp and elsewhere.[65]
This statement is confirmed, of course, by his two panoramic views of the Antwerp countryside of
1575 and 1587 (see Figs. 26, 31). But Grimmer also did more intimate landscapes. One example oc-
curs in an undated oil painting that appeared at auction in London in 1984, depicting a hamlet nes-
tled among some trees.[66] Even closer to Cock's *Small Landscapes* is a group of watercolors that
Grimmer executed in 1587; they include several views of peasant hamlets (Fig. 35) whose delicately
colored, pale washes perfectly express the bleak tonalities of a cold winter day.[67]

Grimmer has also been credited with the preparatory drawings for a set of twelve numbered land-
scapes engraved by Adriaen Collaert and published probably at Antwerp in the 1580s (Fig. 36).[68] The
first sheet is inscribed *Grimmer. By Antwerpen,* and it is generally assumed that, like Cock's *Small
Landscapes,* this series shows rustic views inspired by the environs of Antwerp. If so, Grimmer seems

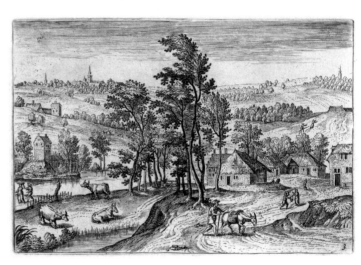

to have exercised considerable artistic license. Generally more spacious in composition than the *dorpshuysboecken*, they also depict hilly terrains that are quite unlike the fairly level plain in which Antwerp is situated. Grimmer, in fact, had been much more faithful to local topography in his *View of the Kiel near Antwerp* of 1578 (see Fig. 26).[69] The *By Antwerpen* views, on the other hand, recall the many painted series of the *Months* and *Seasons* that he produced during his career, and even more closely one of his early landscape paintings, dated 1554, with its typical Flemish cottages set against a grand prospect of river and mountains.[70] It may be that the original drawings for the *By Antwerpen* series were also done about the same time as this picture.

Another set of prints claims to depict rural views of a specific region with more plausibility. This is a series of twenty-four views, this time of localities on the outskirts of Brussels. They were engraved by Hans Collaert, possibly a brother of Adriaen.[71] The details of their publication are ob-

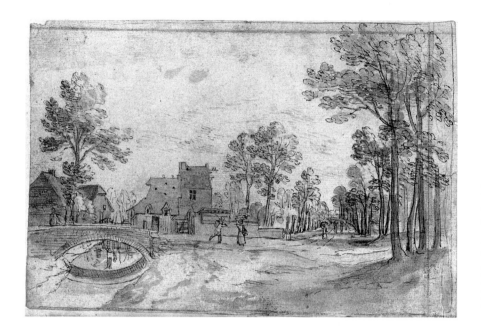

FIGURE 37
Attributed to Jacob
Grimmer, *A View of
Elser Beeke*, drawing.
Cambridge, Mass.,
Harvard University
Museums, Fogg Art
Museum.

scure, but I suspect that they were first issued at Antwerp sometime in the 1580s. Five of the origi-
nal drawings have survived (Fig. 37), executed in black chalk with colored inks and washes.[72] Of the
various artists to whom the drawings have been ascribed, Hans Bol, Gillis Mostaert, and Jacob Grim-
mer, the last-named is the most likely candidate, if only because of his *By Antwerpen* series and his
demonstrated interest elsewhere in domestic scenery.[73] The views in the Collaert series were not the
first of the environs of Brussels; a precedent occurs in the *Chasses de Maximilian*, a series of tapes-
tries for which the cartoons were completed by 1548, the tapestries woven by 1552.[74] Showing the
twelve months, each tapestry, except for February, depicts a courtly hunting scene in the vicinity of
castles, abbeys, and villages in various parts of the forest near Brussels. Although Collaert's Brus-
sels series does not show hunting scenes, it includes not only castles and fine country mansions but
also a number of some quite simple rural views. And unlike Cock's *Small Landscapes* or Grimmer's
By Antwerpen series, these sites are all carefully identified on both the prints and surviving drawings.
Beginning with a view of the ducal palace at Brussels, they include the castle of Revieren; the vil-
lages of Eggevoort, Elsen, and Schaerbeecke (modern Schaarbeke); and several abbeys and "pleas-
ant places" that were swallowed up long ago by the expanding Brussels metropolis.[75]

How many impressions of the *dorpshuysboecken* circulated in the generation after Cock's death in
1570 is not known, but the later history of the original plates can be reconstructed in part. At least
some of the plates remained in the possession of his widow, Volcxken Diericx, for the inventory of
Diericx's estate, made in 1601 just after her death, lists twenty-two plates of *boerenhuyskens*, or "peas-

ant cottages," presumably representing some portion of the *Small Landscapes*.[76] These plates were apparently bought at the sale of Diericx's estate by Philips Galle, Cock's most important successor in Antwerp. Galle seems to have had the other plates already in his possession, perhaps acquired earlier from Diericx. In any case, two further editions of the *Small Landscapes* were issued accompanied by a new title print dated 1601; in one edition, the title print bears the name of Philips Galle as publisher; in the other, Philips's name has been replaced by that of his son and successor, Theodoor Galle.[77] As Manfred Sellink has suggested,[78] Theodoor was probably taking over the family business just at this time, but the appearance of two editions of the *Small Landscapes* in what was very likely a short period also indicates that they were well received by the print-buying public.

The new title print provided by Philips Galle for his 1601 edition of the *Small Landscapes* has a bucolic framework of trees, fruits, vegetables, and animals, along with an inscription that assures the buyer that these views depict "regions and rustic villas in the powerful duchy of Brabant, depicted with graceful elegance by Cornelis Cort."[79] This represents the earliest attempt to assign a name to the original designer of the *Small Landscapes*, and although it has been occasionally accepted by modern scholars, there is no convincing evidence for this attribution. Cort had been trained by Hieronymus Cock, for whom he worked until he departed for Italy in 1565–66; most of his prints for Cock were figure compositions after such Italianizing artists as Frans Floris and Michiel Coxie. After a brief stay in Venice, where he made some prints after Titian, Cort went on to Rome, where he died in 1578. Philips Galle had worked for Cock at the same time as Cort and was probably familiar with the latter's style. Philips may also have known the few landscape subjects that Cort engraved once he had departed for Italy, but these grandiose forest scenes, done after the designs of the Brescian painter Girolamo Muziano, have nothing in common with the *Small Landscapes*.[80] What prompted Philips's attribution to Cort of a set of prints so different from his usual style and subject matter is something we shall probably never know.

In any case, it was with the publication of these, presumably the third and fourth editions of 1601, that the Galles unwittingly launched the *Small Landscapes* on a new phase in their career. This new phase, however, did not find its major development in the Southern Netherlands. While the inspiration of the *boerenhuyskens* can be seen in an occasional painting or drawing by Jan Brueghel and Joos de Momper,[81] the younger Flemish artists generally remained faithful to the rustic landscape forms developed in the generation of Pieter Bruegel the Elder. It was in the Northern Netherlands that the *Small Landscapes* had their most potent and enduring influence.

2

The Rustic Landscape in Holland

CLAES JANSZ VISSCHER

Even as a picture be it never so exquisite, delighteth the eyes a litle
while: So all this varietie of persons and places pleaseth us with the
noveltie, yet but onely for a short season.

— Justus Lipsius, *De constantia*

I t was most probably through the new editions issued by the Galle firm in 1601 that the *dorp-shuysboecken* entered the Northern Netherlands to play a significant role in the early development of the Dutch rustic landscape. Within a period of scarcely more than fifteen or twenty years, the rustic landscape passed through three stages. The first stage began about 1600, possibly earlier, with drawings, some quite casual and often done after life, that artists made for their own use or for the enjoyment of colleagues and patrons. By the middle of the second decade, similar rural views appeared among the landscapes prints that publishers issued in great numbers and often in large series to a public eager for novelty. Very soon thereafter, the rustic landscape entered the domain of painting, rapidly achieving a dominance that it would long maintain in Holland and in Europe in general. Why the *boerenhuyskens*, by now almost a half century old, should have exerted their most profound and long-lasting influence in Holland and why the rustic landscape should have become a staple of Dutch art with such astonishing swiftness are complex questions to which we can propose some answers.

A partial answer, surely, is that the *Small Landscapes* appeared just at the crucial moment when the Dutch Republic was developing its own political and cultural identity. This applies to art as

well. The Northern Netherlands had no distinctive landscape tradition during the sixteenth century. There had been, of course, some superb Dutch painters of landscape in this period. Lucas van Leyden was celebrated for the landscape backgrounds in his engravings; Van Mander considered him superior in this regard to Albrecht Dürer.[1] Jan van Scorel filled many of his paintings with luminous far-flung vistas of mountain peaks, inspired by his travels through the Alps and Italy; and Maerten van Heemskerck, late in his career in the 1560s, produced some landscape paintings with biblical subjects.[2] But these artists were not landscapists but instead primarily figure painters, generalists who painted a variety of subjects, including altarpieces, devotional images, and portraits. Heemskerck's landscapes, in fact, are almost unique in his oeuvre. Indeed, until the last few decades of the sixteenth century, the Northern Netherlands possessed few, if any, artists specializing in the kinds of secular subjects that had long been popular in Antwerp.[3] For the most part, Dutch painters specializing in particular subjects pursued their careers in Antwerp, where they could find an international clientele. Jan Mandyn, for example, was born in Haarlem about 1500 and was working in Antwerp by 1530, where he produced *diableries* in the style of Hieronymus Bosch. Jan van Amstel, to judge from his name evidently a native of Amsterdam, appeared about 1527–28 in Antwerp, where he specialized in biblical and tavern scenes teeming with small figures. Another Amsterdammer, Pieter Aertsen, went to Antwerp sometime before 1535 and studied with Mandyn, after which he earned fame for his remarkably realistic still lifes and market scenes and his pictures of peasant revelry, until he returned to Amsterdam in the mid-1550s.

We know very little about art collecting in the Northern Netherlands during most of the sixteenth century, but the more prosperous Dutch burghers may well have acquired many of their paintings and prints from Antwerp, either directly or through dealers.[4] In any case, the situation for artists changed radically during the last two decades of the century, when large numbers of people fled north from the Southern Netherlands to escape both religious persecution and the economic effects of the Eighty Years' War.[5] It is estimated that some sixty to ninety thousand Flemings went to Holland in the years after 1575, especially after the fall of Antwerp to Spanish troops in 1585. In search of employment no less than religious freedom, these émigrés included a number of artists, among them, according to one historian,[6] some 225 painters, who either directly or after a period of activity elsewhere, between 1580 and 1595 settled in one or another of the Dutch towns.[7] Karel van Mander, a native of Meulebeke in Flanders, long resided in Haarlem before ending his last years in Amsterdam, where he published his *Schilder-boeck* in 1604; Jacob de Gheyn II, born in Antwerp, worked in Haarlem and The Hague. Among the landscapists were Hans Bol and Gillis van Coninxloo from Antwerp, both finally settling in Amsterdam. Roelant Saverij and his brother Jacob, born in Courtrai, worked in Utrecht and in various towns in Holland. Although these Flemish émigrés have been recently studied, their full impact on the course of Dutch painting is still not clearly understood, although it must have been considerable. It may be true that, as Samuel van Hoogstraeten wrote in 1678, "in the be-

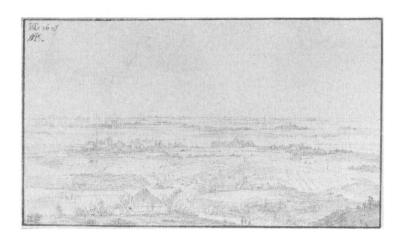

FIGURE 38
Hendrick Goltzius, *View of the Dunes near Haarlem*, 1603, drawing. Rotterdam, Museum Boijmans Van Beuningen.

ginning of our century, the walls in Holland were not hung so thickly with paintings as they now are,"[8] but this situation must have begun to change rapidly. In the first place, the influx of so many painters during a fairly short period undoubtedly made it easier for an increasingly affluent Dutch public to acquire works of art in greater numbers. The Flemish artists offered this expanding market a dazzling array of pictures of the kind that had long been painted in Antwerp: genre scenes, kitchen pieces, and landscapes, as well as such relatively novel subjects as flower pieces and still lifes. Flemish artists must also have taught their Dutch colleagues the advantages of specializing in one of these subjects, and a number of them took on Dutch students, two circumstances that directly affected the development of the Dutch landscape tradition.

The Galle editions of the *boerenhuyskens* thus appeared at a time when Dutch artists were open to a wide variety of artistic influences. Even so, these prints would not have exerted such a decisive influence had there not also been other factors at work, factors that we will examine later. What concerns us here is that the first phase of development in the rustic landscape, in the form of drawings, can be seen in the work of three artists who differed considerably in personality and career: Hendrick Goltzius, Abraham Bloemaert, and Claes Jansz Visscher. Goltzius was a virtuoso draftsman and engraver in Haarlem, who had also been a print publisher for some years before abandoning this enterprise about 1600 to devote himself to painting. Bloemaert was an eminent painter and draftsman working in Utrecht. Visscher, as we have seen, was a draftsman, an etcher, and, perhaps most significantly, at the beginning of his career a major publisher of prints. Of these three artists, the importance of Goltzius in the development of the Dutch rustic landscape has long been stressed;[9] in comparison with the other two artists, however, his contribution was perhaps the most modest in scope. Three drawings survive by Goltzius that show the countryside around Haarlem, two of them dated 1603. One sheet depicts a plowed field and cottages; another represents the dunes near Haarlem (Fig. 38).[10] Occurring among the many landscape drawings of a quite different type in Goltzius's oeuvre, including Italianate arcadian scenes, imaginary mountain views, and fantastic rocks in the style of

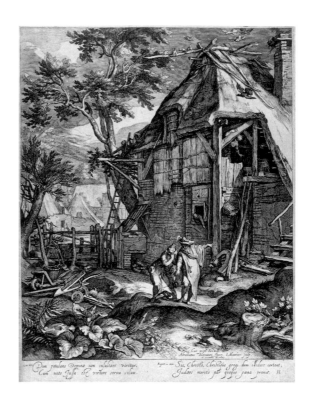

Bruegel, these modest, unpretentious compositions stand out both for their realism and for the seemingly artless simplicity of their compositions. Major landscape elements, such as dunes and plowed fields, are cut off at the lower border in an arbitrary way, as if nothing else was included in the artist's view. Indeed they appear to have been done directly on the spot. Writing sometime before 1604, Van Mander tells us that whenever Goltzius recovered from one of his frequent illnesses, he "had to take daily walks in order to liven his spirits"; it may have been on these occasions that he made his sketches of the Haarlem countryside.[11] However this may be, these drawings differ from the *Small Landscapes* in several respects, particularly in their panoramic format and the somewhat elevated viewpoint of the dune landscape. Nevertheless, we may agree with the consensus that Goltzius's Haarlem drawings were created under the influence of the *dorpshuysboecken*. But Goltzius was not alone in this; about the same time, several of his Haarlem colleagues displayed a similar interest in the local landscape. In a drawing of 1603, his stepson Jacob Matham depicted some farm buildings near the ruins of Brederode Castle; Matham's composition comes even closer to Cock's print series in its concentration on the cottages and sheds.[12] Jacques de Gheyn II also produced rustic views: one drawing shows a farm in early spring or late fall, to judge from the bare branches of the pollarded willows and other trees.[13] Another sheet, this one of a farm cottage, is dated 1603; he later transferred the composition to an etching (see Fig. 101); in this case, however, De Gheyn may have been inspired not so much by the *Small Landscapes* as by the landscapes of Bloemaert, as we shall see.

Coming as they do only a few years after the 1601 republications of the *Small Landscapes*, Gol-

tzius's Haarlem landscapes are usually cited as the earliest examples of their influence in the Northern Netherlands. The impact of Cock's *boerenhuyskens* on Bloemaert is more problematic. From Bloemaert's hand we have a number of drawings that, although more restricted in focus, have much in common with the *boerenhuyskens* in their objective delineation of humble rural scenes.[14] Cottages and barns constitute Bloemaert's major landscape subjects, interspersed with huts, sheds, and other rustic structures; some drawings record well-kept farms, but Bloemaert seems to have been particularly fascinated by structures in an advanced state of decay. A particularly fine drawing now in Cleveland (Plate 2), for instance, features an old shed delineated with loving attention to every detail of its weather-beaten boards and crumbling brick walls.[15] Other sheets show buildings in total ruin; one depicts what probably is a rustic privy (see Fig. 106). Although a group of these drawings is dated 1650, Bloemaert must have begun making them long before, for many of them correspond both in subject and technique to drawings that he had apparently been making for sometime in the vicinity of Utrecht. In his biography of Bloemaert, Karel van Mander tells us that

> with art lovers, there are very subtle landscapes by him [Bloemaert] with some well-observed and burlesque [*drollighe*] peasant houses, peasant implements, trees and pieces of ground—things which are to be seen in great variety round about Utrecht and which are drawn by him; for he does a great deal after life and he has a very clever manner of drawing and penmanship to which he adds some water colors so that it looks particularly good.[16]

If we accept Van Mander's testimony, then Bloemaert must have been producing these rustic scenes sometime before 1604, the year in which Van Mander's *Schilder-boeck* was published, thus about the same time as the rural landscapes of Goltzius, or possibly even a little earlier. The Cleveland drawing, in fact, has recently been dated to the 1590s,[17] and some of the other extant sheets may have originated in the same period. As this is before the publication of the 1601 edition of the *dorpshuysboecken*, Bloemaert may either have conceived his own subjects independently of Cock's prints, or he knew the latter series in an earlier edition.

In any case, Bloemaert's drawings circulated in the Northern Netherlands soon after the turn of the century, probably among colleagues such as the Amsterdam artist Cornelis Ketel, who dedicated a *klinkdicht*, or sonnet, to Bloemaert, consoling him on an illness that had confined him to his bed "in the Golden year [1600]."[18] In Haarlem, Jacques de Gheyn II's *Farm Scene* etching of 1603 may be indebted to Bloemaert's style, and beginning in this year several Haarlem engravers reproduced a number of figure compositions directly after Bloemaert, in which the landscape settings owe much to the style and content of his Utrecht drawings; among them are two large and beautifully executed prints by Jacob Matham, *Abraham Dismissing Hagar* (Fig. 39), dated 1603, and *Parable of the Tares*,

of 1605.[19] About this time, Jan Saenredam issued a large *Ganymede* after Bloemaert.[20] In the same period, Simon Frisius, then working probably in The Hague, etched a landscape after Bloemaert containing a farmhouse and weathered barn.[21]

Despite their depictions of domestic scenery, however, neither Goltzius nor even Bloemaert can be considered as the prime mover in the beginnings of the Dutch rustic landscape. Goltzius's drawings were probably originally undertaken for his personal enjoyment, intended at most to be circulated among a small circle of friends. And it is difficult to see how they could have exerted a significant influence on later developments. Bloemaert's drawings were apparently destined for a rather larger group of connoisseurs and collectors, and their influence on other artists was ultimately more substantial than the early prints by Matham, Saenredam, and Frisius might suggest. But this development occurred only after the rustic scene had been institutionalized, so to speak, in Holland, a process that was preeminently the accomplishment of Claes Jansz Visscher.

Although he was considerably younger than Goltzius and Bloemaert, his contributions followed theirs by only a few years. Born in 1586 or 1587 at Amsterdam, Visscher was a draftsman and an etcher, but his career as a print publisher deserves a closer look before we proceed further, because it represents the final stage of a process that had begun late in the previous century and was to be of paramount importance for the further development of a native school of landscape imagery. With the advent of Hieronymus Cock's publishing house, the Sign of the Four Winds, about 1550, Antwerp gradually achieved a virtual monopoly in print publishing in the Netherlands.[22] Such print publishing as existed in the Northern Netherlands, chiefly in Amsterdam and Haarlem, was conducted on a fairly small scale, and printmakers and designers were just as apt to send their prints and plates to Antwerp. Here, Cock and his colleagues, through their associations with Christophe Plantin and his European connections, had access to foreign markets probably not readily available to Haarlem and other Dutch towns.[23] Thus while a number of drawings by Maerten van Heemskerck were reproduced by the Haarlem printmaker Dirck Volckertsz Coornhert, Heemskerck sent the vast majority of his drawings to Antwerp to be engraved and etched by artists in the employ of Hieronymus Cock and his successors; even some of Coornhert's own plates were shipped south to Cock.[24] Antwerp attracted such Dutch printmakers as Cornelis Cort, who, we may remember, worked for Cock before departing for Italy about 1565. Cock's chief successor, Philips Galle, was himself a Haarlem printmaker who had trained with Coornhert. While still in Haarlem, Galle published prints on his own, but he also executed plates for Cock, and by 1570 had departed Haarlem to settle in Antwerp for good.[25] Antwerp's predominance was first seriously challenged only in 1582, when Hendrick Goltzius, after engraving plates earlier in his career for Philips Galle in Antwerp, established his own publishing enterprise, his first prints proudly inscribed *gedrukt tot Haerlem*, that is, "published at Haarlem."[26] Goltzius ceased his publishing activities about 1600, but only after he had trained his stepson Jacob Matham and other pupils, some of whom published prints under their own name.[27]

Too young to have trained with Goltzius, Visscher is generally assumed to have studied with the Flemish émigré David Vinckboons, painter, draftsman, and occasional printmaker; this is possible, as his early work includes a number of prints after Vinckboons's designs.[28] When Visscher was eighteen, in 1605, he worked as an etcher for the Amsterdam publisher Willem Jansz Blaeu; he also etched at least one plate for Theodoor Galle.[29] Very soon, however, he started publishing prints on his own and was on his way to making the Sign of the Fisher, as he called his shop in a punning reference to his name, as famous as Hieronymus Cock's Sign of the Four Winds and one of the most important print-publishing establishments in Holland. Visscher published numerous prints after contemporary Dutch artists, but he also apparently bought up impressions of old prints as well.[30]

Like Theodoor Galle and many other print publishers before and after him, Visscher also built up his stock of prints through the acquisition on a large scale of used copperplates of other publishers and printmakers, not only the productions of living draftsmen but also old plates after Heemskerck and other well-known artists that had originally been produced for Hieronymus Cock and his successors.[31] Often Visscher obtained these plates only after they had been reissued one or more times previously, including a number of plates originally published by Cock after Pieter Bruegel the Elder.[32] Many of these plates Visscher acquired at various estate auctions in Holland. As early as 1610 he attended the estate sale of the bookseller Cornelis Claesz, possibly of South Netherlandish origins but living in Amsterdam since 1578.[33] In addition to books, Claesz also had a stock of old prints and plates, many of the latter acquired from Antwerp. As we shall see, some of Visscher's most significant purchases were made on this occasion. Visscher also attended the estate sale of the print dealer Nicolaes de Clerck, held at Delft in 1626, in which he bought four plates, and the auction of Hendrick Hondius's estate in 1650, on which occasion he purchased the majority of Hondius's plates.[34] This accumulation of previously owned plates may have made Visscher, as George Keyes has well expressed it, "the hackneyed producer of tired editions of well-known prints,"[35] but it also enabled him to play a crucial role in the development of the landscape print in Holland.

Equally significant, the earliest phase of Visscher's career coincided with the first blossoming of Dutch cartography, a circumstance that goes far to explain his lifelong interest in topographic subjects. His early association with Willem Jansz Blaeu brought him into collaboration with some of the most famous Dutch mapmakers of the period, for whom he etched vignettes, cartouches, and decorative borders, some after designs by Vinckboons. This kind of activity for Blaeu and others continued through the end of the second decade of the century, when such etched decorations were generally left to his workshop; thereafter maps of various kinds, both new maps produced by Visscher, and especially his assistants, and reprints of older maps, became a staple of the Sign of the Fisher.[36] Some of his contributions to these cartographic enterprises consisted of views of Flemish and Dutch cities.[37] Typically these views showed their "profiles," generally visible beyond a watercourse with ships or a broad stretch of rustic scenery outside the city walls, the latter images very much in the

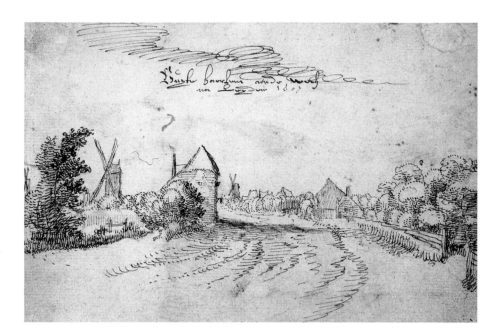

"town-and-country" tradition established in the sixteenth century (see Fig. 25) and continued by Pieter Bast in his views of Franeker and other North Netherlandish towns published between 1598 and 1602. Visscher, incidentally, reissued at least two of Bast's views about 1612.[38] For a map of the Province of Holland published by Pieter van der Keere in 1610, Visscher also provided city views and other subjects, including several vignettes showing some typical employments of Holland and a particularly sensational Dutch "wonder," a countess who in 1276 had given birth to 360 children.[39]

Perhaps as important for the development of Visscher's landscape interests were the many new editions of Lodovico Guicciardini's *Description of All the Netherlands*. Written by an Italian historian and man of letters residing in Antwerp and first published in 1567, this is the earliest detailed description of the Netherlands, its cities and towns, its industry, agriculture, and people. In Holland, the later fortunes of this famous book began with the publication of a French edition by the bookseller Cornelis Claesz in 1609.[40] Its appearance coincided with the beginning of the Twelve Years' Truce between Spain and the Northern Provinces, and it was very much in response to a newly emerging political identity that a number of editions of Guicciardini's work appeared in Holland within the few next years. After his death in 1610, Claesz's plates for the maps and illustrations in this volume were reemployed by Blaeu in the first Dutch translation of Guicciardini, published in 1612, along with new illustrations, among them three views by Visscher of major Amsterdam monuments. For a Latin edition published by Blaeu the following year, Visscher contributed three more etchings, including a view of the New Exchange at Amsterdam. Even though at least one contemporary, Jean

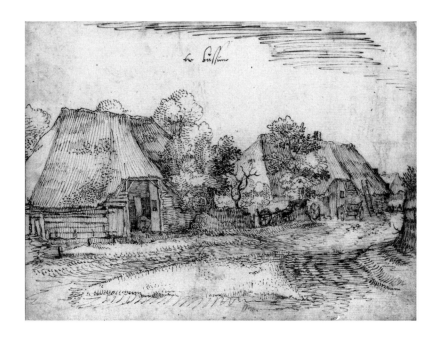

François le Petit, complained that Guicciardini had emphasized Brabant and Antwerp at the expense of the cities of the Northern Netherlands,[41] his *Description* enjoyed enough popularity to engender competition from a colleague, Hendrick Laurensz, who between 1613 and 1625 published four editions of Guicciardini in different languages. Smaller in format than Blaeu's volume, these editions contained numerous profile views of Netherlandish cities, influenced perhaps by the vignettes that Visscher had provided for the mapmakers.

It is precisely in the context of Visscher's city views and other topographic work that we must understand the landscape drawings that he began to produce from 1605 on. In addition to depictions of various notable buildings in Amsterdam, they include scenes of the Dutch countryside: villages, farmhouses, and an occasional rustic *herberg*, or inn.[42] Many of these drawings are uncompleted in the foreground; this suggests that they were done on the spot, although there is some evidence that Visscher may have made at least some of them in the studio, working from sketches of individual buildings and views.[43] In any case, these drawings frequently bear Visscher's signature and the names, presumably added by his hand, of villages and manor houses in the vicinity of Amsterdam, Leiden, and especially Haarlem, as well as various places along the Amstel river such as Rijnsaterswoude and Sloterdijk (Figs. 40, 41). The earliest date on these drawings is 1607; their unpretentious subjects are very much in the spirit of the *Small Landscapes* and so, too, are their viewpoints.

As innovative as they were for the development of Dutch landscape, these little drawings might easily have languished in Visscher's studio, had he not decided to issue a group of them as etchings.

Visscher had already published a number of landscape prints, a phenomenon that distinguishes him markedly from most of the earlier print publishers in Holland. While Goltzius made a number of landscape drawings, his landscape prints are relatively few, being confined to woodcut illustrations for Van Mander's translation of Virgil's *Bucolics* and *Georgics* (see chapter 6) and an independent series of four chiaroscuro woodcuts, generally dated to the early 1590s.[44] The latter series constitutes a sampling of various landscape types, including a coastal scene with cliffs, a mountain scene with a waterfall, and a rustic landscape with a peasant cottage (see Fig. 113). In general, however, neither Goltzius nor the engravers and etchers in his circle produced many prints that can be considered landscapes in the narrow sense of the word. From Jacob de Gheyn II we have a river landscape (about which more later), two farmhouse views, one dated 1603 (see Fig. 101), and finally a suite of six landscape etchings probably after his own designs: not an impressive number of landscapes in a total production of over 430 prints.[45] Jacob Matham and Jan Saenredam between them issued five landscapes with biblical and mythological subjects after Bloemaert; Matham published *Landscape with Daedalus and Icarus* after Goltzius and a large mountain landscape, which, the inscription informs us, was portrayed after life (*ad vivum*) in Bohemia by Roelant Saverij.[46]

In general, the Dutch printmakers before Visscher concentrated on figure compositions. Landscapes were left mostly to several expatriate Flemings who had settled in Holland from the late sixteenth century on. One was Nicolaes de Bruyn, a native of Antwerp first recorded in Rotterdam in 1617, although probably already in the North before then, as he issued a number of landscape prints, dated between 1601 and 1607, after the designs of other Flemish artists then residing in Holland: forest views by Gillis van Coninxloo and David Vinckboons, panoramas by Hans Bol, and the Alpine scenes of Roelant Saverij.[47] De Bruyn's pupil, Jan van Londerseel, working in Amsterdam by 1600, engraved landscape designs by the same artists, especially Vinckboons (Fig. 42), and by Gillis de Hondecoeter.[48] A third expatriate who published the Flemish landscapists was the engraver Hendrick Hondius, who was born in Duffel, Flanders, studied in Antwerp, probably had connections with Philips Galle, and settled in Holland sometime before 1597.[49] His earliest prints include four done about 1600 after a little-known Dutch artist, Gillis de Saen, whose landscapes strongly recall the Flemish world landscapes of the previous century, as well as landscapes after Gillis Mostaert and Joos van Liere (see chapter 1).[50] He also issued two series of landscapes titled *Topographia variarum regionum*, dated 1611 and 1614 respectively, that were etched by Simon Frisius after Matthys Bril, a Fleming working in Italy until his death in 1583.[51] Totaling fifty-two plates, it represents the most extensive landscape series published since Cock's *Boerenhuyskens*, although this would shortly be eclipsed by Visscher. While Hondius's landscapes range from small to medium size, those of Londerseel and especially De Bruyn are often quite large; De Bruyn's *Landscape with Ducks and Waterfowl* after Jacob Saverij, for example, measures almost 45 by 70 centimeters, thus considerably larger than Matham's *Mountain Landscape* etched after Roelant Saverij, and exceeding in scale even the "great

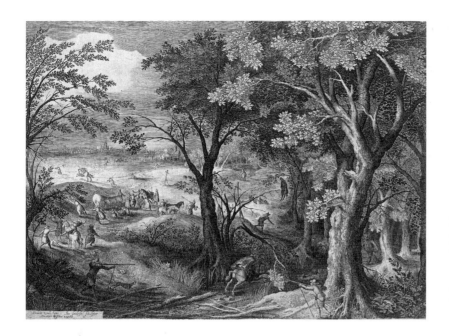

FIGURE 42
Jan van Londerseel, after David
Vinckboons, *Landscape with
Travelers Attacked by a Gang of
Robbers*, engraving. Cleveland,
The Cleveland Museum of Art.

double folios" and "royal sheets" on which many of the larger plates were printed.[52] These large, showy prints, the very "peonies" of the engraver's art with their fine detail and delicate gradations of tone, must have served as eminently satisfactory substitutes for the landscape paintings they so often approach in size.

Visscher never created or commissioned landscape prints of such magnitude, and whereas the landscapes of De Bruyn and Londerseel, and to a large extent those of Hondius, were engraved, the landscapes produced by Visscher and his shop were always etched. This reflects a general trend. As Theodore Schrevelius remarked about midcentury, most of the younger Dutch printmakers abandoned engraving for etching,[53] and with good reason. For one thing, it was cheaper because less laborious. The etcher's needle was faster than the engraver's burin, more closely approximating the draftsman's pen or pencil in ease of execution. Indeed, while engravers generally underwent extensive training, sometimes as goldsmiths, painters often casually took up the etching needle, which more easily rendered the painterly effects of foliage and atmosphere. Visscher must have appreciated the suitability of etching for landscapes fairly early on; he later told Constantijn Huygens that he owed his own facility as a printmaker to an etching of Jacques de Gheyn II, a *Pilgrims at Emaus* set in a "most charming" landscape.[54]

The first landscape prints from Visscher's own hand were probably four plates issued in 1606; they show scenes from the life of Christ after David Vinckboons placed in elaborate forest settings. These were followed in 1608 by four more Vinckboons landscapes, published by someone else.[55] In the same

year he etched a fairly large and elaborate composition after Coninxloo, *Mountainous Landscape with Tobias and the Angel;* published under his own address, it may well reproduce the drawing that Visscher bought at the sale of Coninxloo's estate the same year.[56] This print and an etching after Joos de Momper, the *Autumn* for a set of *Four Seasons* published by Theodoor Galle,[57] were the only landscapes in the older style that Visscher etched himself, and he apparently never commissioned landscapes after the Flemish expatriates then residing in Holland, although this is not certain. His address appears on a number of landscapes engraved by De Bruyn and Londerseel, and while he acquired some of the plates only after they had been reissued by other print publishers, other plates may have come into his hands fairly soon after their execution.[58] This is probably the case with Londerseel's engraving after Vinckboons of *Landscape with Travelers Attacked by a Gang of Robbers* (see Fig. 42), of which there exist fine impressions with Visscher's address.[59] His cartographic and topographic interests, however, soon led Visscher to landscapes of a quite different kind. In 1610 he purchased at least three sets of plates at the auction of Cornelis Claesz's estate; they were the twenty-four scenes of places in the Brussels countryside, after drawings perhaps by Hans Bol or Jacob Grimmer (see Fig. 37), the set of *Labors of the Months* designed by Gillis Mostaert in the spirit of the *Small Landscapes* (see Fig. 34), and very possibly the *By Antwerpen* series after drawings by Grimmer (see Fig. 36).[60] It is likely that Visscher began printing from these plates very soon after he acquired them.

No sets of the Galle editions of the *boerenhuyskens* were included in the 1610 auction of Claesz's inventory; Visscher could have obtained these prints through his association with Theodoor Galle. And we may assume that it was the reissue of this series of prints that prompted Visscher to make etchings after some of his own drawings. These include *View of Diemen*, executed about 1609, and *Country House and Orchard of Jan Deyman* (see Fig. 82), as well as a suite of four views of rural sites near Amsterdam.[61] Visscher also set about etching the only landscape series after his own designs, the *Plaisante Plaetsen*, generally dated to about 1611–12 (see Figs. 58–69).[62] For this series he turned to a group of sketches that he had made a few years earlier, about 1607, of various places near Haarlem. Visscher selected Haarlem for this honor for good reasons, as we shall discover later (see chapter 5), and he was much more concerned than Cock had been in identifying the particular places depicted. In this respect, he may have been influenced by the Brussels series. Not only does Visscher's title plate (see Fig. 58) clearly announce that the rustic scenes that follow belong to the environs of Haarlem, but this page is followed by a table of contents (see Fig. 59) with a list of the specific places, carefully keyed to the number inscribed on each print. Visscher is very much the topographer here, accustomed to labeling views and providing keys to illustrations in the etchings that he added to the maps of Blaeu and other cartographers.[63] Together with the scene on the table of contents, Visscher provides us with thirteen views of hamlets, country roads, and fields, and, as in the *boerenhuyskens*, he includes two country *herbergen*, which he identifies as the establishments of Potje and Pater. Deviating from his model, however, he omitted views of castles and manor houses, although there were

FIGURE 43
Claes Jansz Visscher, title
print, from the *Small
Landscapes*, 1612, etching.
Amsterdam, Rijksmuseum.

a number of such buildings in the vicinity of Haarlem. On the other hand, he adds a ruin, a motif absent in the *Small Landscapes;* the final print depicts some impressive remains labeled *t' Huys ter Cleef,* or "the House at Kleve," a site that would have had strong patriotic associations for the Dutch market.[64] Of the drawings that he employed for his etchings, five have survived, to my knowledge, and in general they show that he adhered with reasonable fidelity to the forms of the farmhouses and other buildings depicted in the various preliminary drawings (see Fig. 40).[65] However, he added or altered such details as foliage, fences, and the like to complete the composition, and he enlivened his landscapes with numerous figures. Visscher may have intended more views for his *Plaisante Plaet-sen;* the table of contents has considerable blank space in the right-hand column for more titles, but what he might have included is a matter for speculation in a later chapter.

In any case, it is conceivable that Visscher interrupted his work on the *Plaisante Plaetsen* to add some of the *Small Landscapes* to his stock of landscape prints. Not possessing any of the original plates, he made etched copies, in smaller format, of twenty-three of the original prints; these he issued in 1612 (Figs. 43–47).[66] Visscher selected most of his views from Cock's second series of 1561, augmented by one print from the 1559 set and a totally new composition apparently of his own invention that served to conclude the series. The original designs were also transformed. The somewhat rigid lines of Cock's prints became more flexible under Visscher's etching needle, softer and more atmospheric. The resulting effect is similar to that of Visscher's own Haarlem views of about 1611–12. He also made numerous minor adjustments to the compositions, including the cloud for-

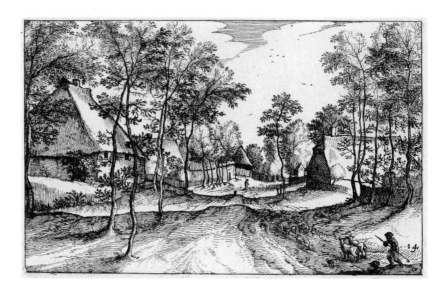

FIGURE 44
Claes Jansz Visscher,
landscape, from the *Small
Landscapes*, 1612, etching.
Amsterdam, Rijksmuseum.

FIGURE 45
Claes Jansz Visscher,
landscape, from the *Small
Landscapes*, 1612, etching.
Amsterdam, Rijksmuseum.

mations and foreground terrain (compare, for example, Figs. 15 and 44). The trees generally assume
a more luxuriant foliage, alleviating the seasonal ambiguity they sometimes display in the original
prints. Visscher also made frequent alterations in the figures; in one instance (Figs. 13, 45), he could
not resist inserting two anglers in a boat at lower left (probably another punning reference to his name).
Despite these changes, however, and an occasional cropping of the composition, Visscher remained
reasonably faithful to the original designs, with one exception. This is the penultimate view (Fig.
46), the only one taken from the original series of 1559 (see Fig. 7). In his copy, Visscher extensively
modified the clouds and trees and replaced the figures in the road with a wayfarer and a flock of birds.

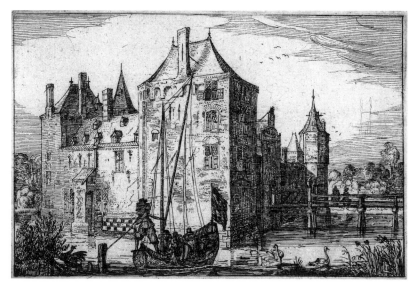

FIGURE 46
Claes Jansz Visscher,
landscape, from the *Small
Landscapes*, 1612, etching.
Amsterdam, Rijksmuseum.

FIGURE 47
Claes Jansz Visscher,
landscape, from the *Small
Landscapes*, 1612, etching.
Amsterdam, Rijksmuseum.

The final and only completely original view in Visscher's series shows an impressive castle surrounded
by a moat (Fig. 47).[67] We may guess why he chose this subject: it balances the large tower depicted
in the first view, often identified, as we have seen, as the Roode Poort, or Red Gate, of Antwerp. Re-
placing Cock's apparently aimless sequence of images and developing further the journey theme of
his *Plaisante Plaetsen*, Visscher in effect conducts his viewers on an excursion, leaving the city gate
and passing through various peaceful scenes in the countryside before arriving at the last scene, where
a boat waits to ferry them to their final destination.

Visscher also provided a new title print for this redaction of the *boerenhuyskens* (see Fig. 43). The

Latin inscription reads in translation: "Some small residences and estates of the duchy of Brabant, delineated by P. Breugelio, and for the sake of painters, engraved and brought into light [published] by Claes Jansz Visscher at Amsterdam, 1612."[68] The first part of the inscription was adapted from Philips Galle's original title print, and Visscher was either unaware of, or chose to ignore, that one of the "Brabantine" sites he reproduced (no. 22) was in fact the Dutch castle of Oud-Alkemade (B. 28). But he deviated from Galle's title print in several respects. One was his assertion that these prints had been made "for the sake of painters" (*in pictorum gratiam*), although it was not without precedent. Cock himself had employed similar language, in a series of landscapes etched after Matthys Cock.[69] Similarly, in a stock list of 1609, the bookseller Cornelis Claesz had recommended his prints as "very serviceable for painters, glass painters, engravers," and the like.[70] Although such appeals very likely constituted an effective advertisement, aimed at a not unimportant segment of their potential audience, we may be sure that all these entrepreneurs were aiming for a much broader market.

Market considerations probably also prompted Visscher's second deviation from Galle's title print, his claim that these views were "delineated by P. Breugelio," that is, Pieter Bruegel the Elder. He reinforced this attribution with the figure of a peasant holding a set of bagpipes, an image evoking Bruegel's scenes of peasant revelry. But precisely why he attributed the *Small Landscapes* to Pieter Bruegel the Elder is something of a mystery. Visscher was well aware, of course, of Bruegel's fame with the general public. Not only did he buy up old plates after Bruegel's designs, but he also published a copy after Bruegel's *Alchemist*. And when he reissued Hendrick Hondius's reversed copy of Bruegel's *Big Fish Eat the Little Fish*, first published in 1619 as a design after Hieronymus Bosch, Visscher did not hesitate to replace Bosch's name with that of Bruegel.[71] Bruegel's name would have appealed more to prospective buyers than that of Cornelis Cort, designated as *inventor* on Galle's original title print. But Visscher may also have known of a little group of drawings very similar in format to the *boerenhuyskens*, views of farms and hamlets bearing Bruegel's name and dates ranging between 1560 and 1562.[72] These sheets were long accepted as authentic productions by Bruegel until 1985–86, when Hans Mielke demonstrated that they were made about a generation later, probably in the 1590s by Jacques Saverij, then working in Haarlem.[73] Mielke further suggested that Saverij intended these drawings as deliberate forgeries, perpetrated to take advantage of the booming market in the art of Bruegel and other earlier Flemish masters. As it happens, Visscher republished another apparent Bruegel forgery, this one an etching by Jacob de Gheyn II, from a plate that Visscher may well have acquired in the 1610 auction of Claesz's estate; a mountain scene with a castle on a high rock, inscribed, *P. Bruegel inv. 1562* and *I. D. Gheijn fe 1598*.[74] If Visscher was also familiar with the "Bruegel" drawings of Jacques Saverij, this may well have led him to believe that it was Bruegel, and not Cort, who had been the real creator of the *Small Landscapes*.

Visscher's *Plaisante Plaetsen* and his copies of the *Small Landscapes* came at a time when other print publishers in Holland were beginning to flood the market with landscape print series of all kinds.[75]

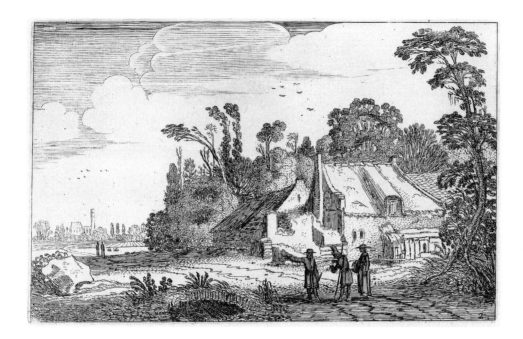

Figure 48
Jan van de Velde,
landscape, from the
Sixty Landscapes,
etching. Amsterdam,
Rijksmuseum.

They included Hendrick Hondius, who had issued his first landscape etchings after Matthys Bril in 1611, Robert de Baudous, of Brussels origin and some ten years Visscher's senior, who had been in Amsterdam since 1591, and Boëtius à Bolswert, who issued a number of landscape prints after his former teacher Bloemaert, as well as the Haarlem printer and bookseller Jan Pietersz Beerendrecht (or Berendrecht).[76] The complex publishing history of their many landscape series can only be suggested here.[77] In 1613 Visscher etched a suite of thirteen landscape prints after the famous marine painter Claes van Wieringen; first published by the Amsterdam printer David de Meyne, they were reissued by Visscher himself in 1620.[78] In 1615 Visscher published under his own auspices eighteen views of landscapes and ruins produced by the Haarlem artist Jan van de Velde, the most prolific landscape etcher of his generation.[79] About 1616 Van de Velde provided twenty-six more landscape prints issued in two series by Visscher, who promptly followed them by three more series by Van de Velde, for a total of sixty etchings, surely the largest series of landscapes published to this date.[80] But this did not exhaust Jan's energy or powers of invention, for he etched thirty-six other landscapes during this period, which Robert de Baudous published in two sets in 1616.[81]

 Van de Velde depicted a wide range of landscape types, his favorite, it seems, being ruins both classical and vaguely medieval, as well as Italianate pastoral views and rugged mountain scenes, but he also etched a number of landscapes typically Dutch in character (Fig. 48). His cousin Esaias van de Velde, however, seems to have specialized in domestic scenery, at least before his departure from

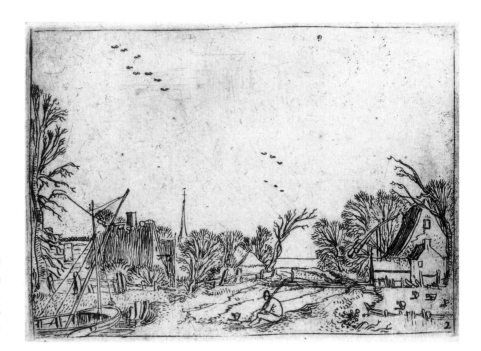

FIGURE 49
Esaias van de Velde,
Village Landscape,
etching. Amsterdam,
Rijksmuseum.

Haarlem for The Hague in 1618. Aside from a few landscape etchings apparently issued on his own (Fig. 49), Esaias also produced several series for Beerendrecht. One set, depicting chiefly various sites around Haarlem, will be discussed in chapter 5, but it should be noted that Visscher later issued most of them in reversed copies with his own address.[82] About 1616 a certain Broer Jansen, active in Amsterdam, issued ten landscape etchings by Willem Buytewech; characteristically, these were reprinted in 1621 by Visscher.[83] Indeed, Visscher also acquired and issued under his own auspices many of the landscape plates originally published by Bolswert, Broer Jansen, and Beerendrecht, sometimes long after their original publication.[84] After Beerendrecht's death in 1645, for example, a number of Esaias van de Velde's plates in his possession were acquired and reissued by Visscher.[85] One of his last such reprints was in 1651–52, just before his death, when he republished the 1611–14 series of landscapes etched by Frisius after Matthys Bril; he must have purchased the plates from the estate of Hondius.[86]

Visscher's endeavors to build up a large stock of landscape prints is well illustrated by his response on a third occasion when he was unable to obtain the original plates. This concerns a series of prints that Bolswert etched and published in 1613–14 after Abraham Bloemaert; consisting of a title plate and nineteen views, they represent a curious melange of subjects.[87] Fourteen plates, however, present a repertoire of farmsteads of a type familiar to us from Bloemaert's drawings (see Figs. 108–110). These prints will be discussed at length later, but we may note here that it was in this form that Bloe-

maert's rustic subjects, so praised by Van Mander, were widely disseminated. Inevitably they also soon attracted the attention of Visscher who, when apparently faced with the inaccessibility of the original plates, did much as he had done in the case of the Galle editions of the *Small Landscapes* and Esaias van de Velde's Haarlem series; he copied some eighteen of Bolswert's prints.[88] Published in 1620, their smaller scale (about half the size of the originals) and simpler execution suggest that Visscher offered these prints as a cheaper edition. Nevertheless, he augmented this series with eight additional cottage scenes, four of which were reduced copies of a set of large Bloemaert landscapes etched by Bolswert about 1612 (and which Visscher would later issue in copies made in his own workshop).[89] The remaining four were derived from two large prints that Jan Saenredam had published after Bloemaert around 1605, the *Ganymede* and *Farmhouse with the Prodigal Son*, as well as Jacob Matham's *Parable of the Tares*.[90] From these divergent sources the industrious Visscher thus assembled a coherent series of twenty-five cottage views, and he replaced the long inscription on Bolswert's original title plate with a shorter one: "Various lovely country houses portrayed from life by A. Bloemaert." In view of the effort that Visscher expended on this set of prints, it is tempting to ask if he envisioned them as the true Dutch successors to the "many and very attractive places" that had been depicted the previous century in Cock's *boerenhuyskens*.

Through his copies of the landscapes of other artists and his copious reissues of previously published plates, Visscher was able to achieve, if not a monopoly, then at least a predominance in the publication of landscapes, as he had done with maps and battle scenes. His struggle to corner the market in this respect recalls the intense competition between Blaeu and Laurensz during this same period to issue the various editions of Guicciardini. The later history of the landscape print at the hands of Visscher and his colleagues and competitors is much too long and involved to discuss in detail, but it suggests that the thirst for novelty in landscape views on the part of the print-buying public continued undiminished. This was especially true of the rustic landscape, and there were many reasons why the public should have been so receptive to these images of the Dutch countryside, both specific sites and what we may call "generic" scenery. All this will be examined at length in later chapters. But it must be emphasized here that this "institutionalizing," so to speak, of the domestic landscape in Dutch art was neither necessarily as deliberate nor as didactic in intention as some scholars have suggested.[91] On the contrary, it was probably the result of circumstances rather more haphazard, and certainly more mundane: the natural desire of print publishers to offer images that would appeal to the public, and in the case of Claes Jansz Visscher, the overweening ambition to carve a large niche in the print market for himself and the Sign of the Fisher.

While the phenomenal success of Visscher and his fellow print publishers must have owed much to the casual purchasers of an occasional print or print series, it must have owed even more to serious collectors, those "print sifters," to paraphrase Joost van den Vondel,[92] who chose prints of all kinds of subject matter and preserved them in albums. At least this is suggested by the few albums

that have survived from the early seventeenth century, such as the two volumes now in the Jesuit College at Trier.[93] Assembled by an unknown collector about 1616–20, they contain a great number of landscape prints of all kinds; among them are a series of landscapes after Esaias van de Velde and many etchings by Jan van de Velde, including the sixty landscapes (some prints represented in several states) published in five series by Visscher, as well as Visscher's own reduced copies of the *boerenhuyskens* and his *Plaisante Plaetsen*.[94] Another album from probably the same time contains some 232 prints, comprising a similar selection of landscapes by Hondius, Visscher, and the Van de Velde cousins, among others, augmented in this case by a group of rustic scenes by the German etcher Matthaeus Merian.[95]

Although the landscapes published by Visscher and his colleagues were generally smaller in scale than the monumental landscapes of the Flemish variety issued by De Bruyn and Londerseel, they may have been occasionally framed and hung on the wall.[96] Indirect evidence for this practice comes from David Beck, schoolmaster and amateur draftsman residing in The Hague during this period. Beck has left us a diary for the year 1624, in which he meticulously recorded his daily comings and goings. He seems to have made a number of landscape drawings, including a *ruijg lantschapken* (coarse little landscape), that he had framed and in one instance covered with a *blaetie moscovisch glas*, or a little sheet of "moscovy glass," or mica.[97] But if prints of native scenery were displayed in the same manner, people must have soon desired more substantial images to display on their walls: it is precisely during these years that the rustic landscape entered the third stage of its development, in the form of paintings. The origins and early history of the domestic landscape in Dutch painting have been amply treated by many scholars; therefore we need only sketch this development with respect to its relationship to printmaking. Here again, precedence must be awarded to Abraham Bloemaert. A number of rustic landscape paintings have been attributed to Bloemaert and dated to the years around 1600 on the basis of their similarity both to the drawings presumably executed in the same period and to the early prints of about 1603–5 after his designs. A *Landscape with the Flight to Egypt* (Plate 3) is dated between 1595 and 1605, while a number of small landscape paintings with biblical or mythological subjects are assigned to the period 1605–10.[98] As in his drawings and the *Cottages* etched by Bolswert about 1613–14, the humble structures and implements of rustic life are rendered with a decorative flourish that often exaggerates their symptoms of neglect and decay. Despite their many realistic details, however, it is difficult to consider them as true emulations of the *boerenhuyskens*, if only because Bloemaert occasionally introduced quite un-Dutch mountains into the backgrounds of his landscapes.

The pioneer in painted scenes of the domestic landscape, it seems, was Esaias van de Velde.[99] Probably another student of David Vinckboons, Esaias was in Haarlem by 1610, although no work from his hand can be documented before 1614, when he produced his first landscape etchings published by Robert de Baudous.[100] Between that year and his departure for The Hague in 1618, he also produced

a great number of drawings and some small paintings devoted to the domestic scenery around Haarlem; a good example is *Riders in a Landscape* of 1614 (Plate 4). Esaias's landscapes, in whatever medium, evoke the flat Dutch terrain much more effectively than had Visscher in his *Plaisante Plaetsen*, and Esaias also depicted the Dutch landscape as it appeared in winter, but in contrast to the crowded ice-skating scenes of Hendrick Avercamp, he reduced the number of figures in favor of an emphasis on natural features, as can be seen, for example, in a *Winter Landscape* of 1614.[101] After 1618 Esaias continued working in the same vein with a series of drawings recording various castles, country houses, and villages in the vicinity of The Hague, but he also produced landscapes of a less local character.[102] In Haarlem, however, the rustic landscape was taken up by his student, Jan van Goyen. Dividing his career between Leiden and The Hague, Van Goyen made hundreds of landscape drawings, recording many places in the local countryside in their variations of terrain.[103] More important, he produced over a thousand paintings depicting similar subjects.[104] As in the case of the Antwerp landscapist Herri Bles a century before,[105] Van Goyen's great productivity was made possible by his development of a restricted palette and fluent, rapid brushwork (see Fig. 1, Plate 12), far different from the more varied and enamel-like colors and the painstaking execution of Coninxloo and the other landscapists of his generation. Although Van Goyen probably developed his subdued tonalities to capture more faithfully the particular qualities of the Dutch atmosphere, his painterly style also enabled him to execute his landscapes more quickly and hence sell them more cheaply.[106] The same would have been true for other landscapists of the so-called tonal school, including Salomon van Ruysdael and Pieter de Molijn. It is possible that such paintings attracted customers who had previously confined themselves to buying prints, but this must remain speculation, because the socioeconomic relationships between prints and paintings have not been sufficiently studied. Nevertheless, it would seem that what Visscher and his colleagues had achieved in prints, Van Goyen and his colleagues soon achieved in painting: they both succeeded in institutionalizing the rustic landscape as a staple subject in Dutch art.

With Van Goyen and other Dutch artists of his generation, the rustic landscape developed many forms that led it far from the *boerenhuyskens* that had inspired it. Nevertheless, the particular vision of Cock's two print series was repeatedly manifested by Van Goyen, by Jacob van Ruisdael, and by a host of other landscapists. Rembrandt, too, reverted to the mode of the *boerenhuyskens* in numerous drawings that he made during his wanderings through the outskirts of Amsterdam, and the *Three Cottages* etching (see Fig. 2) appears almost as a self-conscious evocation of one of Cock's landscapes (see Fig. 6). This is not impossible, for the *Small Landscapes* continued to be available to artists for study and inspiration. The original plates saw the light of day one more time during the second or third quarter of the seventeenth century, when Theodoor Galle's son, Joan Galle, published what have been generally considered the fourth and fifth editions of these prints.[107] Joan Galle seems to have reworked the plates, chiefly by adding new staffage, etched with a vivacity and masterly freedom

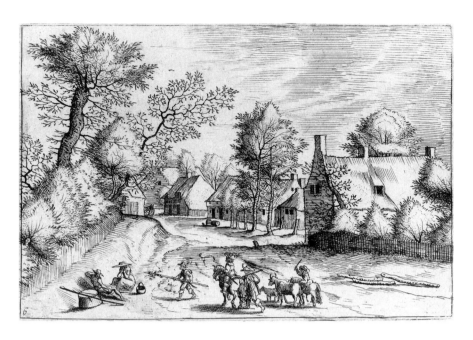

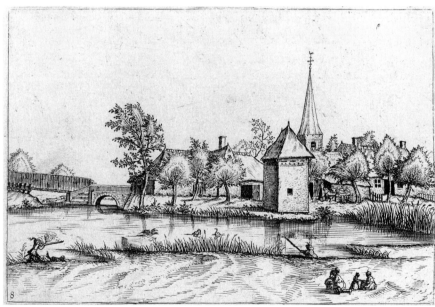

FIGURE 50
After Joos van Liere (?),
landscape, from the *Small
Landscapes*, engraving and
etching, reworked fourth or
fifth state, published by Joan
Galle. Rotterdam, Museum
Boijmans Van Beuningen.

FIGURE 51
After Joos van Liere (?),
landscape, from the *Small
Landscapes*, engraving and
etching, reworked fourth or
fifth state, published by Joan
Galle. Rotterdam, Museum
Boijmans Van Beuningen.

of line quite at variance with the often lumpish figures of the original plates. In one landscape, for example (Fig. 50), the original pair sleeping by the road (see Fig. 10) was augmented by a further group, among them a lansquenet who approaches the sleepers in a somewhat threatening manner. In the landscape with a tower (Fig. 51), Joan introduced a number of figures into the originally un-inhabited landscape (see Fig. 13), including a hunter at lower left shooting at a bird in the water (where Visscher, in his copy of this print, had placed two anglers in a boat; see Fig. 45). Similarly, the plates for Visscher's etched copies of the *Small Landscapes* were also reprinted sometime later in the century by one Pieter de Reyger (recorded in Amsterdam in 1676–77) and still later by Jochem Bormeester, a print publisher who worked in Amsterdam from 1677 to after 1690.[108]

The *Plaisante Plaetsen* that Claes Jansz Visscher had first issued about 1611–12 also had an after-life. A second state, published at some unknown date, substitutes a different set of Dutch verses for the original ones; this state was reprinted in 1718 in a volume titled *Haarlemmer Duinzang*. It was ac-companied by a descriptive text celebrating the beauties of Haarlem in terms that evoked the en-comium inscribed on Visscher's original title print, but with a great wealth of descriptive and his-torical anecdote.[109] Nor did Visscher's activities as a landscapist and topographer escape the notice of his contemporaries. This is suggested by the poem that Jan Six van Chandelier wrote after Vis-scher's death in 1652: he imagines God calling Visscher as he is working on a landscape print, invit-ing him to see the even more beautiful landscapes that exist in Heaven.[110] It was a nice conceit, al-though if any Dutch reader of the period doubted that Heaven could in fact offer scenic beauties surpassing those of Holland, their own *vaterland*, this sentiment would have owed much to the life-long efforts of an enterprising printmaker and businessman who both responded to and created the taste of his age.

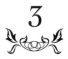

Scriptural Reading

ITS USES AND ABUSES

There is nothing void or idle in any thing.
— Roemer Visscher, *Sinnepoppen*, 1614

Moralizers, you that wrest a never-meant meaning
out of everything . . .
— Thomas Nashe, *Summer's Last*
Will and Testament, 1592

The rustic landscapes of the Dutch Golden Age were long considered to be nothing more than faithful transcriptions of nature, lacking "nothing in terms of natural realism," as Constantijn Huygens wrote of the Netherlandish landscapists in general, "except the actual warmth of the sun and the movement of the air."[1] Created, it seemed, by artists with no other motive than to record an attractive stretch of native countryside, these landscapes appeared as innocent of deeper meaning as a modern snapshot of a pleasant place taken during a summer vacation. They were faithful transcriptions of nature, modified only by the artist's aesthetic temperament and his desire to create a pleasing composition. To a large extent, of course, this characterized the interpretation of seventeenth-century Dutch painting as a whole, an interpretation elaborated during the course of more than two centuries. Joshua Reynolds condemned such realism: with the Dutch, he said, "a history-piece is properly a portrait of themselves"; these same deplorable "local principles," as he called them, extend even to their landscapes.[2] A generally more favorable view of Dutch art emerged in the nineteenth century, when its realism was seen by Goethe, Hegel, and others as an expression of the Dutch national character, and when the French realists began to articulate their own views of literature and the visual arts.[3] The landscapes of Van Goyen, the genre scenes of Pieter de

Hooch, and the portraits of Frans Hals seemed thus to epitomize the ideal of art as "Nature in concentrated form," as Balzac put it; drawing on a recent invention, Thoré-Bürger characterized the work of Dutch artists as "a sort of photography" of their century.[4]

Although as late as 1972, seventeenth-century Dutch painting could still be described as reproducing "probably more completely than any other the world in which painter and client lived,"[5] this understanding of Dutch art was already being modified. Even before 1950, scholars were beginning to ask if its depiction of everyday life and objects did not conceal some deeper meaning,[6] but the widespread interest in the iconography of seventeenth-century Dutch art emerged only after Erwin Panofsky's studies of an earlier phase of Netherlandish realism. Beginning with his epochal article of 1934 on Jan van Eyck's *Arnolfini Betrothal*, and elaborated in his book *Early Netherlandish Painting* of 1953, Panofsky asserted that the realism of early Flemish painting was not, as had so often been claimed, an essentially secular style incongruously employed for the depiction of sacred personages and events, but that it actually reinforced the religious meaning of these images through the use of religious symbols in the guise of everyday objects.[7] Despite a number of challenges, Panofsky's "principle" of disguised symbolism has prevailed in subsequent interpretations of Flemish painting, and comparable ideas soon appeared in studies of seventeenth-century Dutch painting. In his monograph on Dutch still-life painting, published in an English edition in 1956, Ingvar Bergström suggested that many seventeenth-century still lifes, and not only the obvious *vanitas* paintings, portrayed many apparently innocuous objects that symbolized earthly existence, transience, and death. This use of symbolic forms, he suggested, was directly comparable with the "disguised symbolism" that Panofsky had discerned in fifteenth-century painting.[8] Bergström's monograph and other studies have effected a major reevaluation of Dutch painting, in which the work of Eddy de Jongh and the so-called Utrecht School have played a paramount role, beginning with De Jongh's *Sinne- en Minnebeelden* of 1967.[9] De Jongh proposed that the surface realism of Dutch paintings was only an "apparent realism" (*schijn realisme*), disguising an allegorical content most often of a didactic or moralizing character.[10] With the help of a wide variety of seventeenth-century texts, among them the emblem books so much in vogue with the general public in Holland and elsewhere, De Jongh has convincingly demonstrated that such mundane objects as birdcages, bunches of grapes, and pictures-within-pictures and such activities as hand washing and blowing bubbles often functioned as symbolic commentaries on the folly of love, the dangers of fleshly pleasures, and the transience of human life.

Earlier efforts in this new interpretation of Dutch painting focused on still lifes, genre scenes, and portraits. While Wolfgang Stechow, in his magisterial survey of Dutch landscape painting of 1966, acknowledged that other kinds of Dutch painting might have symbolic content, he asserted that landscape, with few exceptions, "did not display—and hardly hid—symbolic elements, either by tradition or for any special effects," and he cited Max J. Friedländer to the effect that "what music is in the

categories of art, landscape is in the categories of painting."[11] But landscape did not long escape the new reassessment. A growing number of scholars have insisted that Dutch landscapes, too, contain more than meets the eye, and that the paintings of Jan van Goyen and Jacob van Ruisdael, for example, are moral allegories, whose symbols can be decoded for modern viewers through what Josua Bruyn has called the "scriptural reading" of various details within each landscape composition. Within the last few years, this interpretation of Dutch landscapes has engendered an often heated controversy concerning their content and significance. The present chapter examines "scriptural reading" as an exegetical approach, as well as the particular problems inherent in its application, in an attempt to assess its validity as a means of understanding Dutch landscape imagery, and the rustic landscape in particular.

The sort of insights offered by scriptural reading may be conveniently examined in the essay that Bruyn published in the catalogue of the exhibition of Dutch landscape painting held in 1987–88.[12] Bruyn's point of departure is the method of the so-called emblematic interpretation developed by De Jongh: "one can hardly expect that it [emblematic interpretation] should be fundamentally different with regard to landscape."[13] It is with this premise that Bruyn embarks on the explication of a number of Dutch landscapes. In Jan van Goyen's *Cottages by the Sea* (see Fig. 1), the two figures lounging near the dilapidated cottage symbolize the sins of sloth and lust. In the middle ground, the carriage stopping by a tavern represents the Christian pilgrims diverted by the sinful world on their way to Paradise. The theme of the pilgrimage of life also informs Van Goyen's *Landscape with Two Oaks* (Plate 5), in which the dead branches of the tree are images of *vanitas;* sloth and lust are once again embodied in the two men chatting beneath them. This unfortunate pair has wandered from the true path of life, but at least one traveler follows the right course: he disappears over the knoll toward the end of his earthly life and the return to his homeland, Heaven, symbolized respectively by the horizon and the distant church spire.

A comparable message is conveyed by Rembrandt's *Landscape with Stone Bridge* (Fig. 52), in which the wayfarer, this time representing the soul, approaches the bridge, a symbol of Christ, to reach the Heavenly Jerusalem symbolized by the city rising in the left distance. One final example may be cited, Ruisdael's *View of Bentheim Castle* (Great Britain, private collection).[14] Observing that Ruisdael has dramatically altered the actual low-lying situation of the castle by placing it on the top of a high cliff, Bruyn interprets the castle as representing the Heavenly Jerusalem, the destination of the travelers in the lower-right corner, who must struggle through the sinful world, symbolized by the forest looming immediately in front of them, before they attain salvation. Dead trees, bridges, coaches stopped before a country inn, seated and lounging figures: these and similar details, Bruyn proposes, were introduced into innumerable Dutch landscapes to imbue them with a high and serious lesson on the proper conduct in this life and the promise of salvation.

Although these interpretations may seem as arbitrary to the modern reader as the moralizations

FIGURE 52
Rembrandt, *Landscape with Stone Bridge*. Amsterdam, Rijksmuseum.

that were attached to the old tales in the medieval *Gesta Romanorum*, they are far from capricious. They are firmly grounded in traditional symbolism, derived from medieval and Renaissance literary and visual sources, including sermons and edifying treatises, moralizing prints, emblem books, and religious poems. The forest as an image of the sinful world, for example, is an ancient commonplace.[15] Dante employed it in the opening canto of his *Inferno*, "I found myself in a dark wood," to allude to his own deviation from the true path of life. The medieval encyclopedist Bartholomaeus Anglicus characterizes the different kinds of woods, the *saltus*, *silva*, and *nemus*, as places of deceit and treachery, while a North Netherlandish allegorical play of 1559 speaks of the forest of the world, *werelds foreest*, as filled with sin and danger.[16] And over a century later, in 1708, Jan Luyken describes the world as a "very dangerous forest."[17] The tavern is the "devil's temple" (as Chaucer put it), where unwary souls are lured into sin; this is an old theme that was used by many artists and writers.[18] Even the interpretation of the bridge in Rembrandt's *Landscape with Stone Bridge* finds parallels elsewhere: these include two commentaries on John 14:6, "I am the way, the truth, and the life," one in the *Mundus symbolicus* of Philippus Picinelli, the other in Jan Luyken's *Bykorf des gemoeds* (The Beehive of the Spirit). It might be added, however, that while these sources are cited by Bruyn,[19] it is unlikely that the Picinelli would have been known in Holland until sometime after its appearance in 1653,[20] while Luyken's treatise was first published only in 1711. Yet the comparison of Christ to a bridge was a traditional motif; it occurs, for example, in *The Dialogue* of Catherine of Siena.[21]

As an example of an unambiguously moralized landscape in the visual arts, Bruyn cites a print of

FIGURE 53
Jacob Matham, after Karel
van Mander, *Allegory of
Human Life*, 1599, engraving.
Amsterdam, Rijksmuseum.

1599 by Jacob Matham after a design by Karel van Mander (Fig. 53).[22] It is a particularly complex allegory on the transience of human life, with life itself symbolized by a luxuriously foliaged tree in a prosperous landscape and death by a desolate rocky scene dominated by a dead tree. Such imagery was hardly unique. A similar use of natural imagery occurs in a German painting of about 1480 (Fig. 54), an allegory on the three ages of human life: one panel shows infants and a couple of young lovers disporting themselves in a verdant landscape; in the other, a corpse lies in a winter scene marked by leafless trees. Much later, living and dead trees were symbolically employed in *De trap des Ouderdoms* (The Staircase of Age), an allegory of the Nine Ages of Mankind published in several different versions by Claes Jansz Visscher and his son.[23] The ever-popular emblem books of the period draw extensively on "natural" symbolism of this sort. And while Bruyn chiefly cites Calvinist literary sources, it must be emphasized that such allegories transcended confessional differences. Bruyn has noted that the *Allegory of Human Life* of 1599 (see Fig. 53) was designed by a Mennonite and engraved by a Catholic.[24] Similarly the "pilgrimage of life," itself a venerable theme in Christian thought, received

FIGURE 54
Master of the Lake Constance
Region, *Allegory on the Three Ages of
Human Life,* c. 1480. Nuremberg,
Germanisches Nationalmuseum.

one of its major seventeenth-century treatments in the *Pilgrimage of the Sisters Duyfken and Wille-mynken*, a Catholic moralizing treatise composed and illustrated by Boëthius à Bolswert and published in 1627, some years after his move to Antwerp; by 1656 it had gone through five more editions.[25]

Because much of this imagery stems ultimately from the Bible, Bruyn's designation of this approach as a "scriptural reading" is entirely appropriate. But Bruyn was not the first to employ this exegetical method in the interpretation of Dutch landscapes. As early as 1971, in a doctoral dissertation written for the University of Hamburg, Willfried Wiegand interpreted a number of landscapes by Jacob van Ruisdael along very similar lines, drawing on contemporary emblematic and religious literature.[26] It is noteworthy that Wiegand turned to emblem books apparently without knowledge of the publications of De Jongh, which had begun appearing only a few years before. Wiegand's study was followed in 1973 by Iouryi Kouznetsov's article on Ruisdael's symbolism, proposing, among other things, that the artist employed dead trees as emblems of death and the Old Testament.[27] In 1980 Hans-Joachim Raupp, in an analysis of a number of paintings by Van Goyen and Ruisdael, de-

veloped the thesis that these landscapes depict the pilgrimage of life, that is, the soul making its precarious way through an essentially sinful world to return to its spiritual fatherland.[28] In an article published in *Artibus et Historiae* in 1987, about the same time as Bruyn's essay, Antoni Ziemba offered a similar interpretation for a group of landscapes by Rembrandt, in particular emphasizing the symbolism of light and shadow in his compositions.[29] Ziemba's reading of Rembrandt's *Landscape with Stone Bridge* (see Fig. 52) shares many interpretative details with Bruyn's reading of the same landscape, although neither writer seems to have known about the other's work.[30]

The scriptural reading of Dutch landscapes has been challenged by a number of scholars.[31] Nevertheless, this mode of interpretation might seem to be an idea whose time most assuredly has come, for many of the basic assumptions of the scriptural readers and much of their methodology have also informed many more recent discussions of seventeenth-century Dutch landscape imagery. It has been suggested, for example, that the dune landscapes with their ramshackle cottages, painted so frequently by Van Goyen and others, are "moralizing terrains," emblems of moral choice inspired by the parable of the houses built on rock and sand.[32] It is also proposed that some of the landscape series etched by Claes Jansz Visscher and Jan van de Velde, among others, present carefully orchestrated sequences of images designed to impart various moral and other lessons to the viewer.[33]

We cannot deny, of course, that some Dutch landscapes apparently have a symbolic content. A prime example is Ruisdael's *Jewish Cemetery*, known to us in the two versions in Detroit and Dresden (Fig. 55).[34] In both pictures we are confronted by cracked sepulchers, crumbling ruins, dead trees, and a rainbow arched across the sky at the left. The modern viewer might well agree with John Constable that in these landscapes the artist had "attempted to tell that which is out of the reach of the art. . . . There are ruins to indicate old age, a stream to signify the course of life, and rocks and precipices to shadow forth its dangers;—but how are we to discover all this?"[35] Whatever the details of Ruisdael's message—and there is some disagreement on this point—it seems fairly clear that he intended these two landscapes as allegories of human life and death.[36] It is also possible, as Bruyn has suggested, that Ruisdael manipulated the actual setting of Bentheim Castle to create an image of the Heavenly Jerusalem, but we cannot be sure. Lying as it did between the Dutch provinces of Overijssel and Drenthe and the prince-bishopric of Münster, the county of Bentheim played a strategic role in the defense of the Republic, and sandstone from its quarries was used in the construction of the new city hall of Amsterdam, two factors that might have contributed to the popularity of Bentheim as a subject in Ruisdael's landscapes.[37] And if he changed its topography, we should remember that like other Dutch landscapists, Ruisdael did not hesitate to move buildings and other monuments, not only in the two versions of the *Jewish Cemetery* but also in his *Haarlempjes* and other views of actual places that are presumably without moralizing symbolic content.

On the other hand, there is no doubt that viewers were capable of using any landscape by Ruisdael, or by anyone else, for that matter, as occasions for metaphorical excursions, just as they did with

FIGURE 55
Jacob van Ruisdael, *Jewish
Cemetery*. Detroit, The
Detroit Institute of Arts.

natural scenery itself.[38] Constantijn Huygens, for example, compared the bare trees he saw in February with godless souls in need, raising their arms heavenward toward they know not what.[39] And Jacob Cats claimed that whenever he walked through the woods, the trees always taught him a lesson and he invariably found something useful for his mind.[40] Even in the Dutch country-house poems, a form of literature that we will examine later, their authors sometimes interrupt an often fulsome praise of natural beauty and the virtues of the rustic life to extract a homely moral from a beehive or a cabbage patch.[41] This taste for allegory was not confined to Holland. An extreme case can be found in Grimmelshausen's *Simplicissimus*, first published in 1668, in which the eponymous hero, finding himself stranded on a desert island and bereft of his holy books, uses the plants growing around him as objects of pious reflections:

> Thus, did I see a prickly plant, forthwith I thought on Christ his crown of thorns;
> saw I an apple or a pomegranate, then I reflected on the Fall of our first parents and
> mourned therefore; when I did draw palm-wine from a tree, I fancied to myself how
> mercifully my Redeemer had shed His blood for me on the tree of the Holy
> Cross . . . [42]

There is no doubt that Simplicissimus's vegetable musings would have struck a sympathetic chord in many people in Holland. Hence the scriptural reading of landscapes offers us valuable clues as to how many seventeenth-century viewers, of any religious persuasion, might have contemplated both the Dutch countryside and its surrogate in a painting or print. And this contemplation could take many forms, as Lawrence Goedde has demonstrated in his excellent study on the tempest scene in seventeenth-century Netherlandish painting.[43] Ludovico Smids recognized this diversity of audience response when he offered a set of sixty prints of castles after drawings made by Roelant Roghman about 1646–47: these prints, Smids assured prospective buyers, can please the eye, commemorate the castles and their historical significance, and be used to construct emblems.[44]

The scriptural readers, however, claim much more. In the first place, they claim that the allegorical content of Dutch landscapes was determined by the artist himself from the outset, that he manipulated his natural and man-made forms for the chief, if not the exclusive, purpose of presenting his moral sermon. As Bruyn says of Rembrandt's *Landscape with Stone Bridge* (see Fig. 52), it is "like his contemporaries' landscapes. . . . a conceivable view, not taken from reality, but devised on the basis of an iconographic program."[45] Furthermore, the scriptural readers assume, indeed sometimes explicitly state, that each time a particular motif occurs in a landscape it is intended to convey the same meaning. Hence, dead trees always symbolize death and the vanity of life; a castle on a distant hill inevitably represents the Heavenly Jerusalem; without exception a bridge signifies Christ who said, "I am the way."

All of this would seem to lead to a conclusion that some of the scriptural readers do not fail to make: that *all* Dutch landscapes of the seventeenth century, at least those of domestic scenery, are allegorical in content, following a tradition supposedly established in the previous century by Patinir, Pieter Bruegel the Elder, and their followers.[46] We are asked to believe, in other words, that when Van Goyen, Ruisdael, and their contemporaries painted landscapes, they were not, in any meaningful way, celebrating natural beauty. Rather, they were employing a limited repertoire of stock motifs to create what are in essence allegorical puzzles whose decipherment teaches the viewer the same unvarying lesson: the world is fraught with sin and temptation, and it is incumbent on every good Christian to ensure his salvation. In this reading, Dutch landscape paintings function as a kind of pictorial *Pilgrim's Progress,* containing the visual equivalents of John Bunyan's Hill of Difficulty, Valley of Humiliation, and City of Destruction.[47] The dunes of the Dutch countryside, its woods, fields, and rivers thus become endlessly repeated metaphors of the sinful world.

There is no doubt that the scriptural reading of Dutch landscape images has proven intellectually very seductive. This is understandable. For one thing, scriptural reading can explain why certain details—figures, landscape elements, and buildings—occur repeatedly in Dutch landscape painting throughout the seventeenth century. More important, however, scriptural reading in effect rescues Dutch landscapists from the charge of appealing only to the eye, of simply recording what they saw; scriptural reading also endows their depictions of even the most commonplace stretch of scenery

with a high moral purpose. Landscape thus becomes yet another example of the "apparent realism" discerned in so many other kinds of subject matter in Dutch painting. Finally, we are offered an explanation as to why such images in prints and especially paintings were collected with such avidity by a "puritanical society," to quote Bruyn,[48] that supposedly strove for piety and moral edification in all phases of life.

But scriptural reading also presents a number of problems. In the first place, the assumption that artists were actually painting "little sermons on sin" seems strangely at odds with the obvious engagement of so many Dutch landscapists with nature itself, with the particular character of exact localities. Examples include the many watercolor drawings that Bloemaert made of various places around Utrecht (see Plate 2), the numerous sketches produced by Visscher and Esaias van de Velde of the countryside around Haarlem, Amsterdam, and The Hague,[49] and, above all, the hundreds of sketches executed by Jan van Goyen on his extensive wanderings in the Dutch countryside.[50] We could also cite Rembrandt's sketching trips around Amsterdam and Ruisdael's excursions to the east in the United Provinces.[51] It might be objected, perhaps, that the landscape sketch differed in mode and purpose from the composed landscape, but this ignores the fact that the drawings of Van Goyen, Rembrandt, and others were incorporated into more finished forms of the etched and painted landscape, which themselves show much of the realism of the sketches. Indeed, it was precisely in his paintings that Ruisdael rendered his foreground trees with such truth to nature that the modern botanist can easily identify them as to species and can find little schematization or distortion.[52] This preoccupation with the *naer het leven* is inexplicable, because any convention of tree, house, and terrain would have served equally well for the sort of allegorical landscapes proposed by the scriptural readers. But it might be argued (as the scriptural readers have not done) that artists employed domestic scenery in their landscapes precisely to bring home more vividly the lessons they sought to inculcate in their audience, that it was their own, familiar, mundane world that was filled with sin and death, in fact, very much as the Calvinist preacher Jacobus Revius insisted in the poem "Werelt" (World), first published in his collection of poems in 1630: the world is filled with sadness and pain, it is to be fled, he counsels, like a faithless and loveless whore.[53] Similarly, John Bunyan speaks of "the wilderness of this world" wherein

> What danger is the pilgrim in,
> How many are his foes,
> How many ways there are to sin
> No living mortal knows.[54]

All this might seem plausible, were it not for the many expressions of a quite different view of nature that we find in Dutch literature of the period. As the critics of scriptural reading have frequently pointed out, Dutch writers from Jan van der Noot through Hendrick Laurensz Spiegel and Karel van

Mander and long afterward celebrated with constantly renewed enthusiasm the visual beauty and amenities offered by the Dutch countryside.[55] Even through the rhetorical conventions of their descriptions there shines forth a genuine love of their native scenery, "those dunes, woods, and brooks . . . that we love so helplessly," as Spiegel expressed it in 1615.[56] Later in the century, incidentally, the English statesman Sir William Temple observed that while the word *vaterland*, "fatherland," was traditionally used elsewhere to describe the "home of our Father," the destination of every Christian pilgrim, the Dutch habitually employed it to designate their own land.[57] And when their contemplation of rustic scenery prompted the Dutch poets to rise to more religious musings, they envisioned nature, not so much as an extended metaphor for human sin and folly, but as an expression of God's goodness and bounty, and the miracle of his Creation. Constantijn Huygens asserts that "the goodness of God is to be seen on every dune's top," while Jacob Cats tells us that people go out into the countryside to "see God therein"; God, he continues, "reveals himself in every piece of creation."[58] Petrus Hondius, in a poem published in 1621, insists that visitors to his country house must worship God in his Creation and adore his wondrous works in every flower.[59] This joyous affirmation of God and nature can equally be found in the country-house poems and in the plays and poems of Joost van den Vondel.[60] All in all, the Dutch poets saw nature as a source of wonder and delight and a reflection of divine beneficence, and there is no reason to believe that the Dutch painters saw their local countryside any differently. Indeed, we might well repeat Bruyn's question concerning landscapes: "When there is no compelling evidence for deeper meanings, why then should one exert oneself further?"[61]

Both Bruyn and Reindert Falkenburg have attempted to meet this objection. Noting that Dutch writers often described nature in conventional terms derived from the pastoral poetry of Virgil and other poets of classical antiquity, Bruyn argues that they wrote for "an audience oriented toward humanist ideas and therefore gave little place for the pietistic conception of the world."[62] Although Bruyn does not explicitly say so, we may infer from his statement that it was for a quite different audience that Van Goyen and Ruisdael painted their presumably "pietistic" landscapes. A variation of this argument was advanced some years ago by Falkenburg. Observing that the pictures discussed by Bruyn include no Italianizing landscapes (such as those by Jan Asselyn, Aelbert Cuyp, and Nicholas Berchem), Falkenburg suggested that such landscapes are not susceptible to the moralizing interpretations of scriptural reading, because they were influenced by the poetic conventions of contemporary arcadian literature, in which Calvinist "pietistic" values found no place.[63] Although Falkenburg has since abandoned this claim,[64] it deserves further attention here if only because it is an assumption, often unspoken, that underlies several more recent discussions of Dutch landscape painting.

Bruyn and Falkenburg, in fact, have presented thoughtful responses to their critics, but they raise a further problem: the implication that Dutch society was divided into two mutually exclusive groups, one imbued by humanist values and which patronized the classically oriented poets (but not, pre-

sumably, the "pietistic" landscape painters), and the other more "pietistic" group, which constituted an audience for the landscapists (but not, presumably, for the classically oriented poets). The problematic nature of this proposition becomes evident when we look at the case of David Beck, a schoolteacher and amateur draftsman residing in The Hague, who has already helped us to understand how drawings and prints were preserved and viewed in the seventeenth century. Since we will encounter him frequently in later chapters, we should get to know him better. There is no doubt that he was a devout Calvinist; more than a *liefhebber* (or "sympathizer," one who attended Reformed sermons without joining the church), he seems to have been an active communicant.[65] Beck faithfully attended the two services offered every Sunday, usually in the Grote Kerk, or Great Church, and noted in his journal of 1624 the subjects of the sermons, whether they were the morning sermons based on biblical texts, or the afternoon expositions of articles from the Reformed Catechism. He read edifying books on religious subjects, and with his family and friends he engaged in the eminently Calvinist practice of singing Psalms in the evenings after meals and around the fire: his favorite, it seems, was Psalm 51, a penitential psalm.[66] Yet he also read Virgil, probably in French, because he knew little Latin, and was engaged in translating the *Georgics* into Dutch; moreover, he wrote a *herder-clacht*, or eclogue, as well as a poem in imitation of Ronsard. His wife having died in childbirth in December 1623, Beck was working on a poetic lament in which Christian sentiments mingle with pagan deities and the bereaved husband figured himself in the persona of the shepherd Daphnis mourning the death of his mistress Orlande.[67] Beck was not a particularly introspective diarist, and it is difficult to determine how he responded to landscapes, either those in his own drawings or those he experienced on his many walks in the vicinity of The Hague. Only once can we make a guess: one Sunday afternoon he climbed a high dune near the city, where he stood "for a good half hour and looked back and forth [*speculeerde over ende weder*]"; the prospect he viewed may well have inspired some thoughts on God's providence, since that had been the subject of the afternoon sermon based, as he tells us, on Questions 26 and 27 of the Catechism.[68]

However this may be, we are more certain about the responses to landscape in the case of Claes Jansz Visscher. As we have seen, the title print to his *Plaisante Plaetsen* issued about 1611–12 contains inscriptions in both Dutch and Latin, the former assuring us that these views depict pleasant places that "can be contemplated with ease by those who have no time to travel far." For many of Visscher's contemporaries, the words *Plaisante Plaetsen* would have brought to mind the Latin *locus amoenus*, the pleasant place associated with the shady groves, cool streams, and verdant meadows celebrated by Theocritus, Virgil, and other poets of classical antiquity. Indeed, the word *amoenus* is translated as *plaisante* or *lustig* (pleasant, enjoyable) in Joannes Servilius's *Dictionarium triglotton*, a dictionary of Greek, Latin, and Dutch, published at Antwerp in 1612.[69] The idea of pleasure is elaborated in Visscher's Latin inscription that describes the "ever-delightful roads" and urges us to let our eyes "roam these open vistas offered by the sylvan surroundings of Haarlem." The accuracy of

these claims will be determined later, but what is important at this point is that the "pleasant places" depicted by Visscher are quintessentially Dutch, specific localities in the vicinity of a specific town, and identified by name in the table of contents. The presence of a Latin inscription on the title print suggests that Visscher was confident that some purchasers of his prints read Latin and were perhaps even familiar with classical and neo-Latin bucolic poetry, purchasers who comprised, in Bruyn's words, "an audience oriented toward humanist ideas."[70]

Nevertheless, Visscher himself would seem to be the very paradigm of the Calvinist "pietistic" artist described by Bruyn. He was an active member of the Dutch Reformed Church and, unlike David Beck, much involved in religious politics. Not many years after the Haarlem landscapes, he issued prints commemorating the defeat of the liberal Calvinist Arminians at the Synod of Dordrecht in 1618–19 and the subsequent arrest and execution of some of their leaders.[71] In 1637 he was part of a church delegation that protested the first performance of Joost van den Vondel's *Gysbrecht van Amstel* on the grounds that it was "full of popish superstitions."[72] Moreover, Visscher was also familiar with the emblematic traditions of his day; he etched the 184 emblems in Roemer Visscher's *Sinnepoppen* of 1613.[73] He also issued at least one set of what might be called "allegorical" landscapes; they were copies mostly in reverse of landscapes drawn from two series produced by the German printmaker Matthaeus Merian the Elder between 1620 and 1624;[74] some were embellished with biblical or allegorical figures. Visscher copied eleven of these landscapes, along with a title print taken from a third landscape series by Merian, and it is instructive to consider the new title that he substituted for Merian's own: "Various pleasant landscapes decorated with *sinnebeelden*," or "emblematic images."[75] "Decorated" is an entirely apt description, for the landscapes possess no intrinsic symbolism of their own.

These copies after Merian remain almost unique in Visscher's oeuvre. Indeed, while the title print and table of contents in Visscher's Haarlem series are not without their allegorical content, the landscapes that follow are devoted chiefly to the "pleasant places" outside the city. The same is true of the series of landscapes that Visscher etched after Cornelis van Wieringen and published in 1613: the title print informs us that these are *Amœniores aliquot regiunculae* (Some pleasant little landscapes [or regions]).[76] Jan van de Velde, incidentally, employed variations of the same Latin formula on several of his etched landscape series produced in the second decade of the century, including the title print of 1616 to the first part of the sixty-plate series published by Visscher.[77] Visscher later added a title print to a landscape series etched by Roelant Roghman, characterizing them as "Pleasant Landscapes or delightful views drawn after life"; the same sentiment reappears on a title print that Visscher provided for a set of Jan van de Velde's landscapes that he published after the latter's death in 1641.[78]

Whether Beck and Visscher were typical of their age and place must at present remain an open question, but it is evident that we must exercise caution in attempting to distinguish between the val-

ues and expectations of the Dutch landscapists and the Dutch poets and their respective putative audiences. Indeed, in the face of the many enthusiastic celebrations of the natural world that we find in Cats, Huygens, and other Dutch Calvinists of the seventeenth century, recent scholars such as E. John Walford and M. de Klijn have asserted that the love of nature in general, and of the Dutch rustic landscape in particular, was an expression of a specifically Calvinist ethos. The fullest elaboration of this claim appears in a small study published by De Klijn in 1982.[79] De Klijn explains that Calvin saw the natural world as a manifestation of God's beneficence, as a miracle worthy to be praised. This positive view of nature encouraged Calvin's followers to turn to the world and study it, thereby contributing to the rise of the natural sciences in the seventeenth century, including the work of Francis Bacon.[80] In this connection, Walford and others have cited the Confession of the Dutch Reformed Church, which asserts that "the world is for our eyes like a beautiful book, in which all creatures big and small serve as letters, to make us aware of the invisible nature of God, to be precise: His eternal power and divinity, as Paul says [Romans 1:20]."[81] In the same vein Huygens characterized the world as the "Book of All Things," "the wonderful book of His six work-days."[82] This concept of God's "Book of All Things" (or "God's First Book"), it is claimed, fostered the rise of Dutch landscape painting, particularly the depiction of domestic scenery. De Klijn goes further: the rustic landscape emerged as a Calvinist reaction to the mannerist exuberance of the Flemish landscape style.[83]

The relationship posited by De Klijn and others between Calvinism and Dutch landscape painting has the merit of correcting the older view of Calvinism as an austere, world-denying faith that contributed nothing to the development of Dutch art in the seventeenth century.[84] Nevertheless, it may well be asked if this relationship can be stated in such exclusive terms. That God is revealed through his Creation and hence Creation is a subject worthy to be studied was an idea current long before the advent of Calvinism.[85] In the thirteenth-century Dutch translation of Bartholomaeus Angelicus's *De proprietatibus rerum*, the prologue justifies the study of the world on the grounds that such a study helps us to understand the Bible better and to direct our thoughts to God.[86] For his part, Conrad Celtis asserted that God is to be seen in the natural world.[87] The great naturalist Jacob Gesner, writing to a friend in 1541, describes how on seeing the Alps he found his spirit "ravished in the contemplation of the Sovereign Architect."[88] Similar ideas were expressed by the schoolmistress and ardent Catholic poet Anna Bijns in several poems of 1567, by the French Catholic theologian Robert Bellarmin in a religious treatise of 1615, and by the Italian Catholic reformer Carlo Borromeo in many of his writings.[89] Catholic writers voiced the same sentiments in seventeenth-century Holland, including Hendrick Laurensz Spiegel and Joost van den Vondel, who converted to Catholicism in 1641.[90] In a poem in his *Hart-spieghel*, Spiegel celebrates his morning's walk through the dunes and polders, where, among other benefits, he can learn from the book of Creation.[91] For Vondel, it is the sight of a particularly beautiful sunset that reminds him that "so shall we see God and the highest majesty, / Reflected in the work of his providence."[92]

The idea that nature is a reflection of God was thus hardly the monopoly of the Calvinists, nor can the origins of the Dutch school of landscape be attributed particularly to Calvinism. It has been argued that Calvin's attitudes toward art created a market for still life, genre, and landscape.[93] However this may be, we must bear in mind that by the time Calvin first published his *Institutes of the Christian Religion* in 1536, artists in Antwerp were already painting secular subjects, especially landscapes, and the purchasers of these new types of pictures must have cut across religious lines. It must also be borne in mind that Calvinism was far from having the overwhelmingly dominant force in seventeenth-century Dutch society that is all too frequently claimed for it. The myth of the "Protestantization" of the Northern Netherlands was challenged as long ago as 1930 by the historian Pieter Geyl and has been disputed by a number of more recent scholars.[94] While the Calvinist Reformed Church was the public church of the United Provinces, it was never a state church in the sense that, for example, the Church of England was, or Calvin's church in Geneva. The Reformed Church was supported, and often controlled, by the authorities, who granted it a monopoly on public worship, but its active, communing membership spread rather slowly.[95] Just a year or so before the Synod of Dordrecht of 1618–19, Johan van Oldenbarnevelt, Grand Pensionary of the Republic, could tell the English ambassador Sir Dudley Carleton that Protestants made up only one-third of the population; "the sounder and richer party," he asserted, remained loyal to the Catholic Church.[96] In Haarlem, for instance, it is estimated that in about 1620 only 20 percent of the inhabitants were Reformed, while 12.5 percent were Catholics, including the print-publishing family of the Mathams, along with a handful of members of other sects; another 15 percent were Mennonites.[97] This leaves about half of the population unaccounted for, and it has been suggested that while some of this group may have attended Reformed sermons as *liefhebbers*, many others probably were "Libertines," the name applied by the Calvinists to those who rejected all confessional churches with their ecclesiastical discipline, or even ignored organized religion in any form.[98] Many Catholics continued to practice their religion in the ancient episcopal city of Utrecht; it is estimated that in the first two decades of the seventeenth century, Catholics made up between a quarter and a half of the city's population.[99] It was also in Utrecht that the Libertines long resisted the efforts of the Calvinists to dominate there.[100]

The religious situation varied, of course, from city to city, and the Reformed Church, especially its more vocal preachers and writers, undoubtedly exerted a far greater influence on Dutch society than the mere recitation of numbers would suggest.[101] This is especially true for that phase of pietistic Calvinism known as the "Further Reformation."[102] Nevertheless, the situation in the United Provinces was one of religious pluralism—Catholics, Calvinists, Lutherans, and Mennonites, as well as Jews, and it has been claimed that the largest group was the Libertines.[103] Indeed, any assertions as to the piety and "puritanism" of Dutch society as a whole must be weighed against the testimony of foreign visitors, from Fynes Moryson in the late sixteenth century to John Evelyn, visiting the Republic in 1641, many of whom commented on the lack of attendance of church services on Sun-

days and the abundance of worldly entertainment and even buying and selling that they observed on the Lord's Day.[104] In 1624 the government in The Hague complained to several sheriffs of Holland that people in the areas under their jurisdiction profaned the Sabbath through dancing and other frivolous amusements.[105] Hence, the many claims concerning a "Calvinist" Dutch Republic must be received with skepticism. A good case in point is the often-voiced assumption that the black color prevailing in Dutch dress of the period was a manifestation of "Calvinist sobriety"; recently, however, it has been demonstrated that this actually reflected an international taste long current in Catholic countries as well.[106] More study is needed, in fact, before we can determine with any precision the actual effect that Calvinism had on the development of Dutch society in general, and its art in particular.[107]

While some Dutch artists, especially painters, tended to work for one confessional group or another,[108] probably most of them produced for an open market, in which they had to appeal to a broad spectrum of tastes and interests. This would have been especially true of the printmakers and their publishers; an exception seems to have been Jacob Matham, a Catholic who engraved a number of religious subjects designed to appeal to his coreligionists.[109] Conversely, although the Calvinist Hendrick Hondius published a number of virulently anti-Catholic prints about 1600, he also issued in the same period a majestic panorama of Rome with an inscription praising the prosperity of that city under the rule of the pope; it is evident that Hondius hoped to attract Catholic purchasers by capitalizing on the Jubilee Year proclaimed by Pope Clement VIII in 1600.[110] Visscher, too, despite his aggressive Calvinist stance, was not above publishing eminently Catholic subjects: they include copies in reverse of a set of female hermit saints that Bolswert had originally engraved after Abraham Bloemaert, as well as a thirty-plate series of saints and hermits in landscapes engraved by Londerseel after the sixteenth-century Flemish artist Marten de Vos.[111] On the other hand, the people who purchased the landscape series of Visscher and Jan van de Velde must have come from various confessional backgrounds; it has been suggested, in fact, that the two albums of prints now in Trier were assembled by a Jesuit priest.[112] The Dutch rustic landscape would have appealed to a wide variety of interests, including national pride, religious sentiment, and scientific interests, but when Visscher and Van de Velde stressed the idea of pleasure in their landscape prints, they were evoking ideas about nature and its depiction in art that were ancient in origin and still potent in the seventeenth century. This tradition merits our further attention, for it helps us to understand many of the conventions employed by the Dutch artists in their depiction of their local countryside.

4

Painting for Pleasure

AN EXCURSUS

In my own field, the history of art, we have become intolerably
earnest. A false prestige has come to be attached to the postulation
of profound meanings or ulterior motives. The idea of fun is perhaps
even more unpopular among us than the notion of beauty.

— Ernst Gombrich

The landscape print series of Claes Jansz Visscher and Jan van de Velde present natural scenery, both domestic and foreign, not as images of the sinful "wilderness of the world," as John Bunyan described it, and against whose seductions Jacobus Revius also warned, but as "pleasant places," a concept that both artists stressed in a number of their title prints. These title prints suggest how contemporary viewers would have looked at such images; for purchasers unfamiliar with this relatively new landscape type in prints, these titles would have served as cues to shape their response to these scenes.[1] In any case, Visscher and Van de Velde were enterprising businessmen, and we may be sure that they capitalized on what they perceived as the potential appeal of these landscapes to the mass market. One such purchaser, incidentally, might have been the poet Cornelis Pietersz Biens, who published a manual on drawing, *De Teecken-Const,* in 1636. Among the benefits offered by drawings to the viewer, he says, they allow us to wander through the "pleasant regions of the world" (*plaesierische landouwen der weereldt*) and nonetheless stay in our study. It should be added that Biens, like Visscher himself, was an active member of the Reformed Church, which he served in various capacities. He also published several tracts devoted to edifying the morals of the laity of all ages, including the *Profitelyck cabinet voor den Christlelycken jonghelinghen* (Profitable cab-

FIGURE 56
Adam Pynacker, *Italianate
Landscape with Two
Crayfishers by a Waterfall*.
Rotterdam, Museum
Boijmans Van Beuningen.

inet for the Christian youth) of 1635.[2] The case of Biens once more points up the problems of determining a specific "Calvinist" or "pietistic" attitude to landscape images.

Biens's testimony is all the more valuable in that it is one of the few responses to landscape images that have come down to us from the seventeenth century. Another piece of evidence comes from Pieter Verhoek, a Dutch poet active in the second half of the century. One of his poems celebrates a cycle of large Italianate landscapes that Adam Pynacker painted about 1665 for a room in the house on the Herengracht recently built by Cornelis Backer, a wealthy Amsterdam magnate. With his bold brush, we are told, Pynacker paints the walls with "ingenious pleasure grounds / And green woods . . . so that anyone who understands Art stands enraptured / And fancies that he beholds Italy with his eyes."[3] The poet also imagines himself walking through this "joyful wilderness." Several surviving landscapes by Pynacker have been identified as belonging to this cycle; they include two paintings now in Rotterdam (Fig. 56).[4] They are typical of the kind of scenery that Pynacker often painted in these years for the great houses of Amsterdam, and their function is suggested by the concluding lines of Verhoek's poem, which merit quoting in full:

Here can Heer Backer, when the trees are devoid of leaves
And the barren field is overwhelmed with dunes
Of drifting snow, contemplate these leafy crowns,
The green of foliage, a Summer for the eye.

Here, worn out by cares of state, he can unstring

His bow, revelling in their contemplation.[5]

Like Visscher's *Plaisante Plaetsen*, Pynacker's landscapes delight the eye and offer a more than passable substitute for the real thing, but Verhoek introduces a further idea: the contemplation of these landscapes can help Becker to relax. This was, of course, a flattering allusion to Becker's importance as a man of affairs, but it echoes a commonplace that can also be found in an often-cited passage in Karel van Mander's *Foundation of the Noble Art of Painting*, first published in 1604. Van Mander introduces his eighth chapter, on landscape painting, by summoning all young painters who have been working too hard. Lay aside your labors, he counsels them, leave the city at dawn, go into the countryside and enjoy natural beauty, learn how to represent it in painting. This form of relaxation is important, he tells us, because "the bow cannot always remain taut."[6] It is significant that Van Mander describes the viewer response to landscape as a relaxing of the bow. As we have seen, Verhoek employed the same metaphor some sixty years later, and both writers were alluding to an often-cited proverb whose meaning is well expressed in an emblem in Thomas Combe's *Theatre of Fine Devices* of 1614.[7] A picture of a man drawing a bow is accompanied by the motto, "No toile can last without his rest; in everything the meane is best," and the epigram beneath explains that as the bow that is drawn with too much strength (will break or snap), so the man who labors to excess is hurt.

Thus in a handful of seventeenth-century sources—the title prints to various series of landscape prints, a drawing manual, a poem on a cycle of painted landscapes, and a poem of instruction for young artists—we can discern a cluster of ideas associating landscape with those pleasurable occasions when one relaxes after more demanding activities. Natural scenery, and its surrogate in art, not only become the *loci*, so to speak, in which tired minds and bodies can be restored but actively contribute to this restorative process. The recreative function of Dutch landscape images has not escaped the notice of previous writers on Dutch landscape painting; what is insufficiently appreciated, however, is the fact that the association of natural scenery, relaxation, and pleasure was both an intimate one and one of long standing. A closer look at this tradition illuminates the role that landscape, as a category of subject matter, played in the art of earlier centuries; this in turn will help clarify how landscape images might have been experienced by the Dutch burghers and their families who purchased the prints of Visscher or the paintings of Jan van Goyen or Jacob van Ruisdael.

Both the natural environment and its depiction in art were frequently brought together with pleasure and relaxation in a wide variety of contexts that can be understood only if we are familiar with the important functions that have traditionally been assigned in human life to both pleasure and recreation. This may not be an easy task, because the whole subject of recreation, entertainment, and amusement has generally been deemphasized in previous accounts of the meaning and function of the visual arts. We have tended to concentrate on the more serious categories of subject matter: religious

art, with its sacred stories, icons, and images intended to instruct and admonish; history painting, with its portrayal of significant and dramatic human actions; allegorical subjects of all kinds; and portraits, which were usually designed to present a flattering image of the sitter for posterity and often to extol his or her virtues and accomplishments, real and imagined. And, as we have abundantly seen, even depictions of the more lighthearted moments of human existence are generally interpreted as concealing matters of grave import, often of an admonitory, moralizing sort. It is not difficult to find support for such interpretations. There have been preachers in every age who thundered denunciations of dancing, courting, feasting, singing, the reading of frivolous literature, sports, and virtually all other pastimes. In the medieval *Vision of Godesalc*, for example, the souls suffering in Hell include people who committed many superfluous actions in sport or idleness; as punishment they have their fingers skinned or crushed.[8] In the *Triumph of Death* of Pieter Bruegel the Elder, the invading corpses fall on a merry company of young folk, and Death attacks the lovers in numerous garden and feasting scenes before and after Bruegel, while in Holbein's *Dance of Death*, the dead bring to a violent end many pleasurable moments in the lives of their living counterparts. Idleness is the canker of the mind, the nurse of evil, the old proverbs admonish us.[9] Roemer Visscher put the matter more succinctly in his *Sinnepoppen:* a picture of an axe thrust into a block of wood is inscribed, "I rest / thus I rust."[10] A fifteenth-century rhetorician, Andries van der Meulen, spoke out eloquently against bodily pleasures of all kinds; even bathing or strolling was an unnecessary pampering of the body.[11] In the seventeenth century, various predicants of the Dutch Reformed Church condemned traditional Sunday pastimes, including walks in the country, because the Sabbath was not established for the pleasure of sinful flesh.[12] The moralists also condemned the Dutch theater of the time, especially comedies, at which, the Reformed preacher Otto Belcampius (or Belcamp) warned, the people waste their time and bring their souls into the greatest peril.[13] In the same vein, Dutch print publishers of the period often added admonitory inscriptions to scenes of music making, fishing, or playing trictrac, for example, denouncing them as idle pastimes or even worse.[14]

It may be, however, that we have taken these naysayers more seriously than did most of their contemporaries. That many people turned a deaf ear to the preachers is suggested by the very fact that the latter had to repeat their warnings and admonitions to every generation. It could be argued, of course, that pleasure is a basic human characteristic; in the sixteenth century, the French physician Laurens Joubert observed that we "are so naturally drawn to delight that all our designs have it as object, as a sovereign good."[15] But infinitely more important, pleasure and recreation had long occupied a legitimate, indeed a very honorable, place in human existence.[16] As Jan van der Groen explains it in his *Nederlandtsen hovenier*, published at Amsterdam in 1669, the need for relaxation stems from the Fall of Man: ever since Adam and Eve were expelled from their life of ease in the Garden, humanity has been forced to work; hence amusement is vital as a means of sustaining life.[17] Van der Groen was thereby defending gardening, the subject of his book, as a recreational endeavor, but it

is doubtful that he would have met with objections from any but his most austerely minded readers. Traditional medical theory taught that every mortal needs occasional respite from hard physical and mental labor.[18] As Sir William Temple put it, writing in the seventeenth century, "Much motion of the same parts of the Brain . . . weary and waste them too fast for repair," as well as other damage, and therefore "none are so excusable as men of much care and thought, or of great business, for giving up their times of leisure to any pleasures or diversions that offend no Laws, nor hurt others or themselves."[19] An influential early defense of recreation occurs in Seneca's dialogue *De tranquillitate animi* (On tranquility of mind), in which he argues that "the mind should not be kept continuously at the same same pitch of concentration, but given amusing diversions," and he elaborated on these diversions in considerable detail.[20] This text was frequently cited by later writers on recreation; Samuel van Hoogstraeten repeated Seneca's words in Dutch, with few changes, in his *Inleyding tot der Hooge Schoole der Schilderkunst* (1678), where he insisted that artists, too, needed recreation, or *uitspanning* (literally, unyoking, or unhitching), as he called it.[21]

But recreation also prolongs human life and affords us more time to glorify God and to work for the salvation of our souls. This was true also of those who were cloistered from the world in the service of God: even monks and hermits should relax at times from prayer and contemplation to prepare themselves for renewed spiritual labors. In this connection can be cited the often-told story of St. John the Evangelist, who on one occasion had to defend himself against the charge of frivolity because he caressed his pet partridge. In his defense, John compared himself to a bent bow that needs an occasional release of tension. In another version of the tale, St. Anthony Abbot employed the same defense to justify his relaxing with some fellow monks.[22] The story of the bent bow, which we have already seen employed by both Van Mander and Verhoek, and used in Combes's *Theatre of Fine Devices*, frequently occurs in other emblem and proverb collections of the period; it was also illustrated by Sebastian Vrancx in his *Flemish Proverbs*, a painting of the early seventeenth century now in Brussels.[23]

One of the most eloquent pleas for recreation on record comes in a defense for the Feast of Fools presented in 1444 before the faculty of theology of the University of Paris:

> Such a diversion is necessary, because folly, which is our second nature and seems
> inherent to man, can thus express itself at least once a year. Wine barrels will burst if
> one does not occasionally release the plug to give them some air. We men are but
> poorly jointed barrels that the wine of wisdom would cause to burst if this wine were
> to stay in a state of constant fermentation under the effect of piety and the fear of
> God. We must therefore give it air, so that it will not deteriorate. This is why we
> allow ourselves to be foolish for certain days, so that we may then return with greater
> zeal to the service of God.[24]

As this plea makes evident, of course, fundamental to such prescriptions was the understanding that recreation was only temporary. Seneca had insisted on this, and Christine de Pizan cites his authority when she counsels us in the prologue to her *Treasury of the City of Ladies* that after great labor the wise man rests, but not for long.[25] Cesare Ripa agrees; in his *Iconologia* he warns us in the section on Diligenza that too much diligence is harmful, as people need to refresh their minds, but a golden mean should be observed between indolence and undue haste.[26] Recreation was recommended equally for children. The sixteenth-century Spanish author Juan Luis Vives and other writers on pedagogy insisted that children must be provided with many opportunities for play, because otherwise, as Jacob Cats would later explain, they will suffer pain and sickness.[27] People engaged in intellectual endeavors, poets, philosophers, and scholars alike, were advised to avoid excessive study and to relax, especially if they were to avoid melancholia (or melancholy), that dread affliction of the spirit.

Based on medical theories that persisted from antiquity well into the Renaissance, melancholia is a subject of "such difficult material," as a seventeenth-century Spanish physician tells us, that "there is so great a diversity of opinion."[28] Briefly put, however, there were two kinds of melancholy. One was "natural" melancholy, which was one of the four temperaments, and which inclined their possessors to intellectual pursuits. The other was a disease, what we might call "pathological" melancholy, brought on by an excess of black bile that caused the body to become cold (or hot under certain circumstances) and dry, rendering its victims sad, fearful, and depressed, incapable of positive thought or action. Ripa aptly personified Melancholy as a grieving and sad old woman seated on a stone, supporting her head on her hands, and wearing ugly clothing without ornament.[29] The treatment of melancholia in both its forms, particularly the pathological variety, consisted of medicine, diet, and the like, as well as recreation and other pleasant diversions. Based on the venerable principle of *contraria contrariis curantur*, or a cure through "a contrarie cause of the same kinde," as Timothy Bright put it about 1586,[30] it was understood that the warm, moist passions, such as joy and pleasure, counteract the adverse effects of the cold, dry passions by expanding the heart and stimulating the production of new blood.[31]

A surprising variety of pastimes were cited as legitimate forms of joy and pleasure, both for melancholics and for healthy people in need of recreation, and some are of particular interest because they involve activities quite often condemned elsewhere by preachers and other moralists. One such pastime was the reading of light and frivolous literature. Although Alexander Barclay and other writers fulminated against the reading of *Robin Hood* and similar works instead of the Holy Scripture,[32] such stories were repeatedly recommended elsewhere for their recreational properties, beginning at least as early as Giovanni Boccaccio in his *Decameron*.[33] Thus in the preface to his edition of Sir Thomas Mallory's *Morte d'Arthur*, William Caxton told his readers they were at liberty to believe or not that Arthur had ever existed, but at least "for to passe the tyme thys booke shal be plesaunte to rede in."[34] Jan van Doesborch promises that his collection of foolish songs (published at Antwerp

in about 1524) will bring pleasure and drive away melancholy; the publisher of a sixteenth-century Netherlandish edition of *Til Eulenspiegel* conveyed to prospective readers his hope that this account of Eulenspiegel's pranks would not offend, but lighten and renew the spirit.[35] The publisher Richard Breton offered his *Songes drolatiques de Pantagruel* (Paris, 1565), a suite of woodcuts showing grotesque figures in the style of Bosch and Bruegel, "for the recreation of witty minds" (*pour le recreation des bons esprits*).[36] William Painter equally extolled the merits of his *Palace of Pleasure*, a collection of stories published at London in 1565: while these stories are profitable, they will also "recreate, and refreshe weried [wearied] minds, defatigated either with painfull travaille or with continuall care, occasioning them to shunne and avoid heavinesse of mind, vaine fantasies, and idle cogitations. . . . The sad," he continues, "shall be discharged of heavinesse, the angrie and cholericke purged, the pleasaunt mainteined in mirthe, the whole furnished with disporte, and the sick appaysed [appeased] of griefe."[37] François Rabelais made very similar claims for his *Gargantua* and *Pantagruel*, and so did Gerrit Hendricxsz van Breughel in his translation of fifty stories from the *Decameron*, published at Amsterdam in 1605.[38]

It requires no great perspicacity to discern in many of these claims a topos employed by publishers, authors, and editors to hawk their wares.[39] Nevertheless, such claims were probably accepted in good faith by many readers; even Luther recommended reading *Til Eulenspiegel* and *Solomon and Marcolph* to drive away the devil.[40] Men as sober as Poggio Bracciolini and Heinrich Bebel assembled collections of *facetiae*, or comic tales, for the recreation of scholars, and similar collections could be found in the libraries of the Protestant polemicist Marnix van St. Aldegonde and Jan van Brouchoven (died 1588), burgomaster of Leiden and *rentmeester*, or bailiff, in the Rhineland.[41] It was this kind of audience that Miguel de Cervantes had in mind when he recommended his *Exemplary Stories*, published in 1613, in the following words:

> My intention has been to set up in the square of our republic a billiard table where
> each one can come to amuse himself without fear of injury; I mean, without hurt to
> soul or body, for honest and pleasant exercises bring profit rather than harm. For one
> is not always in church, places of prayer are not always filled, one is not always at
> one's business, however important it may be; there are times of recreation, where the
> troubled spirit may find rest.[42]

Such recreational literature found many readers in Holland. The various stock catalogues issued by the Amsterdam book publisher Cornelis Claesz reveal that he published 8 percent more titles of fiction in Dutch than of religious works; the former included the immensely popular medieval romance *Amadis van Gaul*, Gerrit Hendricxsz van Breughel's translation of Boccaccio, and *De Ionghe Dotchters Tijt-cortinghe* (The young maid's pastime).[43] In his *Dapes intemptae* of 1623, the Dutch writer

Petrus Hondius enumerates the various kinds of books to be found in the library of "Mouffe-schans," a country house; they include serious works but also "blouwe boeckxkens," or blue books, so called because they often had blue paper covers, light literature intended solely to entertain the tired mind.[44]

Another form of recreation frequently advocated was dancing. Scipio, Seneca tells us, relaxed from his military duties by dancing.[45] Petrarch gave his reluctant approval to dancing: it should refresh the spirit and exercise the body, but not voluptuously intoxicate the mind.[46] As might be expected, the most wholehearted praise of dancing came from the dancing masters of the period. In his *Choreide—Autrement Louenge du Bal aus Dames*, of 1556, Berenger de la Tour d'Albenas praises dancing as beneficial to a person's health; it purges the humors.[47] Similar claims were made by Thoinot Arbeau (Jehan Tabourot), who in his *Orchesographie*, published at Langres in 1588, tells us that dancing is "un art plaisant & proffitable, qui rend & conserve la santé" (a pleasant and profitable art that restores and preserves health).[48] But Hendrick Laurensz Spiegel was no less enthusiastic about its physical and mental benefits: "Dancing sharpens the memory from within, contributes to careful understanding and sharp wits, and teaches every one to be diligent in whatever he does."[49]

Hunting, hawking, and other field sports were frequently recommended as a means of exercise and to preserve one's health. These activities were prescribed by Gentile da Foligno in the fourteenth century, and sometime later Christine de Pizan permitted hunting, even for ladies, if not done to excess.[50] Gaston Phoebus, author of the *Livre de la chasse*, claimed that hunting caused a man to avoid the seven deadly sins; Duke Otto, hero of a prose romance published at Antwerp in 1516, pursued the hunt to drive away melancholy, and the title print of Richard Braithwait's *English Gentleman*, published in several editions in the seventeenth century, illustrates "recreation" with a hunting scene.[51] It is in this context that we can perhaps appreciate the popularity of hunting tapestries and the many prints, often issued in series, devoted to hunting. Prime examples can be found in the series of scenes of hunting, hawking, fishing, and other field sports issued by Claes Jansz Visscher after designs by the Italian draftsman Antonio Tempesta.[52]

Other recreations are even more surprising. Although Sebastian Brant condemned gamblers in his *Narrenschiff* of 1494, he also admitted that gambling was no sin so long as it was done, not for gain, but "for recreation, that is, to sharpen our senses and to enjoy ourselves with our friends."[53] Even carnivals and other popular festivities, whose condemnation by both secular and church authorities has been frequently, perhaps excessively, emphasized by scholars in recent years, found defenders who justified such occasions in the name of recreation. "Lawgivers established holidays," Seneca tells us, "to give people a public mandate to enjoy themselves, thinking it necessary to introduce a sort of balance into their labours."[54] The same argument was advanced, as we have seen, in the plea of 1444 in favor of the Feast of Fools. We encounter it again in a Latin treatise in defense of popular amusements published in 1495 by Theodoricus Gresemundus, who cites the parable of the bent bow to prove his point.[55] In the late sixteenth century, the French lawyer Claude de Rubys of

Lyons insisted that the old and now prohibited forms of popular revelry had offered the common people release from their dreary, impoverished lives and were certainly better than the taverns where the people now spent their spare time carousing and plotting sedition.[56] So however much preachers and writers of moral tracts inveighed against such frivolities, there were others who advocated them or at least suggested that a moderate indulgence in such pastimes was necessary for the preservation of health and, indeed, of life.

In the various medical discussions of recreation, it is, of course, the melancholic who receives special attention. His case was desperate enough to justify the most frivolous diversions. In his encyclopedic *Anatomy of Melancholy*, first published in 1610, Robert Burton poured out for his readers a cornucopia of diversions, among them, fishing, gambling, traveling, dancing, reading, looking at pictures and prints, and watching jugglers and wrestlers. His only qualification was that these be practiced in moderation.[57] Indeed, almost any pastime was condoned for the melancholic that would expand the heart with warm, moist passions and above all incite laughter.[58] The theologians who condemned levity traditionally cited an admonition in the Sermon on the Mount: "Woe to you that now laugh: for you shall mourn and weep" (Luke 6:25), and it was often assumed that Christ himself had never laughed.[59] Nevertheless, the restorative and therapeutic benefits of laughter had long been recognized,[60] and indeed received biblical sanction: "A joyful mind maketh age flourishing, but a sorrowful spirit drieth up the bones"; this is "that familiar proverb," as Folly herself referred to Proverbs 17:22 in Erasmus's *Moriae Encomium*.[61] St. John Chrysostom claimed that laughter had been "placed into our soul so that the soul may rest."[62] Leon Battista Alberti claimed that his *Dinner Pieces*, a collection of amusing anecdotes, provided a way to relieve "the mind's maladies which works through laughter and hilarity."[63] The physician Laurens Joubert devoted a whole treatise, first published in 1560, to the causes and characteristics of laughter; he also informs us that God gave laughter to man "for his recreation in order to conveniently loosen the reins of his mind."[64] Later writers, among them many Dutch and Flemish authors, published numerous *kluchtboeken*, little volumes of humorous anecdotes, whose function is well summed up in the title of one such volume (Antwerp, 1633): *Medicaments against Melancholy*.[65] It was from these and other sources that the Dutch jurist Aernout van Overbeke (1632–1674) assembled his manuscript collection of over 2,400 jokes and anecdotes; in view of his father's death some years earlier from *morbo melancholico*, or melancholic sickness, he may have been arming himself against a similar fate.[66] David Beck also appreciated the value of laughter: he describes a meal over which he and his companions laughed so heartily that they could not eat, and this mirth, he continues, eased his worries concerning a family problem; elsewhere he speaks of being merry in a sad time.[67]

Beck was not alone in Holland. Although Dutch prints of merrymaking frequently carry inscriptions warning against the activities depicted, very comparable scenes could be presented in a more favorable light. In Jan Saenredam's *Four Times of Day*, engraved after designs by Hendrick

Goltzius, *Evening* shows an elegant company eating and drinking around a table; two lovers kiss. The Latin lines inscribed below tell us that "evening drives sorrow and sadness far away, she lightens people's spirits and banishes care."[68] As Jan Jansz Starter assured the readers of his *Friesche lusthof* (Amsterdam, 1621), it is a good thing that one sometimes "de geck laet springen uyt de mouwen" (literally, lets the fool spring from the sleeves), that is, plays the fool; these sentiments are inscribed, incidentally, beneath an engraving of a group of young people drinking and making music by candlelight, under the auspices of Cupid.[69] Among the recreations available to tired artists, Hoogstraeten, drawing as usual on Seneca, includes dancing, playing with children (which Socrates was not ashamed to do), and acting the fool. However, he devotes particular attention to eating with friends and drinking much, even to the point of drunkenness, "not in order to drown ourselves in wine, but in order to wash away [our] cares," because, he explains, "wine moves the spirit from below and heals some illnesses, and also drives out sadness."[70] Such drinking to excess, he nonetheless cautions, we should do only seldom.[71] But the need for laughter and sociability is perhaps summed up nowhere better than by a Dutch poet of the early seventeenth century: "Elck dingh heeft synen tyd: 'tis pryslick dat een man / Is wys in syn beroep en Vroliyck by de kan," which may be paraphrased as "Everything has its time; it is praiseworthy that a man is wise in his calling and joyful in his drinking."[72]

Among the causes of laughter Joubert listed pratfalls and the accidental display of the buttocks and genitalia, apparently without condemning them.[73] But many writers distinguished between decorous and indecorous laughter and insisted that wit and humor should avoid any taint of the indecent. Erasmus hoped that even the most lighthearted conversation would nonetheless have a philosophical flavor.[74] It was a recommendation followed by Jacob Cats in his *Galathee* of 1618; in his dedication to Catherina van Muylwyck, he described the poem as a *boere-werck*, or "peasant work," and says that though much of it consists of jokes and serves as amusement for the sad mind (*droeve geest*), "in joking sometimes something hides / That should be considered useful."[75] In spite of such noble intentions, however, much of the humorous literature offered as a sovereign remedy for tired minds, including the *kluchtboeken*, shows little of what we might call socially or morally redeeming qualities. Even the anecdote collection of Aernout van Overbeke contained a number of scatalogical stories.[76] Often the authors and publishers of such works defended them on the grounds that in addition to their laudable function of provoking laughter, they also edified the reader. This was no novel claim. St. Jerome tells us, for example, that we "will not be able to understand the power of the antidote, unless [we] examine the poisons."[77] Much later, the Italian humanist Guarino Guarini cites Quintilian to the effect that a knowledge of evil is necessary to defend what is right;[78] many editors of light literature often added introductions justifying their often less than edifying texts as suitable to read because they show us what *not* to do.[79] Similarly, Gerbrand Adriaensz Bredero recommended his comedy *The Spanish Brabanter*, published in 1617, both for the alleviation of melancholy spirits and for moral edification.[80] And while Crispijn de Passe II recommended his *Miroir des Plus Belles*

Courtisannes de ce tempes of 1630 to painters and other artists, he also hastened to assure other kinds of purchasers that he showed these beautiful courtesans, not to debauch the public morals, but because of his interest in costumes and to teach us to avoid vice.[81] Nevertheless, we may ask how seriously such admonitions were taken by the Dutch public of the period. At least one Calvinist preacher, Dirck Rafaelsz Camphuyzen, objected to what he considered specious justifications for portraying vice in literature or art.[82]

Indeed, in the face of the seemingly disingenuous disclaimers that we have encountered, we must wonder if the genre scenes that proliferated in Netherlandish art from the early sixteenth century on were chiefly viewed as sober warnings against evil living, as we are so often asked to believe.[83] Jacob Cats called genre paintings "laughable things," although not without wisdom, but perhaps we have overemphasized the "wisdom" of such subjects at the expense of the "laughable."[84] The merry companies depicted by Jan Massys and Jan Sanders van Hemessen, the tavern and brothel interiors of Jan van Amstel, the peasant carousals of Pieter Bruegel and his contemporaries, and the "genre" subjects by their countless successors far into the seventeenth century may have been appreciated not so much for the moralizing message they often possessed, and in the case of prints often had spelled out in inscriptions, as for the humor of their subject matter and the skill of the artist.[85] Like *Til Eulenspiegel* and the countless volumes of *facetiae, kluchtboeken,* and other humorous books that were published in all languages during this period, the depiction of similar amusing situations and characters in the visual arts may well have been intended to be viewed and enjoyed in a similar recreative context.[86] In this regard, we may recall Van Mander's assertion that no one could look at a Bruegel peasant scene, no matter how morose, without at least smiling.[87] Van Mander also tells us how Bruegel, as a joke, added the figures of two copulating peasants to a wall mural showing a summerhouse that Hans Vredeman de Vries painted for a government official, Aert Molckeman, who lived in Brussels. The painting "caused much laughter," and Molckeman was so pleased with Bruegel's embellishment that he refused to have it changed.[88] These are not isolated instances. In a print after Marten de Vos depicting a scene of peasant revelry, including an egg dance, the inscription tells us in part that it is good for a "sick man to laugh seeing these fools dance."[89] It may be noted in this context that the word *drollery,* suggesting something that amuses, was used by English writers and collectors to describe Dutch peasant scenes.[90] That these subjects had their recreative and therapeutic functions is a proposition that cannot be debated here at length, but it deserves further investigation.

One of the most innocuous and most commonly recommended forms of recreation, physical and mental, was going into the countryside and enjoying the amenities offered by nature. Again Seneca set the precedent: "We must go for walks out of doors," he advised, "so that the mind can be strengthened and invigorated by a clear sky and plenty of fresh air."[91] In the Middle Ages, Bruno of Cologne advocated the pleasures offered by nature as a means of refreshing the spirit for the contemplation of God, citing the parable of the bent bow in support of this advice.[92] The thirteenth-century physi-

cian Taddeo Alderotti recommended that his patients should cheer the mind by, among other activities, taking walks (presumably in the country).[93] Petrarch, too, preferred quiet walks for the exercise of both mind and body and thought highly of the recreative effects of the woods and fields.[94] Both the Dutch poet Dirc Potter and the French writer known as the Knight of La Tour Landry describe themselves as walking in the country to drive away melancholy.[95] In the early sixteenth century Marco Vida advocated that the weary student should be allowed "to seek the sweet fields and there oftimes watch the peasant customs," as well as hunt, although he should not let "the day pass wholly by in such diversion."[96] Somewhat earlier, Marsilio Ficino had advocated for the melancholic "the haunting of gardens and groves and pleasant walks along rivers and through lovely meadows," along with horseback riding, driving, and "smooth sailing."[97] Many other writers would have agreed with him, including Christine de Pizan and Conrad Gesner, the latter vowing that he would climb at least one mountain a year for bodily exercise and spiritual delight.[98] Such pastimes continued to be recommended long thereafter. Among the many recreations prescribed by Robert Burton, the most pleasant of all outdoor pastimes is to "walk amongst Orchards, Gardens, Bowers, Mounts, and Arbours . . . in a fair meadow, by a river side, . . . to disport in some pleasant plain, park, run up a steep hill sometimes."[99] Similar advice can be found in Gideon Harvey's *Moribus Anglicus* of 1674 and Gerard van Swieten's *Maladies des femmes et des enfans*, published at Paris in 1769.[100] The citizens of the Dutch Republic were equally convinced of the therapeutic value of nature, at least in the case of the poets: in a passage in his *Hart-spieghel*, Hendrick Laurens Spiegel describes a morning walk through the countryside, undertaken, he tells us, to relax the body and lighten the heart; Joachim Oudaen puts away his books to go for a walk; and Gerrit Bredero confessed:

> This is a great delight for my enjoyment
> That my farm lies so close to the city.
> If I am sad at home, I wander outside the city.[101]

In addition to being an appropriate setting for physical exercise, another benefit of natural scenery, it seems, lay in its predominating color, green. It was an old idea first recorded, perhaps, in the section on gemstones in Pliny's *Natural History*; concerning emeralds, he praises their hue, saying that no color has a more pleasing appearance; it satisfies the eye without cloying it and relieves eyestrain, which is why, he added, we also "gaze eagerly at young plants and at leaves."[102] Pliny's remarks were repeated with approval in Constantijn Huygens's autobiography, and Samuel van Hoogstraeten appropriately introduced the chapter on landscape in his *Inleyding* with an enthusiastic paragraph on the "most pleasant color" (*d'alleraengenaemtste verwe*, by which he meant green) that strengthens and rejoices the eye, although he gives Plutarch as his authority.[103] But even more important, of course, were the pleasures that nature offered the intellect, not only as a manifestation

of God's beneficence, that is, as "God's First Book," as the Calvinists often put it, but also as worthy of investigation for its own sake. As Vives explained it in his book on education:

> For the well-to-do old man, the pursuit of Nature-study will be a great delectation, and it will be a refreshment of the mind of those who have business affairs of their own, or who conduct affairs of state. For not easily will any other pleasure of the senses be found which can compare with this in magnitude or in permanence, since it stimulates the desire of knowledge, which for every human mind is the keenest of all pleasures. Therefore whilst attention is given to observation of nature, no other recreation need be sought.[104]

For Erasmus, too, nature teaches and provides honest pleasures. His garden, Erasmus tells us in *The Godly Feast,* "is intended for pleasure—honest pleasure, that is: to feast the eyes, refresh the nostrils, restore the soul," and also to teach, for Nature "speaks to us everywhere and teaches the observant man many things if she finds him attentive and receptive."[105] Similar ideas were later advanced by the Flemish neo-Stoic Justus Lipsius, who characterized the garden as a place for virtuous recreation and gardening as one of the hobbies and pleasures needed to "divert and console us" in these "hard, iron times."[106]

From the contemplation of nature as a means of relaxation, as therapy for both mind and body, it is but a short step to the contemplation of nature's surrogate in art, a step that was made by Leon Battista Alberti about the middle of the fifteenth century. "We are particularly delighted," he wrote, "when we see paintings of the pleasant countryside or harbors, scenes of fishing, hunting, bathing, or country sports, and flowery and leafy views. . . . Paintings of springs and streams may be of considerable benefit to the feverish."[107] Alberti is, of course, describing landscapes, although the term itself would not be employed anywhere in Europe for almost another half century, but it is clear that for him even the depiction of natural scenery functioned as a source of pleasure and, for the sick, a form of therapy. Alberti's enumeration of the various figures and activities to be seen in a landscape reflects Pliny's descriptions of the subjects painted by Studius (or Ludius) at the time of the emperor Augustus; he was famous, Pliny writes, for his wall paintings showing "villas, harbors, landscape gardens, sacred groves, woods, hills," and so forth.[108] Vitruvius speaks of private houses and their walks (loggias) that were decorated with very similar paintings.[109] Alberti was undoubtedly also familiar with Vitruvius's description of the three kinds of stage settings, one each for tragedy, comedy, and satire. Satire, which Vitruvius described as dealing with peasants and shepherds, called for rustic settings of woods, rocks, and streams, as well as humble cottages.[110]

To my knowledge, however, the ancients never ascribed any therapeutic virtues to the depictions of natural scenery; this seems to have been Alberti's own contribution. This idea, nevertheless, was

to have a long life. Several centuries later, Robert Burton tells us that when Achilles was mourning the death of his friend Patroclus, his mother, Thetis, gave him a "most elaborate and curious Buckler"; among its engraved images were not only battle scenes and the like, but also "hills, dales, towns, castles, brooks, rivers, trees &c., with many pretty landskips, and perspective pieces, with sight of which he was infinitely delighted, and much eased his grief." It is thus understandable that, shortly after this account, Burton includes "excellent landskips" among the works of art that would cheer melancholics.[111] And much later, Camille Corot would say that "if they had only entrusted me with the decoration of hospital wards or even of prisons! My country-sides and my woods would have brought consolation and fewer sad thoughts to the poor unfortunates therein confined."[112]

In this context, it is significant that landscape was also singled out by Alberti as the most suitable subject among the "allures of license and delight" permissible in the *hortus,* or suburban villa, a country retreat not far from the city and intended for pleasure and relaxation after urban cares.[113] This recommendation for villa decoration may have been picked up from the remarks of Pliny and Vitruvius; Alberti may also have been familiar with the *Imagines* of Philostratus, a series of detailed descriptions purporting to be of wall paintings that he had seen, apparently in a villa outside Naples. Whether these *ekphrasi* were based on actual works of art is debatable, but Philostratus tells us that the occasion for his book was as follows: "I was residing outside the walls [of Naples] in a suburb facing the sea where there was a stoa . . . [with] panel-paintings set in the wall."[114] Among them were landscapes, including hunting scenes and seascapes. But despite such precedents in antiquity, it is possible that Alberti simply institutionalized a scheme of domestic decoration widespread in late medieval Europe. In the second half of the fourteenth century, the Great Hall of the Louvre seems to have been decorated with landscapes with birds, deer, and other animals.[115] In the Castello del Buonconsiglio, in the North Italian town of Trento, the Torre Aquila contains a set of frescoes, painted about 1400, depicting the Labors and Pastimes of the Months set in deep landscapes.[116] Remnants of landscape frescoes can also be found in some of the palaces and villas of Tuscany, including the Casa Davanzati at Florence.[117] Natural scenery competed with other kinds of recreational subjects for domestic walls. In the last quarter of the fifteenth century, various palaces in Northern Italy were decorated with complex programs that featured the recreational activities of the court, whose members are depicted eating, hunting, and playing games.[118]

In later periods, paintings of natural scenery often decorated the walls of villas and the loggias of city houses in Italy. The loggia of the House of the Knights of Rhodes was painted with landscapes sometime before 1464, and the loggia of Innocent VIII received similar decoration by Pinturicchio between 1484 and 1487; little remains of either cycle, but Vasari's characterization of the pope's Belvedere frescoes as being in the "Flemish manner" may give us some idea of their original appearance.[119] Many more have survived from the sixteenth century, among them Baldassare Peruzzi's landscape views divided by fictive colonnades in a room in the Villa Farnesina, Rome, the Sala della

Perspettive, painted about 1516, and the set of rooms in the Villa Imperiale in Pesaro that Girolamo Genga decorated shortly after 1530 with similar landscapes viewed behind colonnades.[120] The most famous example, of course, can be found in the Villa Barbaro at Maser, in Northern Italy, of 1557–58, which contains splendid landscapes frescoed by Paolo Veronese and his workshop.[121] Thus Giovanni Battista Armenini was only reflecting current practice (and perhaps echoing Vitruvius) when he recommended in 1587 that the loggias and other open places of country houses be decorated with subjects of "cheerful things, such as delightful landscapes," which, in a manner recalling Pliny, he described as containing "cities, castles, theaters, seaports, fishing, hunting, swimming, and games of shepherds and nymphs." In such decoration, he insisted, "there must be nothing that gives rise to melancholy or boredom."[122]

The evidence for this mode of decoration is more fragmentary elsewhere in Europe, but it should be noted that in the Buen Retiro at Madrid, the Sala de la Conversazión, intended for promenades and conversations, was decorated in the 1630s with a number of paintings depicting hermit saints in wilderness settings.[123] In the Netherlands, the most famous example is the cycle of the *Labors of the Months* that Pieter Bruegel the Elder painted for the suburban villa of Nicolaas Jonghelinck just outside Antwerp.[124] To cite one example from seventeenth-century Holland, the hunting lodge of Prince Frederick Hendrik at Honselaarsdijk was appropriately decorated with pastoral landscapes and hunting scenes.[125] Architectural treatises of the seventeenth century also adhered to this tradition. From Henry Wotton's treatise, first published in 1624, we learn that the subjects of pictures for the house must be appropriate for their location: "that is, *chearfull* paintings in *Feasting* and *Banquetting* Rooms, *Graver Stories* in *Galleries; Land-skips* and *Boscage,* and such wilde works in open *Terraces,* or in *summer houses* (as we call them) and the like."[126] In Holland, it was Gerard de Lairesse who recommended landscapes and beautiful prospects among the subjects suitable to be painted in the upper rooms, as opposed to the grand historical subjects in the audience rooms. Also, he counsels, the summerhouse should feature "Bacchanalian pieces," sportive herdsmen, dancing, brooks, and fountains.[127]

It is doubtful, however, that the accounts of Pliny and Vitruvius and the architectural theorists of later ages prompted the taste for landscape paintings in seventeenth-century Holland. Depictions of landscapes and of nature in general had long been associated with pleasure and relaxation in other than architectural contexts. Michelangelo, for example, in his famous condemnation of Flemish painting reported by Francesco da Hollanda, had to admit that the Flemish artists are very good at painting landscapes and other things that gladden the viewer.[128] A century later, the physician Giulio Mancini, in a treatise on art written between 1619 and 1628, extolled landscape painting as satisfying the imagination and the need for recreation.[129] But perhaps the most provocative statement on landscape painting was made toward the middle of the sixteenth century: "Concerning those things which can be legitimately represented, there are two different kinds. The first consists of histories and the second of trees, mountains, rivers, and persons that one paints without meaningful intention. The first provides instruction, the second exists only to afford us pleasure."[130] This claim, that landscapes

give only pleasure, comes from none other than the very fountainhead of Dutch Calvinism, John Calvin. Landscape was acceptable to Calvin, of course, because it did not lend itself to idolatry, and it was praised in very similar terms by Edward Norgate in his *Miniatura*, written in the 1640s: landscape, he wrote, is a "harmless and honest Recreation, of all kinds of painting the most innocent, and which the Divill him selfe could never accuse of or infect with Idolatry."[131] By the time of Norgate, however, the linking of landscape and pleasure had achieved the status of a topos, as we can see in the expanded edition of Lampsonius's *Effigies* published by Hendrick Hondius first about 1610. Among the artists added by Hondius to the original *Effigies* of 1572 were Hendrick van Cleve, Christiaen van Queborne, and Gillis van Coninxloo; in the inscription accompanying each portrait, their landscapes are characterized as pleasing to, or gratifying, the eyes or providing recreation for the eyes.[132] Similarly, in the title print to what ultimately became the first section of his series of sixty landscapes, Jan van de Velde informed prospective buyers that these scenes were intended not only for the use of painters but also *ad oculorum oblectamentum*, that is, "for the delight of the eyes."[133]

There is yet another association between landscape and pleasure that deserves to be examined. It was first made, so far as I can determine, by Paolo Giovio, when, shortly after 1527, he described some of Dosso Dossi's pictures in the following terms:

> The gentle manner of Dosso of Ferrara is esteemed in his proper works, but most of
> all in those which are called *parerga*. For devoting himself with relish to the pleasant
> diversions of painting he used to depict jagged rocks, green groves, the firm banks of
> traversing rivers, the flourishing work of the countryside, the gay and hard toil of
> the peasants, and also the distant prospects of land and sea, fleets, fowling, hunting,
> and all that genre so pleasing to the eyes in a lavish and festive style.[134]

In labeling landscapes as *parerga*, or "accessories," Giovio, of course, was implying that they were less important than Dosso's *historia*, or narrative subjects with human figures, and the low rank of landscapes in the traditional hierarchy of subjects is well known. But more important for our purposes, not only does Giovio stress the pleasure that such landscapes give to the eye, but he also suggests that the very act of painting these landscapes was a form of recreation for Dosso, a pleasant diversion from more serious painting. A similar idea was expressed sometime later by Paolo Pino in a treatise of 1548. Discussing the landscapes of Girolamo Muziano, Pino tells us that Muziano's competence in this kind of subject is very appropriate, and very agreeable, as much for the painter as for the spectator.[135]

It is more than likely that Peter Paul Rubens would have agreed with this sentiment because, as his nephew Philip would later write to Roger de Piles, when Rubens retired to his château Het Steen, he took great pleasure in living "in solitude, in order to paint vividly and *au naturel* the surrounding mountains, plains, valleys and meadows, at the rising and the setting of the sun, up to the horizons."[136]

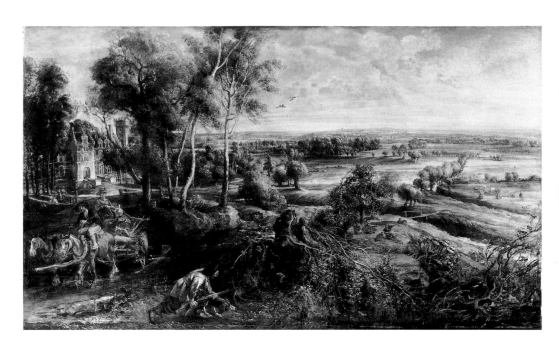

FIGURE 57
Peter Paul Rubens,
*Landscape with Castle
Steen*. London,
National Gallery.

This story receives confirmation from Norgate who in his *Miniatura* writes: "Wherewithall Sir Peter *Rubens* of Antwerp was soe delighted in his Later time [with landscape], as hee quitte all his other practice in Picture and Story, whereby he got a vast estate, to studie this, whereof he hath left the world the best, that are to bee seene."[137] Rubens's dedication to landscape painting in his old age is not without its irony, because as a young Fleming in Italy, he seems to have resisted the prevailing Italian view that Northerners excelled only in landscape painting. Indeed, he rejected the request of an official of the duke of Mantua that he paint a group of woodland scenes.[138] Nevertheless, landscape played an important role in his later work, and in the years of his retirement at Het Steen, withdrawn from both his diplomatic labors and the industry of his workshop, Rubens produced some of the most splendid landscapes paintings of his career, including *Landscape with Castle Steen* (Fig. 57) and *Landscape with the Rainbow*.[139] But this may not have been the first time that Rubens escaped the pressures of the world through landscape painting. In the autobiography of his youth, Constantijn Huygens recounts that when Antwerp was suffering from the plague, Rubens retreated to his summer place, "where he turned to landscapes with the same abundant production and beauty" that he showed in his other paintings.[140] Huygens wrote this account about 1629–31, some years before Rubens bought Het Steen (in 1635), so he must refer to an episode earlier in Rubens's life. Van Mander thus had ample precedent when he advised his young artists to relax, when they were too tired for more serious work, by going out into the country, and it is very likely that he envisioned them as sketching the very landscapes they enjoyed.

The particular variety of pleasure that Rubens must have received from the act of painting is strikingly set forth by Roger de Piles, who may well have had Rubens in mind when he wrote that

> landskip is a kind of painting that represents the fields, and all the objects that belong
> to them. Among all the pleasures which the different talents of painting afford to
> those who employ them, that of drawing landskips seems to me the most affecting
> and the most convenient; for, by the great variety of which it is susceptible, the
> painter has more opportunities, than in any of the other parts, to please himself by
> the choice of his objects. The solitude of rocks, freshness of forests, clearness of
> waters and their seeming murmurs, extensiveness of plains and offskips [*les lointains*,
> or "distant views"], mixture of trees, firmness of verdure, and a fine general scene or
> opening, make the painter imagine himself either a-hunting, or taking the air, or
> walking, or sitting, and giving himself up to agreeable musing. In a word, he may
> here dispose of all things to his pleasure, whether upon land, or in water, or in the
> sky, because there is not any production either of art or nature, which may not be
> brought into such a picture.[141]

Such pleasures, as we have seen, were not restricted to artists alone. Viewers had long used landscape images as occasions for vicarious travel. In the later Middle Ages, the faithful often made spiritual pilgrimages of the Holy Land and other sacred places by means of pictures; Hans Memling's two panoramas, the *Passion of Christ* and the *Seven Joys of the Virgin*, the latter painted for the Italian banker Tommaso Portinari and his family, were undoubtedly intended as the foci of such tours of the spirit through prayer and meditation.[142] Pilgrimages of a rather different sort were undoubtedly afforded by the immensely popular Flemish world landscapes produced in such great numbers during the sixteenth century. We have little direct information as to how people looked at such landscapes; however, with their far-flung vistas and wealth of detail, they have much in common with maps, as I have shown elsewhere, and concerning maps there exists considerable evidence as to how they were viewed in the sixteenth century.[143] Valued as sources of geographic information, maps could even provoke moral contemplation on the smallness of man in the face of a large world, but they were cherished above all as a source of intellectual pleasure. Thomas Elyot's well-known encomium of maps praises them in precisely these terms, and he concludes, "I cannot tell what more pleasure should happen to a gentle wit than to behold in his own house everything that within all the world is contained."[144] This enthusiasm must have been shared by many a beholder of a landscape by Patinir, Bles, or Bruegel. Landscape images as more than passable substitutes for travel did not end with the sixteenth century. Cornelis Pietersz Biens, we may remember, praised draftsmanship because it could show us the "pleasant regions of the world" without leaving our study. In a poem written about 1660

on a series of etched views of the Rhine valley by Herman Saftleven, Vondel says that "if someone wishes to take the air whenever he likes, but in the peace and quiet of his home, he can still go silently up the Rhine . . . all in his own room."[145]

There is no doubt that landscape elements, including dead and living trees, waterfalls, mountains, and fields, were often employed in allegorical contexts; a paradigmatic example, as we have seen, is Jacob Matham's print of 1599 after a design of Van Mander (see Fig. 53). In such cases, however, accompanying texts or figures give us vital clues as to how these elements are to be interpreted. Indeed, landscape could be used as a vehicle for profound philosophical programs; in addition to the *Jewish Cemetery* of Jacob van Ruisdael (see Fig. 55) may be cited certain landscapes of Poussin and Claude, and undoubtedly others. But they remain exceptions. Perhaps we should remember that landscape had long occupied a fairly low rung in the traditional hierarchy of subject matter: Hoogstraeten, for example, placed depictions of everyday life and landscapes above depictions of fruit and flowers and other still-life subjects but below *doorluchtige Historyen*, that is, subjects drawn from secular and biblical history, and from mythology.[146] And it may well be that its lowly status generally exempted landscape from the intellectual and moralizing freight that is often claimed for other kinds of subjects. In any case, we cannot assume a priori that Dutch landscape images possess allegorical meanings, as the scriptural readers so often suggest; rather, each image must be considered on its own. Above all, we must not forget the traditional function of landscape images as surrogates for the experience of nature itself, and precisely how this function was manifested in the Dutch rustic landscape will be examined in the next two chapters.

5

Pleasant Places

THE CASE OF HAARLEM

[T]heir pleasant Walks, their planted Highwayes, which are fenced
with such orderly Hedgerows, [it seems] that the whole country is but
one shady walk by the Riverside, a Paradise.

— *The Dutch Drawn to the Life*, 1664

Why did the Dutch buy such copious numbers of prints and paintings showing views of their native countryside? More precisely, how did they respond to these images? We may find some answers to these questions if we turn to one of the earliest examples of the Dutch rustic landscape tradition in prints, the *Plaisante Plaetsen* published by Claes Jansz Visscher about 1611–12 (Figs. 58–69).[1] I have suggested that Visscher created this series of landscapes in artistic emulation of the *Small Landscapes* first published by Hieronymus Cock, a number of which Visscher had already copied in a series of etchings that he issued in 1612. But the *Plaisante Plaetsen* also represents Visscher's response to a specific place, the Dutch city of Haarlem. This is evident, to begin with, in the title plate (Fig. 58), which is dominated by a complex allegory that commemorates the city's heroism during the Spanish siege for seven months in 1572–73 and its eventual capture by the enemy who held it until 1576. The center of the print is occupied by Haarlem's coat of arms, a shield displaying a sword, four stars, and a cross, resting on a block inscribed with her motto, *Vi[n]cit vim virtus* (Virtue overcomes force), adopted by Haarlem after the siege. Above the arms is a laurel wreath encircling a dead tree, a reference to the famous woods outside the city that had been destroyed by the enemy, and about which we shall hear more later. Behind the heraldic shield appears

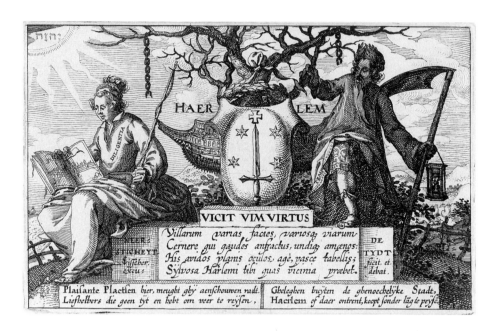

FIGURE 58
Claes Jansz Visscher,
title print, from
Pleasant Places,
etching. Amsterdam,
Rijksmuseum.

FIGURE 59
Claes Jansz Visscher,
table of contents,
from *Pleasant Places*,
etching. Amsterdam,
Rijksmuseum.

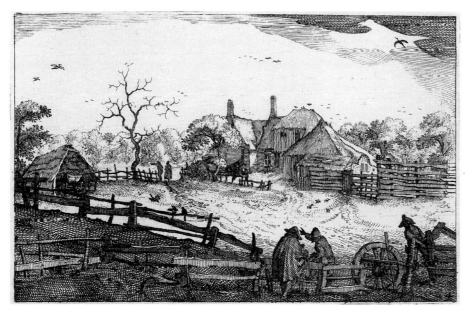

FIGURE 60
Claes Jansz Visscher,
Sandtvoordt, from
Pleasant Places,
etching. Amsterdam,
Rijksmuseum.

FIGURE 61
Claes Jansz Visscher,
Paters herbergh, from
Pleasant Places,
etching. Amsterdam,
Rijksmuseum.

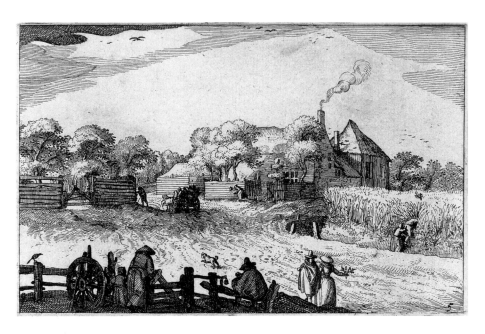

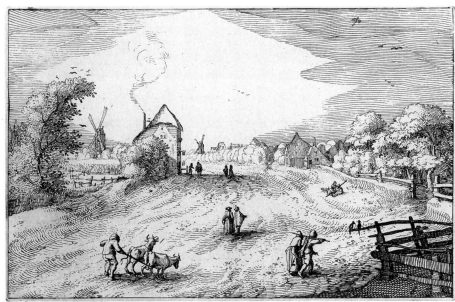

FIGURE 62
Claes Jansz Visscher,
Potjes herbergh, from
Pleasant Places,
etching. Amsterdam,
Rijksmuseum.

FIGURE 63
Claes Jansz Visscher,
Aende Wegh na Leyden,
from *Pleasant Places*,
etching. Amsterdam,
Rijksmuseum.

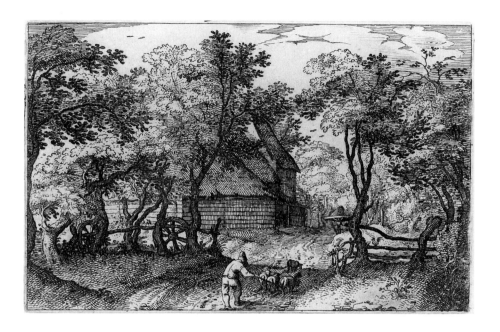

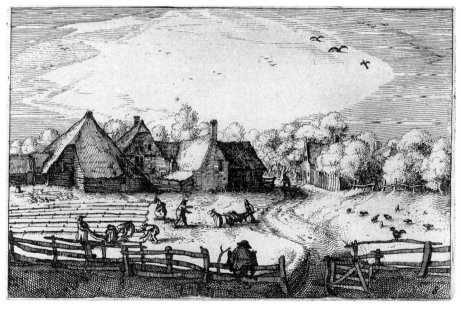

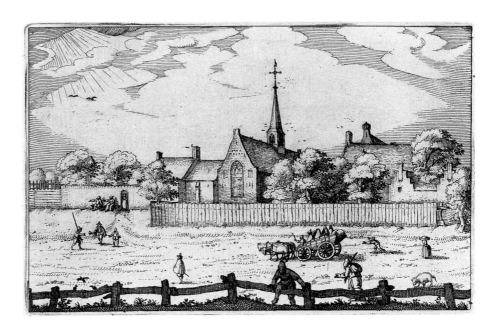

FIGURE 66
Claes Jansz Visscher, *Lasery van Haerlem*, from *Pleasant Places*, etching. Amsterdam, Rijksmuseum.

FIGURE 67
Claes Jansz Visscher, *Plaijsante plaets ae[n]de duy[n] ka[n]t*, from *Pleasant Places*, etching. Amsterdam, Rijksmuseum.

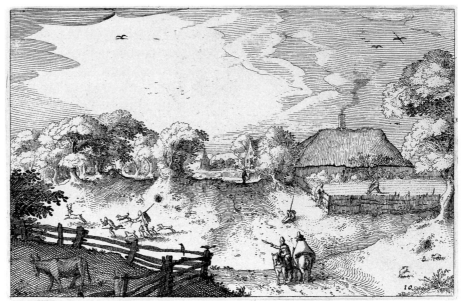

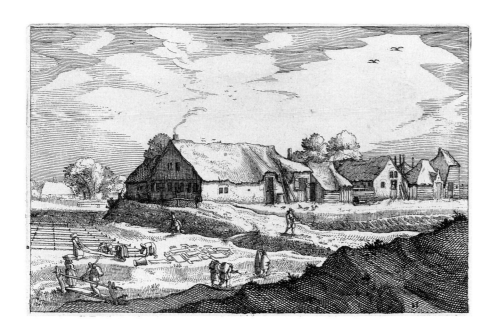

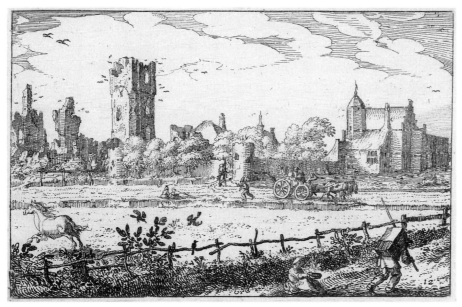

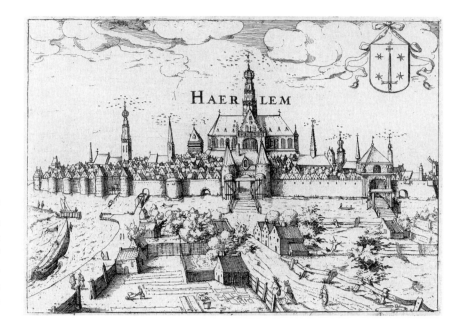

part of a ship with a curious saw-toothed keel; this alludes to a legendary event from Haarlem's more distant past: in 1219, during the Fifth Crusade, Count William I of Holland rescued the city of Damietta from the Egyptians by severing a chain placed by the enemy across the Nile, cutting through it with a ship with an iron saw attached to the keel.[2] The arms and the trophies of Haarlem's history are flanked by the personifications of Industry (Diligentia, or Diligence) and Time.[3] This temporal dimension is placed *sub specie aeternitas* beneath the tetragrammaton of God framed in a sunburst in the upper left-hand corner.[4]

In view of its glorification of Haarlem, we might reasonably expect that the title print would introduce us to a set of views from the city itself, the church of St. Bavo, for example, or the city hall and the weigh house, and perhaps scenes of her industry. This is how Haarlem appears in a view in Jean François le Petit's *Nederlantsche Republijcke*, published at Arnhem in 1615 (Fig. 70),[5] in which the great steeple of St. Bavo dominates the skyline. The bleaching grounds in the foreground were actually much farther away, but they have been brought closer to the city walls to underscore the importance of the linen industry to Haarlem's prosperity.[6] This was also how Visscher had presented his native Amsterdam just a year or so before in a large and elaborate print of 1611.[7] It shows Amsterdam's busy wharves along the river IJ, with the major buildings of the city behind; the format may owe something to the traditional views of Antwerp seen from across the Schelde, but instead of the usual bucolic scene in the foreground, Visscher showed people from near and far, Dutch peasants, including a prominently depicted fisherman, on the right, and exotic turbaned merchants with

laden camels from the Orient, both groups converging with their produce or merchandise on the Maid of Amsterdam, symbol of the emerging new emporium of the North. Amsterdam's prosperity and power were celebrated by many Dutch poets, including Hendrick Laurensz Spiegel, Bredero, and Vondel; even David Beck composed a "Sonnet on Amsterdam."[8] In Visscher's print, the praise of Amsterdam occurs in an extensive accompanying text in letterpress ornamented with further views of the square, the Dam, and three of the city's chief buildings, the Stock Exchange, the Butchers' Halls, and the Fish Market.[9] In the case of Haarlem, however, Visscher celebrated, not the city, but its rustic environs. The Twelve Years' Truce had just been concluded in 1609, affording a tenuous breathing space in the hostilities between Spain and the United Provinces. The cessation of war had traditionally been characterized in terms of the return of peace to the countryside, and this same tradition can be found in Visscher's *Leo Belgicus,* an allegorical map first published in 1609; in the background, two travelers, identified as "Safe Travel," survey a peaceful landscape labeled "the well-being of the land."[10] In a poem published at Haarlem in 1610, it is the Goddess of Agriculture herself who complains about war.[11]

The same idea may well have played a role in Visscher's decision to celebrate Haarlem's countryside instead of the city. This rustic theme is already announced on the title print in the two verses in Dutch and Latin, forming a contrast to the rather recondite allegory of civic virtue and heroism. The Latin lines read: "You who enjoy the varied view of country houses and the surprising turns in ever delightful roads: come, let your eager eye roam these open vistas offered by the sylvan surroundings of Haarlem." Visscher develops this idea in the Dutch verses: "The Pleasant Places here you can contemplate with ease, devotees [*liefhebbers,* i.e., lovers of nature] who have no time to travel far, situated outside the agreeable city [of] Haarlem or thereabouts," and he advises potential purchasers to "buy without thinking for long."[12] In these verses, Visscher sounds several familiar themes. Both landscape images and maps were frequently touted as a convenient means of vicarious travel, while the Antwerp publisher of a 1544 edition of Apianus's *Cosmographia* also offered this volume as a cheaper way of seeing the world.[13] Visscher himself employed the latter topos in a series of hunting landscapes issued in 1612, in which he asserted that their purchase, unlike the activities they depicted, would not clean out our pockets,[14] and varied it in the *Plaisante Plaetsen* with his plea that we "buy without thinking for long." On the other hand, the reference to the *locus amoenus* is Visscher's earliest use of a theme that he later employed in various forms (see chapter 2) in various title prints to his landscape series.

Despite its conventional elements, however, Visscher's invitation to the viewer—and prospective purchaser—was firmly based on fact. Haarlem had indeed long been famous for the scenic beauty of its environs. Already in the previous century, Cornelius Aurelius had called Haarlem an earthly paradise, famous for her pleasant countryside, and Lodovico Guicciardini had characterized her as follows: "Haarlem lies three leagues from Amsterdam and it has beautiful buildings within [the town],

and outside one finds fair fields with a very gracious woods, so that its air in particular is very salubrious, and all around are to be seen many lovely villages and *châteaux* [or castles] close enough."[15] Of these numerous amenities of Haarlem, its "very gracious woods" were especially famous. A remnant of a hunting preserve established by the medieval counts of Holland and mentioned as early as the thirteenth century, the so-called Haarlemmer Hout, or Haarlem Woods, lay to the south of the city along the river Spaarne. Destroyed by order of the town fathers in 1428 to prevent its use as a place of concealment by the troops of Jacoba of Bavaria, the woods were replanted and by the late Middle Ages had been opened up to the citizens of the town.[16] In a *lofdicht*, or laudatory poem, on Haarlem, composed perhaps about 1400, a local citizen, Dirk Mathijsz, described the Haarlem Woods as pleasurable, especially when the birds sang, and where one could hunt rabbits and other small game.[17] It is presumably in these woods that Jan van Scorel, Van Mander tells us, spent his Sundays and holidays engaged in copying "the trees in colors, very subtly and vividly."[18] On the earliest surviving map of Haarlem, made in 1573 by "Master Pieter, certified surveyor of the king's ways,"[19] the Haarlem Woods is a spacious area crisscrossed by many paths and with country houses along its borders. Shortly thereafter, the Haarlem Woods were destroyed a second time, during the Spanish siege of Haarlem, but with the return of peace, the Haarlemmers worked hard to restore their woods, obtaining permission in 1583 from the States of Holland to replace them and importing trees for replanting from many, often distant sources.[20] By 1612, as we are told in the first Dutch edition of Guicciardini, published in that year at Amsterdam, a large part of the woods had been replanted, to the great pleasure of the citizens.[21]

The Haarlem Woods must have revived pretty much within a generation, for it figures prominently in the two poems in which Karel van Mander celebrated Haarlem's fame, both titled "Beeldt van Haarlem," and both probably completed sometime before 1596, although apparently first published only later.[22] In one of these poems, Van Mander enthusiastically characterizes the Haarlem Woods as a *lust woud* (pleasure wood), a place of "joyfully sweet relaxation."[23] Even more eloquent is his other "Beeldt van Haarlem." On the way to Leiden lies *Haarlems foreest*, Van Mander tells us, where the young and old promenade and enjoy themselves on the green, "in order to rejoice the spirit." Here one may "eat, drink, play, read, sing, without fear; here melancholy flees; [this place] appears to be a real *kermis feest* [or carnival, as we might say], for people, like a piece of clothing, must sometimes be aired."[24]

This last "Beeldt van Haarlem" was published in 1610, shortly before Visscher's *Plaisante Plaetsen*. Hardly six years later, in 1616, the Haarlem poet and Calvinist preacher Samuel Ampzing published the first edition of his *Lof der Stad Haerlem in Holland*, an extensive *laudatio* of Haarlem, "the Mother of our freedom," as he called her. It went through three editions, and in the third, that of 1628, he devoted over twenty pages to the beauties of the Haarlem countryside.[25] To the south of the city, along the Spaarne, lies the "Hout van Haerlem," the *lusthof*, or pleasure ground, of our city,

he tells us. It is a summer abode and a quiet retreat free from the noise and anxious clamor of the city. Between the Hout and the city walls lies the Baen, an open field that served as a sports ground, where, among grazing sheep, the townspeople engaged in archery, ball games, and *kolf,* an early form of golf. But Ampzing conducts us to the Haarlemmer Hout only after a walking tour that begins on the beach, and we stroll through the dunes, where he points out a number of noteworthy sights, including a particularly high dune, of which more later. Thereafter, we visit scenic villages such as Duyn, Aelbertsberg, and Bloemendaal, and view a number of castles and country houses, some along the Kleverlaan, a road lying to the north of the city.[26] Ampzing was not alone in celebrating the delights of the Haarlem countryside. They are often described in seventeenth-century songs; a number were gathered in a collection published at Haarlem about 1610 by a poet using the pseudonym "Haerlem Soetendal" (i.e., Haarlem sweet dale); by 1618 it had gone through eight editions.[27] In a later collection, the *Haarlems Oudt Liedt-Boeck,* first published in 1630, one song expresses the wish that "it were always Sunday," because then everyone goes out to Brederode, Zandvoort, the Haarlemmer Hout, and other places around Haarlem.[28]

If Guicciardini's characterization of Haarlem seems like a brief entry in an abbreviated tourist guide, the more extensive descriptions by Van Mander and especially Ampzing read like a public-relations brochure sponsored by a modern chamber of commerce, and indeed, it would be difficult to deny that these two authors betray a strong element of local pride, probably coupled with a justifiable patriotic regard for a city and its pleasure grounds that after their virtual destruction by the enemy had been returned to their former glory and more. But neither Van Mander nor Ampzing was really guilty of an indiscriminate "boosterism." The fame of Haarlem's natural amenities spread beyond the city walls. The Englishman Peter Mundy, touring Holland in 1640, was favorably impressed by the "many pretty groves and woods" near Haarlem, as well as the "faire long rancks of trees with pleasaunt walkes betweene"; beyond the town he found "certaine sandhills called dounes," where one could hunt rabbits.[29] Some years later Nicolas de Parival, born in France but for many years a teacher of French in Leiden, included a long account of Haarlem in his *Delices de Hollande* of 1651. Haarlem, he wrote, is called the second city in Holland, and he described the "forte jolie bois" (extremely attractive woods) and the "montagnes de sable" (sand mountains), and he named a number of pleasant villages in the neighborhood of Haarlem, among them Heemstede, Spaarnwoude, and Tetrode.[30]

The people who enjoyed Haarlem's *plaisante plaetsen* thus were not limited to the local inhabitants. De Parival tells us that many people from Amsterdam promenaded through the Haarlem Woods. Haarlem was within fairly easy reach of Amsterdam. De Parival's claim that boats from Amsterdam departed hourly for Haarlem is amply confirmed by other sources; it has been calculated that by the 1660s the *trekschuiten,* or passenger barges towed by horses (see Fig. 89), carried some three hundred thousand passengers each year between the two cities,[31] and many of them were undoubtedly

bent on a day or two in the country. On one such trip from Amsterdam to Haarlem, John Evelyn in 1641 found the river "ten miles in length, straight as a line and of a competent breadth for ships to sail by one another."[32] Travel to the region around Haarlem became easier with the completion of several canals during the course of the century, the Haarlemmervaart in 1636 and especially the Leidsevaart in 1657.

In the first decade of the century Visscher himself may have been one of the day-trippers from Amsterdam, to judge from the number of drawings he made of places in and around Haarlem beginning in 1607. Alternatively, he may have been a guest in one of the country houses near Haarlem. We can see some country houses already on the Haarlem map of 1573, used as summer residences and weekend retreats for people from the city. Many country estates could be found in the vicinity of Bloemendaal, a village not far from Haarlem: Ampzing lists a number of them.[33] They include the Huis te Aelbertsberg and the Huis te Vogelenzang, both old feudal castles that had been rescued from ruin and rebuilt as country houses.[34] Another was Vollemeer, a farmstead in the dunes, once owned by Maerten van Heemskerck, although this is not mentioned by Ampzing. At his death in 1574, Heemskerck bequeathed Vollemeer to the regents of the Heilige Geesthuis in Haarlem to provide dowries to two young girls annually, on the condition that they would be married on his grave.[35] The house was later destroyed by the sand, but in 1610 the property was acquired by a Haarlem citizen, Jan van Sompel, who rebuilt the house; Ampzing speaks of Sompel's roof visible among new trees.[36] The well-to-do Haarlem brewer and burgomaster Jan Claesz Loo possessed a stately residence, called Velserend. We can see it in a drawing by Jacob Matham of 1627 (Fig. 71), to which he added some verses: "here is his pleasure house, here is his playground," Matham tells us, adding that his country place allows Loo to escape the pressures of his business. However, Loo would have had to travel farther to achieve this end than the drawing suggests. Matham showed Loo's house and formal gardens facing the brewery just across the Spaarne, but actually this country estate was situated some distance from the city and rather far from the Spaarne, toward the coast near the ruins of Brederode.[37]

Other country houses were acquired or built by wealthy merchants from Amsterdam, especially among the numerous villages dotting the region around Haarlem. An early Amsterdam estate was Spieghelenburg, the property of Laurens Jansz Spiegel, a man described by one contemporary as "very rich and mighty of goods"; the estate was celebrated by his brother, the poet Hendrick Laurensz Spiegel, in the fifth book of his *Hart-spieghel*.[38] Another property mentioned by Ampzing, Saxenburgh, near Bloemendaal, was then owned by Joos van der Graft, brewer at the Roode Harte in Haarlem; Ampzing refers to the famous fountain in the garden that all Haarlem, he says, came to see.[39] Later in the century Saxenburgh came into the possession of the Amsterdam businessman Christoffel Thijs; it was at this time that Rembrandt included it in a drawing of the Haarlem dunes and in his "*Goldweigher's Field*," etched in 1651 (Fig. 72).[40] Rembrandt had bought his fine house in the Jodenbreestraat in Amsterdam from Thijs, and since he never paid off the mortgage, it may well have been this matter that brought the artist to Saxenburgh.

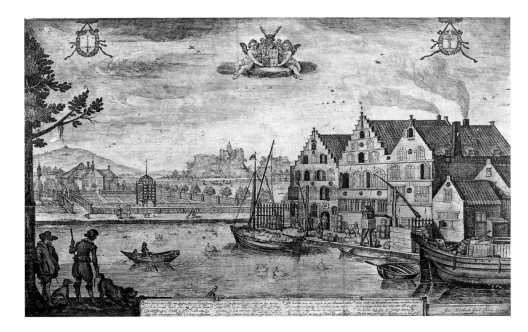

FIGURE 71
Jacob Matham,
*Brewery and Country
House of Jan Claesz
Loo*, 1627, drawing.
Haarlem, Frans
Halsmuseum.

FIGURE 72
Rembrandt, *"Gold-
weigher's Field" (View
of Bloemendaal with
Saxenburgh)*, 1651,
etching and drypoint.
Chicago, The Art
Institute of Chicago.

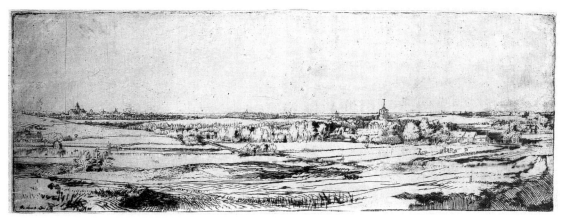

 The significance of the country house for Dutch landscape painting will be explored later, but we have seen enough to realize that when Visscher published his Haarlem views, he could be certain that they would appeal to a broad audience familiar with these particular *plaisante plaetsen,* not only the inhabitants of the town itself but also people in Amsterdam and probably elsewhere in Holland. We do not know what prompted his selection of the particular views, but we can assume that they were popular scenic spots. The first landscape appears on the page with the table of contents, seen as through an arch (see Fig. 59). Our attention, however, is first attracted by the foreground ledge supporting a quill pen, an etching needle, a bottle of etching acid, and other objects that refer to various aspects of the artist's profession, a personal reference that is reinforced by the fisherman seated in the niche below the arch, underneath a fictive banner inscribed with the words: "At Amsterdam Published by

Claes Jansz Visscher living in the Kalverstraet in the [sign of] the fisher."[41] This repeated play on Visscher's name reminds us that he moved only in 1611 into the house in the Kalverstraat, where a number of other printmakers and publishers had their establishments, and De Groot makes the plausible suggestion that the *Plaisante Plaetsen* were intended to advertise his new place of business.[42]

However this may be, Visscher's desire for self-advertisement may also have prompted his choice of scenery to introduce the series, since the view through the arch, as we learn from the table of contents, is the beacon light at Santvoordt, or Zandvoort, as it is now spelled. Zandvoort was a fishing village on the coast east of Haarlem, and we may suspect that Visscher intended another reference to his name. The bird's-eye perspective of the scene suggests the view that sightseers might have enjoyed from the beacon tower, and the few rooftops glimpsed between two of the dunes may be Zandvoort itself. The next print, number 3, brings us to the town (see Fig. 60). We stand near the beach, watching some fishermen stretch their nets to dry. To the right, a road curves along the beach, leading directly to the village, dominated by the spire of the little Gothic church whose neglected condition is indicated by the ruinous transept to the right, damaged in the war with the Spanish.[43] Zandvoort seems to have been popular with the townspeople of Haarlem, who, according to Ampzing, often went there to walk along the beach, watch the waves, and eat freshly caught fish.[44] And it may well have been here that Frans Hals found the models for his paintings of fisherboys and -girls of the early 1630s.[45]

Hadrianus Junius had observed in his *Batavia* of 1588 that there were places in the Haarlem Woods free of *herbergen* and *misdadige kroegen* (inns and criminal taverns), "where the learned can come together, far away from the city noise and country folk."[46] Visscher did not share this prejudice against such establishments, for his next two prints are devoted to the *herbergen* of Pater and Potje (see Figs. 61, 62). Visscher noted on the back of his sketch of Potje's *herberg* that it lay "outside of Haarlem in the Hout,"[47] and the extensive wooded setting of Pater's inn suggests that it also lies in or near the Haarlem Woods. Potje's inn must have been especially popular with the Haarlemmers, for Ampzing mentioned it by name in the first edition (1616) of his *Lof der Stad Haerlem*.[48] As in the case of Antwerp in the sixteenth century, the citizens of Haarlem enjoyed cheap beer in the country inns, free of the taxes levied by their own municipality. This must have been a major attraction of the Hout, which at this time was not under Haarlem's jurisdiction but was part of nearby Heemstede, and the two towns quarreled about the beer sold in inns situated there.[49] This perhaps explains Ampzing's claim that Pater's inn was a place where people could quench their thirst with a glass of creamy milk;[50] he does not mention beer, which presumably would have been a sore point with the Haarlem town fathers. Neither *herberg* in Visscher's series is particularly grand; both could easily be old farmhouses converted to their present purposes. In the scene of Potje's inn, a serving maid emerges from the front gate bearing a large tankard, and, despite Ampzing's claim, it is not unlikely that she carries beer, rather than milk, to the thirsty travelers in the crowded wagon nearby. The place of these two

prints near the beginning of the series may also be a conscious allusion to what Ampzing praised as Haarlem's chief industry, for her many breweries formed a major source of her fame and wealth.[51] Haarlem beer was shipped all over Holland, and some Haarlem brewers, such as Loo, were rich enough to own splendid country estates near the city. Country inns might also provide lodgings for travelers and sightseers who had no access to accommodation in the country houses; many inns beyond the city's jurisdiction also functioned as brothels,[52] but whether either Potje or Pater offered entertainment of this more dubious sort is anyone's guess. Visscher returns to the Haarlem Woods in several other prints. The way to Leiden, depicted in number 6 (see Fig. 63), went directly through the woods, as did the way to Heemstede, a heavily wooded region depicted in the seventh print (see Fig. 64). The eighth view is titled "Bleaching Fields beyond the Hout"; the woods presumably can be seen in the background (see Fig. 65).

Visscher depicts the dunes a number of times, and with good reason, although they represent an aspect of the Dutch domestic landscape whose significance perhaps has not been fully appreciated by historians of Dutch art. Occupying large areas of the coast of Holland and the Haarlemmermeer, these regions of sand hills, lakes, stunted trees, and other vegetation not only serve as a vital buffer zone protecting the inland areas from the ravages of the sea but constitute a remarkable world of their own. They were certainly appreciated by the Dutch of the seventeenth century. Ampzing describes the dunes near Haarlem at considerable length. Among all the dunes, or sand mountains (sandbergen), "whose tops challenge the heavens," as he characterized them, one is the most famous in the whole country. It is very tall and steep and people must climb it on their hands and knees, and when they have reached the summit of this "Atlas" and have caught their breath, they can see a number of places from this high point, including the "merchant city of Amsterdam," "wise Leiden," and even, so Ampzing claims, "rich Alkmaar." He concludes enthusiastically, "what an eyeful [oog-geweij] of all our land."[53]

Ampzing may have described his Dutch "Atlas" with a bit of poetic license, but these "montagnes de sable," as De Parival called them, can often be quite high in elevation, affording magnificent views of the surrounding countryside. Although Ampzing's "Atlas" has not been identified, it may have been not unlike some existing dunes near Haarlem, such as 't Kopje near Bloemendaal (the dune, incidentally, from which Rembrandt apparently took his view of Saxenburgh)[54] or two dunes in the vicinity of Elswout, De Blinkert and Duinlust, the latter some thirty-two meters high.[55] The modern visitor to the Dutch dunes will readily understand why Ampzing celebrated their peculiar beauties so enthusiastically. In the introduction to *Den Nederduytsche Helicon* of 1610, Van Mander claimed that his "Helicon," his mountain of the Muses, would henceforth be situated on the Witte Blinck, another high dune near Haarlem.[56] The earliest known drawings of the Haarlem dunes come from the hand of Hendrick Goltzius (see Fig. 38), although Visscher may well have been the first to depict them in prints. However, it was only the painters, such as Jan van Goyen and Jacob van Ruisdael,

who could adequately convey their special qualities of light, air, and color, as well as the illusion of vast distances they convey within a fairly small space (see, for example, Fig. 1, Plates 1, 5).

Visscher apparently did not depict Ampzing's "Atlas," but he included a number of dunes. In addition to the view of Zandvoort, the nearby coast represented in the table of contents, and the "Bleaching Fields through the Hout," dunes form the subject of two further prints (see Figs. 67, 68), the first of which is labeled a "pleasant place on the dune side." Bisected by a road leading into a village, this landscape shows a farm on the right and, on the left, several hunters and dogs in pursuit of a deer. The dunes were home to small game such as rabbits, as both Dirck Mathijsz and Peter Mundy had testified well over a century apart. Similarly, Van Mander described the rabbits in the dunes as thick as "ants in the grass"; he further speaks of the *herten en hinden,* that is, the harts and hinds that could be found there as well.[57] Hunting in the dunes was restricted to the nobility and a few other privileged social groups. Visscher may indeed have shown nobles hunting, but we cannot be too sure; the regulations restricting hunting to the nobles seem often to have been flouted by other members of society. In 1636 and 1637, for example, the stadhouder Frederick Hendrik received appeals from members of the aristocracy to close the lands around Haarlem and neighboring villages to protect endangered game.[58]

Two of Visscher's dune scenes show the bleaching grounds (see Figs. 65, 68); they remind us that the dunes were especially esteemed for this purpose because of their suitable water.[59] John Locke gave a striking description of this process in the account of an excursion he made from Haarlem to Heemstede in 1684. "Hereabouts," he wrote, "they bleach much linen; they wash it in soap, they soak it in lye several times and also in buttermilk; in washing they rub particularly the selvedges [edges of the cloth]; between these washings they lay it out on the grass, where it lies spread in the sun and is kept perpetually wet with sprinkling on of fair water; the process is too long and of too little consequence to be written all particularly."[60] The bleaching season extended from mid-March to September, and during this period the refuse from the flax made the fresh water dirty and unfit either for drinking or for brewing beer. As a result, many legal battles erupted as the Haarlem brewers sought to curtail the use of dune water by the linen industry.[61] It is in keeping with their celebration of the *locus amoenus* that both Ampzing and Visscher omit any references to this more unpleasant side of life in Haarlem's countryside.

It is rather curious that Visscher omitted any views of the country estates in the vicinity of Haarlem. Indeed, other than the ruined parish church at Zandvoort and the taverns of Pater and Potje, he includes only two buildings that he specifically identifies: the *lasery van Haerlem,* or Haarlem lepers' asylum, and the ruins of the Huis ter Kleef (see Figs. 66, 69). A leper house appears in the *Brussels* series engraved by Hans Collaert, which Visscher reissued perhaps about this time, but this precedent probably influenced him less than the fact that both asylum and ruin, like the Haarlem Woods themselves, had patriotic associations with the city's recent past.[62] The leper house was installed in the former St. James's chapel near Haarlem; during the Spanish siege, the chapel had been the site of the

enemy camp. The Huis ter Kleef, which gave its name to the Kleverlaan running through the Haarlem Woods, was a medieval castle that had been destroyed by the Spanish in 1573. Hence, in addition to being objects of curiosity, the two buildings would have reminded sightseers of a critical episode in Holland's struggle for independence. Indeed, in Pieter de Molijn's great panoramic view of Haarlem, etched by Jan van de Velde and published in 1621, both the Huis ter Kleef and the leper house are featured prominently in the left foreground.[63] It is Visscher's own views of these two ruins that most closely relate to the patriotic theme of his title print.

Visscher may have intended more views for his *Plaisante Plaetsen;* as we have seen, this is suggested by the table of contents: all but one of the titles of the prints are crowded into the left-hand column; the exception is number 12, which occupies the right-hand column by itself, with the rest of the space left blank.[64] Visscher could have included at least two other surviving drawings he made in his perambulations near Haarlem in 1607: a view along the road between Haarlem and Leiden and a view of the Huis te Aelbertsberg near Bloemendaal.[65] Another related sketch by Visscher may be recorded in the two albums of Dutch antiquities and views published by Abraham Rademaker in 1725; one etching shows "Hillegom between Haerlem and Leiden," inscribed with the date 1607. Since Rademaker tells us that he derived many of his views from old drawings found in various collections, it is tempting to suggest that this view of 1607 may have been done after a drawing by Visscher.[66] In any case, Visscher may have thought that his other drawings of Haarlem's countryside would duplicate the views he had already etched; alternatively, he may have abandoned the *Plaisante Plaetsen* in favor of some other project, such as his copies of the *boerenhuyskens.*

The example of Visscher's *Plaisante Plaetsen* was quickly followed by other artists who paid tribute to Haarlem's rural beauties, beginning with Esaias van de Velde, who etched a set of ten views sometime before 1616, when he moved to The Hague (Figs. 73–75). The set was issued by the Haarlem printer and bookseller Jan Pietersz Beerendrecht, who also was active as a print publisher.[67] Quite different in style from Visscher's Haarlem series, the horizontal format of Esaias's compositions allowed the depiction of landscapes that were more extensive than the *Plaisante Plaetsen.* They also differ from Visscher's set in that the first state contained no inscriptions identifying the places depicted; the identifications were added only in the third and fourth states. Not all the plates deal with Haarlem's countryside. Two are of fortifications situated at a fair distance from Haarlem, one on the island of Tholen in Zeeland, the other simply labeled *Forten op t' Schelde* (forts on the Schelde [river]). Catherine Levesque plausibly suggests that the views of these forts would have reminded viewers of the continuing need to defend the far borders of the Dutch Republic, despite the peaceful conditions offered by the Twelve Years' Truce.[68]

Nevertheless, we should beware of trying to read a predetermined program into the series, for its heterogeneous subject matter suggests a casual assembly of landscape subjects on the part of the printmaker or publisher. Indeed, while the title print of the final edition could pass for Dutch scenery, it is graced by a circular temple that for some scholars recalls the Temple of the Sibyl at Tivoli.[69] In

FIGURE 73
Esaias van de Velde,
Spaarwou, from the
Haarlem series,
etching. Amsterdam,
Rijksmuseum.

FIGURE 74
Esaias van de Velde,
Brouwery, from the
Haarlem series,
etching. Amsterdam,
Rijksmuseum.

FIGURE 75
Esaias van de Velde,
*Landscape with
Gallows,* from the
Haarlem series,
etching. Amsterdam,
Rijksmuseum.

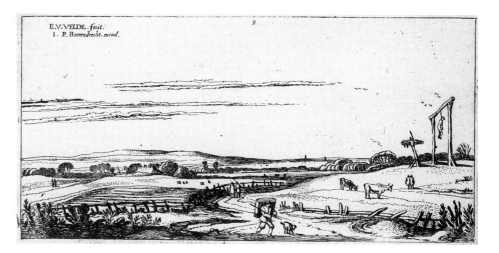

the first two states, only the publisher's name and his place of origin, *Haerlemensis*, occurring on a number of the plates, gives us a clue as to what the prints represent. But if we accept as essentially accurate the place-names inscribed on the later states, most of the views depict specific locations in the countryside around Haarlem: the church tower and village of Spaarwou, or Spaarnwoude (Fig. 73), for which the drawing is preserved in Amsterdam, an ice-skating scene near the Penninccksveer, the penny-ferry on the road between Haarlem and Spaarnwoude, and the road south on the way to Lisse, as well as a farm labeled *Buyten Haerlem* (outside Haarlem). Another scene is identified simply as "brewery" (Fig. 74): its ramshackle old structure has little in common with the grand edifice that Jacob Matham showed as the brewery of Jan Claesz Loo, De Drie Lilien, in his drawing of 1627 (see Fig. 71).

Perhaps the most unusual view in this series is the one inscribed *'t Gerecht buyten Haerlem* (Fig. 75); it shows a great stretch of the Dutch countryside, but at the right is a gallows from which is suspended a corpse and a wheel employed for exposing the bodies of executed criminals. This forbidding prospect is ignored by the travelers, among them a peddler who trudges along the road with a heavy pack on his back and accompanied by his dog. For one scholar, the gallows and wheel add an "ominous note,"[70] but Van de Velde may simply have been reminding the viewer of another aspect of local fame, since one of the official hangmen for the county of Holland made his residence in Haarlem, whence he traveled to execute criminals in other cities.[71] This print may also represent a well-known landmark. *Galgevelden*, or gallows fields, were common features in the vicinity of towns and cities. In a view of an ideal city after Hans Vredeman de Vries, published by Hieronymus Cock in 1562, a *galgeveld* looms on the hill at upper right, above the Renaissance facades and towers.[72] In Haarlem, the gallows field at that time apparently lay south of the city, near where the Crayenestervaart empties into the Zuider Buiten Spaarne. Still to be seen about 1900, the site is now occupied by a Haarlem suburb.[73] As it happens, Van de Velde's print does not conform fully with what we know of the site of the Haarlem gallows field. He shows neither river nor canal in the vicinity; perhaps, as has been suggested, they were not visible from the spot where he made his original drawing. He also included two dunes absent in later written descriptions of Haarlem, but these could have been leveled at some later date. However this may be, gallows were also erected along the roads for the execution of highwaymen and brigands.[74] In a painting of 1627, Esaias showed a scene of highway robbery, in which the gallows in the background serves as a reminder of impending justice.[75] A painting by Frans de Momper depicts a peasant dance outdoors, observed by an upper-class couple in the foreground; on the low hill nearby a gallows stands with a corpse dangling from it, a visual guarantee, as it were, for the peace of the countryside.[76] It is an old idea. In his *Allegory of Good Government*, Ambrogio Lorenzetti had placed a gallows in the hand of Securitas, who hovers outside one of the town gates: only stern and swift justice can assure the security enjoyed by the rural territories under Siena's rule.[77] Esaias's contemporaries may well have felt a similar reassurance when they looked at his *Landscape with Gallows*.

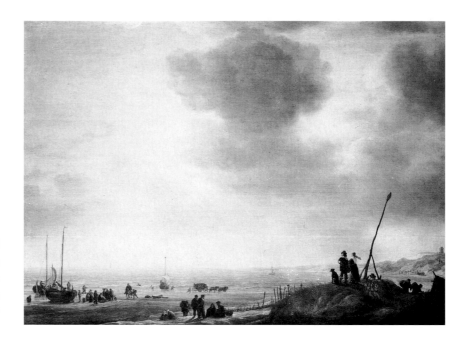

FIGURE 76
Simon de Vlieger,
View of Scheveningen,
1643. The Hague,
Mauritshuis.

Whatever motivated Esaias's choice of subject matter, it may be significant that he does not seem to have duplicated any of the "pleasant places" depicted by Visscher. Conversely, Willem Buytewech, in his suite of ten landscape etchings published about 1616, included two scenes of ruins near Haarlem: Brederode Castle and the Huis ter Kleef, the latter already depicted by Visscher.[78] Both of Buytewech's prints are straightforward views, in which the ruins are presented in reportorial fashion, without the sightseers added by Visscher, and the Huis ter Kleef is shown from the side opposite to the one in Visscher's view. It is rather surprising that Visscher did not illustrate Brederode Castle; not only had it also suffered from the depredations of the Spanish troops, but it was the ancestral seat of Hendrik van Brederode, self-styled "Count of Holland," who had played a crucial role in the early days of the war with Spain.[79] Brederode Castle was frequently depicted in Dutch art. It forms the subject of a drawing that Goltzius made in 1600.[80] Probably shortly thereafter, Jacob Matham issued a print of the site, with a long inscription recounting the early history of the castle.[81] Pieter Jansz Saenredam contributed a view of Brederode to Ampzing's *Lof van Haerlem;* the verses beneath end with the wish that it be restored to its former state.[82] It was also depicted by Meindert Hobbema in a painting now in London.[83]

There is no doubt that Haarlem was one of the most popular places of resort in Holland, but there were others as well. The Hague was equally fortunately situated with regard to natural scenery, as it was close to "the agreeable village of Scheveningen," according to De Parival, "where one goes often in parties to eat fresh fish."[84] Like Zandvoort near Haarlem, Scheveningen also offered

FIGURE 77
Copy after Jacob van
Ruisdael, *View of
Scheveningen*. The
Hague, Mauritshuis.

opportunities for a pleasant stroll along the beach, although it must have been crowded at times, to judge from a view of the village that Simon de Vlieger painted in 1643 (Fig. 76). There is no evidence that bathing and swimming in the sea enjoyed their present popularity,[85] but water recreation of a more decorous sort can occasionally be seen in the beach scenes of the period. In a picture considered to be a copy after Jacob van Ruisdael, possibly by Jan van Kessel (Fig. 77), for example, several ladies and gentlemen, otherwise dressed for the street, wade with great dignity in the tide; their discarded shoes and stockings lie on the beach nearby, guarded by an old woman. Apparently, this was not an uncommon practice. David Beck describes in his diary how one warm June afternoon he and a friend went to "Schevelingen," as he calls it, for some fresh sea air. They washed their feet in the sea, walked along the street, and drank a *kanneken* of beer before going home. At the end of the same month, on a Sunday afternoon, one of David's brothers and a friend went to Scheveningen to watch a sea storm.[86] That Scheveningen was also visited by the wealthy and highborn is suggested by the presence in numerous beach scenes of stately coaches, some emblazoned with their owners' coats of arms, and we can understand why the first paved road in the Republic, the so-called Zee-Straet (Sea Street), was laid in 1665 between Scheveningen and The Hague. This project was instigated by Constantijn Huygens, who commemorated its completion in a poem of more than a thousand lines.[87] Scheveningen's greatest moment, however, must have occurred on 8 May 1660, when Charles II embarked there for England and his throne, an event celebrated in at least one print and several paintings.[88]

Especially renowned, however, was the Haagse Bos, or Hague Forest. The remainder of a large hunting preserve, it, like the Haarlem Woods, possessed a checkered history.[89] It was spared by the Spanish when they entered The Hague in 1574, only to be threatened with extinction by William of Orange, who had wanted to sell the woods; the citizens of The Hague, however, saved them by giving him the money he needed. Long a favorite hunting ground of the counts of Holland, the Haagse Bos in the seventeenth century still boasted an extensive deer park. It had been open to the public since 1614, and in his diary of 1624 David Beck often refers to the *wandelingen* that he and other Haagenaars made through the Bos, often on Sunday after church. (Incidentally, another popular walking place frequented by Beck and his fellow citizens was the Voorhout, a parklike plantation of trees not far from the Binnenhof, the seat of government.)[90] The Englishman William Nicholson, who visited The Hague in 1678, recorded in his travel journal: "The Bosch: which is the largest and pleasantest wood in Holland . . . the greatest part of those many thousands of trees which grow in this wood, are oaks: of which you shall scarce meet with any more in all Holland."[91] Claes Jansz Visscher must have visited the Bos fairly early on; the reverse of his drawing of the Haarlem leper house shows a study of three trees, inscribed "after life on the outer side of the Haagse Bos" and the date 1608.[92] But the Bos does not seem to have inspired the printmakers until about 1650, when Roelant Roghman made a suite of six etchings emphasizing the parklike, pastoral character of the forest (Fig. 78).[93] Thereafter appeared numerous drawings and paintings of the forest by Jan de Bruyn, Jan Lievens, and other Dutch artists. Joris van der Hagen seems to have made views of the Haagse Bos

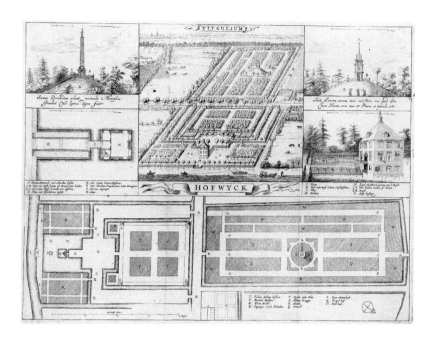

one of his landscape specialties, and it is possible that its great oaks inspired some of the woodland scenes of Jacob van Ruisdael and Meindert Hobbema.[94]

Aside from the public *plaisante plaetsen,* the more affluent members of Dutch society, following the practice established by their Flemish predecessors in Antwerp (and undoubtedly elsewhere) in the previous century, enjoyed the countryside on a more intimate and prolonged basis in their *land-huizen,* or country houses. In this respect, Haarlem was not unique. Almost every Dutch city had its equivalents of Haarlem's Bloemendaal and Saxenburgh. For Leiden, it was Leiderdorp. In his description of Leiden of 1614, Jan Orlers names Leiderdorp together with Coudekerck, Oestgeest, Warmond, Voorhout, and other *schoone Dorpen* (lovely villages) lying in the region around Leiden; these, he tells us, are pleasant places where the citizens can walk and enjoy themselves and where they have country estates. In the second edition of his book, published in 1641, Orlers singles out Leiderdorp as a "lovely and agreeable village" that contained numerous wealthy summer retreats.[95] Similar retreats appeared in the vicinity of The Hague; they include Hofwijk, built by Constantijn Huygens in the 1640s (Fig. 79), and Jacob Cats's Zorgvliet, a property that lay between the city and the sea. These names clearly proclaim the function of these houses, for *Hofwijk* means roughly "leave (or retire from) the court," and *Zorgvliet* may be translated as "flee [from] care." Many country houses were erected along rivers and waterways, not only because of their scenery, but because they offered a cheap and easy means of transportation. Another Zorgvliet, for example, together with a Vliet-zorg, lay on the banks of the Spaarne near Haarlem (Plate 6).[96] A drawing of 1682 attributed to Lau-

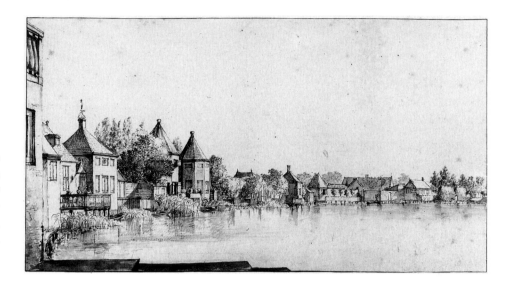



FIGURE 80
Attributed to Laurens
van de Vinne, *Summer
Houses and Pavilions
along the Spaarne*, 1682,
drawing. Haarlem,
Teylers Museum.

rens van de Vinne (Fig. 80) shows a section of the banks of the Spaarne as thickly clustered with country houses and summer pavilions as any modern vacation resort.[97] The banks of the river Vecht, forming part of the water link between Utrecht and Amsterdam, became an increasingly favored place for summer residences, especially for families from Amsterdam.[98] By 1650 travelers on a Vecht *trekschuit* could easily have entertained themselves by watching one country estate after another pass in review, much as we see them in an anonymous print of the period showing a fairly long stretch of the Vecht's northeast bank.[99] The rapid conversion of open land into country estates may well have alarmed some contemporary observers. This is suggested, at least, by Constantijn Huygens's ironic comment on the suburban sprawl of country residences in the Voorburg (a village near The Hague), when he imagined people passing by and complaining that such places as his own Hofwijk had replaced good farm- and grazing land.[100]

Country residences were of various kinds.[101] Some were old castles, belonging to ancient feudal seignories acquired by wealthy patricians as the old Netherlandish nobility died out or became impoverished.[102] Other country places began as simple *hofsteden,* or farms, originally purchased by city residents as land investments or as sources of fresh produce, and were gradually converted into comfortable country houses. Still others were built specifically as summer places; this was especially true in areas that had been newly drained. But whatever their origins, these country houses exerted an incalculable influence on the imagery of the Dutch rustic landscape that has never been explored in detail. Depictions of country houses occur frequently from the seventeenth century on. Some are true "portraits," such as Jan van der Heyden's 1674 view of Goudestein at Maarsseveen on the Vecht, property of the Huydecooper family of Amsterdam (Fig. 81), or the aerial views of his country house and gardens that Huygens published in his *Hofwijck* (see Fig. 79), although here topographical ac-

FIGURE 81
Jan van der Heyden,
View of Goudestein, 1674.
London, Apsley House,
Wellington Museum.

FIGURE 82
Claes Jansz Visscher,
*Country House and
Orchard of Jan Deyman*,
etching. Amsterdam,
Rijksmuseum.

curacy was sacrificed to Huygens's desire to show the gardens as they would appear a century later, when the trees would be full grown.[103] In other country-house views, too, the depiction of the present reality may sometimes have been tempered by the owner's hopes for future improvement.

Very often, however, the owners of country estates seem to have enjoyed seeing their houses placed inconspicuously within a rustic environment. About 1608–9, for example, Claes Jansz Visscher made several drawings, later used in an etching, of the country seat and orchard of Jan Deyman, situated on the way to Sloterdijk, near Amsterdam (Fig. 82).[104] The house itself is all but concealed by the orchard, the foreground given over to a scene of bucolic contentment: two barns with chickens in

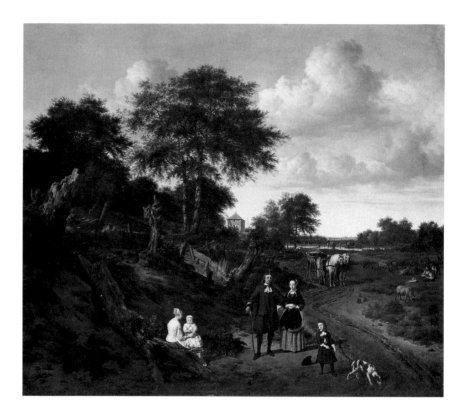

the farmyard, a horseman, and, in what is probably another reference to the artist's name, two men fishing in a canal. Jan van der Heyden, who portrayed Goudestein in 1674, referred to it more obliquely in a landscape now in the J. Paul Getty Museum (Plate 7).[105] That it is nothing more than a simple rustic scene is an illusion quickly dispelled by the signboard hanging on the inn in the right foreground; on it are painted the words *'t Zwarte Varken* (The Black Boar), along with the arms of Maarsseveen, and Goudestein itself can be discerned at a discreet distance in the background. Of particular interest is a family portrait in a landscape executed by Adriaen van de Velde in 1667 (Fig. 83). Unfortunately their identities are unknown, but these people are clearly well-to-do; in the distance we can barely discern the main block of their stately *landhuis*. The owner and his wife stand in the foreground, along with their two children and the nurse, who is seated just left of center with one of the children on her lap. The family has come by carriage from their house, and now they stroll through a peaceful landscape that includes old trees, a dilapidated fence, and at the right a reclining shepherd piping to his flock.[106] Such allusive depictions of country houses may be compared to the *hofdichten*, or "country-house poems," that were very popular in Holland during the seventeenth and eighteenth centuries. These poems were written to celebrate various country houses and the good fortune and consummate taste of their owners.[107] However, they very seldom describe the house in detail; rather,

they dwell on the delights offered by the land itself, the fields and orchards, the gardens, and the beautiful vistas that can be seen on walks in the surrounding countryside. In this respect, the *hofdichten* closely parallel such pictures as the one just described.

While many landscapes contain identifiable country seats portrayed in this oblique fashion, it is sometimes difficult to know if they were specifically commissioned by their owners. A good example occurs in a painting executed by Paulus Potter in 1647.[108] It shows an evening landscape: cows are being milked at lower right, and an upper-class couple pauses in their promenade beside a row of trees in the middle ground; in the distance, beyond wide fields, can be discerned a nobly proportioned structure that has only been recently identified as the Huis de Werve, which stood near Voorburg. This poetic evocation of country peace may well have been painted for its owner, but De Werve is not rendered with complete accuracy, and Potter introduced a very similar house into another painting of the late 1640s;[109] hence, it may simply have been part of his repertoire of landscape motifs. Rembrandt's *View of Bloemendaal with Saxenburgh* (see Fig. 72) poses the same problem: it may have resulted from a specific commission by the owner,[110] or Rembrandt may have chosen the motif for himself. This is equally the case with his etching of Het Torrentje of about 1650, depicting a country house just outside Amsterdam; it is generally assumed that the print was commissioned by the owner, Jan Uytenbogaert, but in the third state, Rembrandt omitted the cupola of the tower, thereby depriving it of its distinguishing feature.[111]

The country-house tradition probably influenced Dutch artists in more subtle ways as well. The river landscapes of Jan van Goyen and Salomon van Ruysdael often contain barges and ferryboats, a reminder of how vital Dutch waterways were for the transport of families and goods to their country destinations. In a river scene by Salomon van Ruysdael (Plate 8), a ferryboat containing cows and farmers and well-dressed people seated in an open carriage moves toward the shore at the left; we may assume that the carriage and its passengers are heading for the turreted building seen above the trees, very likely an old castle converted into a *landhuis*. Philips Koninck was even more allusive: in a panoramic landscape now in Amsterdam, the road at lower left leads to an imposing gate; we are left to conjecture that it continues to some fine country retreat hidden among the trees.[112]

But whether country houses were specifically portrayed or evoked in a less direct fashion, in its various forms the rural retreat afforded wealthy urbanites and their families the opportunity to live the *buytenleven*, or "life in the country," free from the stresses, dirt, and pollution of the city. "God the first garden made, and the first city, *Cain*," as Abraham Cowley put it in the seventeenth century; inspired by Genesis 4:17, this is a topos that occurs at least as early as St. Augustine.[113] In the *Bauwheers wel-leven*, a poem that we will consider at greater length in chapter 6, the author celebrates the delights of a simple country life; in contrast is the city with its foul air and stinking streets that receive only a "handful of air" from between the high facades.[114] His picture of the city may not have been totally unjustified. Most Dutch cities grew during this period, but none more than Amsterdam,

which underwent major expansion about 1612 and again in 1654–62, with the development of the so-called Nieuwe Uitleg in a large area to the south of the old city.[115] In a painting of 1672 Gerrit Berckheyde depicted newly constructed town houses along the Herengracht (Plate 9), a relentlessly urban environment, devoid of trees or even a blade of grass.[116] This rapid growth also affected the older parts of the city, rapidly consuming many of the gardens and other natural amenities that had long existed there. After the developments at midcentury, both within and beyond the city walls, the playwright Jan Vos lamented the loss of trees and especially the Ossenmarkt, or ox market, a favorite promenade.[117]

Life on the country estate was routinely exalted as the summit of human felicity. This theme runs through the *hofdichten*, and it can be found in the poems that Joost van den Vondel wrote for special occasions. One is a poem of about 1658 or 1659, written by way of thanks for some wild game received from his friend Jan Six, who had a country estate called Elsebroeck, at Hillegom, about halfway between Haarlem and Leiden. Vondel praises the trees and flowers, the fresh air and other rustic pleasures that Six enjoyed in his country retreat, far away from the wars and sorrows of the world. Here in Elsebroeck, Six can immerse himself in his studies, and when he is fatigued by such labors, his young wife tempts him outdoors, where they walk in the open air as he recites to her a *veldgedicht*, or poem in praise of country life, and they watch the rabbits and other wildlife in the dunes.[118] A particularly lighthearted example of this genre occurs in a poem that Vondel composed in 1659, commemorating the betrothal of Reinier van Estvelt and Rebeka Bruining. The lover woos his beloved by describing the delights of his estate, Vlierbeeck: the fresh air, the song of the nightingale, the absence of the noise of the city and of the stock exchange (*buiten stadts en beursgerucht*). Here, Reinier tells Rebeka, you can sleep easily at night, drink all the buttermilk you want, and eat honey, cheese, or cream. Overcome by this prospect of rustic contentment, Rebeka finally gives the *Ja-Woord*, that is, her assent, and promises to become his bride.[119]

Vondel sounded a more serious note a year later, in 1660, in a poem that he dedicated to the powerful Amsterdam magnate Cornelis de Graeff, who had been much involved in the construction of Amsterdam's new city hall, begun in 1648. The poem appears in Vondel's translation of Virgil's works, more specifically just before the *Eclogues* and the *Georgics* (here rendered as "Herders-zangen" and "Lantgedichten"), Virgil's poems dealing with country life, and it may have been this circumstance that inspired the general tenor of Vondel's dedicatory verses. De Graeff having just stepped down from the post of burgomaster of Amsterdam, Vondel lavishes considerable praise on him as a wise and farseeing statesman and says that after his hard work for the citizens of Amsterdam, De Graeff can now retire to well-deserved rest and relaxation in the rural surroundings of Soestdijk, his country seat near Hilversum.[120] A painting of 1660, the same year as Vondel's poem, shows De Graeff and his family before the facade of Soestdijk (Fig. 84); the figures are by Thomas de Keyser, but the landscape was painted by none other than Jacob van Ruisdael. De Graeff and his wife are seated in

FIGURE 84
Thomas de Keyser
and Jacob van
Ruisdael, *Cornelis de
Graeff and His Family
before Soestdijk*, 1660.
Dublin, National
Gallery of Ireland.

their fine carriage; other members of the family appear on horseback. There is little in this painting, in fact, that conveys the simplicity of life on the land, and indeed, it admirably serves to remind us that possession of a landed estate could confer another benefit often coveted. Cornelis de Graeff habitually styled himself Heer van Poelsbroek, or lord of Poelsbroek, after the name of another country estate, inherited from his father in 1638.[121]

This was not a whim on De Graeff's part; people who bought up the old feudal manors, or *heerlijkheiden*, in Holland and elsewhere in the Northern Netherlands also employed the titles that had long been associated with them. Through this means wealthy Dutch burghers were able to call themselves Heer van Waveren, Heer van Oudshoorn, and the like.[122] These titles had no official standing in the Dutch Republic and were not as prestigious as the genuine titles that more fortunate Dutch citizens had inherited or obtained from foreign sovereigns. Constantijn Huygens, for example, was knighted in 1621 by James I of England; thereafter Huygens never failed to include his title, *eques*, or "knight," on the title pages of his publications.[123] The unofficial titles acquired with the Dutch manorial estates served nonetheless to distinguish the wealthy patricians from their fellow burghers, and their holders exercised the few feudal rights still associated with the seigneuries that they purchased. In this respect, the current Heer van Maarsseveen, Johann Huydecooper II, may well have been flattered by Van der Heyden's view of the inn 't Zwarte Varken, since it was the place where the local town officials met to conduct business connected with his domain. A champion collector of such

titles was Adriaan Pauw (1585–1653), a wealthy court official and diplomat living in The Hague. Pauw acquired two "genuine" knighthoods, one conferred on him in 1613 by James I, the other, in the order of St. Michael, conferred in 1624 by Louis XIII. In addition, in 1620 he bought Slot Heemstede, an old castle in present-day Heemstede; the possession of this property and a number of other manors allowed Pauw to assume the titles Heer van Heemstede (the title under which Ampzing addressed a poem to him in his *Beschrijving ende lof der stad Haerlem*), Heer van Bennebroeck, and Heer van Nieuwerkerk, among others. However, Slot Heemstede seems to have been his favorite country residence, and it was here that he was buried after his death in 1653.[124] If Rembrandt was as socially ambitious as we have been led to believe, it was a trait that he shared with many of his more preeminent countrymen.[125] And Rembrandt's countrymen, we may suspect, would have agreed wholeheartedly with Daniel Defoe's Dutch merchant of the next century, who said that although purchased titles could not give principles of honor (which must come from birth and blood), "titles sometimes assist to elevate the soul and to infuse generous principles into the mind."[126] Nevertheless, many Dutchmen, including the old nobility of Holland, laughed at people such as Adriaan Pauw. In 1659 Simon van Leeuwen satirized the newly rich burghers who bought the old feudal properties and styled themselves *Ionckers en Me-vrouwen* (squires and ladies).[127] An Amsterdam statesman and part-time genealogist, Gerrit Schaep Pietersz, claimed that these upstarts plucked their titles and genealogies out of the air and from signboards.[128]

Although this subject deserves far more attention than can be devoted to it here, it is evident that the *plaisante plaetsen* of the United Provinces served the urban populace in many ways. They functioned as an urban playground, a place for physical recreation, for mental relaxation, and for escape from the pressures and less pleasant conditions of the city. Possession of a country seat could also confer social prestige, and if the property was a seigneury, the owner acquired a feudal title that, even if not officially recognized in the Dutch state, could enhance his public standing still further. These aspects constitute an important part of the historical context in which we can best understand and appreciate the Dutch rustic landscape.

A census of the various sites in the United Provinces that inspired the Dutch landscapists of the seventeenth century might well show that few "pleasant places" escaped their eyes, from the seacoast and dunes in the west to the rivers and hills on the German border and the northernmost vistas of Groningen and Leeuwarden. Nevertheless, it was chiefly at Haarlem, it seems, that the Dutch first learned that their domestic scenery was worthy of being celebrated in art. It is a striking fact that within a few decades after 1600 a group of distinguished artists congregated in Haarlem and devoted themselves to depicting the local countryside: Esaias van de Velde and to a lesser extent his cousin Jan, as well as Pieter de Molijn, Willem Buytewech, Jan van Goyen, and Salomon van Ruysdael.[129] Not one of these artists had been born in Haarlem, and by 1620 most of them had departed for Amsterdam, The Hague, and other cities in Holland. What drew these artists to Haarlem in the first place

is a subject for speculation. Even before 1600, Haarlem had been a leading art center; Van Mander proudly characterized it as a second Syconia, the ancient Greek city that was home to a number of painters.[130] And in the *Schilder-boeck* he chronicled its artistic heritage that had begun in the fifteenth century with Albert van Ouwater, a contemporary, Van Mander believed, of Jan van Eyck himself, and included such luminaries as Geertgeen tot Sint Jans, Jan Mostaert, Jan van Scorel, and Maerten van Heemskerck. The last decades of the sixteenth century saw the emergence of Cornelis Cornelisz van Haarlem, Hendrick Goltzius, and other artists, and especially the print-publishing endeavors of Goltzius and his successors. Sir Dudley Carleton, the English ambassador, wrote in 1616 that "the painters were chiefest curiosity" in Haarlem,[131] and later writers on the city, including Samuel Ampzing and Theodore Schrevelius, followed Van Mander's lead in celebrating the artists of Haarlem.[132] Indeed, it seems that the town fathers deliberately fostered this image of Haarlem's artistic preeminence in Holland by displaying the works of native painters, both earlier and contemporary, in the Prinsenhof, a former convent later used as a residence of William the Silent.[133]

But why the landscapists in particular should have been attracted to Haarlem, however, is another question. This phenomenon was formerly attributed to the presence there of Frans Hals, a claim that ignores the fact that Hals showed little interest in landscapes of any kind.[134] It has also been suggested that the attraction was Hendrick Goltzius, but we have seen that Goltzius's contribution to the development of a realistic landscape style was minimal at best.[135] However, there may have been other factors. One is perhaps to be found in the tenuous but persistent tradition that connects Haarlem with landscape painting from the earliest times.[136] In his life of Albert van Ouwater, the first Haarlem artist known to us by name, Van Mander tells us that he was "most excellent at faces, hands, feet, and fabrics, as well as at landscape," and describes a "delicate landscape" painted on the predella of an altarpiece.[137] Van Mander adds that the "best and earliest manner of landscape painting originated and began long ago in Haarlem," a claim that would be repeated later by Ampzing.[138] Unfortunately Ouwater's only surviving work is an interior scene, a Resurrection of Lazarus. But already some eighty years before Van Mander, Marcantonio Michiel had described the paintings he had seen in the palace of Cardinal Grimani at Venice; they included many landscapes (*molte tavolette de paesi*) by an "Alberto da Hollanda," whom scholars have identified with Ouwater.[139] Another part of this tradition connects the early development of landscape with Dirck Bouts, not in Van Mander's account of "Dirck van Haarlem," as he called him, but in an unpublished history of Louvain in Latin by Johannes Molanus. Here Bouts is characterized as an artist who won fame for his depictions of the countryside.[140] Molanus identified Bouts as a Louvain artist, but seventeenth-century editions of Guicciardini published in Holland describe a painting by "Dierick van Haerlem" (Dirck Bouts) of the life of St. Bavo, "to which was added the fair countryside around the town of Haarlem, the latter being reproduced to the life" with many landmarks. The same sources tell us that the painting, formerly in the local Augustinian priory, was at that time in the house of one Master T. Blin; unfortunately, it has

since disappeared.[141] That this legendary preeminence in depicting natural scenery inspired the rise of a school of realistic landscape painting in Haarlem is a tantalizing proposition, but one difficult to prove.

It may well be that, like the public in general, the young landscapists coming to maturity in the earlier seventeenth century were attracted by the reputation of the *plaisante plaetsen* to be found outside Haarlem's city walls. While this suggestion is perhaps equally insusceptible of proof, it cannot be denied that the scenery of her countryside played a formative role in their work. Even when they were not depicting specific sites, they evoked her fields and woods, her hamlets and country roads, and above all her dunes, in innumerable drawings, prints, and paintings. Of the older members of the group, only Salomon van Ruysdael and De Molijn remained working in Haarlem after 1632; the major figure among the younger artists, Jacob van Ruisdael, left probably about 1653–54.[142] Those who left sought more lucrative markets elsewhere, Esaias van de Velde in The Hague, Van Goyen in Leiden, Ruisdael in Amsterdam. Yet they did not forget the lessons they had learned in Haarlem. Van Goyen continued to produce dune and coastal landscapes; Ruisdael's famous panoramic views of Haarlem and its dunes, his *Haarlempjes*, were done only after his arrival in Amsterdam, painted, it has been suggested, for Amsterdam patricians who had country retreats in the vicinity of Haarlem.[143] Haarlem's dunes and woods also attracted younger artists, among them Jan Wijnants and Philips Wouwermans, but perhaps more important, the particular vision of the rustic landscape created in Haarlem influenced the interpretation of "pleasant places" elsewhere in Holland and affected many later Dutch landscapists, long after other modes of landscape had come into style. If the rustic landscape was born in Antwerp, there is no doubt that its definitive formulation, its true coming of age, took place in Haarlem.

PLATE I
Pieter de Molijn, *Landscape*, 1626. Braunschweig,
Herzog Anton Ulrich-Museum.

PLATE 2
Abraham Bloemaert, *Farm Buildings*, drawing.
Cleveland, The Cleveland Museum of Art.

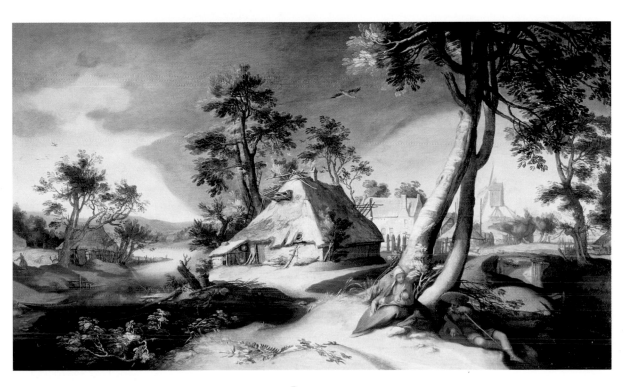

PLATE 3
Abraham Bloemaert, *Landscape with the Flight to Egypt*.
Snite Museum of Art, University of Notre Dame.

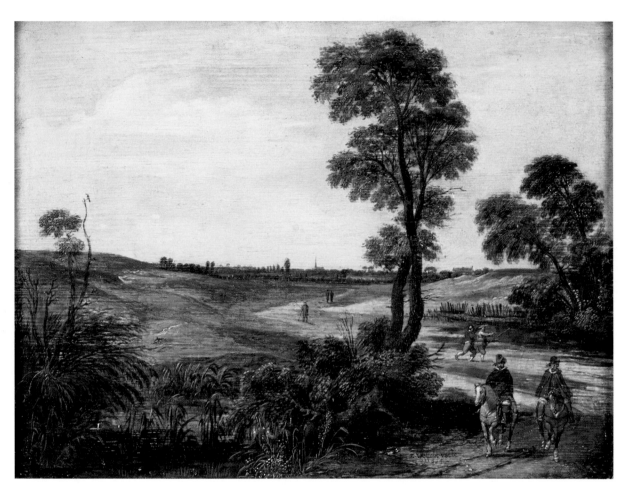

PLATE 4
Esaias van de Velde, *Riders in a Landscape*, 1614.
Enschede, Rijksmuseum Twenthe.

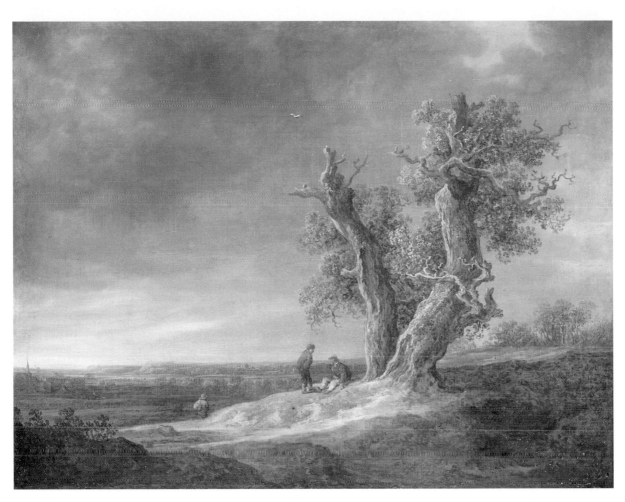

PLATE 5
Jan van Goyen, *Landscape with Two Oaks*, 1641.
Amsterdam, Rijksmuseum.

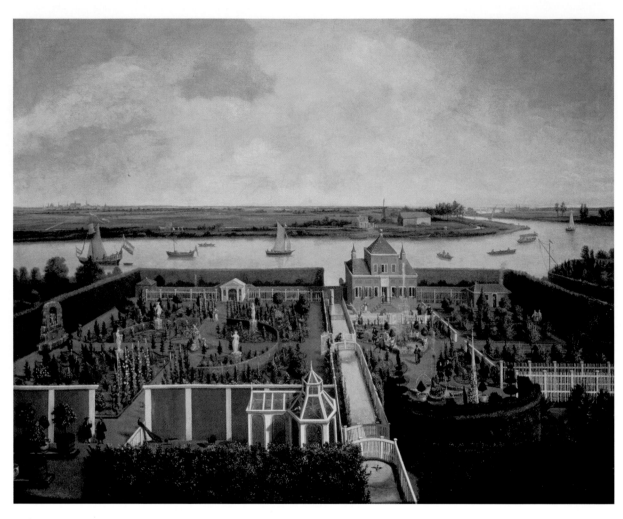

PLATE 6
Anonymous, *The Country Places Vlietzorg and
Zorgvliet on the Buiten-Spaarne near Haarlem*.
Amsterdam, Historisch Museum.

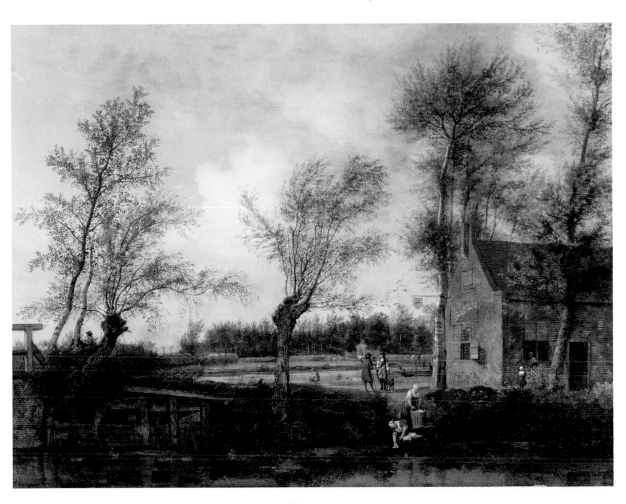

PLATE 7
Jan van der Heyden, *Landscape with the Black Boar Inn*.
Los Angeles, J. Paul Getty Museum.

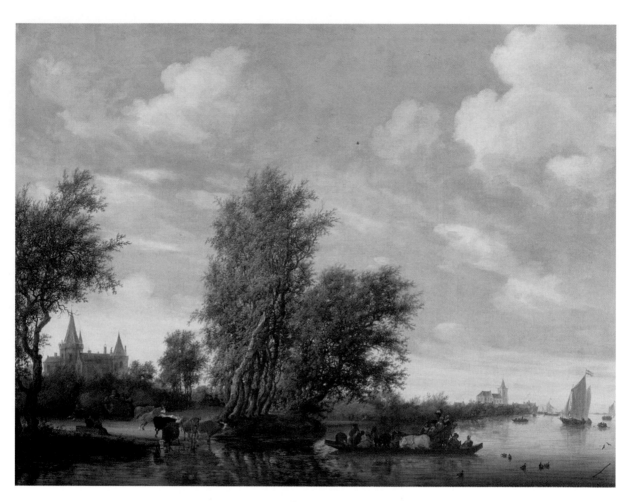

PLATE 8
Salomon van Ruysdael, *River Landscape with Ferry*.
Amsterdam, Rijksmuseum.

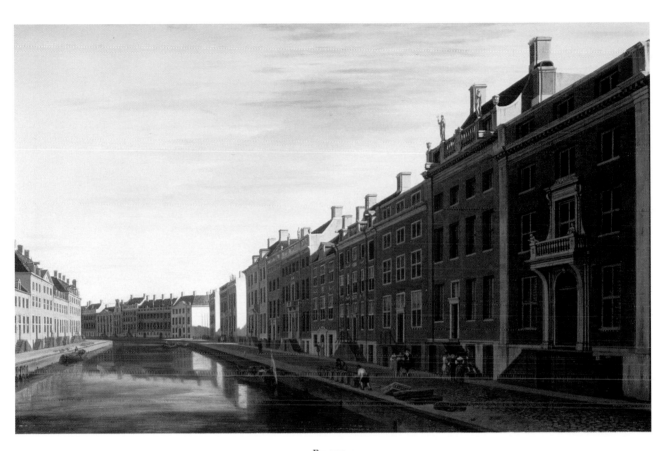

PLATE 9
Gerrit Berckheyde, *Houses on the Herengracht, Amsterdam.*
Amsterdam, Rijksmuseum.

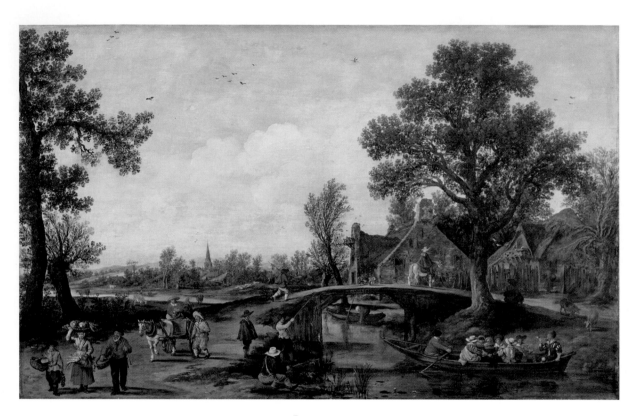

PLATE 10
Jan van Goyen, *Village Landscape*, 1626.
Bremen, Kunsthalle.

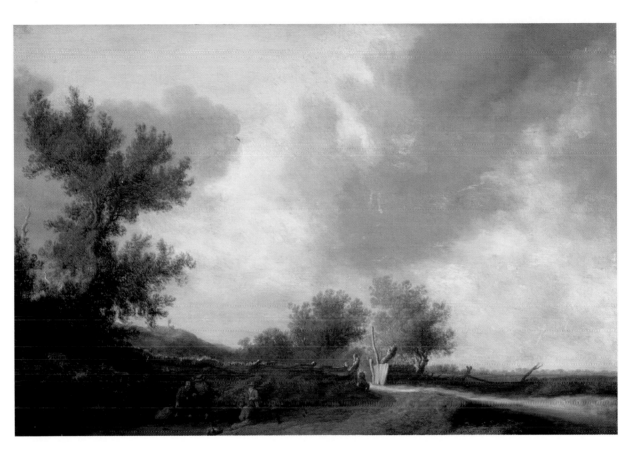

PLATE 11
Salomon van Ruysdael, *Landscape with a Fence*, 1631.
Vienna, Kunsthistorisches Museum.

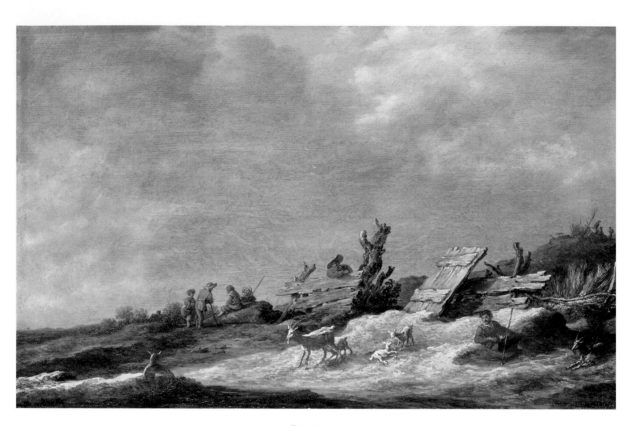

PLATE 12
Jan van Goyen, *Landscape with Old Fence*, 1631.
Braunschweig, Herzog Anton Ulrich-Museum.

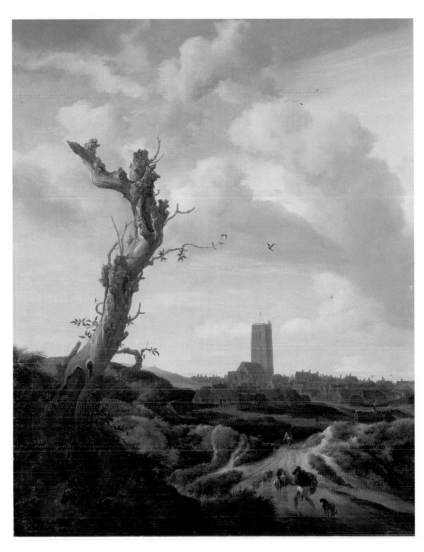

PLATE 13
Jacob van Ruisdael, *View of Egmond on the Sea*.
Manchester, N.H., Currier Gallery.

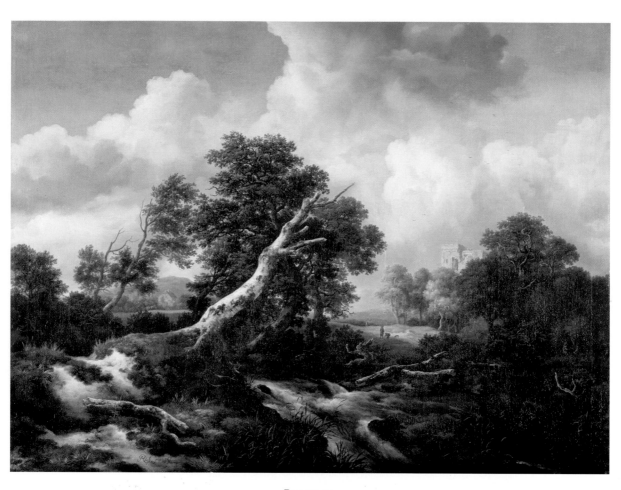

PLATE 14
Jacob van Ruisdael, *Landscape with a Dead Tree*.
Cleveland, The Cleveland Museum of Art.

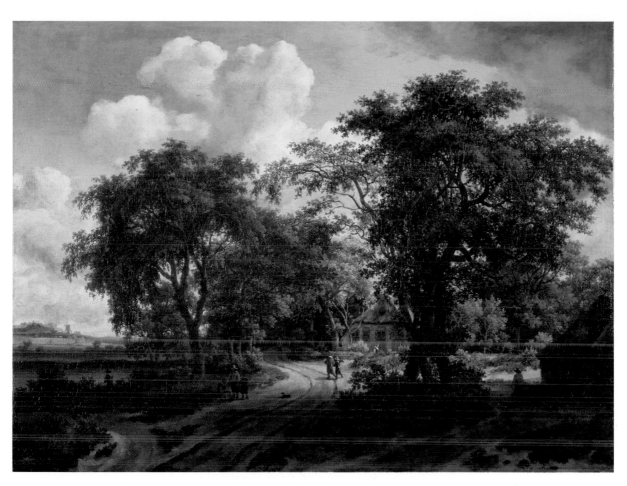

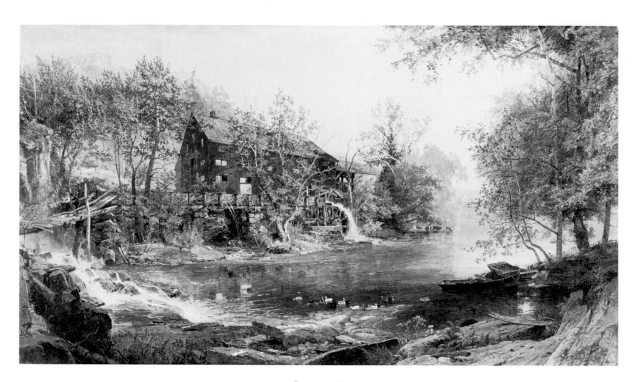

PLATE 16
Jasper Cropsey, *The Old Mill*, 1876.
Norfolk, Va., Chrysler Museum of Art.

6

Labor and Leisure in the Dutch Countryside

There are some really beautiful landscapes in the world, but the
human figures in them are poor, and you had better not look at them.
— Arthur Schopenhauer, *The Pessimist's Handbook*

Many landscape painters . . . frequently seek mean or trifling staffage,
common and silly thoughts and ideas.
— Gerard de Lairesse, *De Groote Schilderboek*, 1707

Dutch landscape paintings, especially views of domestic scenery, are almost always inhabited by anonymous men, women, and occasionally children, who trudge down country roads, herd animals, milk cows and goats, and perform other agricultural tasks.[1] Or they may frequent some country inn, or simply lounge by the side of the road and gossip. It is hardly surprising that until recently, scant attention has been paid to these humble dwellers in the countryside. Their unimportance is suggested by the very term often used to designate such figures, *staffage*, a pseudo-French word inspired by the German *stafiren* or *staffieren*, meaning "to decorate, garnish, embellish."[2] In his *Groote Schilderboek* of 1707, Gerard de Lairesse used the word *stoffagie*, which his English translator rendered as "ornament."[3] Such ornaments were often added by another artist, especially in landscapes containing figures that are larger in scale than usual, and more carefully rendered. In an occasional landscape by Jacob van Ruisdael, for example, the figures were painted by his friend Nicolaes Berchem; a good example is Ruisdael's *Wooded Country Road* of 1652.[4] Some landscapists, including Esaias van de Velde, were very competent figure painters. Generally, however, when artists add their own figures, they are smaller in scale and often shown in less detail than the forms of nature herself. Therefore, this kind of staffage has generally been ignored by modern schol-

ars and critics because it either represented an intervention by another artist or did not loom significantly in the total landscape image. It was, in fact, the proponents of scriptural reading who first looked closely at the figures that appear in landscape paintings. They have discerned certain recurring poses and activities and have suggested that such figures play a crucial role in determining the meaning of various landscape images.[5] We may hesitate to accept their proposals that the travelers in Dutch landscapes are pilgrims on the journey of life, that the bystanders personify the vices of sloth and lust, and that the patrons of country inns are sinners well on their way to perdition. However, there is no denying that the scriptural readers have alerted us to a pertinent issue that deserves further investigation.

The presence in landscape of human figures and their activities, of course, is probably as old as the tradition of landscape depiction itself, a circumstance that we should keep in mind when we encounter complicated explanations of their presence in Dutch landscapes. In his famous account of the first landscapist known to us by name, Pliny describes how the painter Studius populated his views with "people on foot, or in boats, and on land [throngs] of people coming up to the country-houses either on donkeys or in carriages, besides figures of fishers and fowlers, or of hunters and even of vintagers."[6] As we have seen, Pliny's text influenced many subsequent discussions of landscape, including Alberti's recommendation of landscape as suitable for decorating the walls of a villa.[7] Echoes of Pliny can be found in Hadrianus Junius's account of Maerten van Heemskerck, written between 1565 and 1570. Among other things, Junius noted that "Maerten . . . is admirably gifted in depicting, in a most attractive manner, valleys, farmhouses, rivers, straits, sailing vessels, people going to town mounted on mules or vehicles, or people walking, with wide-brimmed hats to protect them from the sun."[8] A generation later, Van Mander modified and partly expanded on Pliny's text in his prescription for landscape painting that he gave in his *Den Grondt:* the artist should show "little figures ploughing or mowing or loading up a cart, and elsewhere fishing, sailing, catching birds, hunting; show how farm girls [*boer-meisjes*] beside green banks ease out fountains of milk with their hands. Show how Tityrus, with his flute, entertains Amaryllis, his beloved among women, resting beneath a beech tree, and delights his flock with the pleasant sound. Show the countryside, town, and water filled with activity, and make your houses look inhabited and your roads walked on."[9] Several generations later, Samuel van Hoogstraeten advocated much the same approach to painting landscapes.[10]

But while this anecdotal embellishment of landscape scenery was derived from Pliny, Van Mander was also describing a time-honored practice. Artists, even those not particularly adept at rendering human figures, had long introduced them, often copiously, into their landscapes. It is easy to see why. Aside from the demands of narratives and other kinds of subject matter, human figures serve an aesthetic function, providing occasional flashes of color that, like wildflowers in a meadow, relieve the restricted range of tonalities that usually prevails in views of fields, foliage, and sky. More significant, their presence helps establish the scale of trees, rocks, and other natural formations. Hu-

man figures may also enhance the sense of space in a landscape, often by implication, by suggesting distances already covered or yet to be traveled; they also encourage us, the beholders, to accompany them vicariously on their journeys. It is in these ways that the human figure traditionally functioned in the landscape imagery of Western art, and the painters of the Dutch rustic landscape maintained this tradition, although they modified it considerably during the course of the century. In its earlier phase, the rustic landscape often functioned chiefly as a setting for a multitude of figures and activities, rather like the village scenes of Gillis Mostaert, Jan Brueghel the Elder, and other Flemish painters (see Fig. 32). Gradually, the figures were reduced in number, scale, and importance; often only a few travelers may be shown. In many landscapes by Jacob van Ruisdael, in particular, they are barely discernible, and the beholder traverses Ruisdael's roads and dunes largely alone.[11] In the course of this development, however, the Dutch landscapists evolved a repertoire of characteristic figure types, poses, and activities. A closer examination of this repertoire reveals much as to how these landscapes might have been received by the urban audience for whom they were intended.

There is no better way to begin our investigation than with the *Village Landscape* that Jan van Goyen painted in 1626 (Plate 10). It is a relatively early work, done well before the onset of his typical monochromatic style. The careful, crisp outlines and bright local colors of this painting reflect Van Goyen's dependence on the style of his teacher Esaias van de Velde, and the number of figures that he includes, as well as their relatively large scale, are characteristics that Van Goyen would generally abandon in his later work. But this very prominence of the figures helps us to appreciate the role that even the minimal staffage would play in his subsequent landscapes. *Village Landscape* invites us to make a *wandeling* through a stretch of the Dutch countryside; to *wandelen* or make a *wandeling*, that is, "to stroll, to ramble, to take a walk"—these old Dutch words are very expressive. David Beck employed them repeatedly to describe his various perambulations through the streets of The Hague, as well as in the Voorhout and the Haagse Bos.[12] Our own *wandeling* may take us along the stream into the left distance, or we can cross the rough wooden bridge into the hamlet at the right. But at every point in our stroll, we encounter people: the peasant family at lower left passes us on their way to market; behind them, the man in the pony cart chats with his companion on foot; two men fish in the stream, watched by a third. Through the arch of the bridge we see a third fisherman upstream handling a net from a boat; approaching the bridge is a second boat, this one filled with an elegantly dressed company of young men and women singing and playing musical instruments; in the stern a man sits apart, smoking his long clay pipe. This last figure is particularly interesting. Tobacco was just coming into widespread use at this time, although not without considerable opposition. In his *Sinnepoppen* of 1613 (with etchings by Claes Jansz Visscher, as we may recall), Roemer Visscher inscribed an image of a tobacco smoker with the following: *veel tijds wat nieuws, selden wat goets* (often something new, seldom anything good).[13] In the 1620s Adriaen Brouwer, then working in Haarlem, showed pipe-smoking peasants in his scenes of rustic taverns, where they sit in an ap-

parent stupor.[14] Van Goyen's smoker, however, suggests that despite such criticism, the use of tobacco was well on its way to being socially acceptable, as, indeed, we know from other sources.[15] Elsewhere in his landscape, we see travelers on foot and on horseback; a man rests in the shade of the tree at the right; in the middle distance can be discerned two men in yet another boat. *Village Landscape* well exemplifies Van Mander's advice to the artist to "show the countryside, town, and water filled with activity, and make your houses look inhabited and your roads walked upon."

The inhabitants of this charming little world may be divided into two social classes. To judge from their costumes, the members of the boating party are from a milieu quite removed from that of the peasants on their left. These merrymakers have come from town or perhaps from a neighboring manor house or country retreat. To the same class probably belong the two anglers on the bank and their companion, and perhaps the man crossing the bridge on horseback. The visiting townspeople are thus contrasted with the people for whom the country is not only their home but the source of their livelihood. These social distinctions were noted some years ago by Hans-Joachim Raupp in his discussion of this painting; he proposed that the anglers and the boating party were intended by Van Goyen to represent the sensual or voluptuous life (the *vita sensualis* or *vita voluptata*), in contrast to the more virtuous active life (*via activa*) exemplified by the peasants.[16] I doubt, however, if this is the case. There is no way to determine whether Van Goyen was representing an actual site near Haarlem, but in spirit the landscape is much like the *plaisante plaetsen* depicted over a decade before by Visscher in his Haarlem series. Nevertheless, some of Raupp's observations are perceptive. The more agreeable activities are enjoyed almost exclusively by the upper classes (an exception may be the man seated beneath the tree, possibly an itinerant peddler with his pack), who, moreover, turn their backs on the peasants going about their everyday tasks. In this respect, Van Goyen expresses the viewpoint of the visitor from town or a country-house owner who sees the countryside as the pleasant setting for his or her own recreations and diversions. The countryside, in other words, has very much become part of the urban playground.

Urbanites make *wandelingen* through the Dutch countryside in many other landscapes of the period, such as Esaias van de Velde's *Ferry Boat* of 1622 in Amsterdam or his splendid *Landscape with Carriage* of 1619, acquired not many years ago by the Minneapolis Institute of Arts.[17] The Dutch landscapists often show urbanites on horseback, hunters with their dogs, and other members of the upper class riding through fields and forest borderlands, sometimes passing by herdsmen with their flocks.[18] Philips Koninck's *Extensive Wooded Landscape* (Fig. 85) offers us a veritable catalogue of country pleasures: men fish from boats in the water below or from the shore; hunters rest alongside the road; an elegant couple strolls on the road. In his *Haarlempjes*, Ruisdael often included several figures, sometimes a solitary wanderer, looking at the dunes and the towers of Haarlem in the distance.[19] David Beck describes an afternoon in August when he climbed the tower of the Great Church in The Hague with some companions and surveyed the land through a *verreziender*, or telescope;

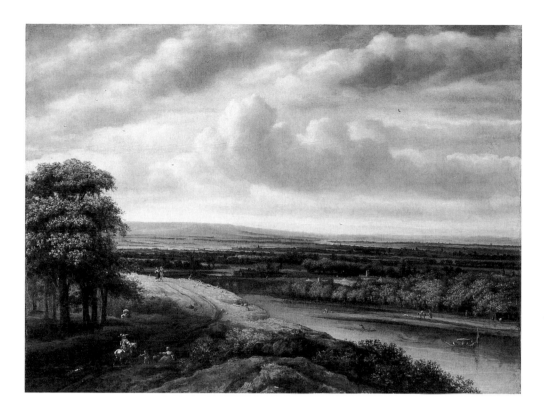

curiously enough, I have yet to discover any wanderer in a Dutch landscape similarly equipped.[20]

This pervasive presence of urban pleasures in the countryside represents a fairly late stage in a pictorial tradition that is rooted in depictions of the Labors of the Months. This tradition received an early and definitive formulation in the calendar scenes of the famous *Très Riches Heures* painted for Jean, duke of Berry, about 1410–12: in the more pleasant seasons of the year, the aristocracy emerge from their castles to engage in amorous dalliance in April, to ride in May and again in August. These courtly diversions are set off against the agricultural labors of the peasants who work the manorial acres, their hard life relieved by modest recreations that are only occasionally depicted by the Limbourgs. This contrast of court and countryside persisted well into the sixteenth century, in the books of hours produced by Simon Bening and his associates. The *Labors of the Months* series painted by Pieter Bruegel the Elder in 1565 owes much to these older calendar scenes, but Bruegel broke decisively with tradition when he focused exclusively on the world of the peasant.[21] Although Bruegel's heroic reformulation of the landscapes of the Months profoundly influenced his Flemish successors, few of them followed his iconography. There are only a few exceptions: the exquisite *Months* etched by Julius Goltzius after Gillis Mostaert (see Fig. 34), which in their simplicity evoke Cock's *Small Landscapes*. Generally, however, the later Flemish artists accentuated the traditional dichotomy be-

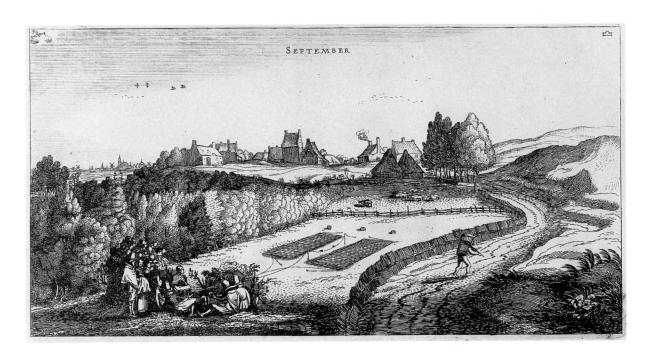

FIGURE 86
Jan van de Velde, *September*, 1616, etching.
Amsterdam, Rijksmuseum.

tween court and countryside in panoramic landscapes teeming with figures. In a set of the *Months* painted between 1584 and 1587 by Lucas van Valckenborch, and the many *Months* series published as prints after Paul Bril, Jan Brueghel the Elder, and Pieter Stevens, among others, courtiers and townsmen enjoy country excursions while peasants labor at their usual tasks.[22] In Valckenborch's *October*, for example, ladies and gentlemen picnic on the hillside in the foreground; in the valley below we see workers toiling at the grape harvest.[23] In general, January and sometimes February are often largely given over to the amusements of town and court: skating, carnival revelry, and the like. The country people on such festive occasions disappear almost completely, but Valckenborch did include a rustic harvest celebration in his *September:* the peasants engage in a lively round dance, solemnly observed by a group of spectators in courtly dress.[24]

Agricultural labors and courtly urban diversions are occasionally given sharp contrast in the Dutch *Months* published in print series during the first two or three decades after 1600; a good example can be found in a set published by Hendrick Hondius in 1614 after designs of Jan Wildens.[25] But this old formula begins to change in the three *Months* series etched by Jan van de Velde, one of them, undated, published by Joannes Jansonius in Amsterdam, the other sets by Claes Jansz Visscher in 1616 and 1618 respectively.[26] In a number of these prints, traditional agricultural labors are crowded out

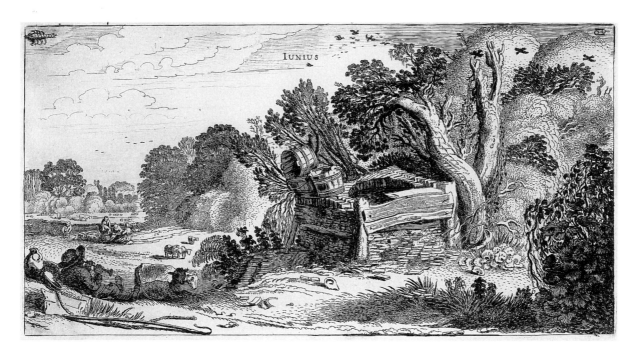

FIGURE 87
Jan van de Velde, *Iunius (June)*, 1616,
etching. Amsterdam, Rijksmuseum.

by urban diversions. In the 1616 series, for example, the old agricultural tasks of February are replaced by a city canal near which people warm themselves at a bonfire. The fruit harvest usually associated with September is exchanged for a scene of bird trapping attended by a company of well-dressed gentlefolk (Fig. 86). In December and January townspeople enjoy their usual winter sport of skating. Peasants dominate some of the other months, but they are usually shown at rest; the appropriate activities, such as plowing and pruning (March) and haymaking (July) have been relegated to the middle distance. In June (Fig. 87), the traditional sheepshearing has disappeared in favor of a reclining shepherd playing his pipe amid his flock.

Similar imagery can be found in Van de Velde's other two *Months* series. In the *Months* of 1618, January and March through May as well as December are given over to urban diversions; city folk watch a boat tossing about in the turbulent waters of February. Country people rest in the heat of June and July, and September features a ferryboat and waiting passengers; only the slaughtering scene in *November* preserves anything of the old iconography. November's peasants also slaughter hogs in Van de Velde's undated *Months,* and their August counterparts in the same series harvest the wheat; otherwise, farmers and herdsmen lounge, while the townspeople drift in boats on the river, ride, or skate on frozen waterways. In most cases, the landscapes tend to be Dutch in character; in fact, a set

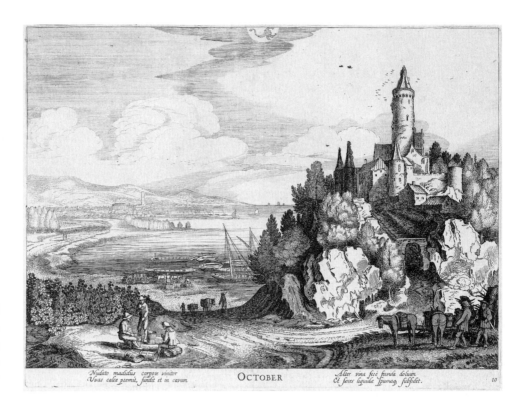

Nudato madidus corpore vinitor
Uvas calce premit, fundit et in cavum OCTOBER Alter vina foce fervida dolium
 Et feces liquidæ spumag subsidet. 10

of impressions of the 1618 series is inscribed in a seventeenth-century hand with identifications of particular places.[27] They include, among others, the "grot Hoff" (i.e., the Binnenhof) in The Hague and various sites in the vicinity of Haarlem. An exception occurs in *October* (Fig. 88): the annotation added to this print identifies it as *Een gesichten van Palarma in Sicilien* (a view of Palermo in Sicily). Indeed, its hilly terrain is distinctly exotic, and it is significant that the same is true of the October scenes in Van de Velde's other two series, especially the *October* of the undated series. These intrusions of foreign locales, however, represent no whim on the artist's part: the Low Countries did not produce wine in any quantity, importing it instead from France and Germany. The English traveler Thomas Coryat informs us that "in most places between Colen [Cologne] and the farther end of the Netherlands even till I cam to Vlyshingen commonly called Flushing the farthest towne of Zeeland, I observed that they usually drink beer and not Rhenich wine, as in the higher parts of Germany. For they have no wine in their country."[28] Hence, even the exotic settings for the vintage can be attributed to Van de Velde's desire to maintain some sort of topographic authenticity.

Just how a traditional theme could be manipulated to engage the interests of a Dutch audience can be seen in Jan van de Velde's *Four Seasons*, published by Hendrick Hondius in 1617 (and reissued by Visscher, of course, presumably after Hondius's death in 1650). Although as venerable a theme

as the Labors of the Months was, it had long been eclipsed by the Seasons by the later Middle Ages and regained popularity only in the sixteenth century. An early example is the series of four woodcuts, dated 1537, by Master AP, an anonymous Netherlandish printmaker, who presented the Seasons in the form of allegorical triumphs.[29] The many depictions of the Seasons that followed include the set of engravings that Hieronymus Cock issued after Pieter Bruegel the Elder and Hans Bol.[30] Very much reflecting in their compositional structure the subjects of the traditional Months, Cock's four prints show both urban pleasures and peasant labors, the latter generally predominating except in the *Winter* print. Like the Months, and occasionally influenced by the Bruegel-Bol series, the Seasons enjoyed great popularity in later Flemish art, both paintings and prints. Jacob and Abel Grimmer painted a large number of *Seasons* cycles, whose simplicity reflects Cock's *Small Landscapes*, focusing on the world of farm and village with only an occasional castle in the middle distance alluding to the court.[31] The various *Seasons* print series produced after designs by Bol, Heemskerck, Marten de Vos, Pieter Stevens, and David Vinckboons were generally more elaborate, dominated by figures; and Claes Jansz Visscher, we may remember, etched a grand far-flung *Autumn* landscape as his contribution to a set of *Seasons* after Joos de Momper and published by Theodoor Galle at Antwerp.[32] Visscher also embellished a world map (engraved by someone else) with etched illustrations of the Twelve Months and the Four Seasons.[33] It may have been about this time that Visscher acquired and reissued the plate of Bruegel's *Spring* with his own address.[34]

Thus Van de Velde may well have been familiar with at least this print after Bruegel, but if so, it left no impression on his 1617 set of the *Seasons* (Figs. 89–92).[35] Both the imagery of this series and their accompanying Latin verses conspire to present an idyllic picture of the country. The *Winter* print (Fig. 92) shows the usual skating scene; the inscription below tells us that cold weather is not boring: Ovid was wrong; our young people skate.[36] Skating was a theme irresistible to the allegorists. The inscription on a later state of *Skating in Front of St. George's Gate* (published by Hieronymus Cock after a design by Bruegel) compares skating to the slipperiness of life itself.[37] Among Visscher's illustrations in Roemer Visscher's *Sinnepoppen* of 1614 is one that shows an ice-skater, and both motto and poem teach us that practice makes perfect.[38] Some years later, Constantijn Huygens, in a breathtaking display of emblematic conceit, would imagine himself looking out the window of his house at Hofwijk at some boys skating on a frozen pond. The patterns created by the skates remind him of the random "whirling courses of our life" and the "webs of our thought . . . which swell to books" that weary old men, make schoolboys weep, and provide surfeits of words, which are like "artful foods / Which sicken us but make the apothecaries prosper."[39] The more prosaic Van de Velde, however, was surely responding to a vastly popular winter sport. Writing in the late sixteenth century about Holland, Fynes Moryson noted that the canals are frozen most of the winter: "so as the Virgins in winter tyme are most brave in apparell, and have most Jollity of meetinges with young men. For they both daly walk into the fields next the townes, and upon the broadest waters slyde

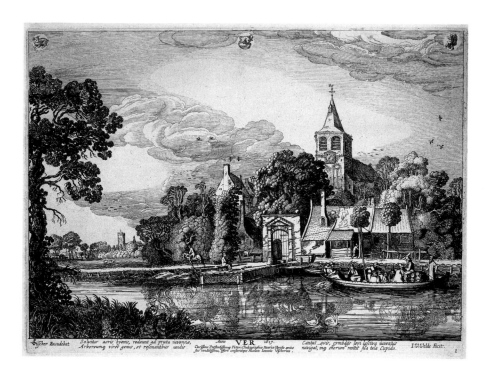

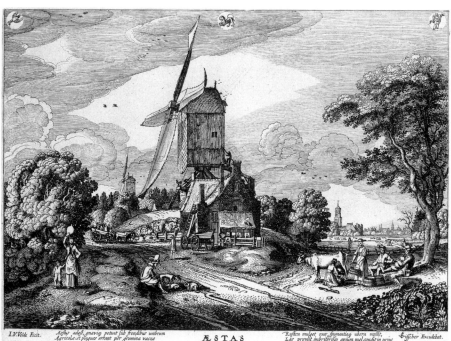

FIGURE 89
Jan van de Velde,
Ver (Spring), 1617,
etching. Amsterdam,
Rijksmuseum.

FIGURE 90
Jan van de Velde,
Æstas (Summer), 1617,
etching. Amsterdam,
Rijksmuseum.

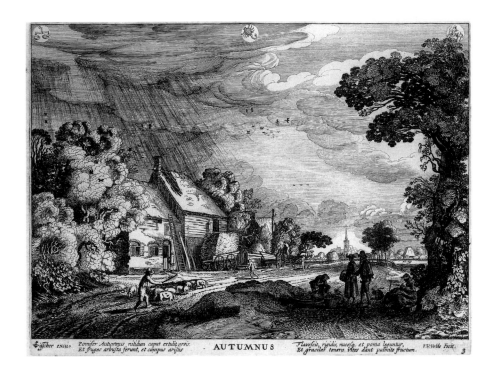

AUTUMNUS

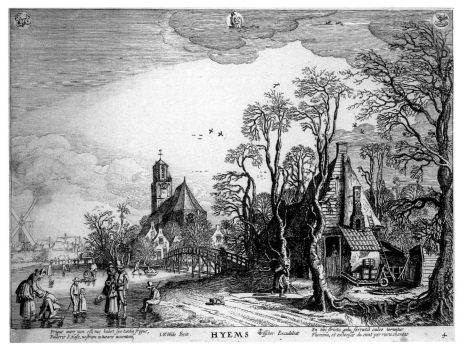

HYEMS

FIGURE 91
Jan van de Velde,
Autumnus (Autumn), 1617,
etching. Amsterdam,
Rijksmuseum.

FIGURE 92
Jan van de Velde, *Hyems
(Winter)*, 1617, etching.
Amsterdam, Rijksmuseum.

together upon the yce." To skate, they put *pattens* of wood on their shoes, with a "long sharpe iron in the bottom to Cutt the yce."[40] A song in celebration of ice-skating in the *Amsterdamsche Pegasus* of 1627 praises it as the "sweetest pastime."[41] It is thus as a pleasurable recreation, and not as an admonition on the vanity of life,[42] that we can best appreciate the many ice-skating scenes that Hendrick Avercamp, a pupil of Coninxloo, began to paint shortly after 1600, as well as those produced by Jan van Goyen and many other artists.[43]

To return to Van de Velde's *Seasons, Spring* (Fig. 89), like *May* in his *Months* of 1616, features a *trekschuit*, perhaps a reminiscence of the old calendar scenes in which May was often represented by one or more young couples in a boat.[44] In Van de Velde's reworking of this theme, the passengers appear to be ordinary travelers, but the verses beneath his *Spring* celebrate the departure of winter and the frolicking of youth, at whom Cupid directs his arrows. May was the favorite month of the poets: Beck records in his diary of 1624 that he wrote two May poems, and elsewhere he speaks of the "sweet and laughing May-weather."[45] The old image of May, incidentally, is perhaps also a distant ancestor of the boating party in Van Goyen's *Village Landscape* of 1626 (see Plate 10).

Bruegel had represented summer as a busy time of harvesting and haymaking. In Van de Velde's *Summer* (Fig. 90) the grain harvest has receded to the right background; in the foreground, except for two young milkmaids, the peasants recline very much at their leisure, one playing a bagpipe. A well-dressed townsman, probably a hunter, sits at rest with his dogs toward the center, and a wagonload of people moves across the middle distance. It is clearly "hot, sultry, and very [much] dog-days weather," as David Beck described it,[46] and we hardly need the poem inscribed below to inform us that "heat reigns all about, and the diligent country man seeks the shadows of the trees," an echo, perhaps of Virgil's description, in the *Georgics*, of shepherds resting under the trees. The peasants in *Autumn* (Fig. 91) are hardly more industrious; here we see no vintage scene, and the traditional pig slaughtering has been replaced by the peasant herding his swine down the road; otherwise, there are only a hay wagon by a barn and a cluster of people standing around a basket, presumably of fruit.

Van de Velde was far from unique in his depiction of country life. It is striking, in fact, just how infrequently the Dutch artists depicted the more strenuous rustic labors, in contrast to their Flemish predecessors. Visscher included a number of agricultural labors in his series of eight vignettes depicting various occupations that were used as illustrations for a map of North Holland and West Friesland published in 1608.[47] Similarly, toward midcentury we find paintings of cottage interiors with peasants at their looms, reminding us that weaving was an important cottage industry.[48] The usual agricultural labors figured prominently in the more traditional depictions of the Months that we find in a set of drawings made by Esaias van de Velde in 1629, and the six or more series of drawings of the Months produced by Alart van Everdingen.[49] It may be significant, however, that such depictions of the Months were seldom issued as independent prints.[50] In one later series that was published, a series of *Months* etched sometime after 1635 after drawings of Abraham Bloemaert by his son Cor-

nelis (later republished by Visscher), we encounter country people loitering before an inn, resting during the harvest, and courting; only in *December* do they bestir themselves to fell trees.[51] Indeed, the agricultural tasks celebrated in the *Georgics* and depicted in the old calendar scenes—plowing, haymaking, harvesting, and fruit picking—seldom appear in views of the Dutch countryside. Even the wheatfields depicted by Jacob van Ruisdael in his later years are empty of laborers. And when Jan van Goyen, for example, and Adriaen van de Velde actually show harvesting or haymaking scenes (Fig. 93), they almost invariably choose the moment when the workers are at rest, eating, chatting, sometimes flirting.

Such imagery may be compared to a set of *Grillen* written by Bredero in 1617, and first published in his *Nederduytsche Rijmen* of 1620.[52] Consisting of twelve four-line verses, they sketch each month in a lighthearted fashion; hard work occurs only occasionally. In March the peasants plow, plant, and prepare the vineyard; the peasants also work in April, but the *Heerschip*, or landowner, amuses himself in the country. In May the farm maid milks the cow, while the city folk make excursions into the land; in June a city youth dallies with a country girl as she shears a sheep. In July a peasant boy and his sweetheart go for a roll in the hay, while in August the poet summons the peasants to the corn harvesting from their carousing before an inn. It has been suggested that these verses may have been intended for a set of *Months* prints that were probably never published,[53] but their brief descriptions of country recreations and dalliances also anticipate the pictures of Jan Steen, Adriaen van Ostade, and other genre painters. Hegel once said of Dutch peasant subjects in general that they

show "the Sunday of life" (*der Sonntag des Lebens*),[54] an opinion that is unfashionable nowadays, but there is no denying that the figures in many Dutch landscapes are permeated by the spirit of Bredero's *Grillen*.

There are further ramifications. The double traditions of the Months and Seasons, as they developed through the sixteenth century, and above all in the majestic panels of Pieter Bruegel, showed the peasant as he might have been viewed by a great landowner, as part of his wealth, agents like the sun and rain working to ensure the fruitfulness of his lands and his own prosperity. However, although great landed estates were typical of the Southern Netherlands, they had few counterparts in the North and became increasingly rare during the seventeenth century.[55] Thus we can understand why the peasants in the *Months* and *Seasons* of Jan van de Velde are depicted, as Walford has perceptively observed of other Dutch landscapes, "not so much as workers of the land but rather as its typical inhabitants."[56] But the peasants in Dutch landscapes are more than mere decorative adjuncts of the "pleasant place." More specifically, they embody the image of the carefree, untrammeled existence that townsmen over the centuries have projected onto the countryside.

This sort of wishful thinking can be found, for example, in the *Bauw-heers wel-leven*, a poem attributed to Pieter Janssoon Schaghen and included in *Den Nederduytschen Helicon*, published at Haarlem in 1610.[57] Basically an elaboration of Horace's *Beatus ille* (Happy the man who, far from business cares . . . works his ancestral acres), with a generous borrowing from the Third Day of Guillaume du Bartas's poem *La sepmaine* of 1578,[58] it celebrates the peaceful life of the farmer in his simple, unpretentious cottage (*slecht recht lant-huys*).[59] Secure from the tumult and intrigues of court and town, he enjoys his humble country pleasures: the fields, the cool streams, his abundantly stocked storerooms, and the embraces of his faithful, hardworking wife. Mundane matters such as plowing, digging, sowing, and the like are also mentioned, but only late in the poem and only briefly; and crop failures and livestock diseases are not mentioned at all. The *bauw-heer* of the poem is a farmer, but a farmer seen through urban eyes.

Thus, if the hardworking peasants in Bruegel's *Months* represent the georgic tradition of country life with its emphasis on the yearly round of agricultural tasks that we find in the farming manuals of antiquity and the Renaissance, the Dutch rustic landscape displays country life in its more agreeable, bucolic aspects, influenced by the pastoral tradition that runs from the ancient Greek and Roman poets through Jacopo Sannazaro and his *Arcadia* to the *Pastor Fido* of Giambattista Guarini. As developed in the visual arts by Giorgione, Giulio Campagnola, and their many followers, the pastoral landscape is inhabited by shepherds leaning on their staves or sitting at their ease; they frequently hold or play some rustic instrument, pipes or the flute, and we may also imagine that they discourse of love.[60] A chiaroscuro woodcut by Hendrick Goltzius reflects this tradition (Fig. 94); done between 1597 and 1600, it shows a couple reclining in an idealized landscape.[61] The most arduous task, it seems, is that of milking, generally allotted to girls and young women. There is little

FIGURE 94
Hendrick Goltzius,
*Couple Seated in a
Pastoral Landscape*,
chiaroscuro woodcut.
Boston, Museum of
Fine Arts.

place in this pastoral world for hardworking, sweating peasants who make love in the hay and carouse in the village *herberg*.

About 1630 the Antwerp artist and art dealer Herman de Neyt issued a suite of twenty-four pastoral landscape prints; although De Neyt ascribed their invention to Titian, they are probably after Campagnola.[62] They bear inscriptions of a georgic and bucolic cast, praising the simple virtues of rural life. It may be that this series influenced Rembrandt, as has been suggested: he was certainly familiar with Venetian landscape drawings of the previous century and perhaps owned some.[63] By this time, however, the pastoral tradition had been long assimilated to the Dutch situation. In his chapter on landscape in *Den Grondt*, Van Mander had made a distinction between the Dutch farmers and the shepherds with their classical names, but this distinction had already been considerably blurred in his translation of some of Virgil's works, published in 1597. This is evident, to begin with, in the homely Dutch titles that Van Mander gave to Virgil's *Bucolics* and *Georgics: Ossen-stal* and *Landt-werck*, that is, "Ox-Stall" and "Land-Work." In one of the dedicatory poems accompanying *Ossen-stal*, Abram van Mijll tells us that Van Mander has made his sheep bleat with a Dutch voice and eat Dutch grass, and indeed, Van Mander added numerous details drawn from his observation of Dutch life.[64] This fusion of antique pastoral with contempory details was deliberate, of course, for at one point in the *Bucolics*, Van Mander addresses his beloved Holland in words richly evoking Virgil's praise of rustic life in the *Georgics:* "You know not, O Land! How fortunate you are."[65]

A similar phenomenon occurs in Dutch pastoral novels, which were frequently set in a specifically

local setting. A striking case is that of *Batavian Arcadia*, written by Johann van Heemskerck in 1627 and published ten years later, with a second edition in 1647. Here the pastoral lovers are contemporary young people from The Hague and Leiden; their adventures take them on visits to a fine country house and then to the beach near Katwijk.[66] For his part, Jacob Cats called his pastoral romance, *Galathee*, a *boere-werck* (peasant work), as we have seen, and he refers often to contemporary country life and peasants.[67] Writers were fond of comparing or contrasting the Dutch countryside with certain "pleasant places" celebrated in ancient poetry. In an often-cited passage, Hendrick Laurensz Spiegel, for example, expressly rejects Parnassus and Helicon in favor of "our country's brooks, meadows, streams, and tree goddesses."[68] Conversely, the anonymous collection of poems published in the 1620s or 1630s under the title *Roemster van den Amstel* (Praiser of the Amstel) peoples the river Amstel with classical water nymphs, and Spiegel and other Dutch poets did not hesitate to introduce similar classical deities into their celebrations of the natural beauties of Holland.[69]

Such classical references, of course, very seldom appear in the visual depictions of Dutch landscapes during this period; it is often assumed that this circumstance reflects a different cultural background of the artist, unfamiliar with the humanistic trappings of the poets. It is far from proven that artists were so "uncultured"; Van Mander assumed some familiarity with classical literature on the part of his young artists, and Visscher, as we have seen, introduced a number of Latin inscriptions into his landscape prints. I suspect that similar evidence could be found elsewhere. But more to the point is the fact that the artists had little need to embellish the natural beauty of the Dutch countryside by populating it with nymphs, satyrs, and other nature deities, as we find, for example, in an illustration from the *Roemster van den Amstel*, in which naked nymphs frolic in a typically Dutch landscape.[70] Nor did artists need to make any overt comparisons with the pleasant places famous from ancient literature. Indeed, they could, and did, evoke the rustic tranquility of the pastoral tradition much more immediately. Visscher, for instance, in his views of Haarlem, shows a herdsman driving a flock along the road to Heemstede (see Fig. 64). Jan van de Velde favored the piping shepherd at rest; he introduced this figure into his *June* from the *Months* of 1616 (see Fig. 87), and again in two scenes from his series of sixty landscapes dating from the same year.[71] In Adriaen van de Velde's *Family in a Landscape near Their Country House* of 1667 (see Fig. 83), the piping herdsman reclining at the right provides an appropriately bucolic atmosphere for the outing of the patrician family. A similar impulse surely lies behind the landscapes of Aelbert Cuyp, which are populated by reposing cattle, reclining herdsmen, and an occasional shepherdess or milkmaid, and it is very much in the same tradition that Paulus Potter depicted the Huis de Werve in his painting of 1647 in which the distant house is upstaged by the milking scene in the foreground.[72]

The assimilation of local scenery to the pastoral tradition is perhaps nowhere more strikingly evident than in the *Amsterdamsche Pegasus*, a collection of songs published in 1627 and illustrated with a number of etchings by Jan van de Velde. Two of the songs have distinctly antique pastoral themes;

one song, celebrating the beauty of the sea nymph Galathea, presents a throng of pagan deities. Yet the landscape etchings that preface these two songs are mundanely Dutch in character, one showing some typical Dutch buildings, along with several ruins, the other a dune scene, both populated by ordinary Dutch figures.[73] The pastoral tradition, moreover, helps us to understand another category of peasant behavior often encountered in Dutch landscapes: country folk who apparently follow no occupation whatsoever, not even a pastoral one, but simply stand or sit by the roadside or lean over fences and lounge in doorways, frequently gossiping with their neighbors. "Nothing happens in his pictures," John Ruskin once remarked of Aelbert Cuyp, "except some indifferent person's asking the way of somebody else, who, by his caste of countenance, seems not likely to know it,"[74] and the same could be said of many other Dutch landscapes. In Van Goyen's *Landscape with Two Oaks* of 1641 (see Plate 5), for example, two peasants rest beneath the great gnarled trees, apparently in conversation. In *Landscape with a Fence*, painted by Salomon van Ruysdael in 1631 (Plate 11), some nondescript people rest in the shadow of a dilapidated fence; another man sits by the gate beyond while his companion gazes over the wall. Examples of such idle country people could be multiplied endlessly, not only in landscape paintings but also in hundreds of landscape drawings and prints produced during the seventeenth century in Holland. Indeed, these idlers, loungers, whatever we choose to call them, singly and in groups, constitute one of the most pervasive motifs in Dutch landscape scenes.

What is the significance of these indolent folk lounging in the Dutch countryside? The scriptural readers have trapped them in their web of interpretation, accusing them of all kinds of serious sins. The conversing men in Van Goyen's *Two Oaks* have been identified as personifications of lust and sloth, and a similar interpretation might be made of the idlers in Ruysdael's *Landscape with a Fence*.[75] In such readings, the figures symbolize the sinners who have strayed in the pilgrimage of life, ensnared in the temptations of this world; as such, they are like the sleeping peasants who do not hear the Gospel in depictions of the Tares Sowed among the Wheat, a biblical parable (Matt. 13:24–30) frequently represented by Abraham Bloemaert.[76]

Yet we should exercise due caution in accepting such interpretations. A more positive interpretation of idleness can be found in a series of sixteen etchings made after the designs of Abraham Bloemaert by his son Cornelis, who published them probably sometime between 1620 and 1625 (Figs. 95–98).[77] An examination of these etchings will help us resolve our problem. They are not really landscapes but figure studies often in the sketchiest of outdoor settings; however, their protagonists do much the same thing as the idlers in the Dutch landscapes, that is, they do very little: they sit, recline, even sleep. The significance of this remarkable group of images is revealed in the title etching (Fig. 95), showing a shepherd asleep face downward on a boulder. This boulder, in turn, is inscribed with a poem that informs us in part, "Otio delectant," that is, *otium*, or leisure, "which restores tired limbs with new strength and provides delight and makes us fit for work." While we are also warned against "lazy rest [that] weakens the body with sluggishness and dulls the mind," a majority of the

images that follow tend to emphasize the positive aspects of *otium*. This is made clear by the Latin verses inscribed at the bottom of each plate. In one print, we see two women gossiping (Fig. 96): "It is vain," we are told, "that business urges you to accelerate the pace when exhaustion and tired limbs require rest." In a scene of a resting peddler, we are admonished that "if you wish to cover a long distance according to plan, you must relieve your limbs with alternating rest." The reclining huntsman in yet another print is accompanied by verses that say, "Happy [he] who completes the work which he started, he is entitled to enjoy leisure safely."[78]

The poem on the title print is signed "H. de Roij," presumably Hendrik de Roij, city physician of Utrecht and a nephew of Abraham Bloemaert's second wife, who probably wrote the other inscriptions as well.[79] But it may be doubted that he was responsible for the choice of subject matter. Indeed the *Otium* series as a whole has about it a strong air of improvisation, as if Cornelis Bloemaert had assembled a disparate group of figure studies (one has Tobias and the Angel in the background), of the kind that his father produced in great numbers all his life, and then hit on a somewhat contrived theme that would help him in marketing them to the print-buying public. In any case, De Roij must have been hard put to maintain the theme of leisure in all the images. In one print, showing a young girl spinning in the company of a youth and older women, it is not leisure but the industry of the spinner that is commemorated in the verse below. Another print shows a group of peasants guzzling and vomiting; here the poet warns against the dangers of excessive drinking. Still another print depicts a sleeping herdsman; beyond are two armed men who must be murderers, to judge from the inscription, in which we are advised to "learn to despise with wise disdain wealth which often leads its owner to a sad death." But even if all the prints do not address the ostensible subject of leisure, this choice of theme was not an act of simple whimsy on the part of either poet or printmaker. It would most likely have been approved by a majority of viewers. This celebration of *otium*, after all, is but another manifestation of the venerable belief, explored at length in chapter 4, that relaxation and recreation were indispensable for the health of both mind and body.

But De Roij's verses also explore other ramifications of *otium* as it was understood in his time. One print shows a simple repast shared by two peasant women and their children, and here we are informed that "this modest meal surpasses the gods' ambrosia, cease therefore to denigrate my misery." In another image, showing a sleeping peasant couple (Fig. 97), the verses below tell us "how generously indigence bestows gentle sleep, which great wealth does not allow one to enjoy." This contrast between carefree poverty and anxiety-ridden wealth, already implicit in the print of the sleeping herdsmen and the two killers, is an ancient commonplace that forms an important aspect of the praise of country life over life at court or in the city; it was sounded by Virgil, Horace, and other classical poets, and was repeated in infinite variations by later writers.[80] Especially popular was a treatise by the Spanish writer Antonio de Guevara, usually rendered in English as *A Dispraise of the Courtier's Life*, first published in 1539; a Dutch translation by Hadrianus Junius appeared at Delft in

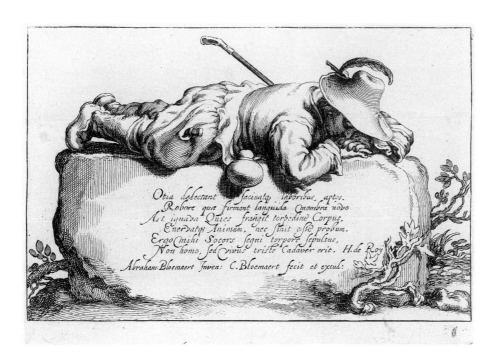

Otia delectant . . . faciuntqʒ laboribus aptos.
Robore quæ firmant languida Cmembra novo
Ast ignava Quies frangit torpedine Corpus.
Enervatqʒ Animum. nec sinit esse probum.
Ergo mihi Socors segni torpore sepultus,
Non homo. sed vivus triste Cadaver erit. H. de Roÿ
Abraham: Bloemaert Inven: C. Bloemaert fecit et excud:

Nequicquam gressum celerare negotia suadent,
Dum requiem languor sessaqʒ membra petunt.

FIGURE 95
Cornelis Bloemaert,
after Abraham
Bloemaert, title print,
from the *Otium* series,
etching. Amsterdam,
Rijksmuseum.

FIGURE 96
Cornelis Bloemaert,
after Abraham
Bloemaert, *Two
Women Gossiping*,
from the *Otium* series,
etching. Amsterdam,
Rijksmuseum.

Aspice quam placidos somnos largitur egestas.
Ducere quos magnæ non patiuntur opes.

15

FIGURE 97
Cornelis Bloemaert,
after Abraham
Bloemaert, *Sleeping
Peasant Couple*, from
the *Otium* series,
etching. Amsterdam,
Rijksmuseum.

FIGURE 98
Cornelis Bloemaert,
after Abraham
Bloemaert, *Goatherd*,
from the *Otium* series,
etching. Amsterdam,
Rijksmuseum.

Non adeas aulam, qui diligis otia mentis:
Hæc nemus umbrosum, vel tibi caula dabunt;

7

1613.[81] *Het leven int land* (life in the country), we are told, is much more beneficial and restful than at court or in the city, the days are longer and clearer, and the cost of living cheaper. Comparable sentiments were voiced by the poets of the *hofdichten*, or country-house poems, then coming into fashion, beginning with Philip van Borsselen's *Binckhorst*, published at Amsterdam in 1613, and Petrus Hondius's *Dapes inemptae*, which appeared at Leiden in 1621.[82] Constantijn Huygens, of course, followed in the same tradition when he named his country retreat Hofwijk, meaning, in effect, "retire from court."

This contrast between court and countryside appears in one final print that we will consider from the *Otium* series (Fig. 98). It shows a seated goatherd leaning against a tree, it might seem in sleep; however, the lines underneath advise us: "You who delight in the leisure of the mind, do not join the court; a shady pasture or a sheepfold will give you this." In this final modulation of the term, *otium* is not merely a restorative for tired limbs and minds but is implicitly contrasted with *negotium*, the absence of leisure, that is, business, occupation, employment. While it could apply to agricultural pursuits, *negotium* generally referred to the world of the marketplace, law court, and other areas of life where we pursue our calling or profession, or otherwise strive to advance our material interests.[83] Negociatio was personified on the triumphal arches erected by the city mint for the state entry into Antwerp of Philip II in 1549.[84] Claes Jansz Visscher treated *negotium* more realistically in his vignettes of the various occupations of town and country, published as decorations of a map of North Holland and West Friesland of 1608, mentioned above, and portrayed it even more vividly in his great view issued in the same year of Amsterdam with her wharves and warehouses along the Amstel river.[85] Commerce and business in general were the aspects of town life most frequently condemned when the city was opposed to the country. They were satirized by Pieter Bruegel the Elder in his *Elck* of 1559, where the same nearsighted merchant repeatedly seeks for his *eigenbaat*, or personal advantage, among the goods of this world, and in *Battle of the Money Chests and Saving Pots* that Hieronymus Cock published several years later after a drawing by Bruegel that is now lost. Both prints, incidentally, were still circulating in the seventeenth century in editions issued by Joan Galle.[86]

Otium is the reverse condition, the freedom from *negotium*, the cares of the marketplace.[87] Medieval writers taught that there were two kinds of *otium*. Petrarch, for one, in his *Remedies against Fortune Fair and Foul*, distinguishes an *otium* that is "sluggish and dull, wholly given to repose" and an active leisure "fit for the philosophically-minded," that is, "full of work even when at ease."[88] *Otium* of the negative sort is the subject of an emblem by Sambucus; it shows a miller sleeping by his windmill where a man stands expectantly with a bag of grain, with the motto: *Otium sortem expectat* (Idleness awaits its fortune).[89] The emblem was taken over by Geoffrey Whitney who in his collection of 1587 glossed it as follows: "Unto this foole, they maie compared bee, / Which idlie live and vainlie hoape for happe."[90] Cesare Ripa described five images of *Otio*, or otium, in his *Iconologia;* in the Dutch edition in 1644, they are called *Leedigheyt* (laziness).[91] Four were identified simply as sloth, but in

one image Ripa defines *Otio* more favorably as "contemplation" (in the Dutch edition, *de spiegelinge of Contemplatie*) and cites the joking words of Scipio, that he was never busier than when he was at leisure.[92] Cicero put it somewhat differently: "Scipio used to say that he was never less idle than when he had nothing to do and never less lonely than when he was alone."[93]

Probably in emulation of this classical ideal, Michel de Montaigne had an inscription placed on his walls that dedicated his ancestral home to *libertati suae tranquillitatique et otio,* that is, to liberty, tranquility, and leisure, made possible by his disengagement from business.[94] In like manner, Constantijn Huygens published in 1625 his *Otium of Ledighe uren* (Otium or Idle Hours), a miscellaneous collection of poems that he had brought together under a title implying that he had composed them during his leisure time; the second title page, incidentally, is represented as a piece of paper attached to the background by two arrows supporting an unstrung bow.[95] This is, of course, a variation of the venerable topos employed by Van Mander and other writers of the period to justify the need for recreation, including, it might be added, the author of a Dutch *kluchtboek*.[96] It is doubtful that Huygens read such frivolous literature; he evidently spent his free time in more intellectual pursuits, and the *locus classicus* for this cultivated leisure had long been the villa and country house. Cicero, for example, advised the orator against reading Plato in preparation for public speeches; such philosophical books "he should keep back for a restful holiday, such as this one [i.e., villa] of ours at Tusculum."[97] Forced to retire from political life, Sallust employed himself at his villa in writing a history of the Romans.[98] In seventeenth-century Holland no less than in ancient Rome, intellectual pursuits distinguished the gentleman landowner from the simple farmer, although there undoubtedly were urban landowners who immersed themselves in the kind of activities described by Vondel in his *Palamedes*, a drama of 1625: "He plants, he sets out seedlings, or he transplants; he catches birds in his net, or inclined with zeal, he catches the darting fish from the river with his bent hook; or if he tires of such sport, he exercises his horses before daybreak, and goes hunting rabbits with his dogs, or rides his horse in the clear sunshine."[99] This mode of existence was scorned by Sallust; he justified writing his Roman history on the grounds that he was determined not to "wear away good leisure in self-indulgent laziness, nor again to carry on a life obsessed by farming and hunting, tasks that belong to slaves."[100] Petrarch agreed, since "to apply one's mind wholly to the soil, without compelling need to do so, this, I think, is disgraceful and indecent for an educated man of probity, since one can hardly find a subject more lacking in noble challenge."[101] And while Constantijn Huygens claimed that it was at Hofwijk that he was *Vrij-heer van mijn tijd,* that is, "lord of my time," he also said that he wrote the poem on his country house to avoid the epitaph, "Here lies / A man who thought it would suffice to plant and dig, / Who followed farmer's arts and never took the time / To ornament his own creation with a song."[102]

But however the *landhuis* owner might actually have occupied himself while residing in the country, seventeenth-century Dutch writers often praise his dedication to things of the mind. Vondel, as

we have seen, imagined Jan Six spending his time at Elsebroeck in study and composing *veldgedichten;* one is tempted to suppose that Rembrandt's famous etched portrait of Six of 1647 (Bartsch 285) shows him at Elsebroeck, surrounded by his books and works of art and reading over some *veldgedicht* that he has just completed.[103] However this may be, a similar note is sounded in the many country-house poems of the period. We will mention only several published fairly close in time to Bloemaert's *Otium* series. In his poem of 1613 on Binckhorst, Philip van Borsselen, for example, describes its fortunate owner, Jacob Snouckaert, as passing his winters on his estate in his *studeer-camer,* or study: "You feed your eager heart with God's word," Van Borsselen tells him, "or you take in hand any edifying book in Latin or French," or "you soothe your melancholy spirit with some work, such as writing a Latin poem in praise of your *landleven* [life on the land]."[104] Petrus Hondius, in his verses of 1621 on the country house Moffe-schans, praises the fine library that he found there: here he is cloistered among the books that "always stand to speak to us" on subjects of all kinds, including the "course of nature from above to below," and we can understand why he subtitled his *hofdicht* "The sweetness of country life accompanied by the books."[105]

It is not to be supposed, of course, that Bloemaert's shepherds and other rustic folk were intended to personify this ideal of intellectual leisure that is implied in the verses beneath his resting goatherd. Nevertheless, his peasants most certainly evoke a range of associations, from the carefree, untrammeled existence of rural life—as seen, as it must be stressed again, from the vantage point of the townsman—to the freedom from business affairs and the tranquility necessary for intellectual pursuits. I would also like to suggest that similar associations would have been evoked by the loungers and gossipers that Van Goyen, Esaias van de Velde, and other artists introduced into their views of the Dutch countryside. These figures, in fact, possess much of the same significance as the shepherds of the pastoral tradition: they represent the pastoral, in fact, in its Dutch mode, differing from the Italianate pastorals of Bartholomeus Breenbergh, Nicolaes Berchem, and a host of other "Italianizing" Dutch landscapists only in degree, but certainly not in kind. Both represent differing aspects of the pastoral ideal. In this respect, the friendship and occasional collaboration of Jacob van Ruisdael and Nicolaes Berchem symbolize the many associations of idea and sentiment shared by the idealized, often heroic arcadian scenes, inspired by the art and landscape of Italy, and the homely, familiar scenery inspired by the Dutch countryside. They were the twin aspects of the simple life, an image of an ideal human existence that has never been more eloquently described than by the sixteenth-century French writer Pierre Charron, in his treatise *De la sagesse,* published in 1603. In the words of the English translation published at London sometime before 1621, Charron tells us that country life confers

> both spiritual and corporall libertie, wisdome, innocencie, health, pleasure. In the
> fields, the spirit is more free and more to it self. . . . This celestial fire that is in us,

will not be shut up, it loveth the aire and the fields; and therefore Columell [i.e., Columella] saith, that the country life is the cousen of wisdome, consanguinea, which cannot be without beautiful and free thoughts and meditations; which are hardly to be had and nourished among the troubles and molestations of the cities.[106]

It was this ideal, I believe, that could be evoked by even the barest stretch of dunes or the humblest cottage in the Dutch rustic landscapes of the Golden Age.

7

Rustic Ruins

I attribute to nature neither beauty nor ugliness, neither order nor
confusion. For it is only in relation to our imagination that we can say
of things that they are beautiful or ugly, ordered or confused.

— Benedict Spinoza, 1665

Though the objects themselves may be painful to see, we delight to
view the most realistic representations of them in art.

— Aristotle

The Dutch rustic landscapes of the seventeenth century—paintings, prints, drawings—
often display the effects of weathering and material decay: the dilapidated farmhouse or
outbuilding, the collapsing wall or roof, the sagging fence. The examples are endless. In
a picture of 1631 by Jan van Goyen (see Fig. 1), the landscape is dominated by a ruinous old farm-
stead; in Van Goyen's dune landscape dated in the same year, the chief feature is a derelict piece of
fencing against which leans a rotting old door (Plate 12). Old and dilapidated cottages can be found
in a number of Rembrandt's landscape etchings, such as *Landscape with Cottage and Hay Barn* (Fig.
99) and *Landscape with Cottage and Large Tree*, both of 1641; in his *Windmill* (Bartsch 233), done
about the same time, he rendered the structure with scrupulous attention to its weathered surfaces.[1]
In addition to man-made ruins, the Dutch landscapists also depict natural decay, especially dead trees
and tree stumps. A superb instance is Ruisdael's early *View of Egmond on the Sea* (Plate 13), in which
the trunk of a dead tree looms dramatically against the sky as the protagonist of the scene.

For the sake of convenience, I designate these dilapidated forms, both man-made and natural, as
"rustic ruins." Ranging from weathering and neglect to downright dereliction, rustic ruins must be
distinguished from ruins of the "noble" variety: not only those of ancient Rome, which had haunted

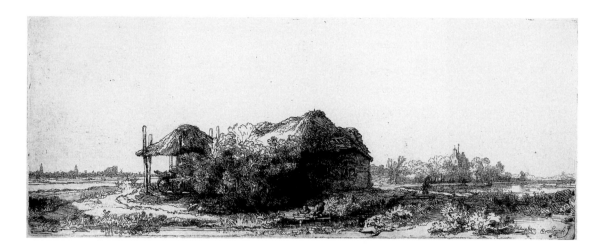

the European imagination for centuries, but also such local monuments as Brederode Castle and the
Huis ter Kleef: with their wealth of historic and patriotic associations, such ruins afforded the more
philosophically inclined sightseer an occasion to muse on the lesson that Jan van de Velde pointed
out on his etched view of Brederode: "What is all people's doing more than vanity?"[2] And when
Constantijn Huygens spoke of the "formless splendor of fallen ruins" (*vel ruinarum in sua canitie et
deformitate elegantiam*), we may assume that he was thinking of the noble kind.[3] Rustic ruins, on the
contrary, at least those made by man, are generally without splendor; they are the remains of a peo-
ple without a history, certainly no history that would have been recognized by the Dutch public of
the period; they evoke, not past greatness, but present impoverishment, crop failures, the abandon-
ment of cultivated land. Such humble ruins are seldom encountered in the earlier history of the

rustic landscape. I have found only a single instance of neglect in the *Small Landscapes* published by Hieronymus Cock: in a sheet from the 1561 series (Bastelaer 45), a shutter dangles by one hinge from the window of a farm building. Ruinous structures are equally rare in the rustic scenes produced by Pieter Bruegel the Elder and his Flemish successors.[4] Nor do they appear in the literary descriptions of the Dutch landscape. Neither the *hofdichten* or other nature poems celebrate neglected and abandoned farmsteads, collapsing walls, and dead trees. So we must ask: just why were these manifestations of physical decay so often introduced into depictions of the Dutch countryside?

Posed this question, a number of scholars have suggested, as we shall see, that the presence of rustic ruins was simply a part of the Dutch commitment to mirror nature in their art: they merely painted what they saw around them. There may be some truth to this. Although the Frenchman Charles Ogier, touring Holland in 1636, found "nothing that smacked of poverty or filth" on a trip from Amsterdam to Leiden, and other visitors were struck by the neatness of Dutch farms and the cultivated appearance of the Dutch landscape in general,[5] ruined cottages and abandoned farms cannot have been completely absent. This would have been especially true during the war with Spain, when parts of the Dutch countryside were ravaged by the enemy. Scenes of *boerenverdriet*, or peasants and peasant villages attacked by marauding soldiers, were popular in both the Dutch Republic and the Spanish Netherlands in the several decades just before and after 1600, and while undoubtedly conventional in their depictions, they very likely reflected circumstances all too often found in reality.[6] However, this appeal to realism only raises a fresh question. Samuel van Hoogstraeten described the seascapes of Jan Porcellis as exhibiting a "selective naturalism" (*keurlijke natuerlijkheyt*),[7] and the term can be applied not only to Dutch seascapes but to other categories of subject matter as well: Dutch artists chose only certain aspects from the multifariously complex world around them. So why would they have so often depicted the kind of subjects that people would most probably have found disagreeable when they encountered them in real life? David Beck, for instance, described the house of a recently deceased recluse that he saw in 1624 in Delft; the building was in such disrepair and its rooms so littered with junk, that to behold it, he said, one might both laugh and cry.[8] And we may suspect that country-house owners, had they discovered ruined buildings or fallen trees on their own property, would soon have taken steps to have them removed.

The exponents of scriptural reading, for their part, have answered this question by equating material decay with evil and moral decay; they assert that when ruinous cottages, barns, dovecotes, and the like appear in the Dutch landscape, they symbolize the transience of life, human sin, and death.[9] There is no doubt, of course, that ruins were traditionally employed in moralizing contexts. In Bosch's *Wayfarer*, for example, the vagabond looks back toward a dilapidated tavern-brothel, symbolic of the debauched life that apparently attracts him still.[10] In a print after Marten de Vos depicting the industrious and the lazy peasant (Fig. 100), the landscape behind the latter shows a farm sorely in need of repair.[11] Another instance most likely occurs in a drawing by Jacques de Gheyn II, signed and

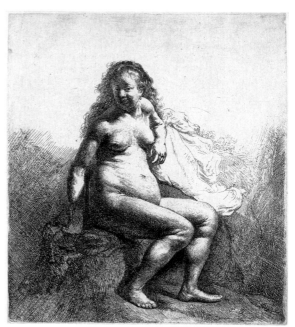

FIGURE 101
Jacques de Gheyn II, *Farm Scene*, 1603, etching. Amsterdam, Rijksmuseum.

FIGURE 102
Rembrandt, *Nude Woman Seated on a Mound*, etching. Amsterdam, Rijksmuseum.

dated 1603, which he reproduced in an etching (Fig. 101). The foreground is dominated by a broken wheel, a few fence posts with some railings attached, and several dead tree stumps. The cottage behind presents a scarcely better aspect; the straw has fallen from the roof, exposing the lath work beneath, and the main door hangs precariously from one hinge. Hans Mielke has plausibly suggested that these details are potent symbols in an allegory of sloth and lust, reflecting the spiritual state of the courting young couple in the foreground.[12] In these three examples, rustic ruins play an unmistakable symbolic role.

But if Van Goyen, Rembrandt, and other Dutch landscapists endowed their scenes of rustic decay and ruin with a similar allegorical significance, this fact was apparently forgotten by Dutch critics of the later seventeenth and early eighteenth centuries. They speak of depictions of material decay in a quite different context, more specifically in terms of those artists who, it was claimed, quite perversely depicted only the ugly in nature. An examination of these objections suggests that for both artists and viewers of the earlier seventeenth century manifestations of decay in images of the Dutch countryside were capable of evoking not only thoughts of sin and death but also ideas of a quite opposite kind.

The earliest extended criticism of this taste for rustic decay comes from Jan de Bisschop, lawyer, gifted amateur artist, and writer on art. De Bisschop was thoroughly committed to the art of antiquity and Italy; shortly after his death in 1671, there appeared his *Paradigmata graphices variorum artificum*, a compendium of images, mostly inspired by classical and Italian art, intended primarily for art lovers but also used as a model book by artists. In his dedication of this volume to Jan Six, De Bisschop insisted that it was "an obvious perversity of our judgment to be persuaded that whatever is unsightly in nature is pleasing and praiseworthy in art, and that consequently a deformed, wrinkled and tottering old man is more suitable for painting [*meer schilderachtig*] than a handsome and youthful one; a dilapidated and irregular building [*een vervallen of ongeschickt gebouw*] than a well-built one in good repair . . . torn and patched clothes than fresh and neat ones." "Yet only recently," he continues, "this error had taken such hold of many of even the greatest of our artists, that everywhere it had the strength of an accepted opinion; and to such a degree that almost everything unpleasing to the eye was especially chosen as an excellent thing to paint." Even a Leda or Danae is represented as "a woman with a swollen belly, pendulous breasts, legs disfigured by garters, and other things of this sort."[13] Rembrandt's etching *Nude Woman Seated on a Mound* of about 1631 (Fig. 102) comes immediately to mind; De Bisschop does not mention Rembrandt, nor does he name any others of the "greatest of our artists" who dedicated themselves to rendering ugly subject matter from nature, because they thought that such subjects were more *schilderachtig*. Nor is it clear what De Bisschop meant by the term *schilderachtig*. This word may be translated literally, of course, as "painterlike," or "painterly," or "suitable for a painting," but he never defines it precisely.

It is significant, however, that the same word reappears in a similar context only four years later

in an account of Rembrandt by Joachim Sandrart in his *Teutsche Academie* of 1675. Rembrandt, he tells us, ignored the rules of art and followed his own inclinations; he also painted few poetic or historic subjects, preferring only simple things without deeper meaning, subjects that he considered "agreeable and *schilderachtige* (as the Netherlanders say)."[14] Sandrart had lived in Amsterdam between 1637 and 1645 and must have been familiar with Rembrandt's art, if not with the artist himself, but he does not clearly indicate what kind of subjects Rembrandt found "agreeable and *schilderachtige*," except that they were simple and neither poetic nor historic.

The lawyer and dramatist Andreas Pels was more definite in his *Gebruik en misbruik des tooneels* (Use and misuse of the theater), published at Amsterdam in 1681. Pels was a founder of the literary society Nil volentibus arduum and an ardent exponent of classical taste. The *Gebruik en misbruik* is a spirited defense of the theater in general and a plea to playwrights to follow the correct rules of their art as exemplified by the French dramatists. It is within this context that Pels introduces a long passage on Rembrandt. Writers, he counsels, should adhere to the correct rules and avoid the example of Rembrandt, that "foremost heretic of art," who "did not subject his pencil to the rules of art." In a passage perhaps inspired by De Bisschop, Pels tells us that should Rembrandt paint a nude, he

> chose no Greek Venus as his mode
> But rather a washerwoman or a treader of peat from a barn
> And called this whim "imitation of nature."
> Everything else to him was idle ornament. Flabby breasts
> Ill shaped hands, nay the traces of lacings
> Of the corsets on the stomach, of the garters on the legs,
> Must be visible if nature was to get her due.
> This was *his* nature which would stand no rules
> No principle of proportion of the human body.[15]

Pels does not use the term *schilderachtig* here, but he does just afterward, when he tells us that Rembrandt wandered through the city of Amsterdam, visiting the New and North Markets, "zealously seeking / armor, helmets, Japanese poignards, fur, / and frayed collars, that he found *schilderachtig*."[16] According to Pels, Rembrandt employed such objects in his history scenes as costumes for Roman heroes and the like. It is tempting to speculate that there was some factual basis to Pels's story: we can imagine Rembrandt visiting the Wednesday rag market in Amsterdam, where, as we are told by one English traveler of the time, people could buy old things taken in pawn.[17] It may be that Pels was thinking of the vaguely Eastern turbans and other costume elements that Rembrandt habitually employed in his biblical narratives; he may also have known a poem of 1654 by his archenemy, the decidedly unclassicist playwright Jan Vos, *Strijd tusschen Dood and Natuur, of Zeege der Schilderkunst*

(Combat between death and nature; or, triumph of painting), which includes a description of a painter's studio equipped with shields, rusted swords, skulls, old books, and similar objects, serving as props for the artist.[18] Rembrandt's use of anachronistic costumes must have particularly galled the classicist Pels.

Pels's account of the scavenging Rembrandt, incidentally, was picked up by other writers. Filippo Baldinucci, in a treatise on engraving and etching published in 1686, devoted a section to Rembrandt, claiming that he received his information about this artist from a former Rembrandt student, the Danish painter Bernhardt Keil. Not only did Rembrandt, he tells us, go about in unkempt and dirty clothes, on which he wiped his brushes while working, but he also attended auctions where he acquired old and used clothing that he considered bizarre and picturesque (*bizarri e pittoreschi*). These he hung on the walls of his studio among the objects he had collected that were of genuine value and beauty.[19] Keil left Holland in 1651, long before Pels's account of 1681, but both he and Baldinucci might have read the revised Latin version of Sandrart's book, published in 1683, in which the story had received a final curious twist. Rembrandt, we learn, accumulated pieces of cloth, old utensils, and similar articles, which the artist erroneously held for rare antiques. Only the ignorant, Sandrart says, will be impressed by this collection; the wise will not be fooled. This story was repeated by later writers as well.[20]

Thus it seems that from about the time of Rembrandt's death onward, Dutch critics were inveighing against what they considered the tasteless portrayal of ugly or deformed subjects in painting, a judgment focused on Rembrandt and apparently inspiring a number of myths about his character. But an even earlier instance of this rejection of the ugly in art can be found in Constantijn Huygens's autobiography, composed between 1629 and 1631. He described with enthusiasm a *Head of Medusa* by Rubens that he had seen in the house of a friend but went on to say he would rather see it in someone else's house than in his own, because, he concluded (rejecting Aristotle's dictum to the contrary), "beautiful subjects can still please even in a presentation less than elegant, but what is ugly can never become charming through its presentation."[21] The increasing frequency of comparable sentiments later in the century reflects the growing classicism that characterized Dutch culture after 1650, partly in response to the increasing influence of the French court. This refinement is apparent, as we have seen, in Pels's treatise on the theater and can also be discerned in the revival of Bredero's plays, which were expurgated of all language, including the word *hoer* (whore), that might have offended audiences of the period.[22] Among the artists who had failed to meet these new standards of refinement only Rembrandt had been specifically named, a tribute, perhaps, to his great fame; however, the list was greatly enlarged by Pels's friend the painter Gerard de Lairesse, who, incidentally, engraved the title print to a later edition of De Bisschop's *Paradigmata*.

In his *Groot Schilderboeck* of 1707, De Lairesse clearly declares himself on the side of the classicists and develops his arguments at much greater length than had his predecessors.[23] De Lairesse

prefers subjects from ancient history and mythology; for modern subjects, citing Frans van Mieris and Gerard Dou as exemplars, he advocates such scenes as two ladies drinking tea in an elegant interior or "parents permitting their children to take some diversions in [a] bath," featuring ideally proportioned nude adolescents and beautifully costumed adults.[24] Hence, it is understandable why, like Pels and De Bisschop, he protests strongly against depictions of the ugly or commonplace. There is hardly a fine interior, he complains, that is unadorned with "pictures of beggars, bordellos, taverns, tobacco smokers, musicians, dirty children on their pots and other things more filthy and worse. Who can entertain his friend or a person of repute in an apartment which is such a mess?"[25] Rembrandt is roundly criticized, of course, along with Jacob Jordaens, Adriaen Brouwer, and "Bamboots" (probably Pieter van Laer).[26] De Lairesse elaborates this complaint in the last three chapters of the section on landscape, where he vehemently condemns landscapes that show "deformed trees, widely branched and leafed, and disorderly . . . full of knots and hollowness, also rugged grounds without roads or ways, sharp hills, and monstrous mountains filling the distance, rough or ruined buildings with their parts in confusion; likewise muddy brooks, a gloomy sky abounding with heavy clouds."[27] He also lists some artists who were wrongly considered *schilderachtig:* Bamboots (Van Laer), Brouwer, Molenaer, and in landscape Bruegel, Paul Bril, Bloemmert, Saverij, and such like masters, to whom, he continues, "I oppose . . . Raphael, Correggio, [Gaspard] Poussin," and others who "follow them in their choices."[28] In the same chapter, De Lairesse also criticizes the misuse of the word *tekenachtig* (designlike or suitable for a drawing), a word, he tells us, that is as much perverted as *schilderachtig:* "for instance, crooked trees abounding with knots and hollowness, rugged clods of earth, broken and sharp rocks," and the like, that have been extolled as *tekenachtig,* "though as absurdly and improperly, as it is to fetch light out of darkness and virtue from vice."

De Lairesse appropriated the word *schilderachtig* for what he considered the "correct" kind of painting; this is made evident in the two final chapters of this section of his book, which he devotes to two contrasting types of landscapes. In the penultimate chapter, titled "Of the *Schilderachtig* Beauty in the Open Air,"[29] he describes himself wandering through a parklike *locus amoenus,* complete with marble fountains, temples, and neatly kept peasant houses with classical architectural details, as well as strategically placed ancient ruins and antique tombs; the weather is fair and the roads are "so neat and level, that in walking you hardly seemed to touch the ground." Such scenery calls to mind the landscapes of Poussin or, closer to home, the occasional classical landscape by Jan van Huysum, as well as De Lairesse's own theater designs and landscape backgrounds.[30] The final chapter offers a landscape of quite the opposite sort, as indicated by its title, "Of Things Ugly [*onschone,* i.e., unbeautiful] and Broken, Unjustly Called *Schilderachtig.*"[31] The author now struggles through a rugged and desolate terrain, without paths or roads, strewn with dead trees and tree stumps, and plagued by earthquakes and storms. Even the ruins differ from those encountered in the previous landscape: they lie on the ground at awkward angles, affording no comfortable seats for the weary traveler, and are

too fragmented to allow the connoisseur an opportunity to appreciate their sculptured reliefs; a corpse spills out of a shattered tomb. In this inhospitable terrain, nevertheless, our author meets various artists industriously sketching the motifs that it offers, because, as one draftsman tells him, "Oh! You cannot imagine how extraordinary, and full of variety these objects are. This is the finest place on earth for a curious artist; all is *schilderachtig;* everything lies so loose, pretty, and wild [*zo los, aardig en woest*]." In the face of such conviction, De Lairesse begins to blame his own judgment, as he says, "for not discovering such beauties as they did," but he quickly recovers from such doubts and does not fail elsewhere to draw the moral of his two parables: "It is therefore indisputable that the painterlike [*schilderachtig*], or most beautiful choice, implies nothing else than what is worthy to be painted; and that the most mean, or what is not beautiful, least deserves that honour."[32]

Aside from the perennial scapegoat Rembrandt, who were the artists who were judged so harshly by the later Dutch critics? For De Bisschop, they were certain "modern" artists; for Pels, it was above all Rembrandt; for De Lairesse, writing about a generation later, they were old-fashioned artists. Among the landscapists he names, aside from "Bruegel," probably the revered Pieter the Elder, were the artists maturing in the late sixteenth and early seventeenth centuries: Paul Bril, Abraham Bloemaert, and one of the Saverij brothers, most likely Roelant, who spent a good many years in the Northern Netherlands. It is not unlikely that De Bisschop and De Lairesse would have regarded with similar distaste the landscapists of the next generation or so, especially Jan van Goyen, Pieter de Molijn, and other landscapists of the so-called tonal period of Dutch painting. In the case of De Lairesse, this is strongly suggested by his complaint about good artists who leave the beautiful color green out of their palettes, using instead black, yellow, and more suchlike faded colors.[33] Indeed, De Lairesse's strictures on gloomy skies and heavy clouds may well allude to the landscapes of the "tonal" painters.[34]

Thus in general, when the Dutch classicist writers employed the word *schilderachtig* in its pejorative sense, it was in a way that remarkably anticipated the use of the word *picturesque* by English writers of the later eighteenth and nineteenth centuries. "There are few words, whose meaning has been less correctly determined than that of the word picturesque," we are warned by Uvedale Price, one of leading theoreticians of the picturesque.[35] But its application to landscape can perhaps be understood if we turn to the second English edition of Gerard de Lairesse's *Groot Schilderboek*. Published in 1817, it was revised and edited by William Marshall Craig. A watercolorist and miniature painter who worked for the English court,[36] Craig inserted his own "Concluding Essay by the Editor" of almost thirty pages at the end of the second volume of De Lairesse's treatise, in which he set forth his personal advice to the painter. He heartily endorsed De Lairesse's dictum that artists should avoid depicting ugly and mean subjects, such as the "licentious revelry and unseemly excesses of drunken boors and profligate women." In the same vein is his enthusiasm for the kind of landscape favored by De Lairesse, that is, the "elegant . . . kind of scenery," as Craig defined it, "in which nature has been forced by skillful hands to spread her beauties over the domains of opulence and taste."[37] He

departed markedly from De Lairesse, however, in at least one instance. In a section titled "On the Picturesque in Rural Landscapes," he wrote:

> [but] there is a consideration distinct from all others that would lead many to the choice of Rural Landscape, for the artist's studies and exertions. The proper scenes with their accessories and appendages, furnish incessant occasion for that roughness and inequality of surface which leads to picturesque expression in painting.—A cottage nearly falling to pieces, but sustained by some rude props; a piece of shattered railing; a thatched roof covered with moss and ivy; the ill-marked pathway through a green lane: or, a carriage road cut into deep furrows—all furnish admirable materials for the pencil. Indeed, it has been most happily remarked . . . that things generally become more picturesque in proportion as they become unfit for the purpose to which they were destined.[38]

The picturesque qualities of the "Rural Landscape" were elaborated by Uvedale Price in his *Essays on the Picturesque,* which had appeared a few years earlier, in 1810. The picturesque, Price tells us, comprises "roughness, and of sudden variation, joined to that of irregularity," and picturesque objects include hovels, old fences, cottages with thatched roofs, especially "when mossy, ragged, and sunk in among the rafters in decay," also the interiors of old barns, old gnarled oaks, and mossy, shattered trees.[39] In contrast, Price tells us, the beautiful landscape is more even, its forms and tones blended in "insensible transitions."[40] Price had discussed this distinction between the beautiful and the picturesque in an earlier treatise, published in 1801; it takes the form of a conversation among three gentlemen walking through the countryside.[41] They come on a hovel beneath a gnarled oak, with an old gypsy and a donkey. When one of the travelers complains that the scene is merely ugly, a companion (speaking for the author) replies that he would call such objects neither beautiful nor ugly, but picturesque; "for they have qualities highly suited to the painter and his art, but which are, in general, less attractive to the bulk of mankind." These qualities are, of course, "roughness, and sudden variation, joined to that of irregularity [that are] the most efficient causes of the picturesque." The travelers encounter other picturesque views, including a rough lane very difficult to walk along and an old parsonage with additions in different styles. When they view a fine and pleasant prospect of the green countryside traversed by a river, the author's spokesman pronounces it merely beautiful; it will appeal to everyone without distinction. The picturesque is a taste that must be cultivated. Price has in effect taken the complaints of De Bisschop, Pels, and De Lairesse and turned them upside down, arguing that "we are amused by ugly objects, if they be also picturesque."[42] Price, of course, could not have consulted Craig's edition of the *Groote Schilderboek,* which appeared only in 1817, but an earlier English translation of it had been in circulation since 1738, and while neither English edition

renders *schilderachtig* as "picturesque" but as "painter-like," it is nonetheless tempting to ask if Price had not in fact read De Lairesse's treatise. Indeed, the "picturesque lane" through which Price's three travelers make their way with considerable difficulty brings to mind De Lairesse's *schilderachtig* landscape of the ugly kind.

However this may be, it is generally agreed that the development of the English picturesque was influenced by the paintings of Jacob van Ruisdael, Meindert Hobbema, Adriaen van Ostade, and other Dutch painters.[43] Price acknowledged as much when he noted that the Dutch were picturesque painters, not merely imitators—they were capable of displaying great judgment in selecting and combining[44]—and in Price's dialogue of 1801, the three gentlemen refer often to Dutch paintings in their aesthetic judgments. But to what extent did Dutch painters of an earlier period appreciate the pictorial possibilities of the ugly? This is not an easy question to answer. Modern scholars have been reluctant to suggest that an actual "cult of the ugly" ever existed in the earlier seventeenth century.[45] It has been claimed that the taste for the ill-formed and commonplace was simply one aspect of the Dutch commitment to depicting the world *naer het leven* (after life) in all of its variety, which dominated much of the "preclassical" period, and that it was this commitment, in fact, that was expressed precisely in the word *schilderachtig*.[46] There is much merit in this idea, as we shall see. But that there existed a positive appreciation of the ugly for its own sake is a possibility that cannot be dismissed so lightly. We should remember how Rembrandt, for example, reworked his etching of a seated nude woman of about 1631, in a second state, deliberately strengthening the indentations in her flesh, provoking later Dutch writers to speak of her having removed her corset and garters; it was this very etching that particularly irritated Pels. And when Jacob van Ruisdael and his pupil Meindert Hobbema journeyed together to Deventer in 1662–63, one of the buildings they both recorded in drawings was an old watermill: Ruisdael characteristically emphasized the weathered walls and supporting posts; the younger Hobbema gave us a rather tidier structure.[47]

There can be no doubt, moreover, that the Dutch landscapists working in the first half of the century shared this propensity for the old, ugly, and ill formed. A closer look at this phenomenon illuminates a very important aspect of the Dutch rustic landscape. De Lairesse's inclusion of Roelant Saverij and Abraham Bloemaert as two of the major exponents of the bad kind of *schilderachtig* was a perceptive observation on his part. During his stay in Prague, where he worked for Emperor Rudolph II, Saverij seems to have been irresistibly attracted to the old, the deformed, and the totally dilapidated: he made innumerable drawings of abandoned urban dwellings and rustic cottages in various stages of dissolution. One of his drawings, for example, shows a ruined house close to a final collapse (Fig. 103). In another drawing, Saverij depicted the interior of a farmhouse sunk into decrepitude, its dangerously sagging ceiling supported by poles thrust against the floor.[48] A similar taste is evident in the drawings he made during his travels through the Tyrolean Alps and elsewhere: fallen trees, gnarled stumps, and dead trees still upright figure prominently in his scenes of forest interiors,

FIGURE 103
Roelant Saverij, *A Ruined House*, drawing. Edinburgh, National Galleries of Scotland.

FIGURE 104
Roelant Saverij, *Road in an Alpine Forest*, drawing. Berlin, Staatliche Museen Preussischer Kulturbesitz, Kupferstichkabinett.

drawn with an abiding interest in the intricacies of their forms and textures (Fig. 104).[49] Many of these elements appear in the landscapes that Aegidius Sadeler engraved after Saverij's designs, especially tree stumps.[50] In a drawing now in the Stifting De Boer, Amsterdam, Saverij immortalized a decrepit cottage near a bridge, a motif that seems to have enjoyed considerable popularity among his Netherlandish colleagues working in Prague.[51] From Saverij's later period in Holland we have a painting of 1615 showing a milking scene in a dilapidated old barn.[52]

Saverij's enthusiasm for the decrepit and misformed in nature was shared by other Netherlandish artists during the later sixteenth and earlier seventeenth centuries. Rubens and Goltzius made careful studies of gnarled tree trunks and roots, an artistic interest that goes back to Titian and his school.[53] But it was above all Abraham Bloemaert who reveled in rustic squalor and decay; it was a taste that he seems to have developed independently of Saverij, who did not settle in Utrecht until about 1619. Bloemaert's drawings of various spots in the countryside around Utrecht, so sought after by local collectors and connoisseurs, include many views of ruinous farm buildings, sagging cottages, and crudely constructed shelters, their weathered boards, peeling plaster, dilapidated roofs and brick walls, and rotting doors, all rendered with a remarkable zeal for the circumstances of their material decay. In an occasional drawing (see Plate 2), the better-maintained dwelling houses are relegated to a less conspicuous place, almost eclipsed by the tumbledown sheds and other outbuildings. In other drawings, he captured with relentless detail whole buildings subsiding into a pile of rubble (Fig. 105), but

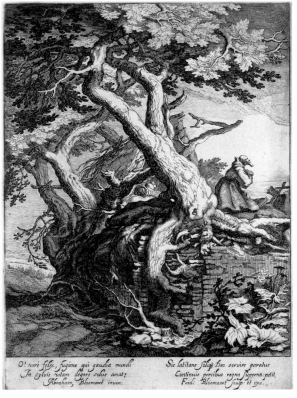

FIGURE 106
Abraham Bloemaert,
Shed, drawing. Paris,
École Supérieure des
Beaux-Arts.

FIGURE 107
Frederick Bloemaert,
after Abraham Bloemaert,
Hermit in a Forest,
engraving. Amsterdam,
Rijksmuseum.

he also rejoiced in even more humble manifestations of rural decay: crude shepherds' huts, weathered bridges, even an outdoor privy that he recorded, door open to reveal its occupant, in a drawing now in Berlin, done apparently after life. It appears, shown from various viewpoints in several later drawings (Fig. 106), and Frederick Bloemaert represented it in a print.[54] And the same outhouse, perhaps, crops up in a landscape etched by Jan van de Velde after Pieter de Molijn.[55] A similar taste appears in many of Abraham Bloemaert's landscape paintings, especially such early works as *Farmhouse with the Nativity,* done between 1605 and 1610; indeed, paintings like these were characterized as *ruynkens* (little ruins) in his own time, to judge from the evidence of a Utrecht inventory of 1603.[56] Like Saverij, Bloemaert's eye for the ruined and misshapen also probed into the natural world: he made many drawings of gnarled or dead trees and contorted roots, and they appear regularly in his paintings and the prints after his designs regardless of subject matter, almost like a signature (Fig. 107).

As we have seen, Abraham Bloemaert's rustic ruins quickly circulated among the general public in the prints after his designs. In the first decade of the seventeenth century, Jacob Matham engraved a number of prints after his drawings. A particularly magnificent specimen is *Abraham Dismissing Hagar,* dated 1603 (see Fig. 39), in which the weathered edifice behind the figures seems in a precarious state: fallen plaster exposes the wooden lath work and brick walls beneath; a window is disfigured by a broken pane; in the upper story, perhaps a storage area, part of one wall seems to have dropped away completely. This doting emphasis on decay, incidentally, is purely gratuitous, for there is nothing in the biblical account (Gen. 16) that suggests that Abraham was anything but prosperous.[57] The dissemination of Bloemaert's dilapidated farmsteads culminated some years later in the series of etchings made after his drawings by Boetius à Bolswert, who published them about 1613–14; we have discussed them in chapter 2.[58] Consisting of a title print and nineteen views, the series presents a curious mélange of subjects: a view of a fairly substantial town, presumably Dutch but otherwise unidentified, a scene of two large and prosperous-looking farmhouses, and a landscape dominated by pumpkins and other vegetables looming portentously in the foreground. The two concluding prints seem to be merely afterthoughts unrelated to the other prints; they show a rocky coastal scene and a mountain view, both in the tradition of Pieter Bruegel the Elder and Roelant Saverij. The remaining thirteen plates, however, constitute a repertoire of farmsteads—rundown and weathered dwelling houses and outbuildings (Figs. 108–110)—of the type familiar to us from Bloemaert's drawings, and, as in the drawings, the landscape elements are generally reduced to a minimum. Beneath Bolswert's etching needle, the rooflines and walls of these structures assume a mannered grace and elegance exceeding even that of Bloemaert's drawings, and the etcher has dwelt lovingly on their manifestations of decay: a wagon shed, for example, sways in impending collapse; in other outbuildings, rooflines sag ominously and walls gape where missing boards have fallen; broken cart wheels litter the farmyards.

In what spirit Bolswert and presumably Bloemaert offered these charming testimonials of rural

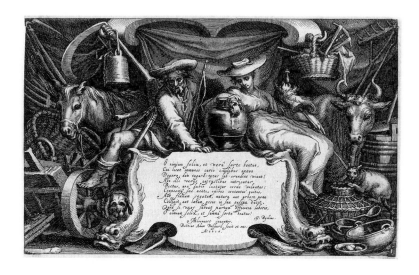

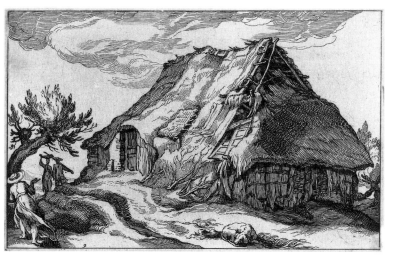

FIGURE 108
Boëtius à Bolswert, after Abraham
Bloemaert, title print from *Farm
Cottages*, etching. Amsterdam,
Rijksmuseum.

FIGURE 109
Boëtius à Bolswert, after Abraham
Bloemaert, *Farm Cottage*, etching.
Amsterdam, Rijksmuseum.

FIGURE 110
Boëtius à Bolswert, after Abraham
Bloemaert, *Farm Cottages*, etching.
Amsterdam, Rijksmuseum.

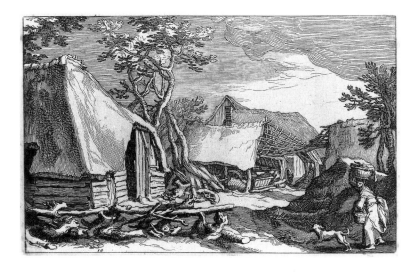

negligence and decay to the public is suggested in the title print (Fig. 108). It bears a short poem by an otherwise unknown G. Rijkius, elaborating on Horace's *Beatus ille,* perhaps under the direct influence of the *Bauw-heers wel-leven.* It celebrates the felicity of the man "who may spend his years free from civic burdens, living safely under the roof of his shed! His mind is not perturbed by many diversions . . . glad for the work of his ancestors and with a serene spirit he gathers the yellow crop or the ripe fruits of the trees or leads the large flocks to his pastures. What if a diligent wife assumes part of the work, oh ever so happy and blessed with a supreme fate is he!"[59] The poem is inscribed within a cartouche on which recline a country man and a country woman, the latter wearing a wide-brimmed straw hat ("such as they are accustomed to wear in the country," as Hadrianus Junius tells us concerning Heemskerck's landscapes),[60] and both wear vaguely classicizing garments, in contrast to the various figures in the cottage scenes, who although elegantly drawn are somewhat more realistically dressed. The peasant couple on the title print are surrounded by farm animals and agricultural implements, a basket of eggs, and the like, not within a stable, as has been suggested,[61] but in a vaguely indicated space dominated by a double arch supporting a swag of drapery. This theme of agricultural plenty sounded in the title print, in both word and image, is echoed in the print of the vegetable garden that appears among the cottage views.

There is not even a hint here that the succession of weather-beaten, often dilapidated farmsteads was intended to symbolize sloth or any other vice. Rather, the scenes constitute the physical setting for the happy life described in Rijkius's poem. This is curious. We generally think of farm life in the past chiefly in terms of the thrifty, well-ordered existence described in the agricultural manuals from Virgil, Columella, and Varro in antiquity to Charles Estienne (or Karel Stevens, as he was known to Dutch readers) in the sixteenth century and his numerous successors, with their prescriptions for the yearly round of labors and the upkeep and repair of agricultural equipment during the long winter months.[62] In such a regimen, Bloemaert's ill-kempt barns and sheds would be unforgivable, betraying the neglect of some "Farmer Slack," whose rundown farm was unfavorably compared in nineteenth-century American agricultural journals with the well-maintained, flourishing domain of "Farmer Thrifty."[63]

Nevertheless, there is considerable evidence that rustic decay and neglect could evoke ideas of a positive kind. One is the humble life, the life of virtuous poverty. The Nativity and Infancy of Christ are often depicted in impoverished surroundings, the simple manger to which Joseph has perhaps made a few repairs to shelter Mary and the Infant. Robert Campin depicted a decrepit manger in his *Nativity* now in Dijon; its daub-and-wattle walls are full of gaping holes.[64] In the *Hours of Catherine of Cleves,* a Dutch manuscript illuminated about 1435, the Holy Family takes its meal in a cramped chamber whose shelf with its collection of pewter to the left of the fireplace cannot distract us from the peeling plaster walls.[65] Similarly, in his *Nativity* engraving of 1504 (Fig. 111), Albrecht Dürer showed Mary and the Child snugly sheltered within an imposing but ramshackle old farm building

whose dilapidated state is rendered with painstaking devotion to the bricks exposed by the fallen plaster and the holes in the thatched roof.

This tradition was continued by Abraham Bloemaert in a painting of 1632 (Fig. 112), in which the Holy Family huddles in a dilapidated cottage kitchen with sagging walls, window frames askew, and the roof open in places to the sky.[66] His only rustic interior scene to have survived, it gives some idea of what the inner spaces of his tumbledown cottages might have looked like. The hermit saints, too, often live in crude huts, often hardly more than a few branches roughly thrown together to support a thatched roof, as in a print of Mary Magdalene that Adriaen Collaert made and published after Marten de Vos.[67] A print after Bloemaert etched by his son Frederick (see Fig. 107) shows an unidentified hermit praying in a sylvan wilderness; close by is his crude shelter tucked among the trees. The accompanying inscription tells us, "O truly happy [he] who loves to spend life in the solitary woods, fleeing the pleasures of the world! Thus hiding and ready to serve only God, he seeks with continuous prayers the supreme kingdom."[68]

Another aspect of virtuous poverty focuses on the simple life lived close to nature, far from court and city. With poverty, Petrarch tells us, "there will be no space for pride in it [your house], nor for envy, nor for disastrous losses and fear of losses, nor for a thousand kinds of suspicions, nor for deceit, indigestion, and the gout, which are permanent guests in the house of the rich."[69] And in Robert Greene's *Pandosto*, Fawnia says of her fellow shepherds, "we are rich in that we are poor with content, and proud only in this, that we have no cause to be proud."[70] Rustic neglect, if not outright ruin, can be discerned in an occasional pastoral landscape of the sixteenth century. An example occurs in Giulio Campagnola's print *Old Man Reclining in a Landscape* engraved about 1510; in the background can be seen a group of weathered buildings that, incidentally, were derived from a drawing by Titian probably inspired in turn by Dürer's prints.[71] There are further examples of rustic ruins associated with humble but virtuous poverty. The cottage of Philemon and Baucis, described in Ovid's *Metamorphoses* as "indeed, a humble dwelling roofed with thatch and reeds from the marsh," was frequently depicted in a state of disrepair, as in a drawing by Taddeo Zuccari and in various woodcut illustrations in sixteenth-century editions of Ovid's text.[72] It is not impossible, therefore, that Bloemaert's cottage scenes could have evoked the humble but virtuous and snugly secure life on the land, far from the "stately mansions" with their "doors inlaid with lovely tortoise-shell," to quote Virgil, the countryside, where the farmer plucks "the fruits which his boughs, which his ready fields, of their own free will, have borne," and where the rudest accommodations are quite sufficient for his needs.[73] This ideal of rustic simplicity was to have a long life; one example occurs in an anonymous Dutch song published several times during the seventeenth and eighteenth centuries, in which the peasants sing of their hard but simple life: they are free from care and sorrow, even if they live in houses without walls or chimneys. Each verse of this song ends with the proverbial phrase: "Dear Lord, daily bread and clothes, heaven, and then nothing more."[74] Constantijn Huygens played on this venerable

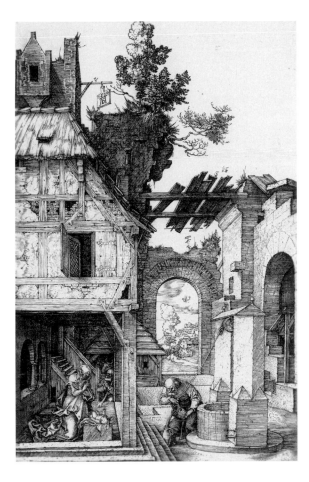

FIGURE 111
Albrecht Dürer, *The Nativity*,
1504, engraving. Cleveland, The
Cleveland Museum of Art.

FIGURE 112
Abraham Bloemaert, *Holy Family
in a Peasant Cottage*, 1632.
Amsterdam, Rijksmuseum.

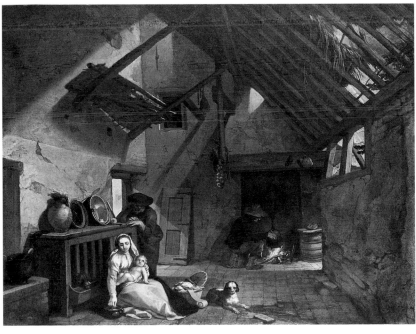

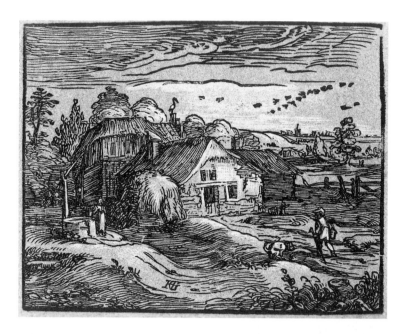

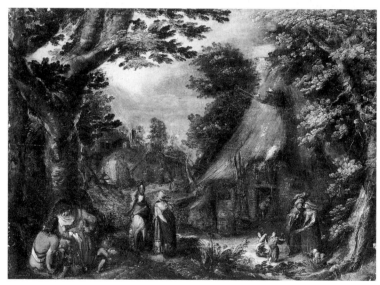

FIGURE 113
Hendrick Goltzius,
*Landscape with Farm
Cottage*, chiaroscuro
woodcut. Amsterdam,
Rijksmuseum.

FIGURE 114
Attributed to Karel van
Mander, *Rustic Landscape*.
Oberlin, Ohio, Oberlin
College, Allen Memorial
Art Museum.

theme in his *Hofwijck*, when toward the end of the poem he rather archly invites the reader into his "cottage," for he will no longer call it a castle, and elsewhere asks if his house should be called a castle or a dovecote.[75]

This is the world of the *Georgics* invaded by the world of the *Eclogues*, and it is in this sense that we can perhaps best appreciate Hendrick Goltzius's *Landscape with Farm Cottage*, a chiaroscuro woodcut of 1597–1600 (Fig. 113), depicting a rustic cottage whose plaster has crumbled away in places to reveal the brick walls beneath. Van Mander expands on the same tradition in his treatise on painting

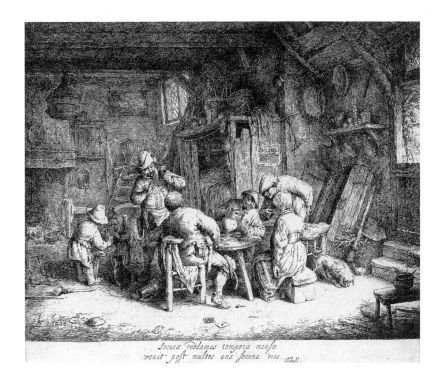

Secura reddamus tempora mensa
venit post multos una serena dies. Tibull.

when he offers the following advice in the chapter on landscape: in depicting shepherds' huts and peasant hamlets in caves and hollow trees and on stakes, he writes, do not paint the roofs in bright, strong colors like vermilion or red lead, but show everything as seen in reality. Roofs and walls are not to be shown with bright red bricks, but rather with turf, reeds, or straw, holed and patched; they can also be plastered in a fantastic manner (*vreemd'lijck*), with the moss growing on them.[76] How Van Mander envisioned such cottages can perhaps be seen in a landscape attributed to him (Fig. 114), in which the thatch-roofed cottages seem to merge with the surrounding landscape. Incidentally, his inclusion of caves and hollow trees among dwellings is intriguing; as Hessel Miedema suggests, they recall traditional representations of hermits in the wilderness,[77] although the caves, at least, may have a more mundane origin. Both Felix Platter (in 1557) and his much younger half brother Thomas Platter, Jr. (in 1599) describe their tours through the Loire valley, where they saw many caves inhabited by country people.[78] Van Mander could have encountered similar rustic dwellings on his travels.

Later in the century, Adriaen van Ostade depicted peasant families praying at the table or engaged in innocent household tasks in cottage interiors with the plaster peeling from the walls and domestic utensils scattered on the floor.[79] No satire or mockery is necessarily intended in these scenes: a print by Ostade done about 1647 (Fig. 115) shows a peasant family eating and drinking in just such a rustic interior; not unlike the sentiments in Cornelis Bloemaert's *Otium* series, the accompanying inscription tells us in effect that these peasants take their pleasures only after much hard labor.[80] A sim-

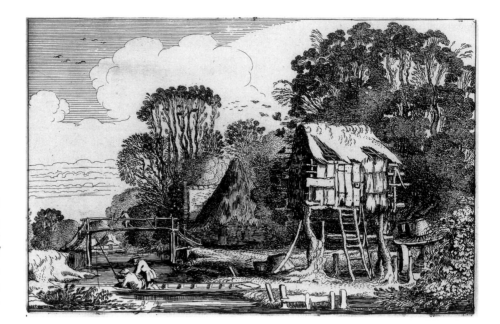

ilar theme of rustic felicity may well pervade Abraham Bloemaert's *Cottages*, even though this idea, not unlike the concept of leisure in his *Otium* series, probably served chiefly to unify a diverse group of images in the most casual manner. But in any case, Bloemaert's series proved to be immensely popular. The original plates by Bolswert were published in two later editions at Amsterdam, one by Cornelis Danckertsz (act. 1630–56) at some unspecified date, the other in 1664 by a certain F. de Witt.[81] Claes Jansz Visscher, who had already published many rustic views of his own, may well have capitalized on Bolswert's departure from Amsterdam about 1620 to issue his own copies of Bloemaert's *Cottages* about this time, but with a number of modifications. As we have seen, he discarded the vegetable garden and the last two landscapes and reduced the remaining compositions in size, intermingling them with eight more cottage views taken from various sources.[82] And while retaining the composition of Bolswert's title print, he replaced Rijkius's verses with the laconic inscription "Various lovely country houses done from life by A. Bloemaert."[83] I have already suggested that Visscher envisioned this series of prints as the true successor to Cock's *dorpshuysen;* he may also have seen Bloemaert himself as the Dutch successor to Pieter Bruegel the Elder, the artist to whom Visscher had attributed his own copies of the *Small Landscapes* published in 1611.

It is difficult to determine if, and to what extent, the first edition of Bloemaert's *Cottages* and Visscher's copies of about 1620 might have influenced later artists. The fact remains, however, that examples of rustic dilapidation soon appeared in depictions of the Dutch countryside. Only a few examples can be cited. In a drawing of 1628 Esaias van de Velde shows a ruined farmhouse on a stormy

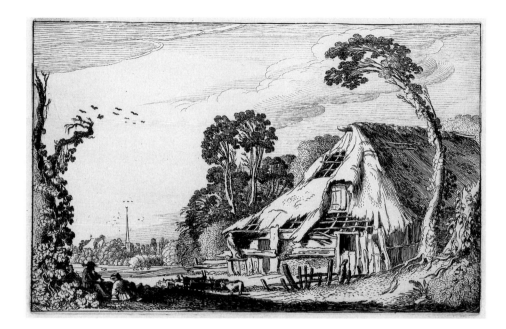

day; weathered and ramshackle structures occur elsewhere in his work.[84] The industrious Jan van de Velde introduced a strikingly derelict dovecote into his *Landscape with Two Men Fishing and Dovecote* from his series of sixty landscapes of 1616 (Fig. 116). While dovecotes were sometimes associated with idleness and drunkenness,[85] this was probably not Van de Velde's intention, for he featured weathered and ramshackle farm buildings in several other views from this series (Fig. 117); they were among the views intended, as he stated in one of his title prints, for the pleasure of the eyes.[86] These views of rustic ruins are often intermingled with those of "noble" ones; it might be supposed that he meant to imply a comparison (or contrast) between the noble ruins with their evocations of ancient history and great men performing noble deeds and the humble cottages and barns that, however old, belonged to those without a history. But this is uncertain, if only because, perhaps significantly, rustic ruins and their noble counterparts never occur within the same landscape.

Jan van Goyen was perhaps also inspired by the rhythmic lines of Bloemaert's *Cottages*. Although he eschewed Bloemaert's elegance of form, his humble cottages and barns display similar sagging roofs and swaying walls that reinforce the main diagonals of the landscape; often these man-made structures are scarcely distinguishable from the very earth into which they seem to sink (see Fig. 1, Plate 12). Van Goyen's sketchbooks show that he often searched out such motifs on his rambles through Holland and elsewhere. During a trip to Brabant about 1648, he concentrated not so much on the imposing Renaissance structures he saw in Antwerp and Brussels but on their medieval city gates, as well as the villages in the surrounding countryside; among the latter he sketched a ruined church and

inn in Brasschat in the vicinity of Brussels.[87] In at least one case he went so far as to invent a ruin: when he sketched the tower of the church at Warmond, near Leiden, he substituted a crumbling upper stage for the well-preserved spire. The resulting motif must have pleased him for he later introduced it into several paintings.[88]

Van Goyen's taste for rustic ruins was matched by that of Pieter de Molijn who, in a remarkable suite of four etchings dated 1626, depicted crumbling buildings and fences. A particularly spectacular ruin appears in one of these prints (Fig. 118), dominated by a shed whose rotted boards totter on the brink of utter disintegration. Similarly, Jacob van Ruisdael frequently introduced weather-beaten watermills and cottages into his landscapes, as in *Two Windmills and Open Sluice* of 1653,[89] or his etching *The Little Bridge* (Fig. 119). There is, by the way, an art to depicting ruins: whether rustic or noble, they must be sufficiently complete to evoke some idea of their former state. Some two centuries later, the heroine of one of Mrs. Gaskell's novels (*North and South*, 1854–55) exclaimed that she must capture some ruined cottages "before they tumbled down and were seen no more. Truly, if they are to be sketched—and they are very picturesque—we had better not put it off." De Molijn instinctively followed this principle, and so did Jacob van Ruisdael, when he sketched a ruined cottage on the verge of a final collapse. One of his most popular motifs, it appears in a number of paintings by other artists, including Emanuel Murant (Fig. 120), a landscape painter who seems to have specialized in farm scenes with heavily weathered and ruinous buildings.[90]

This penchant for cottages, barns, fences, and other rustic monuments in a state of wrack and ruin goes considerably beyond the simple desire to capture life in all of its diverse aspects. It suggests, rather, a deliberate striving for certain pictorial effects. This is certainly true of Van Mander's prescriptions for representing peasant dwellings. While undoubtedly concerned with their realistic depiction, he also characterizes them as *vreemde* and as *seldtsamer cluchten*, that is, strange and bizarre or grotesque whimsicalities, in a word, what we might term "quaint."[91] This smacks less of moral judgment than of aesthetic taste. A similar taste appears in Van Mander's life of Hans Bol, where he describes a painting of Daedelus and Icarus that he had seen; it showed a castle on a rock: "so subtly and precisely was that rock covered in moss overgrown and with its many colors handled in a sure way; and also that quaint old structure of the castle [*oudt vreemdsche gebouw van dat Casteel*] was wonderfully inventive, as if it were growing out of the rock."[92] Van Mander was not alone in his appreciation of the effects of weathering and decay. Giorgio Vasari had already admired the "fine old German cottages" that Dürer had carefully rendered in his engraving *The Prodigal Son among the Swine*, devoting much attention to their weathered surfaces.[93] This taste for the irregular in forms and surfaces appears elsewhere in the sixteenth century. It is implied, for example, by Paolo Pino, in his *Dialogo di pittura* of 1548, when he explained to his readers that the Northerners (by which he meant the Flemish) are good landscape painters, the reason being "that they depict the landscapes they inhabit, *which on account of their wildness produce the greatest pleasure* [italics mine]. But we Italians are in the world's garden, which is more delightful to look at than to depict."[94] Sometime later, in 1579,

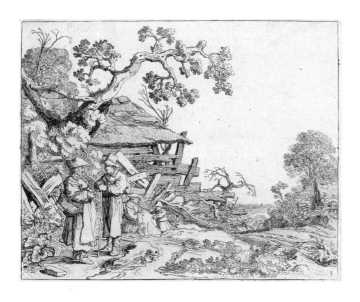

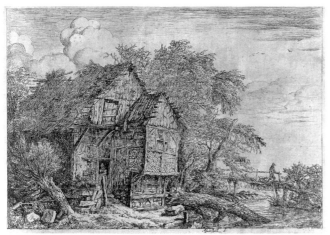

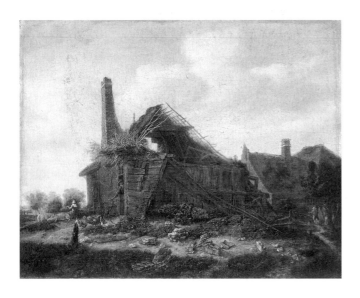

FIGURE 118
Pieter de Molijn, *Landscape with Two Peasants Conversing*, 1626, etching. Cleveland, The Cleveland Museum of Art.

FIGURE 119
Jacob van Ruisdael, *The Little Bridge*, etching. Cleveland, The Cleveland Museum of Art.

FIGURE 120
Emanuel Murant, *Farmhouse in Ruins*. Amsterdam, Rijksmuseum.

an anonymous writer, known only as E. K., compared Edmund Spenser's poetic style to certain beautiful pictures that also contain contrasting "rude thickets and craggy clifts [cliffs]," before which "ofttimes we fynde ourselves, I knowe not how, singular delighted with the shew of such naturall rudenesse and take great pleasure in that disorderly order."[95] This passage was repeated almost verbatim by Franciscus Junius in his *Painting of the Ancients in Three Bookes*, first published in London in 1638.[96]

About a generation after Van Mander, the same aesthetic sensibility was evinced by Cornelis Pietersz Biens in his *Teecken-const* of 1636, in which he advises the artist on the choice of landscape subjects. "For the cottages," he wrote, "choose the old, curious [*houbollige*], broken and half-fallen peasant houses covered with reeds or straw, with overgrown green plants [*bewasssen*], with old walls, broken doors and windows," accompanied by "curious [*drollig*] haystacks, dovecotes [*vogelhuysen*], plows, wagons, animals or fowl, and decorated with *hecken* [trellised?] trees or such like."[97] It is obvious that Biens was cribbing from Van Mander's *Schilder-boeck*; like Van Mander, he even advises the young artist to choose the morning to go into the countryside. He exceeded his predecessor by far, however, in his enthusiasm for picturesque decay. Biens supplemented Van Mander's prescriptions with a passage on the depiction of trees: the artist, he counsels, should mix tall, well-grown trees with those that are thin and crooked.[98] Although he names no individuals, he may well have had in mind such artists as Bloemaert and Roelant Saverij, as well as more recent landscapists. We have seen that old, crooked, and dead trees, Nature's own rustic ruins, were among the favorite subjects of Saverij and Bloemaert (see Figs. 104, 107). Often they were carefully studied in individual drawings. Similar trees and weathered tree stumps were often included by later artists as major compositional elements in their landscapes. In Visscher's *Country House and Orchard of Jan Deyman* (see Fig. 82), for example, a pollarded tree frames the right side of the composition, its bare branches forming an intricate pattern against the summer landscape.[99] A favorite tree was the oak: a monumental painting by Van Goyen in Rotterdam shows a group of peasants lounging beneath a magnificent, storm-blasted old oak,[100] while a similar tree occurs in Rembrandt's etching *The Omval* (Fig. 121), a natural wreck, but still sprouting living branches. In a landscape with the Flight to Egypt from the circle of Rembrandt, the whole left side of the composition is filled with the weatherbeaten roots and trunks of two enormous entwined, gnarled trees.[101]

It was Jacob van Ruisdael, however, who even more than Bloemaert was the master of the ruined tree. His *View of Egmond on the Sea* (Plate 13) is only among the earliest of a long succession of landscapes in which dead and dying trees and tree stumps play a significant role (Plate 14). They rise from amid living foliage or stand starkly isolated against the sky; they lie uprooted across streams and along roads; their blasted trunks and stumps occupy a whole corner of our field of vision. They are dead, but it is questionable if they symbolize death in some carefully premeditated allegory of human transience. Ruisdael employed a visual rhetoric more potent than traditional symbolism. His dead trees replace to a large extent the human presence that gradually recedes, indeed almost disappears, in many

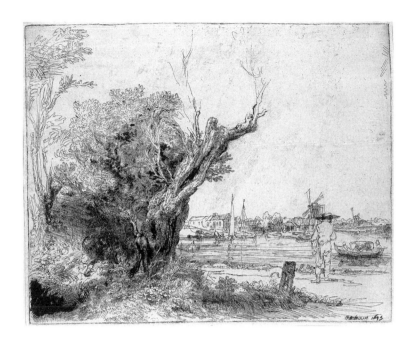

of his later landscapes. Dead trees provide contrasting areas of color, especially the beeches and oaks whose patchy white and ocher trunks stand out against the prevailing green. They also provide contrasting movement, creating diagonals and horizontals against the sturdy verticality of the living forest. And unlike most foliated trees, they are, above all, very expressive. Constantijn Huygens likened bare trees to the godless who stretch up their hands in beseeching but futile prayer. But Ruisdael's bare trees are incomparably more; they are the protagonists in a natural drama: living, flourishing, dying, and decaying. Like classical ruins in an arcadian landscape, with their collapsed walls and fallen columns, but in a way that De Lairesse would not have understood, Ruisdael's dead and recumbent trees are powerful evocations of a history of change and decay: it is not human history, but its poignant analogy in nature.

Ruisdael's dead trees and weather-beaten cottages were taken up by other artists of the period, particularly by Jan Wijnants, who seems to have made a specialty of such rustic decay (Fig. 122); indeed his cottages and trees are treated in a "hard-edge" style that exaggerates every symptom of their dissolution.[102] Parallels can be found in the depictions of other subjects. Rembrandt, for instance, was not alone in exploiting the wrinkled faces and bodies of the old and the tattered clothing of the poor and destitute as opportunities for depicting complex textures and visually intricate plays of light and shadow. Such effects can be commonly found in the work of artists in the generation just preceding Rembrandt, in the peasant tavern interiors of Adriaen Brouwer, for example, and in Frans Hals's *Malle Bobbe* of about 1631–35.[103] Stylistically speaking, of course, these images might simply

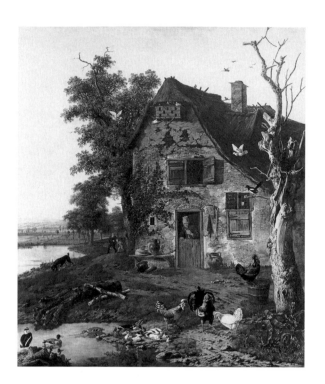

FIGURE 122
Jan Wijnants and Dirck
Wijntrack, *Farmstead*, 1654.
Present location unknown.

be seen as an expression of the baroque as defined long ago by Heinrich Wölfflin, especially demonstrating his categories of "painterly" and "unclearness,"[104] but there is no doubt that their style and more particularly their choice of subjects remarkably anticipate the later picturesque. Indeed, according to the later classicizing Dutch critics, the earlier artists justified this subject matter precisely on the grounds that it was *schilderachtig*.

Nevertheless, there is no evidence to support the occasionally voiced conjecture that the English word *picturesque* was itself derived from the Dutch *schilderachtig*.[105] Both words now carry essentially the same meaning. In the seventeenth century, however, *schilderachtig* possessed a wider range of meanings. These have been carefully analyzed in two illuminating articles by Boudewijn Bakker tracing the history of the word from its earliest known occurrences in the writings of Van Mander.[106] Van Mander used the word nine times in various contexts. In some instances, he employed it to mean "like a painter" or "suitable to a painter."[107] Elsewhere it has the sense of "being like a painting," or "suitable for a painting." Bakker correctly concludes that Van Mander used this term chiefly when he was discussing the representation of nature.[108] In speaking of Cornelis Molenaer's landscapes, for example, Van Mander remarks that he has never seen more attractive and *schilderachtiger* (tree) leaves.[109] A comparable range of meanings can be found in later Dutch writers, including the notion of being faithful to life. This is evident in the case of Bredero. In the foreword to the third edition

of his *Geestigh Liedt-Boecxken,* published in 1618, Bredero explains that he has chosen the Netherlandish tongue over the artificial language of learned writing because "as a painter, I have followed the *schilderachtig* saying that 'the best painters are those who come closest to life.'"[110] In the introduction to his *Spanish Brabanter,* published in the same year, he tells us that "I place before your eyes here, nakedly [*naacktelijk*] and *schilderachtig,* the abuses of this modern, depraved world."[111]

Nevertheless, by the early eighteenth century, *schilderachtig,* with all its variations of meaning, had long been employed in discussions of natural scenery, whether actual or as depicted in art. The earliest recorded example (itself suggesting earlier usage) occurs in Constantijn Huygens's poem *Ooghentroost* (Consolation of the eyes), written in 1647; here Huygens criticizes certain arrogant artists who stroll through the countryside and say, "that is a *schilderachtig* view. I cannot excuse this; it is thoughtlessly said. It seems to me that they say: God makes ingenious copies of our originals, and may well rejoice himself in the model; even if it was from our hand, it could not be more beautiful."[112] As Bakker has suggested, *schilderachtig* in this context may mean "fit to be painted."[113] In any case, it seems a curious sentiment from a man who almost twenty years before had devoted many words of praise to the Dutch landscape painters whose works he had seen in his youth.[114] Some years later Huygens's argument was repeated in Willem Goeree's *Inleyding tot de practijck der algemeene schilder-konst,* first published in 1670. Goeree did not hesitate to use the word *schilderachtig* in several senses, much as Van Mander had, speaking of some *schilderachtig* verses of Virgil, and he also describes drawing a landscape from life, or, "to speak in a *schilderachtig* manner, to imbue it with life."[115] Such usage was not uncommon by this time. Jan Six van Chandelier, for example, expresses his desire to praise the landscape of the village of Oostkapelle in a *schilderachtig* manner.[116] Samuel van Hoogstraeten, in his *Inleyding tot de Hooge schoole der Schilderkonst* of 1678, writes that a painter can learn sometimes from poets, when "he hears them sing in such a *schilderachtig* manner about landscape."[117] Goeree, however, vigorously condemned the application of the word to objects in nature, remarking that "it is clear from what has gone before that when we behold something pleasant in nature, the proverb 'that is *schilderachtig*' is being used improperly, . . . as if the creatures [made by God] were merely almost as charming, elegant and pleasant as the painted things, which is a great error, unless one intends to say that *schilderachtig* means worthy of being painted for its pleasantness, good selection and grandeur." He concluded his argument by quoting the appropriate lines from Huygens's *Ooghentroost.*[118] It should be noted that in his insistence that *schilderachtig* should denote only pleasant objects, Goeree also placed himself squarely in the camp of De Bisschop, Pels, and De Lairesse.

A variation of this argument appears in *De Schoole der Wereld,* a translation by Frans van Hoogstraeten of an edifying treatise by the English divine Joseph Hall and first published in 1682. Hoogstraeten added a poem of his own composition titled "On Viewing a *Schilderachtig* Landscape"; its message is that worldly beauty and pleasure are not comparable to the beauty of Heaven and the joy of the Blessed.[119] The accompanying illustration by Arnold van Houbraken shows what Jan Em-

mens has correctly described as "a kind of simplified version of Hobbema's *Avenue at Middelharnis*,"[120] although it has been supplemented by some rocks and fir trees in the right middle distance, evoking the landscapes of Allart van Everdingen. Hoogstraeten's poem rings a change on Constantijn Huygens's strictures against characterizing real landscapes as *schilderachtig* by insisting that worldly beauty cannot be compared to that of Heaven.

But while the more pious-minded may have objected to the comparison of God's own creation to a painting made by human hands, their complaints were increasingly ignored. The Catholic poet Reyer Anslo, for example, likens God himself to a painter, and in the next century Hendrick Korneliszoon Poot urged his readers to go from town into the May countryside and let their eyes wander joyfully through "God's landscape painting."[121] And it seems that some people had no scruples in describing actual scenes or objects in nature as *schilderachtig*. Samuel van Hoogstraeten, for example, tells us that the Italian landscape painter Girolamo Muziano held that the chestnut tree was the most *schilderachtig*, while other artists awarded this distinction to the oak.[122] Several writers used *schilderachtig* consistently to characterize certain things they saw on their travels. Among them is the artist Willem Schellinks, who kept a diary of a tour of France that he made in 1664 with Lambert Doomer. He recorded in his sketchbook a number of views he saw along the way, some of which he described as *schilderachtig*. One was a strange-looking bridge that peasants crossed with their donkeys, an animal unfamiliar to the Dutch.[123] A second bridge, spanning the Loire, is "long and *schilderachtig*," while a hermit's hut on a rock by a river is described as "very *schilderachtig* and pleasing."[124] Another traveler with an eye for scenery was Huygens's son Constantijn the Younger. During his stay in England between 1688 and 1696, he found the hills and valleys (*hooghten en[de] leeghten*) of the countryside "in many places very beautiful and *schilderachtig*," a judgment he had earlier applied to several locations in Belgium.[125] This eye for the pictorial possibilities of natural scenery was no doubt encouraged by his early training as a draftsman; the elder Huygens believed that a knowledge of drawing was useful (like a modern camera) when one traveled, because much writing could be avoided if one could capture a given locality in a sketch.[126] Following this precept, his son recorded in numerous drawings the various places he saw during his journeys in the service of the stadhouder-king William III.[127] If Huygens sketched any of the views described in his journals, they apparently are lost, but his surviving landscape drawings do not include the sort later condemned by De Lairesse as the false *schilderachtig*. One last writer may be cited, Arnold van Houbraken, who tells us that when Roelant Saverij was in the service of Rudolph II, he traveled through the Tyrol, sketching in a book all the views of landscapes and waterfalls "that appeared to him *schilderachtig*." Hardly fifteen years before, De Lairesse had included Saverij among those benighted artists who practiced the bad *schilderachtig*, but it is highly doubtful that Houbraken made any such distinction; elsewhere he tells us that the break of day presents the "*schilderachtigste*" views to depict on panel.[128]

While the word *schilderachtig* was increasingly being used to signify "like a picture" or "suitable

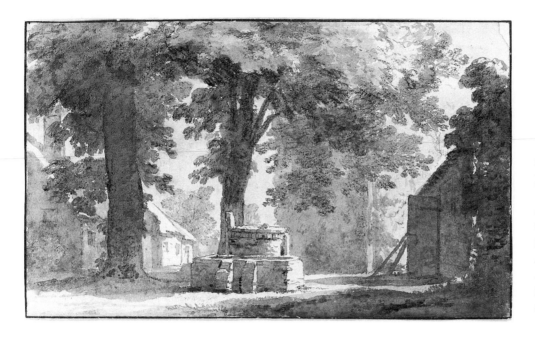

FIGURE 123
Jan de Bisschop,
*Village with Houses
and a Well*, drawing.
Cambridge, Mass.,
Harvard University
Art Museums, Fogg
Art Museum, Loan
from Maida and
George Abrams.

for a picture," most often, apparently, in connection with landscape, it did not necessarily signify the qualities of the "quaint," the ugly, and the misshapen that De Lairesse and his generation attributed to the earlier Dutch artists. This is why I am inclined to doubt that the word *schilderachtig* influenced the development of the English term *picturesque* as an aesthetic concept. Indeed, in a Dutch-English dictionary published at Amsterdam in 1766, *schilderachtig* is translated as "pretty, neat, handsome," with no reference to picture making,[129] and the various English editions of De Lairesse, as we have seen, translate *schilderachtig* as "painter-like."[130] It was only during the course of the eighteenth century that *schilderachtig* began to be used unambiguously in its modern sense, at first as a translation of the English word *picturesque* itself.[131] It was, in fact, not the Dutch word but Dutch art itself that exerted such potent influence on English concepts of the picturesque in the eighteenth and nineteenth centuries.

This long use of *schilderachtig* to characterize natural scenery helps explain, perhaps, De Lairesse's emphasis on landscape images in his discussion of the true and false *schilderachtig*. And it is not unlikely that De Lairesse would have looked on the rustic landscape drawings of Jan de Bisschop as examples of the true *schilderachtig* (Fig. 123). They conform to the traditional rural scene in subject and composition, but conspicuous by their absence are the weather-beaten and dilapidated structures that we today, like Uvedale Price before us, find so "picturesque" in the works of the older Dutch landscapists. No dead tree stumps detract from the natural beauty and flowing contours of De Bisschop's trees, and his cottages and farm buildings are neat and well maintained. But what can be said

of De Bisschop tends to be true also of many Dutch landscapists who came of age around the middle of the century and later. This is the case, for example, of the views of the Haagse Bos by Roelant Roghman (see Fig. 78). Even in the rustic scenes of Meindert Hobbema (Plate 15), we usually encounter cottages and farm buildings that are better kept than those in the landscapes of his teacher Ruisdael, and fewer dead trees litter his roads, fields, and forests.

A similar change in taste, and in manners, too, can be observed in the depictions of other subjects as well. The humble still-life pictures in the monochrome style by Pieter Claesz and Willem Claesz Heda gave way to the splendidly showy *pronk* still lifes of the new age, among them the creations of Abraham van Beyeren and Willem Kalf; the rowdy, often drunken peasants in the paintings of Adriaen Brouwer and the earlier work of Adriaen van Ostade tended to be replaced by more discreet country folk in the later paintings of Ostade, while artists of the following generations concentrated on fashions and pastimes of the middle class.[132] This new aesthetic, of course, had been anticipated as early as 1630 by Constantijn Huygens when he said that a picture of an ugly subject can never be painted so that it pleases as much as a beautiful subject.[133] Conversely, the earlier aesthetic was not without its champions even later; some twenty years later, Jan de Brune de Jonge claimed that people enjoy seeing the portrayal of what they would shrink from in reality.[134] It is with considerable enjoyment, one suspects, that De Brune would have contemplated the landscapes of Bloemaert, Van Goyen, and Ruisdael. Long before the English coined the term *picturesque*, one of its key doctrines, it seems, had been discovered by the Dutch: that even the humblest and the ugliest objects, to paraphrase Jan van de Velde, can serve the pleasures of the eye.

Conclusion

DECEPTIVE VISIONS

The ploughed field, the farm-yard, the lowing kine collecting for the
dexterous hands of the milk-maid, will become important features in
such combinations [in the rural landscape]: These open the heart to a
contemplation of the usefulness of rural labours, and lead the wealthy,
who live in cities and great towns, to wish for a participation in pursuits,
which bring health of body and tranquillity of mind.

— William Marshall Craig

The rustic scene first emerged as a major landscape subject in art in the Northern Nether-
lands during the first decades of the seventeenth century. It was not invented by the Dutch,
however, but owes its origins to the enterprise of Hieronymus Cock who some half cen-
tury before had published two sets of prints depicting farms, cottages, roads, and the like, presum-
ably situated, as he stated on the title print of the first series, in the vicinity of Antwerp. Although
intimations of the rustic landscape can be discerned in earlier Flemish art, especially in the back-
grounds of figure paintings and in artist's model books, Cock's *Small Landscapes* constitute in essence
a true novelty; they appeared, however, in a city where novelties were the stock-in-trade of artists
and print publishers who sought to appeal to an international market. This was true above all of land-
scape: the second half of the century saw a proliferation of landscape types by Flemish artists work-
ing in Antwerp and elsewhere. Especially popular, in both paintings and prints, were village scenes
crowded with figures, often set against far-flung vistas that had little in common with the Flemish
countryside. In the face of such competition, Cock's *dorpshuysboecken* exerted a marginal and ill-
defined influence during this period. It was only after 1600 and in other places that their quiet inti-
macy and restricted view of rural scenery received a further and infinitely richer elaboration.

Before the republication of the *Small Landscapes* in 1603, artists in the Northern Netherlands were already recording the local countryside in drawings. Hans Bol sketched a polder near Delft in 1583, and perhaps as early as the 1590s Abraham Bloemaert began making his drawings of peasant houses, farm implements, and the like, in the environs of Utrecht. Nevertheless, the *Small Landscapes* may well have inspired Hendrick Goltzius and his circle to look more closely at their own Haarlem dunes, and Claes Jansz Visscher to sketch views of the countryside around Haarlem, Amsterdam, and elsewhere. And it was in 1603 that Jacob Matham produced the first of his engravings after designs by Bloemaert, who in turn drew on his own drawings for their landscape settings. But vastly more important for future developments was the republication of Cock's *boerenhuyskens*, which demonstrated that such humble landscape subjects, inspired by local scenery, could be profitably disseminated to a larger audience in the form of prints.

This lesson, however, was largely ignored by the older generation of printmakers, who were chiefly engravers. This is true even of the Flemish expatriates living in the Dutch Republic, who had a virtual monopoly in the production of landscape prints; in general, they remained faithful to the Flemish tradition stemming from Bruegel and his age. Instead, the "institutionalization," so to speak, of the rustic landscape fell to a younger generation; born between 1580 and 1596, they all practiced etching, a technique less laborious than engraving and more suitable for depicting the atmospheric effects of landscape, and, as it happens, most of these artists were of Dutch origin.[1] Of this group, Visscher played a paramount role. He was uniquely qualified: he had a deep and abiding interest in topography and landscape, and he had overweening ambitions as a publisher, who, to judge from his success, possessed an uncanny sense of what subjects would appeal to his audience.

Beginning with the *Plaisante Plaetsen* and his copies after Cock's *Small Landscapes*, published in the period 1610–12, Visscher seems quickly to have generated an insatiable demand for such landscape series, and within a few years the market was flooded with landscape etchings, both rustic and otherwise, by such artists as Esaias and Jan van de Velde, and Willem Buytewech, as well as a number etched by Boëtius à Bolswert after Bloemaert. Many of these prints were issued by Visscher, who sooner or later acquired numerous plates that had been commissioned by other publishers. After about 1614, Esaias van de Velde began producing painted landscapes very similar in style to his drawings and prints of rustic scenery, followed in the next decade by Jan van Goyen, Pieter de Molijn, and other painters working in Haarlem. But although Visscher dominated this process, he did not bring it about single-handedly. Rather, it was the cooperative effort of artists, print publishers, and above all the many buyers of prints (and later, paintings), collectors and casual purchasers alike, who ensured the enduring popularity of the rural scene in Dutch art.

Before the advent of Visscher and his generation, the art-buying public both in the United Provinces and elsewhere had favored the blatantly foreign and exotic in their landscape paintings and prints— remote Alpine prospects, Tyrolean forest interiors, and idealized arcadian scenes. Just why the Dutch

should now seek landscapes of what presumably they could readily see for themselves in the vicinity of their own towns and cities is a question not easy to answer. While Cock's *boerenhuyskens* demonstrated to artists and audiences alike that their own domestic scenery was worthy of commemorating in art, this was probably only a contributing cause. We may dismiss the claim that rural landscape images functioned primarily as vehicles for moral instruction, as updated versions, so to speak, of the venerable theme of the pilgrimage of life. When Dutch writers contemplated their native landscape in a religious mood, they were far less apt to view its dunes, fields, and woods as metaphors of the sinful world than as the beneficent and praiseworthy manifestations of "God's First Book." Related to this religious impulse is a genuine and often-expressed love by Dutch writers for their country, and it may be no coincidence that the emergence of the native Dutch landscape as a staple subject in prints, beginning with Visscher's *Plaisante Plaetsen* of 1611–12, occurred within a few years after the signing of the Twelve Years' Truce with Spain. But perhaps one of the most cogent factors in the swift rise of rustic scenes in public favor was that they offered a surrogate for the kinds of *"plaisante plaetsen"* that viewers frequently enjoyed at firsthand. Landscapes both foreign and familiar, actual and depicted, had long served as sources of pleasure, a tradition to which Visscher and Van de Velde specifically alluded in the title prints of several of their landscape series. It must be emphasized, however, that this pleasure was by no means a simple one, nor was it always hedonistic, and its manifold ramifications are suggested by what artists included in their landscape images and what they omitted.

The Dutch landscapists presented a highly selective, even distorted view of their native countryside. We would never turn to their depictions to learn what the rural social and economic conditions were actually like in the Dutch Republic during the seventeenth century. In this period, Edward Norgate wrote that landscape is nothing but a "deceptive vision," "a kind of cousning or cheating your owne Eyes, by your owne consent, and assistance and by a plot of your owne contriving."[2] Norgate was describing the effects of aerial perspective, but his words serve well to characterize landscape in a more general sense, and the Dutch rustic landscape in particular. The Dutch scene offered indeed a "deceptive vision": following the precedent set by the *boerenhuyskens*, its creators showed rustic existence purged of its more arduous or commercial aspects. Absent for the most part are traces of the great urban enterprises that transformed the Dutch countryside during the seventeenth century: the system of canals and locks that facilitated travel between towns and the drainage projects that substantially increased the land area of Holland.[3] Equally ignored are the hard facts of farm life. Plowmen and sowers are rarely encountered, harvesters mostly relax in the noonday shade of overshadowing trees; herdsmen pipe to their flocks or repose with their companions in the pastures; the most demanding labor, it seems, is performed by the milkmaids. Even more often, country people simply walk along the road or lounge by a gate or tavern entrance and pass the time of day. It is not the world of the *Georgics* but that of the *Eclogues*, the pastoral world of Theocritus, Virgil, and their

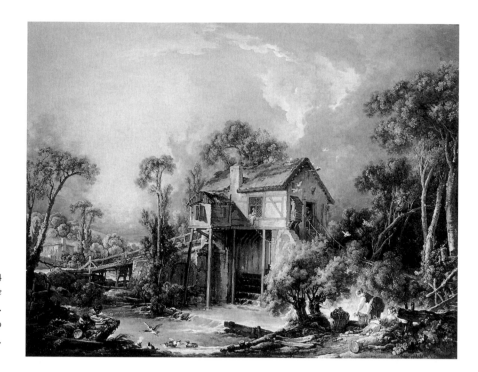

followers recast in the homely Dutch vernacular. And while ruinous cottages and collapsing barns, so roundly condemned by later Dutch critics of a classicizing persuasion, may well have been intended to exert the sort of visual intrigue later codified in the picturesque aesthetic, less extreme manifestations of weathering and neglect only enhanced the sense of rustic simplicity and freedom from care.

It is thus as an extension of the pastoral mode so popular in Dutch poetry and art of the Golden Age that we can thus best appreciate the Dutch rustic landscape. It was, to say it again, the townsmen's view of the country as a *locus amoenus*, where "young and old come forth to play / On a Sunshine Holyday," as Milton put it.[4] It is a place whose freedoms and pleasures afford a welcome but temporary escape from the social constraints and pressures of the city, a place where *negotium* is exchanged for *otium*. At its simplest, the rustic landscape invites its viewers to make a *wandeling* in the fresh air, tipple at the village inn, engage in casual flirtations. It can also commemorate concerns of a different kind, in which rustic simplicity is replaced by an all too urban ostentation: pride of ownership and social status exalted by titles acquired with landed estates, and dominion over virtuous country folk contented with their humble lot. But the rural scene may also present an *otium* of a more intellectual order: the leisure for contemplation and study, the *negotio animi*, or business of the soul, valued by poets and philosophers throughout history.

Whether a playground for urban recreations or an attainable arcadia for more contemplative minds, the celebration of the immediate and homely, as reinvented by the Dutch, soon took hold of the European imagination, alongside landscapes more distant in time, space, or imagination. As early as 1620, as we may remember, Matthaeus Merian published a set of Swabian landscapes that he etched after Antonie Mirou, inspired, perhaps, by the rustic scenes of Visscher (who would publish his own copies of a selection of these plates), Jan van de Velde, and others.[5] But the earliest example may well be six views that Merian etched of rural views in the neighborhood of Nuremberg, published in 1616; impressions of the first state were included by the compiler of the Washington album of prints (discussed in chapter 2), adding them, significantly, just after Visscher's *Plaisante Plaetsen*.[6] This is not the place, however, to follow in detail the later fortunes of the rustic landscape in European and American art, although such a study would be a worthwhile and enlightening enterprise. But it would also be complicated, if only because we would have to describe and account for the many permutations of the rural landscape as it was adapted to accommodate differing conditions, including the advent of the train and later the automobile, which facilitates the townsperson's "day in the country" in ways never dreamed of by the Dutch burghers of the Golden Age, and the camera, which captures our "pleasant places" almost instantaneously, if no less deceptively than did the artists of earlier times.[7] This survey, moreover, ideally would include works as diverse as François Boucher's *Mill at Charenton* of 1758 (Fig. 124), a rococo confection inspired by the landscapes of Abraham Bloemaert,[8] the many paintings in which John Constable celebrated the countryside of his childhood, and Jasper Cropsey's *Old Mill* (Plate 16). Painted in the centennial year 1876 to commemorate a structure thought to date back to the War of Independence, it is also steeped in a nostalgia for a simpler rural existence.[9] We would also have to consider latter-day manifestations of the rustic scene in postcards and calendar illustrations, greeting cards, and reproductions of the paintings of Grandma Moses.[10] For no matter how banal their format, these "pleasant places" have not lost their power in this increasingly urbanized world, offering us glimpses of an alternative way of life attainable perhaps only in our imagination. This is the enduring legacy of Hieronymus Cock and Claes Jansz Visscher.

Notes

Introduction

Epigraph: Quoted in G. Brugmans, *Onder de loupe van het buitenland* (Baarn: N. V. Hollandia-Drukkerij, 1929), p. 102.

1. Quoted in Gibson 1989a, p. 54.
2. Gibson 1989a, pp. 55, 63 respectively.
3. Hoogstraeten 1969, p. 232.
4. Virgil, *Eclogues*, 7:1, 6; see Virgil 1974, 1:49.
5. Houbraken 1943–53, 1:51.
6. Huygens 1977, p. 21, line 148; I deviate from the translation given in Huygens 1996, p. 139.
7. De Vries 1986, pp. 80–82; Adams 1994, pp. 40–41, 48–51. The intensively cultivated landscape of the Northern Netherlands in the seventeenth century, especially Holland, Zeeland, and Friesland, is emphasized by Israel 1995, p. 563; and J. D. H. Harten, "Stedelijke invloeden op het Hollandse landschap in de 16de, 17de en 18de eeuw," *Holland, regionaal-historisch tijdschrift* 10 (1978): 114–134.
8. See, for example, Buijsen 1993; and Stone-Ferrier 1992.

9. See Stone-Ferrier 1985b.

10. Huygens, *Hofwijck*, paraphrased from Schmidt 1988, p. 23.

11. See Adams 1994, p. 37.

12. Hoogstraeten 1969, p. 135; quoted in De Jongh 1995, p. 108.

13. For the stylistic development of the rustic view, see Stechow 1966, pp. 13–128.

14. Stechow 1966, pp. 129–182. Succinct but informative surveys of Dutch landscape painting appear in Chong 1997; and Slive 1995, pp. 177–212.

15. Eugène Fromentin, *The Masters of Past Time* (1876; London: Phaidon, 1948), p. 97.

16. This term, in fact, occurs in the title of an exhibition of Dutch prints held in 1983 (see Lawrence 1983).

17. For the term "scriptural reading," see Bruyn 1987–88.

18. An excellent survey of the various associations that Dutch landscapes probably evoked in seventeenth-century viewers is offered by Haverkamp Begemann and Chong 1986.

19. For the Flemish background, see Gibson 1987; Gibson 1989a; Gibson 1990.

Chapter 1

Epigraph: *Pronstelcatie . . . van Meester Malfus Knollebol* (Antwerp, [1561]), pp. 86–87, lines 54–65; quoted in Van Kampen et al., 1980, p. 87. I have accepted the suggestion of the editors (p. 86, note to line 61) that the words *plucke* and *koeketel* may be the names of taverns. The "cow-kettle" (*koeketel*) was a kettle in which food was cooked for cows. For this information and assistance in the translation of this text, I am very grateful to Wim van Anrooij.

1. Riggs 1977; Rotterdam 1988.

2. Gibson 1989a, pp. 35–36, on the significance of Cock's landscape series.

3. Van Bastelaer–Gilchrist 1992, pp. 70–77, nos. 19–32; Bierens de Haan 1948, pp. 216–222, cat. nos. 248–289; Franz 1969b, 1:216–221; Riggs 1977, pp. 252–254, no. R-16, and p. 370, nos. 231–232. The second series of at least 27 plates is exceeded only by Cock's series of architectural views after Hans Vredeman de Vries (29 plates; Hollstein 47, nos. 72–100), *Funeral of Charles V* (34 plates, Riggs, no. 57), and the 45-plate series of portraits of European rulers (Riggs, no. 268).

4. Van Bastelaer–Gilchrist 1992, illustrate 17 landscapes, but other authorities have listed as many as 36; see Riggs 1977, p. 370, nos. 231–232. Some of these, however, may have been the new prints that Cock apparently added to the combined first and second series in their second state (see below).

5. The inscription in Latin and Dutch reads in part: *Multifariarum casularum ruriumq[ue] lineamenta curiose ad vivum expressa. Vele ende seer fraeye gheleghentheden van diverssche Dorpshuysinghen, Hoeven, Velden, Straten, ende dyer ghelijcken, met alderhande Beestkens verciert. Al te samen gheconterfeyt naer dleven, ende meest rontom Antwerpen ghelegehen sijnde. Naer dleven* [i.e., *naer het leven*] ("[done] after life," the equilvalent of *ad vivum* on the title print of the second series), as Freed-

berg has suggested, did not necessarily mean "done directly after life" but also "in a lifelike manner." See Freedberg 1980, pp. 10–11; also Claudia Swan, "*Ad vivum, naer het leven,* from the life: Defining a Mode of Representation," *Word & Image* 11 (1995): 353–372.

6. The inscription reads: *Praediorum villarum et rusticarum casularum icones elengantissimæ ad vivum in aere deformatae.*

7. The letter *B* followed by a number refers to the illustrated catalogue of the two series of *Small Landscapes* in Van Bastelaer–Gilchrist 1992.

8. Bierens de Haan 1948, p. 219.

9. This identification was made by Van Bastelaer (Van Bastelaer–Gilchrist 1992, p. 68), who cites a watercolor, location unknown, as a prototype for this print.

10. What is possibly a second inn without a signboard may appear in Fig. 13, where a group of people is seated at a table in front of the house to the right of the tower on the bank.

11. Spickernagel 1972, pp. 103–104.

12. For the various drawings that have been connected with the *Small Landscapes,* see Hans Mielke in Berlin 1975, pp. 139–140; Haverkamp Begemann 1979, pp. 25–27 (repeated in Van Bastelaer–Gilchrist 1992, pp. 68–69); Liess 1979–82. Haverkamp Begemann 1979, also lists 8 other drawings from the same group that were not used for the prints.

13. Not listed in Haverkamp Begemann 1979; listed as no. 4 in Berlin 1975, by Mielke, who states that it appears, to judge from a photograph, to be a copy. However, a close examination of the original drawing suggests that it is not a copy. The inscription *P. Breughel 1625,* at lower left, the date largely effaced, appears to be a later addition, possibly a mistaken reference to Pieter Brueghel the Younger.

14. Berlin 1975, p. 140, cat. no. 184.

15. For this relationship between preliminary drawing and print in the case of Pieter Bruegel's *Large Landscapes,* see Gibson 1989a, pp. 65–66.

16. See Mielke in Berlin 1975, pp. 139–140, who notes that the same hand added the figures in prints after Hans Vredeman de Vries made about the same time by the Duetecum brothers.

17. Peter Parshall, "Imago contrafacta," *Art History* 16 (1993): 570–572.

18. For the various attributions proposed for the *Small Landscapes,* see Mielke in Berlin 1975, pp. 139–140. For a more recent attribution of the drawings to several artists, including Bruegel himself, see Liess 1979–82.

19. Haverkamp Begemann 1979, pp. 17–28. For Van Mander's account, see Van Mander–Miedema 1994–, 1:286.

20. Haverkamp Begemann 1979, pp. 21–24, who links the wooded landscapes with Gillis van Coninxloo, like Van Liere also active at Frankenthal; see also Orenstein 1994a, nos. 13, 15, 52, 53 (*View of a Town on a River*), 63 (*I. Van lier inv.* on the second state).

21. Gibson 1989a, pp. 64–66; Vergara 1989, pp. 80–88.

22. Riggs 1977, pp. 335–336, no. 103 (Gassel), and 273–279, nos. 38–50 (Matthys Cock); Gibson, 1989a, pp. 20, 35–36.

23. For various rustic scenes, see, for example, Wilhelm Hansen, *Kalenderminiaturen der Stundenbücher. Mittelalterliches Leben im Jahreslauf* (Munich: Callwey, 1984); Moxey 1989, pp. 35–66, with further references.

24. Ill. respectively in Panofsky 1955, fig. 94; and Filedt Kok 1996a, p. 97, cat. no. 78.

25. See Gibson 1989a, for Patinir et al.; and for Coecke's picture (Vienna, Kunsthistorisches Museum), see Georges Marlier, *La Renaissance flamande. Pierre Coeck d'Alost* (Brussels: Robert Finck, 1966), p. 271, fig. 213.

26. Berlin, Staatliche Museen, Preussischer Kulturbesitz, Kupferstichkabinett, no. 79 C 2. See Berlin 1975, pp. 134–135, cat. no. 181, with further literature. For a different account of the origins of the *Small Landscapes,* see Spickernagel 1972, and Spickernagel 1979, who locates the origin of this landscape type in the *Scena satiryra,* Sebastiano Serlio's third type of stage setting. A critique of this theory is offered by Hans-Joachim Raupp, *Bauernsatiren. Entstehung und Entwicklung des bäuerlichen Genres in der deutschen und niederländischen Kunst, ca. 1470–1570* (Niederzier: Lukassen Verlag, 1986), pp. 310–316.

27. I am grateful to Holm Bevers, curator of the Berlin Kupferstichkabinett, who displayed the *Antwerp Sketchbook* to participants of a conference on Herri Bles held at Princeton in October 1995.

28. Brussels, Musées Royaux des Beaux-Arts de Belgique, inv. no. 4630; see Berlin 1975, pp. 135–137, cat. no. 181; Burton Dunbar, "Some Observations on the *Errera Sketchbook* in Brussels," *Bulletin, Musées Royaux des Beaux-Arts de Belgique, Bruxelles* 21 (1972): 53–82. Stylistically related to the *Errera Sketchbook* is a drawing, showing a hamlet, in Budapest; see Gerzi 1971, 1: cat. no. 70; 2: ill. p. 65. Gerzi dates it to 1545–50.

29. Formerly on the art market in Paris; see Gibson 1989a, p. 32 n. 139; listed in Friedländer 1967–76, 13:107, under Supplements to Herri Bles, as on the Paris art market, with Kleinberger in 1936.

30. Haverkamp Begemann 1979, p. 23; for both versions, see Gibson 1989a, p. 32.

31. Burton L. Dunbar, "The Landscape Art of Cornelis Massys," 2 vols., Ph.D. diss., University of Iowa, 1972, 1:41–48; 2:228–229, cat. no. P2.

32. On the development of peasant subjects in Netherlandish art from 1550 on, see Gibson 1991, pp. 32–33, with further references.

33. Starn 1994, pp. 82–87; Linda Koch, "Two Lorenzetti Landscapes: Documents of Siena's Territorial Expansion," *Rutgers Art Review* 7 (1986): 21–42; Frugoni 1991, pp. 164–179.

34. *The Nuremberg Chronicle: A Facsimile of Hartmann Schedel's "Buch der Chroniken," Printed by Anton Koberger in 1493* (New York: Landmark Press, 1979): see, for example, the illustrations for Ulm (fols. CXCv–CXCIr); Passau (fols. CXCIXv–CCr); Prague (fols. CCXIXv–CCXXXr). For Ertzlaub's watercolor, see Wood 1993, p. 129, fig. 92.

35. Classen 1991. For some medieval examples, see Frugoni 1991, pp. 57 (Tours), 69 (Metz), 72 (Milan).

36. Included in his *Historie van Belgis* (Ghent, 1574); republished in Marcus van Vaernewyck, *Die edel stede van Ghendt* (Antwerp: De Sikkel, n.d.), unpaginated, see esp. verses XV–XXV.

37. Mielke 1996, cat. no. 43, fig. 43; for the print by Frans Huys after the drawing, see Van Bastelaer–Gilchrist 1992, cat. no. 205.

38. Delen 1930, cat. no. 11 and pl. 5. For other sixteenth-century views of Antwerp, see Delen 1930.

39. The inscription reads: *Hier machmen Antwerpen Plaisant Aenschouwen gelegen aend Schelde met die Vlaemsche Landouwe.* Substantially the same inscription occurs on Melchesidek van Hoorn's circular view of Antwerp, published by Cock in 1562; see Delen 1930, p. 36, pl. 14.

40. Quoted in Noë 1954, p. 1, with the note that the *Herfstgedicht* was published in the 1626 edition of Van Mander's *Gulden Harpe*, pp. 636ff.

41. For some other views of Antwerp, see Delen 1930, cat. no. 64, pl. 21, and cat. no. 121, pl. 32, respectively.

42. Hollstein 1:166–176; Amsterdam-Toronto 1977, cat. nos. 28, 30, 31; and *Enkhuizen* 1994.

43. Monballieu 1974; Monballieu 1987; Gibson 1991, pp. 26–32.

44. Gibson 1989a, p. 74 n. 129, with further references.

45. Gibson, 1991, p. 26. For country houses in the Netherlands in general, see the informative study by H. A. Enno van Gelder, *Nederlandse dorpen in de 16e eeuw,* Verhandelingen der Koninklijke Nederlandse Akademie van Wetenschappen, afd. Letterkunde, n.s., 59, no. 2 (1953), pp. 39–67. Further investigation of this subject would help us to understand the popularity of many subjects in Netherlandish art of this period.

46. See note for epigraph. For this and other mock predictions, see also Van Kampen et al. 1980; Gibson 1991, p. 29; Monballieu 1974.

47. Monballieu 1974, 1987.

48. See K. G. Boon, *Netherlandish Drawings of the Fifteenth and Sixteenth Centuries,* 2 vols., Catalogus van de Nederlandse tekeningen in het Rijksmuseum te Amsterdam, 2 (The Hague: Government Printing Office, 1978), 1:190, cat. no. 511, which erroneously reverses the inscriptions. The two inscriptions read, in Dutch: *Dit Staet beij Hoboken 1563/19 September* (recto) and *Dit staet buten Hantwerpen 1563 den 21 Septembar op Matteus dach* (verso). Boon suggests that the monogram *IvLER* (joined) appearing on both sides of the drawing might be that of Joos van Liere.

49. Monballieu 1974; Monballieu 1987; Gibson 1991, p. 29.

50. Van Kampen et al. 1980, p. 195, lines 75–76.

51. Bredero 1982, p. 100, lines 1600–1602; p. 118, lines 2127ff., respectively. Bostoen 1994, p. 28, characterizes Jerolimo as an Antwerp swindler from the *lage adel,* or low nobility. He would have come from a low and dubious nobility, indeed, if he came from Hoboken.

52. Monballieu 1974, pp. 142–143; Van Mander–Miedema 1994–, fol. 261v (p. 305). I am very grateful to Professor Pierre Colman, of the Université de Liège, for the photograph illustrated here.

53. Entry by Alphonse Wauters in *Bibliographie Nationale* (Brussels: Bruylant-Christophe & Cie, 1884–85), 7:314–324.

54. Van Bastelaer claims that the two series together comprised 51 plates, although he catalogued only 46, the number found by Bierens de Haan in the most complete set known to him, in Berlin (Riggs 1977, p. 370). According to Gilchrist (Van Bastelaer–Gilchrist 1992, p. 77), the second state of the second series contains 10 plates not found in the first state, but the existing sets of the combined second state appear to be incomplete, so the problem seems impossible of resolution at present.

55. A. J. J. Delen, *Histoire de la gravure dans les anciens Pays-Bas et dans les provinces Belges des origines jusqu'à la fin du XVIIIe siècle*, 2 vols. in 3 parts (Brussels and Paris: G. Van Oest et al., 1924–35), vol. 2, pt. 2, pp. 152, 153, 154, 157. Plantin exported various prints from the stock of Cock's widow, Volcxken Diericx, and her second husband, Lambert Bottin, but apparently not those issued by other Netherlandish publishers of the period.

56. This tradition is manifested even more strikingly in two imposing panoramas painted by Hans Bol, one dated 1575 (Brussels, Musées Royaux des Beaux-Arts; copy in better condition in Copenhagen), the other of 1578 (Los Angeles County Museum of Art), in which the city of Antwerp is almost wholly submerged in the surrounding countryside. Ill. in R. H. Wilenski, *Flemish Painters*, 2 vols. (London: Faber and Faber, 1960), 2: pl. 43 (Brussels version); and Briels, 1987, p. 173, fig. 216 (Los Angeles version).

57. For some examples, see Georg Braun and Frans Hogenberg, *Civitates orbis terrarum. The Towns of the World, 1572–1618*, with an introduction by R. A. Skelton, 6 pts. in 3 vols. (Cleveland and New York: World Publishing Co., 1966), 1: nos. 2 (Seville), 3 (Valladolid), 11 (Liège), 19 (Utrecht), 21 (Groningen); 2: nos. 21 (Maastricht), 30 (Campen).

58. For examples by Bol and Mostaert, see Franz 1969b, 2: figs. 290, 293, 295, and 328–331.

59. See Ertz 1986, pp. 192–256; Ertz 1979, pp. 214–228.

60. F. Grossmann, *Bruegel. The Paintings: Complete Edition* (London: Phaidon Press, n.d.), pls. 141, 145.

61. See Gibson 1989a, pp. 74–75, for these and similar landscapes by Bruegel.

62. Gerzi 1971, 1:43–44, cat. nos. 80, 81; 2: ills. p. 77. Gerzi notes the similarities of these sheets to the *Small Landscapes*.

63. The Hague, Bredius Museum; see Stephen J. Kostyshyn, "'Door tsoecken men vindt': A Reintroduction to the Life and Works of Peeter Baltens alias Custodius of Antwerp (1527–1584)," 3 vols., Ph.D. diss., Case Western Reserve University, 1994, 2:597–600, cat. no. 30; color ill. in Albert Blankert, *Museum Bredius. Catalogus van de schilderijen en tekeningen*, 3d ed. (Zwolle: Waanders; The Hague: Museum Bredius, [1991]), p. 80, cat. no. 8.

64. Hollstein 8:142, nos. 37–48; Hollstein 14:91, nos. 4–15, first state inscribed: *G. Mostaert inv. Jul. Goltzius sculp. H. van Luyck excud;* a full set of impressions in Amsterdam, Rijksprentenkabinet. See also

Franz 1969b, 1:236. The second state carries the address of Claes Jansz Visscher (Hollstein 8:142), discussed in chapter 2.

65. Van Mander–Miedema 1994–, 1: fol. 256v (p. 285). For Grimmer, with further literature, see De Bertier de Sauvigny 1991; Allart 1991–92, pp. 113–148.

66. London, Christie's, 14 December 1984, lot 116, ill.

67. Franz 1969a.

68. Franz 1969b, 2: figs. 347–358.

69. Antwerp and its surrounding polders are presented in a dramatic bird's-eye view in a painting by Abel Grimmer (Antwerp, Museum voor Schone Kunsten); see De Bertier de Sauvigny 1991, p. 36, pl. 10.

70. Now in the Harvard Art Museums, Cambridge, Mass.; see Gibson 1989a, p. 80 and fig. 6.6.

71. Hollstein 3: nos. 149–172. For the later history of this series, see chapter 2.

72. The drawings are preserved in an album, presumably compiled in the sixteenth century, now in the Harvard Art Museums.

73. Franz 1988, esp. pp. 102–104; Amsterdam, Christie's, *Dutch, Flemish, and German Drawings*, 30 November 1987, lot 6, pp. 12–18; catalogue notes based on the research of An Zwollo.

74. Sophie Schneebalg-Perelman, *Les Chasses de Maximilien. Les Enigmas d'un chef d'œuvre de la tapisserie* (Brussels: Editions de Chabasso, 1982)

75. The environs of Brussels and their history are discussed in detail in Alphonse Wauters, *Histoire des environs de Bruxelles. Descriptions des localités qui formaient autrefois l'ammanie de cette ville*, 3 vols. (Brussels: C. Vanderauwera, 1855). I am indebted to A. Monballieu for this reference.

76. Duverger 1984, p. 35: *Negen coperen plaeten van Boerenhuyskens; Dertien coperen plaeten van Boerenhuyskens . . .*

77. Theodoor Galle's edition of the *Small Landscapes* of 1601 has long been known, and old references to a 1601 edition by Philips were assumed to be erroneous. However, a complete set of the 1601 edition with a title print bearing Philips's address was recently with the Dutch art dealer Theo Laurentius of Voorschoten, who generously shared his discovery with Manfred Sellink. I am immensely obliged for this information to Dr. Sellink, who will discuss this print in his forthcoming study on Philips Galle.

78. In a personal communication to the author.

79. This edition is described in Bierens de Haan 1948, pp. 216–217. The Latin inscription reads: *Regiones et villae rusticae ducatus potissimum a Cornelio Curtio in Pictorum gratiam artifiose depictae: A Philippo Gallaeo excusae in lucem editae Antwerpiae M. D. CI.* In the other edition of 1601, *A Theodoro Galleo* has been substituted for Philips's name.

80. For several examples and a good discussion, see Manfred Sellinck, *Cornelis Cort, "contich plaet-snijder van hoorne in Hollandt" (Accomplished Plate-Cutter from Hoorn in Holland)* (Rotterdam: Museum Boijmans Van Beuningen, 1994), pp. 176–182, cat. nos. 61, 62. Two drawings probably made when

Cort was still in the Netherlands, and later published as prints by Joris Hoefnagel, show panoramic landscapes in the style of Matthys Cock; see Nina Serebrennikov, "Imitating Nature / Imitating Bruegel," in *Pieter Bruegel*, ed. Jan de Jong, Mark Meadow, Herman Roodenburg, and Frits Scholten, *Nederlands Kunsthistorisch Jaarboek* 47 (1996): 222–246.

81. Ertz 1979, pp. 217–218 (drawing in Cleveland); Ertz 1986, pp. 392–396 (drawing in Russia), who notes the influence of the *Small Landscapes* on a drawing by Brueghel (Russia, private coll.). Rubens also made a number of drawings of rural localities, very much in the spirit of the *Small Landscapes;* see *Corpus Rubenianum, Part XVIII. Landscapes and Hunting Scenes, I. Landscapes*, by Wolfgang Adler (London: Harvey Miller; Oxford and New York: Oxford University Press, 1982), cat. nos. 3, 5, 8, 9.

Chapter 2

Epigraph: Justus Lipsius, *Two Bookes of Constancie*, 1st ed. (London: Richard Johns, 1594), trans. Sir John Stradling, ed. with an introduction by Rudolf Kirk, notes by Clayton Morris Hall (New Brunswick, N.J.: Rutgers University Press, 1939), p. 76, quoted in Leeflang, 1995, p. 276.

1. Van Mander–Miedema 1994–, 1: fol. 212r (p. 106).

2. Gibson 1989a, pp. 41–43. For Jan van Scorel, see also Molly Faries and Martha Wolff, "Landscape in the Early Paintings of Jan van Scorel," *Burlington Magazine* 138 (1996): 724–733.

3. Cf. Montias 1987, p. 458. Major exceptions were such portrait specialists as the Frisian artist Adriaen van Cronenburgh; see G. J. Hoogewerff, *Noord-Nederlandse schilderkunst*, 5 vols. (The Hague: Martinus Nijhoff, 1936–47), 4:400–413.

4. For the Dutch art market and collecting about 1600, see Bok 1994–95; Bok 1994, pp. 53–96. The circulation of Flemish art in the Northern Netherlands requires investigation; suggestive, however, is *Landscape with the History of Tobias* (Haarlem, Frans Halsmuseum, inv. no. I-279), attributed to Patinir but probably by an Antwerp follower, that was in the possession of a Haarlem family by the 1570s (Van Bueren 1993, pp. 281–284). The earliest record known to me of the import of Flemish art for sale in Holland occurs in 1608, when the Amsterdam painters' guild complained about certain dealers who acquired paintings from Antwerp and sold them illegally (Van Miegroet and De Marchi 1996, p. 36; I am grateful to Nadine Orenstein for this reference).

5. Briels 1985.

6. Briels 1987, p. 13. For Flemish immigrants in Haarlem, see Rau 1996; Biesboer 1996.

7. Briels 1985, pp. 107–116; Briels 1987.

8. Hoogstraeten 1969, p. 237.

9. Reznicek 1961, 1:130–133; Stechow 1996, pp. 17–18; Freedberg 1980, pp. 25–28. Even before Goltzius, Hans Bol, soon after settling in Holland in 1584, had sketched a polder near Delft, showing a canal flanked by farms; a year or so later he used this view in his painting *Abraham and the Three Angels* of 1586 (Dresden, Gemäldegalerie). See Van Suchtelen 1993, pp. 223–225, and figs. 6, 7.

10. Reznicek 1961, 1: cat. nos. 400, 404; 2: figs. 380, 381.

11. Van Mander–Miedema 1994–, 1: fol. 284r (p. 394).

12. Signed and dated *I. Matham fe./1603;* Berlin, Staatliche Museen, Preussischer Kulturbesitz, Kupferstichkabinett, inv. no. 13326; see Wederkehr 1991–92, p. 241, and p. 240, fig. 151; Leeflang 1997, p. 62, fig. 5.

13. Berlin, Staatliche Museen, Preussischer Kulturbesitz, Kupferstichkabinett, inv. no. 5204; see Judson 1972, fig. 30; Amsterdam 1993–94, pp. 642–643, cat. no. 315. The male figure seated rather pensively in the foreground of this drawing has inspired a recent study: Gerlinde Lütke Notarp, "Jacques de Gheyn II's *Man Resting in a Field:* An Essay on the Iconography of Melancholy," *Simiolus* 24 (1996): 311–319.

14. Stechow 1966, pp. 25–26, argues that in their focus on buildings, these drawings do not qualify as true landscapes. Bloemaert's role in the early development of Dutch landscape painting is more positively evaluated by Rolph Grosse, *Die holländische Landschaftskunst, 1600–1650* (Berlin and Leipzig: Deutsches Verlags-Anstalt, 1925), pp. 12–16. There is no detailed catalogue of Bloemaert's drawings, but one is under way by Jaap Bolten (Roethlisberger and Bok 1993, 1:13).

15. Gibson 1990, pp. 25–26.

16. Van Mander–Miedema 1994–, 1: fol. 298r (p. 450).

17. By Jaap Bolten in a letter of 30 January 1997 to Sabine Kretzschmar, then assistant curator of prints, The Cleveland Museum of Art. The Cleveland drawing may have been one that Bloemaert kept for himself, or copied, because the same ruinous shed, with only a few changes, appears in Bloemaert's painting *Landscape with Tobias and the Angel,* cut into two halves sometime before 1797 (British private collection and St. Petersburg, Hermitage), also a studio replica. See Roethlisberger and Bok 1993, 1:141–143, cat. no. 98; 2: figs. 171–173, where it is dated c. 1605–10.

18. Published in *Den Nederduytschen Helicon* (Haarlem, 1610), p. 214; see Ter Winkel 1899, p. 256. The *Gouden Jaar* was the Jubilee Year proclaimed by Pope Clement VIII in 1600. Ketel dedicated a similar *sieck-troostigh klinckdicht* in the same collection to Goltzius (ibid., p. 215). See also Roethlisberger and Bok 1993, p. 19, who note that Cornelis Cornelisz van Haarlem owned a painting by Bloemaert.

19. Roethlisberger and Bok 1993, 1: cat. nos. 69 and 84 respectively; 2: figs. 118, 144. In 1606 Matham sold four tickets for a Haarlem lottery to Bloemaert, further evidence of the connection between Haarlem and the Utrecht artist. Bloemaert also seems to have known Hondius, in whose home at Leiden Arnout van Buchell (Arnold Buchelius) saw some works by him in 1605. See Roethlisberger and Bok 1993, p. 623: "Documents."

20. Roethlisberger and Bok 1993, 1: cat. no. 85; 2: fig. 145. Sabine Kretzschmar has discovered other Bloemaert motifs used by the Haarlem printmakers, which she plans to publish after further research.

21. Roethlisberger and Bok 1993, 1:114–115, cat. no. 69, and pp. 131–132, cat. no. 84; 2: figs. 118, 144 respectively (Matham); 1:132, cat. no. 85; 2: fig. 145, and 1:135–136, cat. no. 88; 2: fig. 153 respectively (Saenredam and Frisius).

22. For a good account of print publishing in the Netherlands in the sixteenth and early seventeenth centuries, see Orenstein 1996, pp. 14–21; also see Jan van der Stock, *Printing Images in Antwerp: The Introduction of Printmaking in a City, Fifteenth Century to 1585,* trans. Beverly Jackson, Studies in Prints and Printmaking, 2 (Rotterdam: Sound & Vision Interactive, 1998).

23. Even some of the copperplates of Lucas van Leyden, presumably after his death, ended up in Antwerp, where some were reprinted in the third quarter of the sixteenth century by Maarten Peeters; see Filedt Kok 1996a, pp. 10, 12, 14; Bart Cornelis and Jan Piet Filedt Kok, "The Taste for Lucas van Leyden Prints," *Simiolus* 26 (1998): 18–86, esp. 21–22. Similarly, a number of woodcuts after Cornelis Anthonisz of Amsterdam were published at Antwerp by Hans Liefrinck and Sylvester van Parys; see David Landau and Peter Parshall, *The Renaissance Print, 1470–1550* (New Haven and London: Yale University Press, 1994), p. 221.

24. The Amsterdam engraver Harmen Jansz Muller also made prints after Heemskerck and others for the Antwerp publishers; see Filedt Kok 1994–95, pp. 225–226, who notes that while Muller also issued prints on his own, prints with his address appear regularly only after 1590; see also Orenstein 1996, p. 18.

25. Veldman 1991. I have not had the opportunity to consult Manfred Sellink, "Philips Galle (1537–1612): Engraver and Print Publisher in Haarlem and Antwerp," Ph.D. diss., Vrije Universiteit, Amsterdam, 1997. An exception to this trend was the printmaker-publisher Cornelis Bos, who settled in Antwerp in 1537 but fled in 1541 to escape persecution for his Protestant beliefs, ending up in Groningen, where he worked until his death in 1555. See Coelen 1995.

26. On the early history of print publishing in Holland, see Orenstein et al. 1993–94, pp. 175–195; Orenstein 1998. For Goltzius, see Nichols 1991–92; Filedt Kok 1991–92; Sellink 1991–92. It was in 1582 that Goltzius engraved a portrait of Philips Galle; see Filedt Kok 1996b, pp. 61–62.

27. For Goltzius's pupils and their relations with him, see Filedt Kok 1991–92, pp. 182–196; and Wederkehr 1991–92.

28. For Visscher's life and career, see Simon 1958; Van Eeghen 1990; Orenstein et al. 1993–94, pp. 189–194.

29. Perhaps Visscher obtained his commission through Hendrick Hondius, who maintained his contacts with Antwerp long after his move to the Northern Netherlands; see Orenstein 1996, pp. 24, 26.

30. Arnout van Buchell, sometime after 1619, describes seeing the *Twelve Dances* of Heinrich Aldegrever for sale in Visscher's shop, at two *schellingen* each, a set of the "gods" by Jacob Binck at six *stuyvers*, and two prints by Marcantonio Raimondi after Raphael, the *Massacre of the Innocents* and the *Judgment of Paris,* at three *stuyvers* apiece; see Arnoldus Buchelius, *"Res pictoriae." Aanteekeningen over kunstenaars en kunstwerken* . . . , ed. G. J. Hoogewerff and J. Q. van Regteren Altena, Quellenstudien zu holländischen Kunstgeschichte 15 (The Hague: Martinus Nijhoff, 1928), pp. 46–47.

31. Orenstein 1996, p. 17, notes that neither Cock nor Philips Galle reissued the plates of other publishers.

32. For a list of Visscher's reissues and copies after Bruegel, see Van Bastelaer–Gilchrist 1992, in the index under "Visscher." They include the third states of *Christ and the Adulteress*, *Wedding of Mopsus and Nisa*, and *Drunken Peasant Pushed into a Pigsty* (engraved by Jan Wiericx), the *Battle of Messina* in 1632 in a sixth state, and the eighth state of the *Sleeping Merchant Robbed by Monkeys*.

33. See Van Selm 1987, for the 1610 auction and its list, pp. 225–233.

34. For De Clerck's sale, see Montias 1982, pp. 276–277; and for that of Hondius, see Orenstein 1996, p. 58.

35. Keyes 1979, p. 10 n. 22.

36. For Visscher's cartographic and topographic activities, including maps of battles and sieges, see Hollstein 38–39: no. 36ff., esp. nos. 196–264.

37. For examples, see Hollstein 38–39: nos. 211, 214, 217, 219, 221, 222, with dates in the first state ranging from 1608 to 1633.

38. Hollstein 1: nos. 8–16, 18, 19. Visscher's address occurs on later states of nos. 13 (Franeker) and 16 (Leeuwarden), the latter with the date 1645, as well as no. 7, a bird's-eye view of Amsterdam.

39. Hollstein 38–39: no. 219; Levesque 1994, fig. 42; the map was engraved by Abraham Goos.

40. De la Fontaine Vervey 1976, esp. pp. 21–28 for the Dutch editions.

41. Le Petit 1615, in his dedication to the States General, fol. (***) 3 verso.

42. It is now believed that Visscher's earliest landscape drawings are three sheets whose draftsmanship shows the influence of the prints that he made about the same time after David Vinckboons (see below) and are dated to the same time or earlier, c. 1605; see Amsterdam 1993–94, pp. 649–650, cat. no. 323.

43. This seems to be the case for Visscher's etching *Country House and Orchard of Jan Deyman* (Fig. 82), for which there exist both a preliminary drawing of the whole composition (Haarlem, Rijksarchief) and a study of the farmhouse at the left (recently acquired by Amsterdam, Gemeentearchief). Peeters and Schmitz (1997, pp. 38–43) convincingly argue that the study of the farmhouse was done after life and then integrated with at least one other study, now lost, in the Haarlem sheet, the latter followed by yet another drawing before the final print.

44. Amsterdam-Cleveland 1992–93, pp. 173–189, cat. nos. 49–52.

45. Hollstein 7: nos. 338, 287–294 respectively.

46. Hollstein 11: nos. 356 (after Goltzius) and 360 (after R. Saverij).

47. Hollstein 4: no. 15ff.

48. Hollstein 11: no. 2ff.

49. For Hondius, see Orenstein 1996.

50. See Orenstein 1994, nos. 4, 17, 26, 51 (Gillis de Saen, which prints, the author suggests, were issued as a set); 18 (G. Mostaert); and 9 (P. Stevens). Hondius also did several landscapes in a simi-

lar style after his own designs (nos. 8, 11, 12ff.). For Hondius's landscapes in his *Months* series after Stevens, see chapter 6 below. In addition, he republished a number of landscape etchings by Jacques Saverij (Orenstein 1996, p. 207, cat. nos. 542–549).

51. Hollstein 7: nos. 40–63, 64–91 respectively (under Frisius).

52. I.e., *groot dubbel folien* and *reael bladt;* see Orenstein et al. 1993–94, p. 172; Orenstein 1996, pp. 131–132. For the De Bruyn print, see Hollstein 4: no. 170.

53. Schrevelius 1648, p. 381.

54. Huygens 1994, p. 75; the print by De Gheyn remains unidentified. Ger Luijten has suggested that the widespread employment by Visscher and other Dutch artists of pure etching, as well as certain stylistic elements, was influenced by the etchings of Jacob and Roelant Saverij; see Amsterdam 1993–94, p. 664, cat. no. 334.

55. For these two series, see Hollstein 38–39: nos. 1–8. A *Christ and the Woman of Samaria* after Vinckboons (H. 9) is undated but was probably done in the same period.

56. Van Eeghen 1990. See Hollstein 38–39: no. 10.

57. Hollstein 38–39: no. 12, inscribed *Theodorus Galle excudit. Jodocus de Mompere inventor. CJVisscher fecit.*

58. The annotations in Hollstein on the later states of these prints are incomplete, but Nadine Orenstein informs me that many of De Bruyn's plates, first published by Londerseel, were later published by his son-in-law François de Beusecom, as well as by Robert de Baudous, before their acquisition by Visscher. See also Orenstein et al. 1993–94, p. 171.

59. Although only one state of this print, with Visscher's address, is listed in Hollstein (no. 84), I have found what seems an earlier state, before this address, in the Amsterdam Rijksprentenkabinet.

60. See Claesz 1609, fol. 3v, col. 1. These three series, in the order they appear in the list, are *Idem* [refers to the previous item, a series of *Months* by Bol, possibly Hollstein nos. 523–534] *vierkante van Mostaert / twee op een blat / 6. folien; 24 Brusselsche Landtschappens van Bol 12. bladen;* and *12. Brabantsche Lantschapkens van twee op een blat / 6 bladen.* The last item bears neither the name of the designer nor the places represented, but it is doubtful that they are stray plates or prints from Cock's *Small Landscapes.* It is tempting to identify them as the *By Antwerpen* series, although if so, it is curious that the catalogue entry mentions none of the inscriptions present in the first state. The attribution in Claesz's catalogue of the Brussels series to Bol is interesting, because his name does not occur on the presumably first state of this series issued by Hans Luyck. Was this Claesz's own label, or did another, hitherto unknown state, this one labeled as by Bol, intervene between the first state and Visscher's reissue? In any case, it appears in Visscher's edition as *H. Bol delineavit ad vivum CIVisscher exc.* If the publisher of the Brussels series, designated by the initials *H. V. L.,* was Hans van Luyck, as often supposed, Claesz could have obtained the plates from Van Luyck in Amsterdam, where the latter seems to have established himself in the 1580s. See chapter 1 for the contents and earlier history of these three series.

61. For *View of Diemen*, see Amsterdam 1994–95, p. 652, cat. no. 326; for the *Country House and Orchard of Jan Deyman*, and the set of views around Amsterdam, see Hollstein 38–39: nos. 195, and 140–143 respectively.

62. For this series, see Bakker 1993; Amsterdam 1993–94, pp. 653–655, cat. no. 327, with bibliography; Levesque 1994, pp. 35–54.

63. See also the cogent observations along the same lines made by Levesque 1994, esp. pp. 35–40.

64. For this site, see chapter 5 below.

65. See Simon 1958, cat. nos. 127–138. Drawings have survived for the following prints: nos. 2 and 6, *Beacon Light at Zandvoort* and *The Way to Leiden* (Amsterdam, Rijksprentenkabinet, inv. no. A4701E, verso and recto respectively); no. 5, *Potje 's Herberg*, dated 1607 (Haarlem, Gemeentearchief); no. 9, *The Leper House at Haarlem*, dated 1607 (Rotterdam, Museum Boijmans Van Beuningen, inv. no. MB 1941 / T.13); and no. 11, *Bleaching Grounds at Haarlem in the Dunes* (Haarlem, Gemeentearchief). Their precise relationship to the final etchings, as we have seen, is unclear; see Peeters and Schmitz 1997, pp. 38–43.

66. Hollstein 38–39: nos. 292–317. Roethlisberger and Bok 1993, 1:200, state that for no. 25 Visscher utilized a print from his copies of a set of landscape etchings after Bloemaert (see below). This is incorrect: the Bloemaert landscape occurs only in the set of impressions preserved in Brussels, added in a second state (number changed from *24* to *25*) to replace II. 316 of the original set; see Hollstein, p. 143, no. 289, and p. 147, no. 316.

67. Identified in Hollstein 38–39: no. 317, as possibly Castle Warmond.

68. The original inscription: *Regiunculæ, et villæ aliquot ducatus Brabantiæ, à P. Breugelio delineatæ, et in pictorum gratiam, à Nicolao Ioannis Piscatore excusæ, & in lucem editæ, Amstelodami, 1612.*

69. For these series with the inscriptions given in full, see Riggs 1977, p. 273, cat. no. II. A. 38–50. In a suite of grotesque ornaments published by Cock in 1557 after Cornelis Floris, the title plate asserts that these prints are for the use of artists (Riggs 1977, p. 327, nos. 65, 66). I am indebted to Boudewijn Bakker for these observations.

70. Claesz 1609, fol. 1v; Van Selm 1987, pp. 21, 219. Comparable sentiments occur elsewhere. In Conrad Gesner's *Historiae animalium*, published between 1551 and 1587, the reader is informed that Gesner's plates are intended for all lovers of the arts: physicians, painters, sculptors, and so forth (cited in Briels 1987, pp. 186–187). Closer to Visscher's time, in 1630, Crispijn de Passe II tells the viewers of his *Miroir des Plus Belles Courtisannes de ce tempes* (Hollstein 16: no. 183) that he wants to provide the latest information on feminine fashions for the benefit of "Painters, carvers and Picture makers" (quoted from the English translation in Kettering 1983, p. 51).

71. Van Bastelaer–Gilchrist 1992, p. 267, no. 198, and p. 192, no. 140 respectively. Visscher's attribution of the *Big Fish* to Bruegel is remarkable, since his name never appeared on previous states of either the original print or the copy; see Van Miegroet and De Marchi 1996, p. 46.

72. Münz 1961, cat. nos. 34–37, 45; figs. 33–36, 44.

73. Mielke 1985–86.

74. Van Bastelaer–Gilchrist 1992, p. 99, no. 94; the original drawing, attributed by Mielke to Jacques Saverij, is in the Berlin Kupferstichkabinett (Münz 1961, cat. no. 38, fig. 37). An entry in Claesz 1609, fol. 2v, *Lantschapken van Brueghel een half bladt* (a little landscape by Bruegel, a half sheet), has been identified as the print in question.

75. Some idea of the extent and diversity of these landscape prints can be gathered from perusing De Groot 1979, figs. 13–87.

76. For these and other print publishers mentioned below, see Waller 1938, most of them listed in "Aanhangsel B. Uitgevers van prenten en kaarten." The earliest known etchings of recognizably Dutch landscape scenery appeared in 1603, De Gheyn's *Farm Scene*, previously mentioned, and the *Sailboats* of Robert de Baudous, published by Hondius; for the latter, see Orenstein 1996, p. 48, fig. 28.

77. A valuable survey of this subject, with emphasis on Visscher, can be found in Orenstein et al. 1993–94, pp. 192–194.

78. Hollstein 38–39: nos. 327–340 (title print and 13 landscapes); also ill. in Levesque 1994, figs. 89–101. The title print is inscribed at the bottom: *Impressae Amstelodami in aedibus Davidis de Meine. 1613.*

79. Hollstein 33–34: nos. 178–195; Amsterdam 1993–94, pp. 660–662, cat. no. 331.

80. Hollstein 33–34: nos. 232–291.

81. Hollstein 33–34: nos. 196–215, 216–231.

82. Hollstein 4: no. 15ff.; Keyes 1984, pp. 318–334, cat. nos. E7–E33. For the copies published by Visscher of the *Haarlem* series, see Keyes 1984, pp. 337–338, cat. nos. A7–A14.

83. Hollstein 4: nos. 35–44.

84. These include plates by Esaias van de Velde first published by Beerendrecht, which Visscher probably acquired after the former's death in 1645; and Bolswert's plates, which would have been available after his death in 1634.

85. Orenstein et al. 1993–94, p. 194; Keyes 1984, cat. nos. E20–E33.

86. Hollstein 7: nos. 40–63, dated 1651, and nos. 64–91, in the second state, dated 1652.

87. Hollstein 3: nos. 338–357; and Roethlisberger and Bok 1993, 1:195–200, nos. 230–249; 2: figs. 349–368.

88. Inscribed *Verscheijden aerdige Landhuijsen nae t'leven Gekonterfeijt, duer* ABLOEMAERT *t'Amsterdam by CIVisscher.* See Hollstein 38–39: nos. 266–291; Roethlisberger and Bok 1:199–200.

89. For the undated Bolswert series, see Roethlisberger and Bok 1993, 1:194–195, cat. nos. 226–229, who date them shortly after 1612 and note that Hollstein errs in seeing the copies as a second state of Bolswert's plates issued by Visscher.

90. Visscher published each half of the *Ganymede* as a separate landscape print and retained the biblical or mythological subjects of all three prints.

91. See, for example, Levesque 1994, and the review of this book in Leeflang 1995b, pp. 276, 278.

92. Vondel uses the term *prentenziften* (print sifting); see Amsterdam 1997, p. 19.

93. Koppe 1988; Koppe's discussion of these albums is summarized Ger Luijten, "Two Early Seventeenth-Century Print Albums in Trier," *Print Quarterly* 6 (1989): 313. For earlier print albums, see Parshall 1982; Parshall 1994. Other print albums of the seventeenth century are discussed in Amsterdam 1997, pp. 21–24.

94. For another large collection of Dutch prints assembled in the second half of the seventeenth century, see J. van der Waals, *De prentschat van Michiel Hinloopen* (Amsterdam: Rijksmuscum, 1988).

95. The album is the so-called *livre de paissage* (Washington, D.C., National Gallery of Art, 1071.63.1, nos. 1–232), which I examined in March 1998. This magnificent volume deserves to be better known. The album concludes with four anonymous prints of the Four Seasons, apparently previously unrecorded. For the Merian prints, see chapter 8 below.

96. See Amsterdam 1997, p. 21. The use of prints other than maps as wall decoration has frequently been noted before but needs further study. See, for example, the testimony of Jan Jansz Starter, a Dutch poet who in 1621 recommended that prints of the triumphal procession of William the Silent be displayed in every home in the Dutch Republic (De Bièvre 1988, p. 325).

97. Beck 1993, pp. 167 (12 September), 187 (14 October), 192–194 (25–26 October), 198 (1 November). For the muscovy glass, see pp. 200–201 (7 November). His close friend, the artist Herman Jansz Breckenfelt, framed one of his landscapes; Breckenfelt also drew landscapes, at least some of which he preserved in his *Lantschap-Boeck;* see ibid., p. 37 (23 January). I am immensely indebted to Reindert Falkenburg for calling my attention to Beck's diary.

98. See Roethlisberger and Bok 1993, 1:110–111, no. 63; 2: color pl. VII and fig. 112. For other examples, see ibid., 2: figs. 157, 167, 168, 174–176.

99. For a group of rustic landscape paintings attributed to Jan van de Velde, see J. G. van Gelder, "Jan van de Velde, 1593–1641, teekenaar-schilder. Addenda I," *Oud Holland* 70 (1955): 21–40, esp. 34–39. None of the paintings are dated or signed, but Van Gelder dates them between 1618 and 1622. Since one of them reproduces one of Van de Velde's prints, their precise relationship to the artist remains problematic, as does their place in the early development of Dutch landscape painting.

100. Keyes 1984.

101. Cambridge, Fitzwilliam Museum; Keyes 1984, cat. no. 71, fig. 3.

102. For a survey of Van de Velde's landscape development, see Keyes 1984, pp. 44–76; a number of his landscape drawings are discussed in Keyes 1987.

103. Beck 1972–91; for the drawings, see vols. 1 and 3 (*Ergänzungen*).

104. For the paintings, see Beck 1972–91, vols. 1, 3.

105. Gibson 1989a, p. 27.

106. Chong 1987, pp. 112–113; Montias 1987; Sluijter 1996.

107. Van Bastelaer–Gilchrist 1992, p. 88, and Bierens de Haan 1948, pp. 216–217 list two later states (here labeled nos. 4 and 5) bearing the address of Joan Galle. The prints were divided into four series of twelve each and renumbered; in the fifth (or sixth) and last state, the reference to Theodoor

Galle is omitted. Van Bastelaer–Gilchrist notes that these editions were supplemented by a few other landscape prints, perhaps after Hans Bol or Pieter van der Borcht. The usual numbering of these editions has been complicated by the recent discovery of the second edition of 1601.

108. For states 2 and 3, see Hollstein 38: no. 292; for De Reyger and Bormeester, see Waller 1938, pp. 475, 430 respectively.

109. Hollstein 38: no. 149, for the second state; the title print with the new verses ill. in Levesque 1994, fig. 29. The second state was reprinted in [Ghysbrecht Tysens], *Haarlemmer Duinzang, ter eere van de zelfs vermákelyke Land- en Watergezigten, van Sandtvoort af tot Haarlem. Versierd met twaalf naaukeurige Afbeeldingen* (Amsterdam: by Hendrik Bosch, Boekverkoper, over 't Meisjes Weeshuys, 1728). Brief comparisons of Tysens's text with the 1628 description of Haarlem by Samuel Ampzing (see chapter 5) appear in Levesque 1994, pp. 49–53. For Tysens, a dramatic poet, see A. J. van der AA, *Biographisch woordenboek* (Haarlem: J. J. Van Brederode, 1874), 18:272–274.

110. *Poesy van J. Six van Chandelier* (Amsterdam, 1657), book 5, p. 295, quoted in Simon 1958, p. 19. Cornelis de Bie, *Het gulden Cabinet* (Antwerp: Juliaen van Montfort, 1662; reprinted, with an introduction by G. Lemmens, Soest: Davaco, 1971), p. 461, also reserves special praise for Visscher's landscapes (Simon 1958, pp. 18–19).

Chapter 3

Epigraphs: "Daer is niet ledighs of ydels in de dinghen," Visscher 1614, "Het eerste schock," emblem I; the translation quoted from Schenkveld 1991, p. 85, with one change; and Nashe 1985, p. 148.

1. Huygens 1994, p. 79.

2. *Discourse Four* (1771); see Joshua Reynolds, *Discourses on Art*, introduction by Robert Lavine (New York: Collier Books, 1961), p. 65.

3. Useful surveys of earlier evaluations of Dutch painting appear in Demetz 1963; Białostocki 1988; De Jongh 1992b; Carasso 1992; Grijzenhout 1992; Meijers 1992; Franits 1994.

4. Honoré de Balzac, *Lost Illusions*, trans. and introduced by Herbert J. Hunt (Middlesex: Penguin Books, 1971), p. 210 (part 2, chap. 4); W. Bürger, quoted in Hecht 1986, p. 175, from W. Bürger, *Les Musées de la Hollande* (Paris, 1858), 1:323.

5. K. H. D. Haley, *The Dutch in the Seventeenth Century* (London: Thames and Hudson; n.p.: Harcourt Brace Jovanovich, 1972), p. 134.

6. See De Jongh 1992b, pp. 307–314, who calls this the "incubation period" of the iconographic study of seventeenth-century Dutch art.

7. See Erwin Panofsky, "Jan van Eyck's Arnolfini Portrait," *Burlington Magazine* 64 (March 1934): 117–128; idem, *Early Netherlandish Painting: Its Origins and Character*, 2 vols. (Cambridge, Mass.: Harvard University Press, 1953), esp. 1:131–148, "Reality and Symbol in Early Flemish Painting."

For critical discussions of the "principle" of disguised symbolism, see, among others, Benjamin 1976; Marrow 1986; Bedaux 1990; Hall 1994; Calkins 1995.

8. Ingvar Bergström, *Dutch Still-Life Painting in the Seventeenth Century,* trans. Christina Hedström and Gerald Taylor (1947; New York: Thomas Yoseloff, 1956); for the discussion of Panofsky, see his Epilogue, pp. 291–292. A brief summary of Bergström's interpretations appears in Kristine Koozin, *The Vanitas Still Lifes of Harmen Steenwyck: Metaphoric Realism,* Renaissance Studies, 1 (Lewiston, N.Y.: Edwin Mellen Press, 1990), pp. iii–vii. The influence of Panofsky's "principle" of disguised symbolism on students of seventeenth-century Dutch painting has been observed by De Jongh 1992b; and Franits 1994. Even before Bergström, Herbert Rudolph had studied the *vanitas* theme in Dutch painting; see his "'Vanitas.' Die Bedeutung mittelalterlicher und humanistischer Bildinhalte in der niederländischen Malerei des XVII. Jhdts.," in *Festschrift Wilhelm Pinder zum sechzigsten Geburtstag* (Leipzig: Verlag E. A. Seemann, 1938), pp. 405–433.

9. De Jongh 1967. De Jongh developed these ideas in a number of articles and especially two exhibition catalogues, Amsterdam 1976, and Haarlem 1986. Similar interpretations have been advanced by other scholars, for example, Brusewicz 1982.

10. De Jongh 1971; this translation of *schijn realisme* is taken from Westermann 1996, p. 199.

11. Stechow 1966, p. 11, quoting Max J. Friedländer, *Landscape, Portrait, Still-Life: Their Origins and Development* (1950; Oxford and New York: Philosophical Library, 1963), p. 143. Stechow's lack of interest in the symbolic content of Dutch landscapes was criticized in Snoep-Reitsma and Blankert 1967–68, pp. 100–103.

12. Bruyn 1987–88; these ideas are elaborated in Bruyn 1994.

13. Bruyn 1987–88, p. 84. As Mariët Westermann usefully reminds us, however (1996, p. 199), emblem books are only one of the many sources that De Jongh has used.

14. Ill. in Bruyn 1987–88, p. 99, fig. 23.

15. See Paul Piehler, *The Visionary Landscape: A Study in Medieval Allegory* (Montreal: McGill-Queens University Press, 1971), pp. 72–78; Marianne Stauffer, *Der Wald. Zur Darstellung und Deutung der Natur im Mittelalter,* Ph.D. diss. (Bern: Francke, [1959]), pp. 141ff.

16. For Bartholomaeus Anglicus, see A. Kolve, *Chaucer and the Language of Narrative: The First Five Canterbury Tales* (Stanford, Calif.: Stanford University Press, 1984), pp. 110–111. The *werelds forest* is mentioned in a play of 1559 by Louris Jansz; see *Noordnerlandse rederijkerspelen,* ed. N. van der Laan (Amsterdam and Brussels: Elsevier, 1949), p. 39, line 208.

17. Bruyn 1987–88, p. 91.

18. Chaucer, *Canterbury Tales,* "The Pardoner's Tale" (VI [C], lines 480–482): the tavern is the "devels temple" whose acolytes are "devels officieres" who "kyndle and blowe the fyr of lecherye / That is annexed unto glotonye." For the tavern as a place of sin, see esp. Renger 1970. The inn often occurs in sixteenth-century Flemish *rederijker* drama as the place where the *sinnekens* (i.e., "vices") lead their victims into the final stages of sin.

19. Bruyn 1987–88, p. 97.

20. The *Mundus symbolicus* of Picinelli (Philippus Picinellus) was first published in Italian, *Mondo simbolico*, at Milan, in 1653 (not 1635, as in Bruyn 1987–88, p. 97), the first Latin edition in Cologne, 1681.

21. Catherine of Siena, *The Dialogue*, trans. and intro. Suzanne Noffke, preface by Giuliana Cavallini (New York and Mahwah, N. J.: Paulist Press, 1980), pp. 64–71. The editor (p. 64 n. 1) suggests that Catherine may have drawn the image of the bridge from St. Gregory.

22. Bruyn 1987–88, pp. 86–87.

23. Hollstein 38–39: no. 299, possibly after a print by Salomon Saverij (Hollstein 24: no. 194). A dead tree in a winter landscape also appears in the *Boom der Sonde* (The Tree of Sin), an illustration by Theodoor Galle for J. David's *Christlijcke Waersegghen* (Antwerp, 1603); ill. in Knipping 1974, 1:31, fig. 21.

24. Bruyn 1987–88, p. 88. Such moralizing images, however, are characterized as specifically Protestant by Brusewicz 1982, p. 1.

25. Boëthius à Bolswert, *Duyfkens en Willemynkens pelgrimagie . . .* (Antwerp: H. Verdussen, 1627); new ed. by H. J. A. Ruys (Utrecht: A. Oosthoek, 1910). See Knippenberg 1981; Knipping 1974, 1:73. For earlier examples of the Christian pilgrim and related ideas, see Falkenburg 1988, esp. pp. 85–92, 101–112.

26. Wiegand 1971.

27. Kouznetsov 1973.

28. Raupp 1980.

29. Ziemba 1987.

30. See also Moxey 1986, for a comparable interpretation of a landscape by Alexander Keirincx. The methods of scriptural reading have been applied to landscapes of the sixteenth century. Falkenburg 1988, interprets Patinir's *Rest on the Flight* in Madrid and several versions of his *St. Jerome in the Wilderness* as allegories of the pilgrimage of life. See also Reindert L. Falkenburg, "Marginal Motifs in Early Flemish Landscape Paintings," pp. 153–169, in *Herri met de Bles: Studies and Explorations of the World Landscape Tradition*, ed. Norman E. Muller, Betsy J. Rosasco, and James H. Marrow (Turnhout: Brepols, 1998).

31. See, among others, Slive 1988a, p. 398; Brown 1988, pp. 78–79; Bakker 1993; Leeflang 1995b; and esp. Goedde 1997. For critiques of the "emblematic interpretation" in general, see also Sluijter 1988; Sluijter 1991; Hecht 1992; Briels 1987, pp. 282–285 (on Dutch painting in general) and 339–340 (on landscapes specifically). Thoughtful reviews of the controversies concerning the meaning of Dutch painting are offered by De Jongh 1992a; Franits 1983–85; Franits 1994.

32. Lawrence 1987, esp. p. 192. Other studies of Dutch landscapes influenced by scriptural reading include Schneider 1990, and Walford 1991; the latter's ideas are summarized in Russell 1992.

33. See Bakker 1993; Levesque 1994.

34. The Hague–Cambridge 1981–82, pp. 67–77, cat. nos. 20–21.

35. Quoted from C. R. Leslie, *Memoirs of the Life of Constable*, ed. Jonathan Mayne (London: Phaidon Press, 1951), pp. 318–319.

36. While most critics stress the positive message in these two pictures, Wiegand 1971, pp. 82–84, interprets them as an allegory of human vanity symbolized by the Jewish tombs. For a commentary on this reading, see The Hague–Cambridge 1981–82, p. 74.

37. For Ruisdael's pictures of this site, see Büttner and Unverfehrt 1993, and esp. pp. 72–74 for the use of Bentheim sandstone. Bentheim's crucial position on the Dutch border is vividly evident in a map in Israel 1995, p. 737; its role as a Dutch client was threatened in 1668, when the count of Bentheim was persuaded to convert to Catholicism (Israel 1995, p. 783).

38. A similar point about natural objects and Dutch art in general is made by Linda Freeman Bauer, "Seventeenth-Century Naturalism and the Emblematic Interpretation of Paintings," *Emblematica* 3 (1988): 209–228, esp. 211.

39. In the epigram "Boom" (Tree), dated 1 February 1656. See Huygens 1892–99, 5:302; reprinted in *Voet-maet, rijm en reden. Bloemlezing uit Huygen's gedichten*, ed. F. L. Zwaan (Zwolle: W. E. J. Tjeenk Willink, 1963), p. 115; an English translation of the poem in Schenkveld-van der Dussen 1986, p. 74.

40. In his *Spieghel van den Ouden ende Nieuwen Tijdt* (The Hague: Isaac Burchoorn, 1632; reprinted with an introduction by H. H. Zwager, Amsterdam: Facsimile Uitgaven Nederland N. V., 1968), part 3, p. 136, emblem XL; quoted in Beening 1963, p. 160; English translation in Haak 1984, p. 137.

41. See Van Veen 1985, p. 118; examples are given in his summaries of the poems.

42. H. J. C. von Grimmelshausen, *The Adventurous Simplicissimus: Being the Life Description of the Life of a Strange Vagabond Named Melchior Sternfels von Fuchshaim*, trans. A. T. S. Goodrick (Lincoln and London: University of Nebraska Press, 1962), p. 373 ("Continuatio," chap. 23).

43. Goedde 1989.

44. Ludovico Smids, *Schatkamer der Nederlantse oudheden . . .* (Amsterdam: P. De Coup, 1711); see Leeflang 1993, p. 29.

45. Bruyn 1987–88, p. 98.

46. See Moxey 1986; Falkenburg 1988; Brumble 1979. For a somewhat different view of sixteenth-century Flemish landscape painting, see Gibson 1989a, pp. 13–14; Gibson 1989b.

47. Bunyan 1957, pp. 40–41, 55, 45 respectively for examples.

48. Bruyn 1987–88, p. 100.

49. For Esaias van de Velde's drawings of localities around The Hague, see Keyes 1987.

50. For Van Goyen's drawings, see Beck 1972–91, 3:7–131. For a sketching tour made by Van Goyen in the mid-1640s, see the excellent study by Buijsen 1993.

51. For Rembrandt, see Bakker 1990; Bakker et al. 1998–99; Stone-Ferrier 1992. For Ruisdael's excursion along the Dutch-German border in the east, see The Hague–Cambridge 1981–82, pp. 20–21; Walford 1991, p. 6.

52. Ashton, Davies, and Slive 1982.

53. *Bloemlezing uit de Over-Ysselsche Sangen en Dichten van Jacobus Revius,* ed. W. J. C. Buitendijk; rev. ed. J. van Vloten (Zutphen: W. J. Thieme and Cie, n.d.), pp. 33–34.

54. Bunyan 1957, pp. 9 and 299 respectively.

55. Beening 1963; Van Veen 1985.

56. Spiegel, *Hart-Spieghel;* quoted in Freedberg 1980, p. 12.

57. Sir William Temple, "An Essay upon the Origin and Nature of Government, Written in the Year 1672," in *Works,* 2 vols. (London: J. Round et al., 1740), 1:100; quoted in Adams 1994, p. 44. See also J. W. Muller, "Vaderland en Moedertaal," *Tijdschrift voor Nederlandsch Taal- en Letterkunde* 47 (1928): 43–62, esp. 45.

58. Huygens, quoted in Beening 1963, p. 136; Cats, *Sorghvliet* (1656), quoted in Freedberg 1980, p. 14.

59. Petrus Hondius, "Hof-wetten," in Hondius 1621, p. 530.

60. Beening 1963, esp. pp. 96–130 on Vondel; Van Veen 1985; see also Schenkeveld-van der Dussen 1986.

61. Bruyn 1987–88, p. 85.

62. Bruyn 1987–88, p. 93.

63. Falkenburg 1989, esp. p. 135 and n. 12. The article constitutes a vigorous and wide-ranging attack on the so-called association method of interpreting Dutch landscape images (exemplified by Haverkamp Begemann and Chong 1986), and on the opponents of scriptural reading in general, who are condemned for their "positivistic" views.

64. See esp. Falkenburg 1999.

65. For the status of *liefhebbers* in the Dutch Reformed Church, see Kaplan 1995, pp. 33–34. Beck is described as a dedicated member of the Reformed Church by Veldhuijzen; see Beck 1993, p. 12.

66. Beck 1993, p. 29 (7 January) ff. Beck mentions Psalm 51 on 17 different occasions; see ibid., p. 12.

67. Beck 1993, pp. 138, 140ff. (translation of Virgil); 213 (Ronsard: 29 November). See also pp. 273–279 for the poem on his wife's death, "Daphnis Clachten op de doodt van zijne Orlande." For Beck's admission that he knew little Greek or Latin, see Beck 1993, p. 11.

68. Beck 1993, p. 124 (30 June); for *speculeeren,* see *Woordenboek* 1882–, vol. 14, pt. 2, cols. 2638–2639. *Speculeeren* also may be translated as "think over," "reflect," "contemplate," and it is possible this is what Beck meant.

69. Joannes Servilius, *Dictionarium triglotten* (Antwerp: Hieronymus Verdussen, 1612), sv. *amoenus.*

70. Bruyn 1987–88, p. 93.

71. Hollstein 38–39: nos. 28, 29, 34, 35, 46.

72. Simon 1958, p. 16; Bakker 1993, p. 105.

73. Hollstein 38–39: nos. 427–611.

74. For Merian's two series, and the particular prints copied by Visscher, see Wüthrich 1966–96, 1: cat. nos. 448–489.

75. Hollstein 38–39: nos. 38–49; on the title print, in part: *Verscheyden Playsante Lantschappen met Sinne-beelden Verciert.* Visscher took the title print from Merian's *Swabian Journey* series; see Wüthrich 1966–96, 1: cat. no. 422.

76. Hollstein 38–39: no. 327.

77. Hollstein 33: nos. 178, 196, and 232.

78. The title print for the Roghman series is inscribed *Plaisante Lantschappen ofte vermakelijcke Gesichten na t'Leven* . . . (Hollstein 38–39: no. 318). For the title print of the Van de Velde land-scapes, see Hollstein 33–34: no. 333.

79. De Klijn 1982.

80. Similar claims for the relationship between Calvinism and science, although stated in more general terms, were made by Abraham Kuyper in 1898; see Abraham Kuyper, *Lectures on Calvinism: Six Lectures Delivered at Princeton University under Auspices of the L. P. Stone Foundation* (Grand Rapids, Mich.: Wm. B. Eerdmans Publishing Co., 1931; reprint, 1994), pp. 110–141. De Klijn's reference to Bacon in the context of Calvinism is confusing, if only because Bacon was hardly a Calvinist but a staunch supporter of the Church of England.

81. Quoted with one minor change from Leeflang 1997, p. 113 n. 157. This is from the Dutch Confession of 1562; Leeflang notes that almost the same passage begins the Dordrecht Confession of 1619. See also Walford 1991, p. 20; see also p. 210 n. 25, for similar ideas elsewhere in the Reformed Confession and Catechisms.

82. Huygens 1977, p. 169, line 1601. For "God's First Book," see Leeflang 1993, pp. 24–25. Elsewhere Huygens refers to "God's two books" (i.e., the Bible and nature, line 1524); see Sutton 1987–88, pp. 12–13.

83. De Klijn 1982, p. 55; he does not cite any names but presumably had in mind such artists as Coninxloo and Roelant Saverij.

84. The Remonstrant poet and preacher Dirck Rafaelsz Camphuyzen, who had formerly been a painter, published about 1620 several poems, one a translation of a poem by his colleague I. Geestrianus that condemned art of any sort, not only religious subjects and nudes but even the decoration of household furniture and windows. Surely we may assume that this was very much a minority opinion. See J. A. Emmens, "Apelles en Apollo: Nederlandse gedichten op schilderijen in de 17de eeuw," pp. 24–27, in Emmens, *Opstellen. J. A. Emmens verzameld werk* 3 (Amsterdam: G. A. Van Oorschot, 1981); Leeflang 1993, p. 25.

85. Ernst Robert Curtius, *European Literature and the Latin Middle Ages,* trans. Willard R. Trask, Bollingen Series 36 (New York: Harper Torchbooks, 1963), pp. 319–326, on the "Book of Nature." See also Walford 1991, pp. 20–21; and esp. Leeflang 1993, pp. 24–25; Leeflang 1997, p. 97, who emphasizes that the idea of nature as "God's First Book" was equally current among Catholics and other religious dominations in the Dutch Republic.

86. Cited in Pleij 1990, p. 34.

87. Cited in Wood 1993, pp. 178–179.

88. Quoted in Gibson 1989a, p. 55.

89. Anna Bijns, *Refereinen: naar de nalatenschap van Mr. A. Bogaers*, ed. W. L. van Helten, 2 vols. (Rotterdam: J. H. Dunk, 1875), 1:433–440 (*Refereyn* LXII, LXIII); cited in Beening 1963, pp. 34–35. For Bellarmin and Borromeo, see Jones 1993, pp. 88 and 76–80 respectively.

90. A similar point is made by Leeflang 1988, p. 8.

91. Cited in Walford 1991, p. 22.

92. Quoted in Haak 1984, p. 136.

93. Büttner-Unverfehrt 1993, p. 31; Larsen-Davidson 1979, pp. 49–63.

94. Geyl 1930. For later discussions, see, among others, Schutte 1988; Boxer 1990, pp. 126–148; Visser 1994; Van Thiel 1990–91, esp. pp. 49–62.

95. Schutte 1988; Duke 1990a; Duke 1990b; Visser 1994; Israel 1995, esp. pp. 361–367.

96. Quoted in Duke 1990b, p. 269.

97. Spaans 1989, p. 299; Israel 1995, pp. 655–656.

98. Spaans 1989; Kaplan 1995, pp. 29, 68. For the Libertines, see Kaplan 1995, pp. 33–34 and passim. For the Calvinists and Catholics before 1650 in the Dutch Republic, see Israel 1995, pp. 361–398, 450–477.

99. Kaplan 1995, pp. 274–278.

100. Kaplan 1995.

101. This point is made by Kaplan 1995, pp. 29–30.

102. Van Lieberg 1994; Israel 1995, pp. 474–477, 690–699.

103. Kaplan 1995, p. 300. This pluralism of Dutch religious life is also well conveyed by the essays in the volume *The Emergence of Tolerance in the Dutch Republic*, ed. C. Berkvens-Stevelinck, J. Israel, and G. H. M. Posthumus Meyjes (Leiden, New York, and Cologne: E. J. Brill, 1997).

104. Moryson notes that the churches were seldom full in the Dutch Republic, "for many sectaryes, and more merchaunts proeferring gayne to the duties of Religion, seldom come to church." In Leiden, he often observed "at tymes of divine service, much more people to be in the markett place than in the Church" (Moryson 1903, p. 281). During his trip to Holland in 1641, John Evelyn went to the Amsterdam Exchange on Sunday after church to see the Dog Market, which lasted until two in the afternoon; see Evelyn [1907], 1:24.

105. Van Deursen 1991, p. 240. For similar complaints in several church synod documents of this period, see Visser 1994, p. 396 n. 15.

106. Groeneweg 1995. A rather discursive account of the wearing of black from the court of Philip the Good of Burgundy to the present appears in John Harvey, *Men in Black* (Chicago: University of Chicago Press, 1995). While recognizing the international currency of black, Harvey nonetheless sees its popularity in seventeenth-century Dutch costume as an expression of "Calvinist" anxiety and piety (pp. 88–90, 118–119).

107. Scholars have long voiced a similar caution; see Slive 1956; Slive 1995, pp. 5–6; Berg 1986, esp. p. 78; and Falkenburg 1998. Schama 1987, has especially been criticized for his portrayal of the Dutch Republic as a Calvinist society; see, for example, Israel 1987, p. 1268; Price, Haitsma Mulier, and Van Nierop 1989.

108. Groenveld 1995, pp. 49–54. However, denominational lines were not always followed strictly, for Protestant painters seem to have worked for Catholic patrons, and vice versa; see Volker Manuth, "Denomination and Iconography: The Choice of Subject Matter in the Biblical Painting of the Rembrandt Circle," *Simiolus* 22 (1993–94): 235–252, esp. 238. Incidentally, whether Jan van Goyen was Catholic, as is so often assumed, is uncertain. Although a daughter married the Catholic Jan Steen, there is to my knowledge no documentary evidence concerning Van Goyen's own religion.

109. Orenstein 1998, p. 157, who notes, however, that Matham inherited and reissued the plates of his stepfather Goltzius, which already contained numerous secular subjects.

110. Orenstein 1994, no. 43; Orenstein 1995, esp. pp. 246–250. For other "Catholic" subjects published by Hondius, see Ilja Veldman, review of Orenstein 1996, in *Speculum* 25 (1997): 360, although, as Veldman notes, it is not always clear if Hondius was motivated by purely aesthetic reasons or was trying to attract Catholic buyers.

111. For the copies after Bolswert, see Roethlisberger and Bok 1993, 1:183, copies after nos. 189–214; for the Londerseel series, see Hollstein 11: nos. 30–59. How many prints from the Bolswert series were copied by Visscher is not clear. In the impressions of this series in the Rijksprentenkabinet, Amsterdam, only three prints bear Visscher's address, and they apparently do not belong to the same series as the others. To these examples may be added other prints not in Hollstein, a Passion series and an *Assumption of the Virgin* after Veronese, found by Ger Luijten in the print room in Copenhagen (Statens Museum for Kunst); see Amsterdam 1997, p. 128 n. 1.

112. Koppe 1988, p. 223.

Chapter 4

Epigraph: Ernst Gombrich, "Huizinga and 'Homo Ludens,'" *Times Literary Supplement,* 4 October 1974, p. 1089; I owe this provocative statement to Paul Barolsky, who quotes it in his *Infinite Jest: Wit and Humor in Italian Renaissance Art* (Columbia and London: University of Missouri Press, 1978), p. 2.

1. In a similar manner, the earliest Dutch publishers of vernacular literature instructed their readers as to the content and value of their books and, in at least one case, how to hold the book when reading it; see Pleij 1987, pp. 47–48. My thanks to Diane Scillia for this reference.

2. De Klerk 1982, for the quotation, see p. 49.

3. Amsterdam-Boston-Philadelphia 1987–88, pp. 397–400, cat. no. 66; Harwood 1988, pp. 31–32. The

first known publication of Verhoek's poem occurs in Arnold Houbraken's *Groote Schouburgh*, first published in 1718–21, in his life of Pynacker; see Houbraken 1943–53, 2:77–78.

4. For the four paintings thought to be from this cycle, see Harwood 1988, pp. 92–95, cat. nos. 77–80.

5. Quoted in Harwood 1988, p. 32; Amsterdam-Boston-Philadelphia 1987–88, p. 399.

6. Van Mander–Miedema 1973, 1:202–205, verses 1–3. An English translation in prose of this chapter appears in London 1986, pp. 35–43. The same prescription, including the need to relax the bow, is repeated in Hoogstraeten 1969, p. 231.

7. Thomas Combes, *Theatre of Fine Devices* (London: Richard Field, 1614; reprint, San Marino, Calif.: Huntington Library, 1983), emblem XXV. For this proverb, see note 23 below.

8. Alison Morgan, *Dante and the Medieval Other World* (Cambridge: Cambridge University Press, 1990), p. 120.

9. Charles G. Smith, *Spenser's Proverb Lore* (Cambridge, Mass.: Harvard University Press, 1970), pp. 154–155.

10. Visscher 1949, p. 22 ("Het eerste schock," no. XXII): "Rust ick / soo roest ick."

11. *Van der ketyvigheyt der menschelicker naturen*, preserved only in a printed edition of the next century (Ghent, 1543); quoted in Pleij 1990, p. 36.

12. See Van Duersen 1991, p. 240. Objections to Sunday walks and other pastimes are voiced by Simon Simonides, *Vierbaeck van Godts oordeelen over Nederlant ontstoocken in de Rijp* (Rotterdam, 1655), quoted in Schotel n.d., p. 171.

13. Otto Belcampius, *Hora novissima, dat is laetste uyre* (Amsterdam: Joannes van Ravensteyn, 1661), quoted in Van Stipriaan 1996, p. 22, with further examples; see also ibid., pp. 35–37; and Westermann 1997, p. 178 n. 26.

14. For some examples, see Amsterdam 1997, cat. nos. 8, 39, 55.

15. Joubert 1980, p. 16.

16. In recent years, a number of writers, most notably Olson 1982; Pleij 1990; and Van Stipriaan 1996, have studied the traditional role of recreation in Western culture, and I have gratefully made use of both their material and their conclusions.

17. Cited in Erik de Jong, "For Profit and Ornament: Function and Meaning of Dutch Garden Art in the Period of William and Mary," in *The Dutch Garden in the Seventeenth Century*, ed. J. D. Hunt. Dumbarton Oaks Colloquium on the History of Landscape Architecture XII (Washington, D.C.: Dunbarton Oaks Research Library and Collection, 1990), p. 19 and n. 16.

18. Olson 1982, pp. 39–127.

19. Temple 1972, p. 91.

20. Seneca 1994, pp. 95–99; the quotation is on p. 95.

21. Hoogstraeten 1969, pp. 199–200; the metaphor of unhitching is from Seneca 1994, p. 95.

22. Olson 1982, pp. 91–93. The stories of both saints were included in the thirteenth-century *Legenda Aurea;* see Jacobus de Voragine, *The Golden Legend: Readings on the Saints*, trans. William Granger Ryan, 2 vols. (Princeton, N.J.: Princton University Press, 1993), 1:54 and 94 respectively.

23. The proverb of the bent bow and its classical sources discussed in Stoett 1943, 1:103, no. 299; and Olson 1982, pp. 90–93ff.; see also Henkel and Schöne 1967, cols. 1507–1508. For the motif of the bent bow in Vrancx's picture, see J. Grauls, "Het spreekwoorden schilderij van Sebastiaan Vrancx," *Bulletin Musées Royaux des Beaux-Arts de Belgique* 9 (1960): 10–164, esp. 121, no. 24. A poem by Anna Bijns celebrates the need for recreation, each verse ending with the refrain "The bow cannot always be under tension"; see *Nieuwe Refereinen van Anna Bijns,* ed. W. J. A. Jonckbloet and W. L. van Helten (Groningen: J. B. Wolters, 1880), pp. 1–3.

24. Quoted from the *Patrologia latina*, vol. 207, col. 1171, by Jean Delumeau, *Sin and Fear: The Emergence of a Western Guilt Culture, Thirteenth–Eighteenth Centuries,* trans. Eric Nicholson (New York: St. Martin's Press, 1990), p. 128. For all its eloquence, however, this plea failed to move the faculty of Paris, who condemned the Feast of Fools; see Olson 1982, p. 151.

25. Seneca 1994, pp. 95, 97; De Pizan 1989, p. 69.

26. Ripa 1971, p. 345.

27. Vives 1971, p. 121; for Cats, see Marieke van Doorninck and Erika Kuijpers, *De geschoolde stad: Onderwijs in Amsterdam in de Gouden Eeuw,* Amsterdamse Historische Reeks (Amsterdam: Historisch Seminarium van de Universiteit van Amsterdam, 1993), p. 17.

28. Thomas Murillo y Velarde, *Aprobacion de ingenios, y curacion de hipochondricos . . .* (Zaragoza, 1672); quoted in Teresa Scott Soufas, *Melancholy and the Secular Mind in Spanish Golden Literature* (Columbia and London: University of Missouri Press, 1989), p. 12.

29. Ripa 1971, p. 499, sv. "Malinconia. Swaermoedigheyt."

30. Bright 1940, p. 242.

31. For a good but succinct discussion of melancholia and its treatment, see Dixon 1995, pp. 197–207. See also Stanley W. Jackson, *Melancholia and Depression from Hippocratic Times to Modern Times* (New Haven and London: Yale University Press, 1968); and Schmitz 1972, pp. 116–156. As Dixon 1995 has shown, women who exhibited the same symptoms were usually diagnosed as hysterics; an exception can be found in Bright 1940, pp. 250–251, who refers briefly to female melancholics.

32. For Barkley, see Aurelius Pompen, *The English Versions of the Ship of Fools: A Contribution to the History of the Early French Renaissance in England* (New York: Longmans, Green and Co., 1925), p. 109, section 36. Cf. Eucharius Eyering, *Proverbium copia* (1601), who complains that people learn the stories of Marcolphus and Eulenspiegel more readily than God's commandments; see Malcolm Jones, "Marcolf the Trickster in Late Medieval Art and Literature, or; the Mystery of the Bum in the Oven," *Spoken in Jest,* ed. Gillian Bennett, Folklore Society Mistletoe Series, 21 (Sheffield, Eng.: Sheffield Academic Press; Ithaca, N.Y.: Cornell University Press, 1991), p. 165. For the recreational aspects of literature, see esp. Olson 1982.

33. For the *Decameron* as recreational literature, see Van Stipriaan 1996, pp. 61–65.

34. *The Prologues and Epilogues of William Caxton,* ed. W. J. B. Crotch, Early English Text Society, original series, 176 (Oxford, 1928; reprint, New York: B. Franklin, 1971), p. 93.

35. De Refereinenbundel van Jan van Doesborch, ed. C. Kruyskamp, 2 vols. (Leiden: E. J.Brill, 1940),

p. iii, title on fol. 179a. Uilenspiegel-Geeraedts 1986, p. 93, "Die Prolooghe." For similar claims for other Netherlandish books of the period, including several songbooks, see *Nyeuwe clucht boeck* 1983, pp. 39–40.

36. Walter S. Gibson, "Bosch's Dreams: Responses to Bosch's Imagery in the Sixteenth Century," *Art Bulletin* 74, no. 2 (June 1992): 212 and fig. 13 on p. 213, with further references.

37. William Painter, *The Palace of Pleasure*, ed. Joseph Jacobs, 3 vols. (New York: Dover Books, 1966), 1:13.

38. François Rabelais, *Gargantua and Pantagruel*, trans. J. M. Cohen (London: Penguin Books, 1955), p. 435 (De Rocher, 1979, pp. 73, 130); see also Michael J. Heath, *Rabelais,* Medieval and Renaissance Texts and Studies, 130 (Tempe, Ariz.: Medieval and Renaissance Texts and Studies, 1996), pp. 42, 91, 140. Gerrit Hendricxsz van Breughel, *De tweede 50. lustige historien ofte Nieuwicheden Johannis Boccatii* (Amsterdam, 1605); see Stipriaan 1996, p. 82.

39. Van Stipriaan 1996, pp. 30–32, also asks if such recommendations of their books by publishers were not merely a formula.

40. Pleij 1990, p. 94.

41. Pleij 1990, p. 95; for Van Brouchoven, see also *Nyeuwe clucht boeck* 1983, p. 14. For the presence of such literature in Dutch libraries, see Van Stipriaan 1996, pp. 82–84, who also notes that Marnix possessed two copies of the *Decameron* in Italian (p. 84).

42. Cited by C. A. Jones in Cervantes 1972, p. 9.

43. Van Selm 1987, pp. 181–182.

44. Hondius 1621, pp. 398–399. I have yet to find a study of blue books in seventeenth-century Holland, but for France, see Geneviève Bollème, *La Bibliothèque bleue: Littérature populaire en France du XVIIe au XIXe siècle* (Paris: Julliard, 1971).

45. Seneca 1994, p. 95.

46. Petrarch, *De remediis*, book 1:24; Petrarch-Rawski 1991, 1:73–78.

47. Clive 1961, p. 315.

48. Clive 1961, p. 316.

49. Spiegel, "Het lof van danssen," quoted in Van Stipriaan 1996, p. 27.

50. Olson 1982, p. 59; De Pizan 1989, p. 97. For other medieval examples, see Olson 1982, pp. 119–127; Rodgers 1967, p. 47.

51. Olson 1982, p. 124 (Gaston Phoebus); Pleij 1990, p. 21 (Duke Otto, in *Margarieta van Lymborch*). I consulted two editions of Braithwait's work (London, 1630, 1641) in the Chapin Rare Book Library, Williams College, whose custodian, Robert Volz, I thank for his help in locating them.

52. Hollstein 38–39: nos. 344–359. Other examples include the *Hunts of Maximilian* tapestries discussed in chapter 1 and the *Venationes, Piscationes et Aucupii Typi,* 54 plates published by Philips Galle after Hans Bol (Hollstein 3:52, nos. 110–163).

53. Pleij 1990, p. 68, citing a Netherlandish edition of the *Narrenschiff* published in 1504.

54. Seneca 1994, p. 97; repeated in Hoogstraeten 1678, p. 199.

55. Pleij 1979, p. 52. Even some churchmen admitted that Sundays and saints' days could be used for needed merrymaking and recreation, so long as these pastimes were not vicious or conducive to sin; see Rodgers 1967, pp. 45–49.

56. Cited by Davis 1965, p. 97.

57. Burton 1927, pp. 439–464 (part 2, sect. 2, memb. 4). Similar remedies are listed in Bright 1940, pp. 247–265.

58. For the therapeutic functions of laughter, see Dixon 1995, pp. 171–173; Dekker 1997; Verberckmoes 1998.

59. Van Stipriaan 1996, pp. 22–23; Dekker 1997, pp. 15–17; Verberckmoes 1998, pp. 250–254. Similarly the so-called Letter of Lentulus, supposedly written during Christ's lifetime and popular in the later Middle Ages, asserts that Christ wept at times, but he never laughed; see Giles Constable, *Three Studies in Medieval Religious and Social Thought* (Cambridge: Cambridge University Press, 1995), p. 235.

60. Schmitz 1972, pp. 135–165.

61. See Harry Vredeveld, "'That Familiar Proverb': Folly as the Elixir of Youth in Erasmus' *Moriae Encomium*," *Renaissance Quarterly* 42 (1989): 78–91, esp. 88–89. The passages from Luke and Proverbs are quoted from the Douay-Rheims Bible.

62. Quoted in Aron Gurevich, *Medieval Popular Culture: Problems of Belief and Perception* (Cambridge: Cambridge University Press, 1988), p. 251 n. 6.

63. Leon Battista Alberti, *Dinner Pieces: A Translation of the "Intercenales,"* trans. David Marsh, Medieval and Renaissance Text and Studies, 45 (Binghamton, N.Y.: Medieval and Renaissance Texts and Studies in Conjunction with the Renaissance Society of America, 1987), p. 15, preface addressed to Paolo Toscanelli. Mealtime had long been seen as a recreational occasion for light conversation, jokes, and even ribald stories to dispel melancholy and enhance digestion; see, for example, Michel Jenneret, *A Feast of Words: Banquets and Table Talk in the Renaissance* (Chicago and Cambridge: University of Chicago Press, 1991), esp. 91–97 passim.

64. Joubert 1980, pp. 94–95. See also Vera Cecília Machline, "The Contribution of Laurent Joubert's *Traité du ris* to Sixteenth-Century Physiology of Laughter," in *Reading the Book of Nature: The Other Side of the Scientific Revolution*, ed. Allen G. Debus and Michael T. Walton, Sixteenth-Century Essays and Studies, vol. 41 ([Kirksville, Mo.]: Sixteenth-Century Journal Publishers, 1998), pp. 251–264. In a letter to Constantijn Huygens, Jacob van der Burgh makes a similar point about laughter: "I would not wish a wise man never to laugh and deprive himself of a faculty that is proper to him and not given to the rest of [God's] creatures"; quoted in Stipriaan 1996, p. 36. For Joubert's *Traité du ris* in general (republished Geneva, 1973), see De Rocher 1979; Verberckmoes 1998, pp. 60–63. Some dubious claims have been made in recent years concerning the role and function of laughter in the early modern period. Peasants and other uncouth members of society might engage

in hearty laughter, we are told, but the upper classes were expected to exert more self-control; see esp. Miedema 1977, p. 211, and for a critique of this view, Van Stipriaan 1996, pp. 22–23.

65. Richard Verstegen, *Medicamenten teghen de Melancholie* (Antwerp, 1633); see Verberckmoes 1998, p. 210. For Dutch and Flemish *kluchtboecken*, see Dekker 1997, pp. 32–48; Verberckmoes 1998, passim, esp. pp. 101–143.

66. Aernout van Overbeke, *Anecdota sive historiae jocosae. Een zeventiende-eeuwse verzameling moppen en anekdotes*, ed. Rudolf Dekker, Herman Roodenburg, and Harm Jan van Rees (Amsterdam: P. J. Meertens-Instituut, 1991); for the contents, see also Dekker 1997, pp. 66–158, who notes other private Dutch joke collections of the period (pp. 44–46); for Van Overbeke's father, ibid., p. 57.

67. Beck 1993, pp. 106 (2 February) and 167 (13 September) respectively.

68. Amsterdam 1997, cat. no. 7, ill. p. 73. Crispijn de Passe I adapted this composition for illustrations in two of his publications; in one, he added an inscription condemning the behavior depicted, another example of the various, often contradictory meanings that images could acquire in different contexts; see ibid., p. 74 and fig. 5.

69. Quoted in Van Stipriaan 1996, pp. 25 and 24, fig. 3.

70. Cf. Richard Braithwaite, *The English Gentleman and the English Gentlewoman*, 3d ed., rev. (London: John Dawson, 1641), p. 100, who renders the same passage from Seneca as "Wee will drink not to drowne us, but to drowne care in us: Not to reave sense, but to revive sense."

71. Hoogstraeten 1969, pp. 199–200. Following Seneca, he continues this section with a discussion of the "divine frenzy" that, according to the ancient poets, was induced by wine.

72. Briels 1987, p. 98, from a poem by Petrus Scriverius, published in J. J. Starter, *Friesche Lust-Hof* (Amsterdam, 1621).

73. Cited by De Rocher 1979, pp. 22–29, from the 1579 edition of Joubert's treatise, pp. 17–19.

74. Sullivan 1994, pp. 33–34. In his commentary on the proverb *Ollas ostenare* (*Adages* 2.2.11), Erasmus again condones the speaking of ridiculous and squalid subjects as a means of relaxation, so long as the pleasure is mixed with profit; see *The Collected Works of Erasmus*, *Vol. 33*, *Adages II i 1 to II vi 100*, trans. and annotated R. A. B. Mynors (Toronto: University of Toronto Press, 1991), p. 94.

75. Quoted in Kettering 1983, p. 132 n. 25.

76. Dekker 1997, p. 91. The *Heptameron* of Margaret of Navarre, first published in 1558, contained three stories quite scatalogical in nature, including "An odorous adventure which befell Madame de Roncex" (*Heptameron*, Second Day, Novel II), which were replaced by less salacious *nouvelles* in later sixteenth-century editions.

77. Quoted in Caroline Walker Bynum, *The Resurrection of the Body in Western Christianity, 200–1336* (New York: Columbia University Press, 1995), p. 87.

78. Paul F. Grendler, *Schooling in Renaissance Italy: Literacy and Learning, 1300–1600*, The Johns Hopkins University Studies in Historical and Political Science, 107th series, no. 1 (Baltimore and London: The Johns Hopkins University Press, 1989), pp. 251–252.

79. One of the earliest examples appears in Gerard Leeu's 1479 edition of *Reynaert de vos* (Reynart the fox), where he assures his readers that the book is intended for both their amusement and their benefit, for they can learn how to protect themselves from the tricks described therein; see Pleij 1987, p. 50. A similar claim is made in Uilenspiegel-Geeraedts 1986, p. 92. In several books, *Tghevecht van minnen* and *Dat bedroch der vrouwen*, published by Jan van Doesborch at Antwerp in 1516 and c. 1528–30 respectively, the prologues recommend their texts as a means of teaching the reader the pitfalls of sexual license and the wiles of deceitful women; see P. J. A. Franssen, *Tussen tekst en publiek. Jan van Doesborch, drukker-uitgever en literator te Antwerpen en Utrecht in de eerste helft can de zestiende eeuwe* (Amsterdam and Atlanta, Ga.: Rodopi, 1990), p. 101. In his *Nieuwe wereldt vol gecken* (The Hague, 1641), Isaac Burchoorn tells the reader that he presents his series of disreputable characters as a contrast to honorable virtue (Van Stipriaan 1996, p. 50).

80. Bredero 1982, pp. 37–39. The same claims for amusement and moral instruction are made by Cornelis van der Plasse in his preface to the 1619 edition of Bredero's plays (Bredero n.d., pp. 21–23). For popular Dutch novels of the period with similar introductions, see Van Deursen 1991, pp. 136–137.

81. For De Passe, see chapter 1. For other examples, see De Jongh 1996–97, p. 44; and De Jongh in Amsterdam 1976, pp. 27–28.

82. Dirck Rafaelsz Camphuyzen, *De stichtelyke Rymen* (Hoorn, 1624), cited in De Jongh 1996–97, p. 44. For similar complaints from Dutch writers of the period, see Westermann 1997, pp. 122–123. This problem was recognized early on. A twelfth-century collection of exemplary tales, the *Disciplina clericalis* of Petrus Alphonsus, is presented in the form of a dialogue between father and son; the latter shows so avid an interest in the often ribald details of these stories that his father must remind him of their moral purpose. See *The One Hundred New Tales (Les cent nouvelles nouvelles)*, trans. Judith Bruskin Diner, Garland Library of Medieval Literature, vol. 30, Series B (New York and Boston: Garland Publishing, 1990), p. xviii.

83. A classic study in this vein is Renger 1970.

84. Briels 1987, p. 86 n. 4. For some recent, and welcome, exceptions to this tendency, see Mandel 1996, and Westermann 1997.

85. A similar suggestion with regard to emblem books is made by Karel Porteman, "Het embleem als 'genus iocosum.' Theorie en praktijk bij Cats en Roemer Visscher," *De zeventiende eeuw* 11, no. 2 (1995): 184–197.

86. Some thoughtful strategies for a reconsideration of seventeenth-century Dutch genre scenes are found in Westermann 1997; for similar observations, see Hecht 1992.

87. Van Mander–Miedema 1994–, 1: fols. 266r–v (pp. 322–325). For Bruegel's peasant scenes, see Gibson 1991.

88. Although there are several discrepancies in this account, it may reflect an actual incident; see A. Monballieu, "Een werk van P. Bruegel en H. Vredeman de Vries voor de tresorier Aert Molckeman," *Jaarboek, Koninklijk Museum voor Schone Kunsten, Antwerpen* (1981): 113–135.

89. Hollstein 44:236, no. 1283; 46: pl. 160; citation from the French verses. After writing these lines, I was gratified to discover the same observation in Westermann 1997, p. 135 n. 133.

90. See the examples cited in the *Oxford English Dictionary* under "drollery." The use of this word to characterize certain Dutch paintings merits further study.

91. Seneca 1994, p. 97.

92. Cited in R. W. Southern, *The Making of the Middle Ages* (New Haven, Conn.: Yale University Press, 1953), p. 168; see also Olson 1982, p. 92 n. 4.

93. Olson 1982, p. 58.

94. Petrarch, *De remediis*, 1:25; Petrarch-Rawski 1991, 1:78.

95. Pleij 1990, pp. 91–93.

96. Marco Girolamo Vida, *The De arte poetica*, trans. Ralph G. Williams (New York: Columbia University Press, 1976), p. 25. This treatise was first written c. 1517; a later version was published in 1527.

97. Ficino 1989, pp. 135–136. For similar recommendations from writers of this period, see Schmitz 1972, pp. 139–141.

98. De Pizan 1989, p. 97, who recommends, as a summertime recreation, meandering "here and there" in the garden. For Gesner, in a letter of 1546 to Jakob Vogel, see W.-A.-B. Coolidge, *Jacob Simler et les origines de l'Alpinisme jusqu'en 1600* (Grenoble: Allier frères, 1904), p. IV. Nature as a source of recreation is a topos employed several times by Miguel de Cervantes in his *Exemplary Stories*. In the prologue, he supports his claim that his stories provide recreation by comparing them with the planting of groves and the cultivation of gardens; elsewhere, in the story "The Glass Student," actors are compared to "woods, groves, restful landscapes, and all those things which provide honest recreation." See Cervantes 1972, pp. 16, 140.

99. Burton 1927, p. 443 (part. 2, sect. 2, memb. 4). In literature, melancholic characters are related to landscape in two ways. Arcadian landscapes offer them refuge from the world (as in the case of Jacques in Shakespeare's *As You Like It*); wild, inhospitable landscapes echo their inner feelings. However, neither type of landscape necessarily offers them any therapeutic benefits. See Winfried Schleiner, *Melancholy, Genius, and Utopia in the Renaissance* (Wiesbaden: Otto Harrassowitz, 1991), pp. 222–232; Helen Watanabe-O'Kelly, *Melancholie und die melancholische Landschaft. Ein Beitrag zur Geistesgeschichte des 17. Jahrhunderts*, Baseler Studien zur deutschen Sprache und Literatur, 54 (Bern: Francke Verlag, 1978). I am indebted to Laurinda Dixon for these references.

100. For Harvey and Van Swieten, see Dixon 1995, p. 230.

101. See Walford 1991, p. 22; Freedberg 1980, p. 15; Briels 1987, p. 367 respectively.

102. Pliny, *Natural History*, vol. 10, trans. D. E. Eichholz (London: William Heinemann; Cambridge, Mass.: Harvard University Press, 1962), pp. 212–213 (book 37, 16, 62–63).

103. Huygens 1994, p. 110; Hoogstraeten 1969, p. 231. The belief in the therapeutic properties of green

for the eye was repeated by Ficino, who held it to be the color of Venus and links it expressly with growing things; see Ficino 1989, pp. 35, 203–207.

104. Vives 1971, p. 171.

105. *The Colloquies of Erasmus,* trans. Craig R. Thompson (Chicago and London: University of Chicago Press, 1965), see esp. pp. 51 and 48 respectively.

106. Quoted in Mark Morford, "The Stoic Garden," *Journal of Garden History* 7, no. 2 (1987): 169.

107. *De re aedificatoria,* 9:4; quoted from Alberti 1988, pp. 299–300. I have amended their translation of *regionum* from "landscape" to "countryside," following Gombrich 1971, p. 111.

108. Pliny the Elder, *Naturalis historiae,* 35:116–117; see Pliny 1968, p. 147.

109. *De architectura libri decem,* 7:5:2; Vitruvius 1960, p. 211.

110. *De architectura libri decem,* 5:6:9; Vitruvius 1960, p. 150.

111. Burton includes landscapes with "Dutch-works, and curious Cuts of [Aegidius] Sadler of Prague, Albert Durer, Goltzius, Urintes [Vrintes, possibly Frans Floris de Vriendt], &c." For the passages cited in the text and this note, see Burton 1927, p. 454 (part 2, sect. 2, memb. 4); also Dixon 1995, p. 199.

112. Quoted by Albert Dubuisson, "Some Personal Reminiscences of Corot," *International Studio* 51 (January 1914): 211.

113. Alberti 1988, pp. 294, 299.

114. Philostratus, *Imagines;* Callistratus, *Descriptions,* with an English translation by Arthur Fairbanks, Loeb Classical Library (Cambridge, Mass.: Harvard University Press; London: William Heinmann, 1931), pp. 4–7, book 1, introduction.

115. Martindale 1981, p. 112. Even earlier are the hunting and fishing scenes in the so-called Deer Room of the papal palace at Avignon, painted possibly by Matteo Giovanetti about 1343; see Sylvan Gagnière, *The Palace of the Popes at Avignon* (Paris: Caisse nationale des monuments historiques, 1975), pp. 30–34.

116. Enrico Castelnuovo, *I mesi di Trento. Gli affreschi di Torre Aquila e il gotico internazionale* (Trento, 1986).

117. Maria Fossi Todorow, ed., *Palazzo Davanzati,* Biblioteca de "Lo Studiolo," 2 (Florence: Becocci, 1979), p. 17, figs. XX, XXIV; p. 20, figs. XXIX, XXX.

118. Martindale 1981, pp. 116–119, who sees Mantegna's Camera degli Sposi, which has been the subject of a number of erudite interpretations, as a courtly domestic decoration of this type, calculated to divert the visitor with its wit and astonish with its artistic virtuosity, both qualities eminently manifested in the ceiling fresco. See also Evelyn Samuels Welch, "Galeazzo Maria Sforza and the Castello di Pavia, 1469," *Art Bulletin* 71, no. 3 (September 1989): 352–375, esp. 365–366.

119. Guido Fiorini, *La Case dei Cavalieri di Rodi al Foro di Augusto* (Rome: Libreria dello Stato, 1951); Sven Sandström, "The Programme for the Decoration of the Belvedere of Innocent VIII," *Konsthistorisk tidskrift* 29 (1960): 35–75, esp. 37–40.

120. Paolo d'Ancona, *The Farnesina Frescoes at Rome* ([Milan]: Edizioni del Melione, [1955]); Bernhard Patzak, *Die Villa Imperiale in Pesaro. Die Renaissance- und Barokvilla in Italien, III* (Leipzig: Klinkhardt & Biermann, 1908), pp. 264ff.

121. Rodolfo Pallucchini, *Gli affreschi di Paolo Veronese a Maser* (Bergamo: Istituto italiano di arte grafische, 1939).

122. Giovanni Battista Armenini, *On the True Precepts of the Art of Painting*, trans. and ed. Edward J. Olszewski (N.p.: Burt Franklin and Co., 1977), p. 266.

123. Barbara von Barghan, *Philip IV and the "Golden House" of the Buen Retiro: In the Tradition of Caesar*, 2 vols. (New York and London: Garland Publishing, 1986), 1:191–209. Barghan is undoubtedly correct in her claim that this cycle of paintings reflects multiple levels of meaning, including the idea of "contemplative retreat," but it is significant that landscapes should be featured in a space designed for relaxation.

124. Gibson 1989a, pp. 69–74.

125. Kettering 1983, p. 112.

126. Sir Henry Wotton, *The Elements of Architecture Collected by Sir Henry Wotten, Kt., from the Best Authors and Examples* (London: John Bill, 1624); I quote from the edition in *Reliquiae Wottonianae* (London: printed by Thomas Maxey for R. Marrin, G. Bledel, and T. Garthwait, 1651), p. 287.

127. De Lairesse 1969, 7:8; De Lairesse 1817, 1:47. See also Kettering 1983, pp. 90–91.

128. Francesco da Hollanda, *Dialogos de la pintura* (1528); see Francesco da Hollanda, *Four Dialogues on Painting*, trans. A. F. G. Bell (Oxford and London: F. G. Bell, 1928), p. 16.

129. Giulio Mancini, *Considerazioni sulla pittura*, ed. and intro. Adriana Marucchi, commentary by Luigi Salerno, presentation by Lionello Venturi, Accademia Nazionale dei Lincei, Fonti e documenti inediti per la storia dell'arte, 2 vols. (Rome: Accademia Nazionale dei Lincei, 1956–57), 1:114. See also Lagerlöf 1990, pp. 32, 35.

130. Jean Calvin, *Institution de la Religion Christienne* (Geneva: Cirard, 1545), ed. J. Benoit (Paris: J. Vrin, 1957), p. 135: "Quant des choses qu'on peut licitement representer, il y en a deux espèces. En la première sont contenues les histoires, en la seconde, les arbres, montaignes, rivières et personnages qu'ont peint sans aucune signification. Le première espèce emporte enseignement, la seconde n'st que pour donner plaisir"; quoted in Keith P. F. Moxey, *Pieter Aertsen, Joachim Beuckelaer, and the Rise of Secular Painting in the Context of the Reformation* (New York and London: Garland Publishing, 1977), pp. 165–166.

131. Norgate 1997, pp. 82–83; see Gombrich 1971, p. 107.

132. Hendrick Hondius, *Pictorum alliquot celebrium praecipue Germaniae inferioris effigies* (The Hague: Hendrick Hondius, 1610): no. 35, Hendrick van Cleve (*Qua pinxit recreat mirifice haec oculos*); no. 45, Christiaen van Queborne (*Omnia grata oculus*); no. 46, Gillis van Coninxloo (*Mirifice haec oculos*).

133. Hollstein 38–39: no. 216.

134. Quoted in Gombrich 1971, pp. 113–114; F. Gibbons, *Dosso and Battista Dossi: Court Painters at Ferrara* (Princeton, N.J.: Princeton University Press, 1968), p. 86.

135. Pardo 1984, p. 372. Along similar lines, the humanist Francesco Negro, writing in the late fifteenth century, recommends painting in general as a proper occupation for patrician youth, affording a "remedy for excessive study and no less an approach to virtue and an honorable relaxation of the mind and the body"; quoted in Patricia Fortini Brown, *Art and Life in Renaissance Venice* (New York: Harry N. Abrams, 1997), p. 59. A seventeenth-century Dutch writer claims that the writing of light literature afforded the author welcome relief from his more serious efforts; see Isaac Burchoorn, *Klucht-hoofdige snorre-pijpen, quacken, en quinck-slagen* [The Hague, c. 1641], quoted in Van Stipriaan 1996, p. 240 n. 69.

136. Quoted in Vergara 1982, p. 12.

137. Norgate 1997, p. 84.

138. Gibson 1989a, p. 83.

139. For Het Steen and the landscapes Rubens painted there, see Brown 1996, pp. 60–70.

140. Huygens 1994, p. 80. See also Vergara 1982, p. 13 n. 40.

141. Roger de Piles, *The Principles of Painting*, quoted in Elizabeth Gilmore Holt, *A Documentary History of Art*, 3 vols. (Garden City, N.Y.: Doubleday Anchor, 1958), 2:177.

142. Norbert Schneider, "Zur Ikonographie von Memlings 'Die Sieben Freuden Mariens,'" *Münchner Jahrbuch*, 3d ser., 24 (1973): 2–32; E. Kluckert, "Die Simultanbilder Memlings: Ihre Wurzeln und Wirkung," *Das Münster* 27 (1974): 284–295. For other types of spiritual pilgrimages, see Jeremy Bangs, *Cornelis Engebrechtsz.'s Leiden. Studies in Cultural History* (Assen: Van Gorcum, 1970), pp. 58–63.

143. Gibson 1989a, p. 54.

144. Thomas Elyot, *The Boke called the Governour*, 1:77–78; quoted in Foster Watson, *The Beginnings of the Teaching of Modern Subjects in England* (London: Sir I. Pitman & Sons, 1909), pp. 92–93; see also Gibson 1989a, p. 54.

145. Vondel, *Op het Kunstboeck van Herman Zachtleven, vermaert Schilder en tekenaer*, in Vondel 1927–37, 9:300, 302; for short but useful discussions of this poem, see Freedberg 1980, p. 16; Schulz 1982, p. 8.

146. Hoogstraeten 1969, p. 87.

Chapter 5

Epigraph: *The Dutch Drawn to the Life* (London: for Tho. Johnson and H. Marle, 1664), p. 64.

1. Bakker 1993; Levesque 1994, pp. 35–54.

2. Bakker 1993; Van Anrooij 1993; see also De Bièvre 1988, p. 317, who notes that the reference to Damietta also had a more recent significance, since a similar chain supposedly had been placed between two towers on either side of the Spaarne but was destroyed by the Spanish.

3. For these figures, see Leeflang 1993, pp. 25–27.

4. This typically Protestant bias against depicting the deity in anthropomorphic form was manifested by Visscher in his reissue of *The Story of Noah* prints after Heemskerck, in which the figure of God was burnished out and replaced with the sacred monogram; see Ilja M. Veldman, *Maarten van Heemskerck*, part 1, ed. Ger Luijten, *The New Hollstein: Dutch and Flemish Etchings, Engravings, and Woodcuts, 1450–1700* (Roosendaal and Amsterdam: Koninklijke van Poll, in cooperation with the Rijksprentenkabinet, Rijksmuseum, Amsterdam, 1993), pp. 16–22, nos. 2–7, third state. For a similar practice by Hondius, see Orenstein 1996, pp. 98–99.

5. This illustration seems to be based on a view of Haarlem of about 1590, used in Braun and Hogenberg, *Civitates orbis terrarum;* ill. in Biesboer 1996, p. 35, fig. 1.

6. In Le Petit 1615, p. 82. The illustration was previously used in Guicciardini 1612; see Stone-Ferrier 1985b, p. 427, fig. 12, who notes the liberties taken in depicting the bleaching fields so close to the town walls. For Haarlem's linen industry, see below.

7. For the complete print, see Levesque 1994, p. 39, figs. 43a and b. Visscher may have been inspired by the publication in the same year of J. Pontanus's *Rerum et urbis Amstelodamensium historiae,* a historical description of Amsterdam that appeared in a Dutch edition in 1616.

8. Beck 1993, p. 280, composed 24 September 1624. For the others, see Gelderblom 1994, pp. 9–10.

9. A good illustration in Levesque 1994, figs. 43–44.

10. Levesque 1994, pp. 61–62, figs. 67–68. For the traditional relationship between peace and the countryside, see Gibson 1991, pp. 24–26, 44, with further references.

11. In *Den Nederduytschen Helicon* 1610; see Vermeer 1993, p. 85.

12. The English translation, with one change, from De Groot 1979, caption for fig. 23.

13. Gibson 1989a, p. 54.

14. For Visscher's hunting series after Tempesta, see chapter 4 n. 52, above.

15. Cornelius Aurelius, *Defensorium gloriae Batavinae,* written c. 1509–10, first published in 1586, quoted by Leeflang 1995a, p. 116, from Ampzing 1628; and Guicciardini 1567, pp. 179–180. For a detailed and well-documented account of Haarlem's environs and its fame, see Leeflang 1997, pp. 57–79.

16. Springer 1896, pp. 5–8.

17. Rugters van der Loeff 1911, p. 14. The poem was previously dated c. 1483; for the new dating, see Leeflang 1997, p. 58 n. 22, with further references.

18. Van Mander–Miedema 1994–, 1:197 (fol. 234v).

19. Eisler 1914, p. 172; see also Springer 1896, p. 6, who dates the map to 1550. The king in question, of course, was Philip II of Spain.

20. Springer 1896, pp. 7–8; De Bièvre 1988, p. 317.

21. Guicciardini 1968, p. 201b. This information was duly repeated in Le Petit 1615, pp. 82–86. The 1609 edition of Hadrianus Junius's *Batavia* also refers to the woods near the city as a *wandel- en spel plaats* for the citizens.

22. Rugters van der Loeff 1911, pp. 19–38; for the dating of Van Mander's two poems, see pp. 8–9.

23. Rugters van der Loeff 1911, p. 35, verse 19.

24. Rugters van der Loeff 1911, p. 22, verse 9; see also Leeflang 1997, pp. 64, 66, who notes Van Mander's debt to Mathijsz's poem.

25. Ampzing 1974, pp. 70–92. For the various editions of Ampzing's book (1616, 1621, 1628), see the introduction to the 1974 facsimile of the 1628 edition; De Bièvre 1988, pp. 308–312; Leeflang 1995a, pp. 120–122.

26. For a map of Haarlem and environs of 1590, showing the Haarlem Woods, De Baen, and a number of other places described by Ampzing, see Leeflang 1997, p. 56, fig. 2.

27. Grootes 1993a, pp. 102–105; Leeflang 1995a, p. 120; Leeflang 1997, pp. 89–90.

28. Leeflang 1993, p. 32. For other examples, see Leeflang 1997, pp. 89–91, who counts at least 30 Haarlem songs from the seventeenth century.

29. *The Travels of Peter Mundy in Europe and Asia, 1608–1667*, ed. Richard Carnac Temple, vol. 4, Hakluyt Society, 2d ser., no. 55 (London: Hakluyt Society, 1925), p. 65.

30. De Parival 1697, p. 93. There are numerous later editions in French, also at least one Dutch edition, *De vermaeckelijckheden van Hollant* (Amsterdam, 1661).

31. De Vries 1974, p. 209. For the development of water routes and barge traffic in general, see ibid., pp. 205–209; De Vries 1978, esp. pp. 77–110.

32. Evelyn [1907], 1:27.

33. Ampzing 1974, pp. 77–92. For these and other estates in the vicinity of Bloemendaal, see Hoekstra 1947, pp. 111–142.

34. Ampzing 1974, pp. 77 and 87 respectively; see also Hoekstra 1947, pp. 114–117.

35. For the bequest, see Van Mander–Miedema 1994–, p. 246 (fol. 247r); Van Mander does not mention the country place, for which see Hoekstra 1947, p. 118.

36. Ampzing 1974, p. 86; Hoekstra 1947, p. 119.

37. For this drawing and its inscription, see Hoekstra 1947, p. 116; Schmidt 1978, p. 439; De Bièvre 1988, p. 325; Maastricht-Haarlem 1996, pp. 37, 84–85, cat. no. 56.

38. Hoekstra 1947, pp. 119–120.

39. Ampzing 1974, p. 77; Hoekstra 1947, p. 116.

40. Van Regteren Altena 1954; Stone-Ferrier 1985b, pp. 130–131. For a painting of the same view occasionally attributed to Rembrandt, see Schneider 1990, pp. 215–218.

41. *t'Amsterdam, Gedrukt by Klaes Janss Visscher wone[n]de inde Kalverstraet inde Visscher;* see Bakker 1993, pp. 103–104, for another interpretation of this print.

42. De Groot 1979, caption to fig. 24.

43. Levesque 1994, p. 52. The church is shown from the opposite side in another view of Zandvoort, this one a drawing by Jan van de Velde (Paris, École Nationale Supérieure des Beaux-Arts; ill. in J. G. Van Gelder, *Jan van de Velde, 1593–1641. Teekenaar-schilder* [The Hague: Martinus Nijhoff, 1933], fig. 39, cat. no. 63).

44. Ampzing 1974, p. 71.

45. This suggestion is made by Hoekstra 1947, p. 129. See Washington-London-Haarlem 1989–90, pp. 226–235, cat. nos. 34–36, in which Seymour Slive rejects, rightly I believe, Koslow's interpretation of these figures as personifications of sloth; see Susan Koslow, "Frans Hals's *Fisherboys:* Exemplars of Idleness," *Art Bulletin* 57, no. 3 (September 1975): 418–432.

46. Quoted in Leeflang 1995a, p. 116, from the Dutch ed. of 1609, fols. 5r–9r.

47. The drawing is inscribed *buyten haerlem den hout / geneamt Pottadies huys*, transcribed in Simon 1953, cat. no. 38.

48. Samuel Ampzing, *Beschrijvinghe ende Lof der Stad Haerlem* (1616), p. 12; see De Bièvre 1988, p. 309. I cannot locate this reference in the 1628 edition of Ampzing's work. Had Pater closed his doors for the last time in the interim?

49. For this information I am much indebted to Frans Tames of the Haarlem Archives and to Truus van Bueren, who obtained it for me.

50. "Of een Roomtje gaen / of voor den dorst te drincken"; see De Bièvre 1988, p. 329 n. 39.

51. See the passage from Ampzing, 1621 ed., quoted in Stone-Ferrier 1985a, p. 66.

52. B. H. D. Hermesdorf, *De herberg in de Nederlanden* (Arnhem: Gysbers and Van Loon, 1977), pp. 256–275.

53. Ampzing 1974, pp. 71–76.

54. Stone-Ferrier 1985b, p. 430.

55. My warmest thanks to Truus van Bueren and Frans Tames for this information. An even higher dune, more than forty meters, can also be found in Bloemendaal.

56. *Nederduytschen Helicon* 1610, p. 7; quoted in Vermeer 1993, p. 82. For the Witte Blinck, see also Leeflang 1997, pp. 67–69.

57. Rugters van der Loeff 1911, p. 21, verse 6.

58. Sullivan 1984, p. 36. For hunting in general in the Dutch Republic, see ibid., pp. 33–45.

59. Regtdoorzee Greup-Roldanus 1936; Stone-Ferrier 1985a, 1985b.

60. Quoted in Van Strien 1993, p. 306.

61. Regtdoorzee Greup-Roldanus 1936, pp. 228–242.

62. Levesque 1994, pp. 53–54.

63. Hollstein 33–34: no. 167.

64. The same observation is made by Bakker 1993, p. 103, who suggests that there is room for 20 titles.

65. These are *Farm outside Haarlem on the way to Leiden* (formerly The Hague, Dr. P. Beelaerts van Blokland) and *Huis Aelbertsberg near Bloemendaal* (Haarlem, Gemeentearchief); see Simon 1958, cat. nos. 36 and 40 respectively.

66. Rademaker 1725, no. 67. Allowing for the intervention of the etcher, nothing in its style or composition would preclude the ascription of the original drawing to Visscher. Rademaker includes other views dated between 1607 and 1609; see nos. 10, 11, 13, 31.

67. Keyes 1984, pp. 320–322, cat. nos. E10–19; Levesque 1994, pp. 55–72.

68. Levesque 1994, p. 70.

69. Levesque 1994, p. 59.

70. Levesque 1994, p. 70.

71. Jelgersma 1978, p. 43. According to Dekker 1997, p. 103, the other hangman of Holland lived in Dordrecht.

72. Hollstein 47: no. 89, a sheet from the *Small Architectural Perspective Views*.

73. Jelgersma 1978, pp. 42–44.

74. Jelgersma 1978, pp. 42–43.

75. Location unknown; see Keyes 1984, cat. no. 57, fig. 28. Van de Velde included gallows fields in other scenes of banditry and highway attacks; see Keyes 1984, cat. nos. 21, 67, D22, as well as in more "benign" landscapes, such as Keyes cat. no. 115.

76. Brussels, Musées Royaux des Beaux-Arts de Belgique, inv. no. 6046; a good ill. in Alice I. Davies, *Sixteenth- and Seventeenth-Century Paintings in the Springfield Museum of Fine Arts* (Springfield, Mass.: Museum of Fine Arts, 1993), p. 99.

77. Securitas is thus the counterpart of Timor, or Fear, in Ambrogio's fresco of the Unjust City; see Starn 1994, pp. 70–71; Frugoni 1991, p. 167.

78. Hollstein 4:72–75, nos. 1–10 (title print and 9 prints). See also Levesque 1994, pp. 73–88.

79. Van Nierop 1993, pp. 186–187.

80. Reznicek 1961, 1:423, cat. no. 321, 2: fig. 350.

81. Hollstein 11: no. 304. The print was etched by Gerrit Adriaensz Gouw, c. 1610. For the print and its inscription, see Bakker and Leeflang 1993, pp. 46–47.

82. For this print, see chapter 7 n.2.

83. For the Hobbema landscape, recently on loan from the National Gallery to the Mauritshuis, The Hague, see Neil MacLaren, *The Dutch School, 1600–1900*, rev. by Christopher Brown, 2 vols., National Gallery Catalogues (London: National Gallery, 1991), 1:179–180, no. 831; 2: pl. 159.

84. De Parival 1697, p. 104.

85. Ampzing, however, speaks of swimming in the sea at Zandvoort; see Leeflang 1997, p. 87.

86. Beck 1993, pp. 109 (5 June) and 124 (30 June).

87. Constantijn Huygens, *De niewe zee-straet van 's Gravenhage op Schevening;* see Huygens 1892–99, 7:111–135; Constantijn Huygens, *Zee-straet*, ed. L. Strengholt (Zutphen, 1981). Fine coaches appear, for example, in numerous beach scenes, presumably of Scheveningen, by Adriaen van de Velde, including pictures in Buckingham Palace (inv. no. 169) and the Mauritshuis, The Hague (inv. no. 198).

88. See the print by Dancker Danckertsz (Hollstein 5:132, no. 44 with ill.); and the paintings by Willem Schellinks (New York, Anderson Galleries, 14 May 1935, lot 1172) and Johannes Lingelbach (Amsterdam, Rijksmuseum, inv. no. C1224).

89. For a short history of the Haagse Bos, see Dumas 1991, pp. 177–179.

90. Beck 1993, pp. 76, 77, 86, 89ff.

91. Dumas 1991, p. 185 n. 11; quoted from *Art in Seventeenth-Century Holland,* exh. cat. (London: National Gallery, 1976), p. 53.

92. Rotterdam, Museum Boijmans Van Beuningen, inv. no. MB 1941 / T.13 verso, inscribed: *nae t leeven aen de buijten cant haech bos na grave,* with the date *1608* corrected from *1607;* transcribed in Simon, 1958, cat. no. 71.

93. Hollstein 20:82–89, nos. 33–38, with ills.

94. Dumas 1991, pp. 179–184ff.

95. Orlers 1614, p. 8; Orlers 1641, p. 9. An early view of Leiderdorp, before the onset of this development, can be found on a sheet from Esaias van de Velde's sketchbook of c. 1629; see Keyes 1984, cat. no. D114 (Paris, Louvre).

96. For this picture, see Maastricht-Haarlem 1996, pp. 62–63, cat. no. 42.

97. This drawing apparently inspired an etching by Jan Vincentsz van der Vinne; ill. in Leeflang 1997, p. 100, fig. 51.

98. Van Luttervelt 1970. For country places owned by Amsterdammers before 1625, see Meischke 1978.

99. Leiden, University Library, Bodel Nijenhuis Collection, portfolio 335*N20; ill. in Schwartz 1983, pp. 206–207, fig. 7.

100. Huygens 1997, p. 242, lines 2375–2380.

101. For remarks on this subject, see Hoekstra 1947; Van Luttervelt 1970; Mieschke 1978; Schmidt 1978.

102. For the Dutch nobility, see Van Nierop 1993.

103. Huygens 1996, pp. 137, 139, lines 127–139. See also De Vries 1990.

104. For Visscher's drawings of Deyman's country house, see Amsterdam 1993–94, pp. 651–652, cat. no. 325; Peeters and Schmitz 1997.

105. Schwartz 1983.

106. Another allusive "portrait" is Jan Wijnants's *Country House in a Wooded Landscape* of 1667 (Madrid, Thyssen Collection, inv. no. 437), depicting a country house half-concealed behind a screen of trees; in the foreground, a boy fishes and well-dressed people stroll about.

107. Van Veen 1985; and De Vries 1998, which appeared too recently for me to consult.

108. Collection of the duke of Westminster, Eaton Hall, Chester; ill. in The Hague 1994–95, pp. 80–83, cat. no. 9.

109. *Cows Reflected in the Water,* The Hague, Mauritshuis; see The Hague 1994–95, pp. 95–98, cat. no. 14.

110. This is the suggestion of Stone-Ferrier 1985b, p. 430; Stone-Ferrier 1992, p. 422.

111. B. 223; see *Rembrandt: Experimental Etcher,* exh. cat. (Boston, Museum of Fine Arts; New York, Pierpont Morgan Library, 1969), pp. 42–46, cat. no. V. For the supposition that the print was commissioned by Uytenbogaert, see Stone-Ferrier 1992, p. 422.

112. Amsterdam, Rijksmuseum, inv. no. A 207.

113. Cowley, *The Garden*, quoted in Van Veen 1985. For this theme, see Gail Kern Paster, *The Idea of the City in the Age of Shakespeare* (Athens: The University of Georgia Press, 1985), pp. 9–10; James M. Dean, *The World Grown Old in Later Medieval Literature* (Cambridge, Mass.: The Medieval Academy of America, 1997), pp. 125–129.

114. Strengholt, 1977, p. 38, lines 46–50. Similarly, in a Dutch songbook (*Amsterdamsche Pegasus*, 1627, pp. 3–4), a song titled "'t Lant-levens Wellust" tells us that compared to the springtime countryside, "the musty city stinks" (*Dan so stinckt de muffe stadt*).

115. For a brief sketch of Amsterdam's growth, see Van Luttervelt 1970, pp. 33–34.

116. It was probably this picture to which Vondel addressed a short poem, "Op *De nieuwe Herengracht*, gschildered door Gerrit Berckheyde," in which he tells the reader that in view of the troubled times caused by the French invasion of the Dutch Republic in 1672, it would be better to buy the painting than to build a new house. See Vondel 1989, p. 40.

117. Van Luttervelt 1970, pp. 35–36.

118. Joost van den Vondel, "Danckoffer Aen den Heer Joan Six. Voor zyn ooft en wiltbraet my uit zyne hofstede toegezonden," in Vondel 1927–40, 6:698–701; also in modern Dutch spelling in Vondel 1989, pp. 54–58. Vondel's image of Six's wife taking him away from his studies for an open-air stroll may be compared with the marriage portraits in which the wife is shown distracting her husband from his books; David Smith (*Masks of Wedlock: Seventeenth-Century Dutch Marriage Portraiture*, Studies in the Fine Arts: Iconography, no. 5 [Ann Arbor, Mich.: UMI Research Press, 1984], pp. 132–134) argues that such portraits reflect the tension between masculine scholarly preoccupations and the duties owed a wife; these pictures may also define one of the wife's own duties, that of ensuring that her husband does not work too hard.

119. For the "Ja-Woord," see *Woordenboek* 1882–, vol. 7, pt. 1, col. 240, sect. 3.

120. Vondel 1927–40, 6:86–87.

121. See *Nieuw Nederl. biog. woordenboek* 1911–37, 2:492.

122. See Elias 1903–5, 1:LXXXI; Van Nierop 1993, pp. 69ff. *Heer* was a title roughly analogous to "Lord of the Manor," although with important differences. Cities also bought up manors in their vicinity to bring the surrounding countryside under their jurisdiction (Van Nierop 1993, p. 155). Country house owners in the Spanish Netherlands also obtained titles with their estates, but under somewhat different circumstances; see Dreher 1978a; Dreher 1978b.

123. Huygens 1996, p. 15.

124. For Pauw's career, see *Nieuw Nederl. biog. woordboek* 1911–37, 10:714; Van Nierop 1993, pp. 213–214. For Ampzing's poem, see Ampzing 1974, p. 88.

125. This interpretation has been advanced by Gary Schwartz and Simon Schama, among others, for which see the critical response by Julius Held, *Rembrandt Studies* (Princeton, N.J.: Princeton University Press, 1991), pp. 6–7.

126. Daniel Defoe, *Roxana, the Fortunate Mistress*, 1724; I quote from the Signet Classics edition (New York: New American Library, Signet Classics, 1979), pp. 207–208.

127. Quoted in Van Nierop 1993, p. 37.

128. Cited in Elias 1903–5, 1:LXXXI. For the use of forged and doctored epitaphs to bolster claims to nobility, see Marten Jan Bok, "Laying Claims to Nobility in the Dutch Republic: Epitaphs, True and False," in *Ten Essays for a Friend: E. de Jongh 65, Simiolus* 24, nos. 2–3 (1996): 107–124. Schaep himself seems to have indulged in this practice (ibid., p. 124).

129. See esp. London 1986, pp. 21–22.

130. Van Mander–Miedema 1994–, 1:174 (fol. 229r), in the life of Jan Mostaert.

131. Dudley Carleton: *Dudley Carleton to John Chamberlain, 1603–1624. Jacobean Letters,* ed. Maurice Lee, Jr. (Brunswick, N.J.: Rutgers University Press, 1972), p. 218.

132. Ampzing 1974, pp. 344–375; Schrevelius 1648, pp. 361–390.

133. For Haarlem's self-image as an artistic center, see Van Bueren 1993, esp. pp. 232–258.

134. Stechow 1966, p. 19, rejects this notion.

135. Stechow 1966, p. 17, suggests that Goltzius was a major attraction, but this is rejected by Slive 1995, p. 180, among others.

136. The excellent discussion of this subject in Leeflang 1997, pp. 80–83, appeared after I had written an earlier draft of this section of chapter 5.

137. Van Mander–Miedema 1994–, 1:81 (fol. 205v). Leeflang 1997, pp. 82–83, reminds us that the earliest surviving use of the term *landscape* occurs in a contract of 1485 for an altarpiece at Haarlem.

138. Leeflang 1997, p. 81, quoting Ampzing 1974, p. 345.

139. Gibson 1989a, p. 38, with further references.

140. Molanus (Joannes Vermeulen): *Joannis Molani Historiae Lovaniensium libri XIV;* see Hans-Wolfgang von Löhneysen, *Die ältere niederländische Malerei. Künstler und Kritiker* (Eisenach and Kassel: Erik Räth Verlag, 1956), p. 126; I have followed the interpretation of this passage in Leeflang 1997, p. 82.

141. Guicciardini 1968, p. 80a, which mentions only that it is in the possession of an art lover (*liefhebber*). He is named as "Master T. Blin" in a 1613 edition of Guicciardini published in Arnhem; see Wolfgang Schöne, *Dirc Bouts und seine Schule* (Berlin and Leipzig, 1938), pp. 247–248, doc. 8; Albert Châtelet, *Early Dutch Painting: Painting in the Northern Netherlands in the Fifteenth Century,* trans. Christopher Brown and Anthony Turner (New York: Rizzoli, 1981), p. 75; Leeflang 1997, pp. 81–82.

142. It is uncertain to what extent the exodus of artists from Haarlem may be related to the gradual decline of its linen industry during the course of the seventeenth century; see Regtdoorzee Greup-Roldanus 1936, pp. 267–285; Bisboer 1996, pp. 59–60.

143. Büttner and Unverfehrt 1993, p. 37. For Ruisdael's *Haarlempjes,* see also Stone-Ferrier 1985b, pp. 119–129, 144–145.

Chapter 6

Epigraphs: Arthur Schopenhauer, *The Pessimist's Handbook: A Collection of Popular Essays*, trans. T. Bailey Saunders, ed. with an introduction by Hazel E. Barnes (Lincoln: University of Nebraska Press, 1964), p. 222, with one emendation of my own; and De Lairesse 1740, 1:121 (1:2:15), "Veele Landschapschilders zoeken gemeenlyk slegte of geringe stoffagie, gemeene en onnoozele gedachten of verbeeldingen."

1. I had chosen the title for this chapter before I saw the similar title Anna C. Knaap used for a section of her excellent 1996 essay, "From Lowlife to Rustic Idyll." I hope she will not object to my keeping a phrase that, after all, we both saw as aptly conveying the substance of our respective texts.

2. For the Dutch word and its variants, see *Woordenboek* 1882–, 15:473 (s.v. *staffier*), 1803 (s.v. *stoffage*).

3. De Lairesse 1817, 1:79 (1:2:15).

4. Los Angeles, Los Angeles County Museum of Art; ill. in Walford 1991, p. 80, fig. 70. For examples of such collaboration with other landscapists, see Sutton 1987–88, p. 7.

5. See chapter 3 on interpretations by Bruyn and Raupp of the figures in Dutch landscape paintings.

6. Pliny 1968, pp. 146–149, both Latin and English.

7. See chapter 4.

8. Junius 1588, pp. 238–239; I use the translation in Veldman 1977, p. 98.

9. Van Mander–Miedema 1973, 1:217 (*Den Grondt*, 8:41–42).

10. Hoogstraeten 1969, pp. 136–137 (book 4, chap. 5).

11. For a similar observation, see Walford 1991, p. 72.

12. For examples of Beck's use of *wandelen, wandeling*, see Beck 1993, pp. 76 (14 April), 84 (28 April), 162 (25 and 26 May), etc.

13. Visscher 1949, p. 132 ("Het derde schock," no. X). For pipe smoke as an emblem of vanity in a poem by Willem Godschalck van Focquenbroch (1640–1670), see B. de Light, "Fumus gloria mundi," *De nieuwe taalgids* 63 (1970): 249–260, esp. 257–258; the poem and an English translation in Schenkveld 1991, pp. 86–88.

14. For examples, see Wilhelm von Bode, *Adriaen Brouwer. Sein Leben und seine Werke* (Berlin: Euphorion, 1924), pp. 26–66. Hendrick Hondius published a print in 1645 after Brouwer showing a man lighting a pipe from a bowl of coals held by a woman, accompanied by an inscription beginning: *Weer aen 't smoken, weer aen 't stinken* (again smoking, again stinking); see Hollstein 3: no. 18 (a good impression in the Rijksprentenkabinet, Amsterdam).

15. Ivan Gaskell, "Tobacco, Social Deviance, and Dutch Art in the Seventeenth Century," in *Holländische Genremalerei im 17. Jahrhundert, Symposium 1984, Jahrbuch Preussischer Kulturbesitz*, Sonderband 4, ed. Henning Bosck and Thomas W. Gaehtgens (Berlin: Gebr. Mann, 1987), pp. 117–137. See also Amsterdam 1997, cat. no. 76.

16. Raupp 1980, pp. 101–102.

17. Keyes 1984, pp. 148, cat. no. 104, and 123–124, cat. no. 18, respectively. Keyes gives a detailed analysis of the latter painting, plausibly suggesting that it represents a political allegory in which "political authority harmonizes with the peacefulness of the countryside."

18. A number of examples illustrated in Stechow 1966.

19. Examples in Burke 1974; The Hague–Cambridge 1981–82, cat. nos. 44, 45; Walford 1991, pp. 112ff.

20. Beck 1993, p. 147, entry for 8 August. This recent invention did not long escape the emblematists. About the same time that Beck wrote his diary, Adriaen van de Venne designed a number of emblems for Johannes de Brune's *Emblemata;* one shows a man looking through a telescope, with the inscription "Envy finds advantage in another's bad [fortune]." See Johannes de Brune, *Emblemata of Zinne-werck* (Amsterdam: Ian Eversten, 1624), p. 333, emblem XLVII.

21. For Bruegel's series and the earlier tradition of the *Months,* see Gibson 1989a, pp. 69–74.

22. For some *Months* series engraved by Aegidius Sadeler after Bril and Stevens, see Hollstein 21–22: nos. 123–141. For Valckenborch, see Wied 1990, pp. 28–29, and cat. nos. 46–52.

23. Wied 1990, cat. no. 49.

24. Vienna, Kunsthistorisches Museum, inv. no. 5684; ill. in Wied 1990, p. 155, cat. no. 48. See ibid., pp. 145–146, cat. nos. 31, 32, and color pl. 9, for a composition in two copies, that show a group of urbanites observing a village kermis, but here their gravity is relieved by the bagpipes held by one of the townsmen.

25. Hondius engraved four of the plates; the remainder are by Andries Stock and Jacob Matham; see Hollstein 11: nos. 361–364 (Matham); Hollstein 28: nos. 11–14 (Stock); Orenstein 1994a, nos. 72–75, with ills. (Hondius).

26. Hollstein 23–24: nos. 46–57 (1616), 34–45 (1618), 58–70 (undated).

27. Hollstein 33–34: nos. 34–45.

28. Thomas Coryat, *Coryat's Crudities, harshly gobled up in five months travells in France, Savoy, . . . ,* 2 vols. (London: W. Stansby, 1611; Glasgow: J. MacLehose & Sons, 1905), 2:360, in the section on "Nimmegen" (Nijmegen).

29. Hollstein 13: nos. 1–4. Van Straaten 1977, pp. 32–34, suggests a German origin for these prints, but they are more likely by a Dutch artist.

30. Amsterdam 1997, pp. 58–62, cat. no. 4.

31. See the *Table analytique* of subjects in De Bertier de Sauvigny, 1991, pp. 391–395.

32. For Visscher, see chapter 1. For some other *Seasons* series, see Hollstein 3: after Bol: nos. 228–231 (Jan Sadeler) and 249–252 (Hendrick van Schoel); Hollstein 6: s.v. Julius Goltzius, nos. 31–34 (after Marten de Vos; the designs re-engraved by Nicolaes de Bruyn; see Hollstein 2: nos. 190–193); Hollstein 21–22: nos. 142–145 (Aegidius Sadeler after Pieter Stevens). For Heemskerck, see Ilja M. Veldeman, "Seasons, Planets, and Temperaments in the Work of Maerten Heemskerck," *Simiolus* 11 (1980): 149–176. A set of *Seasons* after Vinckboons was published by Hondius in 1617 (Orenstein 1996, pp. 73–74).

33. Hollstein 38–39: no. 207; the map is probably by Abraham Goos.

34. See Van Bastelaer–Gilchrist 1992, no. 200, states B, C, for the Visscher reprint. The estate of Volcxken Dircx contained a "Twelve Months" on four plates by Bruegel (Duverger 1984, p. 31); if these were in fact the Bruegel-Bol *Seasons*, Visscher may have acquired the plate from Theodoor Galle. Van Bastelaer-Gilchrist 1992, cat. nos. 201, 202, lists copies by Hendrick Hondius of both the *Spring* and *Summer* after Bruegel recorded in the catalogue of the Marcus collection, Amsterdam, 1770. He may also have copied Bol's *Autumn* and *Winter*, although the evidence is tenuous; see Hollstein 3: nos. 205, 206, under Bol. In any case, none of these copies is listed in Orenstein 1994a.

35. Hollstein 23–24: nos. 26–29.

36. The English translations of the inscriptions on these prints taken from De Groot 1979; see also Tokyo-Kasama-Kumamoto-Leiden 1992–93, cat. nos. 27 A–D.

37. Van Bastelaer–Gilchrist 1992, cat. no. 205, state B.

38. Visscher 1949, p. 129 ("Het derde schock," no. VII: *Gheoeffent derf*).

39. Huygens 1996, p. 155, lines 2742–2764.

40. Quoted in Moryson 1903, pp. 383–384.

41. *Amsterdamsche Pegasus* 1627, p. 66, song no. 5.

42. Such interpretations are often advanced; see, for example, Amsterdam-Boston-Philadelphia 1987–88, p. 257.

43. For examples, see Van Straaten 1977, pp. 95–133.

44. For examples, see Wilhelm Hansen, *Kalenderminiaturen der Stundenbücher. Mittelalterliches Leben in Jahreslauf* (Munich: Callwey, 1984), pp. 80–83, figs. 46–52.

45. Beck 1993, pp. 99 (20 May), 105 (30 May) for the May poems; p. 88 (4 May) for the quotation. Elsewhere (p. 91, for 8 May), he speaks of a "very temperate sweet May day."

46. "Heet, bang ende recht honsdag-weder"; see Beck 1993, p. 139 (25 July); for similar expressions, see pp. 101 (24 May), 102 (25 May).

47. Published by Herman Allertsz; see Hollstein 38–39: nos. 116–123; Levesque 1994, pp. 38–39 and fig. 41.

48. Stone-Ferrier 1985a, pp. 41–55.

49. Keyes 1984, pp. 231–232, with further references. For Everdingen, see Davies 1972.

50. Traditional Month scenes continued to appear in almanacs and calendars; for an example probably dating from 1666, see Amsterdam 1997, cat. no. 75.

51. Roethlisberger and Bok 1993, 1: cat. nos. 409–420; 2: figs. 78–89. The original drawings are here dated c. 1625–35.

52. Bredero 1986, pp. 160–164.

53. Bredero 1986, p. 74.

54. Georg Wilhelm Friedrich Hegel, *Äesthetik*, ed. Friedrich Bassenge (Berlin: Aufbau-Verlag, 1955), pp. 803–804; quoted in Białostocki 1984, pp. 423–424, and Białostocki 1988, p. 168. See also Hein-

rich Gustav Hotho, *Geschichte der deutschen und niederländischen Malerei*, 2 vols. in 1 (Berlin: M. Simion, 1842), 1:351; concerning the peasants depicted in Dutch painting, he wrote that they "sit like gods on Mount Olympus, laughing and quarreling, untouched by worry, labor, and need, and unconcerned with contrition or repentance, with fame or the limits of human existence" (quoted in Demetz 1963, p. 113).

55. Israel 1995, p. 197; De Vries 1974, pp. 35–41.

56. Walford 1991, p. 204.

57. *Nederduytschen Helicon* 1610, pp. 233–238. For the author, see Strengholt 1977.

58. J. A. N. Knuttel, "Bauw-heers Wel-leven," *Tijdschrift voor Nederlandsche taal- en letterkunden* 46 (1927): 180–185. For the *Beatus ille*, see Horace's second epode, first line.

59. The expression *slecht en recht* inspired an emblem in Roemer Visscher's *Sinnepoppen* (*Tweede Schock*, no. X) to characterize the simple, upright lives of humanity in the Golden Age; see Visscher 1949, p. 71.

60. For the pastoral landscape, see Hunt 1992; Washington 1988.

61. Hollstein 8: no. 242; Amsterdam-Cleveland 1992–93, pp. 180–183, cat. no. 50.

62. Cafritz 1988a; Bert W. Meijer, *Hommage à Titien, vers 1490–1576: Dessins, gravures et lettres autographés de Titien et d'artistes du nord*, exh. cat. (Paris, Institut Néerlandais; Florence, Instituto Universitario Olandese, 1976), pp. 36–37, cat. nos. 22, 23. For De Neyt, see Erik Duverger, "Aantekeningen betreffende de Antwerpse schilder en kunsthandelaar Herman de Neyt (1588–1642)," *De zeventiende eeuw* 6 (1990): 69–75.

63. For the influence of the Venetian pastoral landscape drawings on Rembrandt, including a drawing attributed to Domenico Campagnola that he reworked, see Cafritz 1988b. The role of Venetian art generally on Rembrandt's landscapes is discussed in Schneider 1990, pp. 55–57.

64. Abram van Mijll, *Mandra, Ecloga ofte Veldt-dicht over de Oversettinghe van de Bucolica van Virgilius ghedaen door Karel van Mander*, quoted in Jacobsen 1972, p. 86. See ibid., pp. 86–94, for the "local color" in Van Mander's translation.

65. "Ghy weet / o Landt! Niet / hoe gheluckigh dat ghy zijt"; Karel van Mander, *Bucolica*, quoted in Jacobsen 1972, p. 76; cf. Virgil, *Georgics*, 2:458–459: "Oh happy husbandmen! Too happy, should they come to know their blessings!" (Virgil 1974, 1:149).

66. Kettering 1983, pp. 71–73.

67. Kettering 1983, p. 23.

68. Quoted in Freedberg 1980, p. 12.

69. For the *Roemster van den Amstel*, see Beening 1963, pp. 185–190, who discusses other nature poets with similar classical interests.

70. Ill. in Beening 1963, opp. p. 188.

71. Hollstein 23–24: nos. 247, 281.

72. See chapter 5.

73. *Amsterdamsche Pegasus* 1627, the illustrations to "'t Lant-levens Wellust," p. 2, and "Het soet Nymphje Galatee," p. 96. Jan van de Velde contributed ten illustrations to this collection; see Hollstein 33–34: nos. 445–454; the illustrations discussed are nos. 445 and 451 respectively.

74. *The Art Criticism of John Ruskin,* ed. Robert L. Herbert (Garden City, N.Y.: Anchor Books, 1964), p. 328.

75. For Bruyn on Van Goyen, see chapter 3; for a detailed description of the figures in the Ruysdael landscape, see Falkenburg 1989, pp. 145–146.

76. Roethlisberger and Bok 1993, 1:129–132, cat. nos. 83, 84; pp. 260–261, cat. no. 391.

77. Roethlisberger and Bok 1993, 1: cat. nos. 297–312; 2: figs. 434–449; Amsterdam 1997, pp. 195–198, cat. no. 37. The English translations of the inscriptions are from Roethlisberger and Bok 1993.

78. This print is anticipated by an early-fifteenth-century Veronese drawing depicting a man and dog sleeping, while a horse stands nearby; the sheet is inscribed: "Relax after your work is done." See George Szabo, *Fifteenth-Century Italian Drawings from the Robert Lehman Collection,* exh. cat. (New York: The Metropolitan Museum of Art, 1978), cat. no. 5. Szabo suggests that both image and inscription refer to some popular saying.

79. Amsterdam 1997, p. 195.

80. Pauline M. Smith, *The Anti-Courtier Trend in Sixteenth-Century French Literature* (Geneva: Droz, 1966); Gibson, 1991, pp. 19–23.

81. Antonio de Guevara, *Menosprecio de corte y albadanza de aldea;* published in Dutch as *Misprijzing der miserie des hofs ende der hoocheyt / met lof van kleynen ende leeghen state* (Delft: Adriaen Gerritsz, 1613). For Guevara and his treatise, see Gibson 1991, pp. 20–21, with further references.

82. For these two poems, see Van Veen 1985, pp. 14–18 and 19–23 respectively.

83. Thus an eighteenth-century set of 20 picture tiles showing various crafts and professions, and now in the Rijksmuseum, Amsterdam (inv. no. BK 1955-384), is very appropriately inscribed *Negotium.*

84. [Cornelis de Schryver], *Spectaculorum in susceptione Philippi Hisp. prin. divi Caroli. V caes. An. M.D. XLIX. Antwerpiae aeditorum, mirificus apparatus. Per C. Scribionium Grapheum* (Antwerp: Petro Aloesten 1550), fol. N3v. Dutch and French editions were also published. On the arch labeled *Privatum Monetariorum,* Dea Moneta stands before Saturn and presents her children Opulencia, Copia, Negociatio, and Civilitas.

85. For the view of Amsterdam, see chapter 5.

86. Lebeer 1969, pp. 77–81, cat. no. 26, and pp. 136–137, cat. no. 54 respectively; Van Bastelaer–Gilchrist 1992, cat. nos. 152 and 146 respectively, with notes on later states. See also Ethan Kavaler, "Pictorial Satire, Ironic Inversion, and Ideological Conflict: Bruegel's *Battle between the Piggy Banks and Strong Boxes,*" *Pieter Bruegel,* ed. Jan de Jong, Mark Meadow, Herman Roodenburg, and Frits Scholten, *Nederlands Kunsthistorisch Jaarboek* 47 (1996): 155–179.

87. For this contrast, see Dixon 1995, p. 162. For *otium* as a *negotium animi,* or negotiation of the soul, see Hans-Joachim Raupp, "Zeit in Rubens' Landschaften," *Walraff-Richartz-Jahrbuch* 55 (1994): 168.

88. Petrarch, *De remediis*, 1:21; Petrarch-Rawski 1991, 1:62–63. Similarly, the fourteenth-century humanist Nicholas of Clémanges says in a letter: "Do not be ashamed of this illustrious and glorious leisure in which great minds have always taken pleasure"; quoted in Jacques Le Goff, *Intellectuals in the Middle Ages* (Cambridge, Mass.: Harvard University Press; Oxford: Blackwell, 1993), p. 163.

89. Joannes Sambucus, *Emblemata, et Aliquot Nummi Antiqui Operis* (Antwerp: Christophe Plantin, 1566), p. 92.

90. Geoffrey Whitney, *A Choice of Emblemes*, ed. Henry Green, introduction by Frank Fieler (Leiden: House of Christopher Plantin, 1586; New York: Benjamin Blom, 1967), p. 26.

91. Ripa 1971, pp. 282–283. For Ripa's linking of *otium* with contemplation, see Thomas Nashe, who speaks derisively of "[t]hat heaven . . . called Contemplation, as much as to say as a most pleasant sloth," in *Summer's Last Will and Testament*, in Nashe 1985, p. 188.

92. Ripa 1971, p. 283.

93. Cicero, *De officiis* 3.1–2; quoted from *De officiis*, trans. Walter Miller, *Cicero in Twenty-eight Volumes* (Cambridge, Mass.: Harvard University Press, 1968), 21:271.

94. Quoted in M. A. Screech, *Montaigne and Melancholy: The Wisdom of the "Essays"* (London: Penguin Books, 1991), p. 65. It may have been in a rather different spirit that earlier in the century Federigo Gonzaga had dedicated his pleasure palace in Mantua, the Palazzo del Tè, to his use in "honest leisure," according to an inscription in the Sala di Psiche; see Frederick Hartt, *Giulio Romano*, 2 vols. (New Haven, Conn.: Yale University Press, 1958), 1:126, 128. I am grateful to E. J. Johnson for this reference. In an emblem by Alciatus (Alciati) (ed. Padua, 1621), a youth mourns the death of his friend, asking, "Will you no longer while away pleasing leisure-time [*otia grata*] with me in study?" (Andreas Alciatus, *Index emblematicus*, ed. Peter M. Daly with Virginia W. Calahan assisted by Simon Cuttler, 2 vols. (Toronto: University of Toronto Press, 1985), emblem 157.

95. Schenkveld-van der Dussen 1987, 1988.

96. J. Tamboer, *Het toneel der snaaken*, many editions; quoted in Dekker 1997, p. 40. For the motif of the unstrung bow, see chapter 4.

97. *De oratore*, 1.51.224; see Cicero, *De oratore*, trans. E. W. Sutton, ed. H. Rackham, Loeb Classical Library (London: William Heinemann; Cambridge, Mass.: Harvard University Press, 1967), 1:159. For the villa as a place of cultivated leisure, see John H. D'Arms, *Romans on the Bay of Naples: A Social and Cultural History of the Villas and Their Owners from 150 B.C. to A.D. 400* (Cambridge, Mass.: Harvard University Press, 1970), pp. 12–17.

98. Sallust, *Catilinae coniuration*, 4.1.2; quoted in Leach 1974, p. 68.

99. Vondel, *Palamedes*, 1625; see Vondel 1927–40, 2:704–705 (act 3, lines 1363–1389. In the next century, Adriaan van Royen describes life on his country estate in comparable terms in his poem *Otium* of 1776 (Van Veen 1985, pp. 102–103).

100. Sallust, *Catilinae coniuration*, 4.1.2; quoted in Leach 1974, p. 68.

101. Petrarch, *De remediis*, 1.57; Petrarch-Rawski 1991, 1:172. Petrarch will allow the educated man an occasional agricultural task for recreation, but not as a means of livelihood.

102. Huygens 1977, p. 219, lines 2166 and 17–20 respectively; the latter quoted from Huygens 1996, p. 137. For a useful discussion of Huygens's *Hofwijck*, see De Vries 1990.

103. For Vondel's poem, see chap. 5; for the print, see Holm Bevers, Peter Schatborn, and Barbara Wezel, *Rembrandt: The Master and His Workshop* (New Haven and London: Yale University Press, 1991), pp. 231–232, cat. no. 23.

104. Quoted in Van Veen 1985, p. 16; see also pp. 123–124.

105. Hondius 1621, pp. 324–332; for the passages quoted, see p. 325. Cf. Huygens, who in his *Hofwijck* lists among the amenities of his country estate the books whose fruit, unlike the "fruit of the stomach," cannot rot or be touched by death (Huygens 1977, p. 177, lines 1695–1700). For his part, Burton cites Seneca to the effect that "to be at leisure without books is another Hell, & to be buried alive" (Burton 1927, p. 459 [part 2, sect. 2, memb. 4]).

106. Pierre Charron, *De la sagesse* (Bordeaux: Simon Millanges, 1601); *Of Wisdome* (London: printed for Edward Blount and Will Aspley, [1612?]; reprint, Amsterdam: Theatrum Orbis Terrarum; New York: De Capo Press, 1971), p. 207; quoted in Amy Walsh, "Imagery and Style in the Paintings of Paulus Potter," Ph.D. diss., Columbia University, 1985, pp. 302–303. Columella was a Roman writer of the 1st century A.D., author of *De rustica*, an agricultural treatise.

Chapter 7

Epigraphs: Quoted in Władysław Tatarkiewicz, *History of Aesthetics*, ed. J. Harrell, 3 vols. (The Hague and Paris: Mouton; Warsaw: PWN-Polish Scientific Publishers, 1974), 3:380, no. 30; and Aristotle, *Poetics: The Complete Works of Aristotle*, ed. J. Barnes, 2 vols. (Princeton, N.J.: Princeton University Press, 1984), 2:2318.

1. Bartsch 226, Bartsch 233 ill. in Hollstein 19:188, 193 respectively.

2. Done after a design by Pieter Jansz Saenredam, the print was a double-page illustration in Ampzing 1628, between pp. 193 and 194 (Hollstein 33–34, no. 422). For the text and translation, see *Catalogue Raisonné of the Works by Pieter Jansz Saenredam, Published on the Occasion of the Exhibition "Pieter Jansz Saenredam"* (Utrecht: Centraal Museum, 1981), cat. no. 181 and fig. 183.

3. Huygens 1994, p. 72, in which Huygens observes that Hendrick Hondius, from whom he learned drawing, had a hard style of engraving that was ill suited to render such forms as grass, leaves, and "the formless splendor of fallen ruins." For the original Latin, see Worp 1891, p. 109. I am indebted to Peter Lautner for help in determining the precise meaning of this passage.

4. A notable exception is Cornelis van Dalem's enigmatic *Landscape with Farm* of 1564 (Munich, Alte Pinakothek, inv. no. 12044), depicting a dilapidated farm cottage in the foreground with a ruined

church in the distance. See Leo van Puyvele, *La Peinture flamande au siècle de Bosch et Brueghel* (Paris: Elsevier, 1962), p. 251, color pl. 31.

5. Ogier's comment quoted from Van Deursen 1991, p. 19. A traveler to Holland in 1691 writes that the Dutch peasant keeps his farmland as carefully as a courtier keeps his beard, his house as neat as a lady who has just left the dressing room; quoted in Robert Fruin, "De Nederlander der zeventiende eeuw door Englischen geschetscht," in *Robert Fruin's Verspreide geschriften*, ed. P. J. Blok, P. L. Muller, and S. Muller, 11 vols. (The Hague: Martinus Nijhoff, 1901), 4:250.

6. Jane Susanna Fishman, *"Boerenverdriet": Violence between Peasants and Soldiers in Early Modern Netherlands Art*, Studies in the Fine Arts: Iconography, vol. 3 (Ann Arbor, Mich.: UMI Research Press, 1982). For what may be the earliest depiction, by Pieter Bruegel the Elder, see Gibson 1991, pp. 43–44.

7. Hoogstraeten 1969, p. 238; quoted in Stechow 1966, p. 11.

8. Beck 1993, p. 83 (25 April).

9. For the equation of rustic ruins with sin, see chapter 3. For other scholars, rustic ruins evoke the idea of human transience in contrast, or subordinated, to eternal nature; see Haverkamp Begemann 1959, p. 42. On the other hand, the motif of the tree stump rising from a pool in certain Dutch and Flemish landscapes has been interpreted as a symbol of resurrection after death; see Härting 1995, pp. 85–88, 91.

10. Rotterdam, Museum Boijmans Van Beuningen; see Walter S. Gibson, *Hieronymus Bosch* (London: Thames and Hudson; New York: Praeger, 1973), pp. 103–106, figs. 85, 86.

11. Veldman 1992, p. 244. Similarly, Philips Galle's engraving of the sluggard and the slothful, illustrating verses from Proverbs 6 and 24, includes not only the broken stone wall of the slothful man's vineyard (Prov. 24:31) but a ramshackle barn not mentioned in the text. See Arno Dolders, *Netherlandish Artists. Philips Galle. The Illustrated Bartsch*, 56 (New York: Abaris Books, 1987), p. 288, no. 074:1 (from a series depicting the fate of the slothful; an impression in the Rijksprentenkabinet, Rijksmuseum, Amsterdam).

12. Hans Mielke, review of K. G. Boon, *Netherlandish Drawings of the Fifteenth and Sixteenth Centuries (Catalogue of the Dutch and Flemish Drawings in the Rijksmuseum*, vol. 2), in *Simiolus* 11 (1980): 46, under no. 233. See also Bruyn 1987–88, p. 86. Similarly, in a painting of 1616 by Esaias van de Velde (Keyes 1984, cat. no. 44 and fig. 78), bandits attack some travelers before a ruined farmhouse that in this case may symbolize evil, although we shall see that Van de Velde appreciated ruins for their own sake. In Philips Wouwerman's *Landscape with a Rider* (Haarlem, Frans Halsmuseum), a horseman doffs his hat to an old woman and a girl seated with her breasts exposed; the prominent dead tree nearby may underscore the sinful nature of this encounter.

13. De Bisschop, *Paradigmata*, 1671; the English translation taken from Van Gelder and Jost 1985, 1:228, slightly amended to reflect the Dutch text more closely. This passage is discussed in detail by Bakker 1995, pp. 156–159.

14. *Joachim von Sandrarts Accademia Todesca della architettura, scultura & pitture, oder Teutsche Acade-*

mie der edler Bau-, Bild-, und Mahlerey-Künste von 1675: Leben der berühmten Maler, Bildhauer und Baumeister, ed. and with commentary by A. R. Peltzer (Munich: E. Hirth, 1925), p. 203. For this passage, see Slive 1953, pp. 84–94; Emmens 1968, pp. 66–71.

15. Pels 1978, pp. 77–78, lines 1096–1129; the English translation quoted from Slive 1953, p. 102.

16. Pels 1978, p. 78, lines 1118–1120.

17. Van Strien 1993, p. 137.

18. Jan Vos, *Alle de gedichten,* 2 vols. (Amsterdam: Gerrit & Hendrick Bosch, 1726), 1:193–207, esp. 204. See also Emmens 1968, p. 131. The plot can be summarized as follows. Jupiter sends Death to punish humanity for its sins. Death is opposed by Nature who visits the studio of Painting to seek his help. Curiously enough, this potential ally of Nature is surrounded by the emblems of death: rusty swords, a skull and bones, and old books, typical props for a *vanitas* still life. See further Gregor J. M. Weber, *Der Lobtopos des "lebenden" Bildes. Jan Vos und sein "Zeege der Schilderkunst" von 1654,* Studien zur Kunstgeschichte, 67 (Hildesheim, Zurich, New York: Georg Olms, 1991).

19. Filippo Baldinucci, *Cominciamento, e progresso dell'arte dell'intagliare in rame, colle vite molti de' più eccelenti Maestri della stessa Professione* (Florence: Stamperia di P. Matini, 1686); see Slive 1953, p. 113.

20. Joachim von Sandrart, *Academia nobilissimae artis pictoriae . . .* (Nuremberg: Christian Sigismund Froberger, 1683), p. 323; for this account, see R. W. Scheller, "Rembrandt en de encyclopedische kunstkamer," *Oud Holland* 84 (1969): 81–147, esp. 142–145.

21. Huygens 1994, pp. 80–81. In this connection, Huygens also recounts the story, first told by Pliny (*Naturalis historia,* 35. 25; Pliny 1968, p. 92), of the German envoy who was shown a painting that had been set up in Roman Forum, showing an aged shepherd with his staff. When asked if he had any idea of the picture's worth, the envoy replied that he would not have the shepherd himself as a gift (ibid., p. 81).

22. De Jongh 1995, p. 101. For the "purification" of Dutch drama after 1660, see Van Stipriaan 1996, pp. 46–47.

23. L. de Vries 1998, for a valuable account of De Lairesse's life and art theories; see also the excellent recent study by Claus Kemmer, "In Search of Classical Form: Gerard de Lairesse's *Groot schilderboek* and Seventeenth-Century Dutch Genre Painting," *Simiolus* 26 (1998): 87–115.

24. De Lairesse 1817, 1:113–120 (book 3, chap. 2).

25. De Lairesse 1969, 1:171 (book 3, chap. 1); translation from Slive 1953, p. 161.

26. De Lairesse 1969, 1:185; 1817, 1:121 (book 3, chap. 3). Van Laer was a painter of *bamboccianti,* or street scenes with beggars, peddlers, and like subjects.

27. De Lairesse 1817, 1:286 (book 6, chap. 15). De Lairesse's complaint about gloomy skies is not the first; Van Mander reports in *Den Grondt* (8.15) that some people claimed that the Netherlanders never painted fair weather but always depicted rainy skies full of clouds (Van Mander–Miedema 1973, p. 209).

28. De Lairesse 1817, 1:286 (book 6, chap. 15); the passage on the Netherlandish painters cited from De Lairesse 1969, 1:419.

29. De Lairesse 1817, 1:287–292 (book 6, chap. 16).

30. Good examples by Van Huysum are a pair of paintings in Amsterdam, *Arcadian Landscape with Fishermen* and *Arcadian Landscape with a Sacrificial Feast;* ill. in *All the Paintings of the Rijksmuseum in Amsterdam* (Amsterdam: Rijksmuseum; Maarssen: Gary Schwartz, 1976), pp. 294–295, inv. nos. A185, A186. For De Lairesse's landscapes, see L. de Vries 1998, pp. 158–163, figs. 43–46.

31. De Lairesse 1817, 1:292–296 (book 6, chap. 17).

32. De Lairesse 1817, 1:285 (book 6, chap. 15).

33. De Lairesse 1817, 1:241 (book 6, chap. 5).

34. For the *schilderachtig* skies of Van Goyen and other landscapists, see the excellent studies by Falkenburg 1996; Falkenburg 1997.

35. Price 1810, p. 37.

36. For Craig (act. 1788–1828), see George Smith, *The Dictionary of National Biography*, ed. Leslie Stephen and Sidney Lee (London: Smith, Elder & Co., 1885–1901; reprint, Oxford: Oxford University Press, 1993), 3:1376–1377.

37. De Lairesse 1817, 2:284, 285.

38. Elsewhere Craig recommends the depiction of children in rural scenes as appropriate for the lady artist, who can add "cottage steps, broken banks, styles, gates, hovels, and rustic apartments," since "all offer materials for that sportiveness of pencil, which we have called the picturesque" (De Lairesse 1817, 2:284, 285).

39. Price 1971, 1:51 (on roughness), 1:55–57, 341 (on picturesque forms in the landscape).

40. Price 1971, 1:102ff., in an extended comparison between a beautiful and a picturesque river.

41. *A Dialogue on the Distinct Character of the Picturesque and the Beautiful* (London: printed by D. Walker for J. Robson, 1801), summarized in Hussey 1967, pp. 69–77.

42. Price 1971, 1:202; see also Hussey 1967, p. 11.

43. For the influence of Dutch painting on the development of the picturesque, see chapter 8 n. 7.

44. Price 1971, 1:325–327.

45. See Simon Schama, "Dutch Landscape: Culture as Foreground," in Amsterdam-Boston-Philadelphia 1987–88, p. 72; Emmens 1968, p. 129.

46. Bakker 1994, pp. 14, 22; Bakker 1995, pp. 150, 152; Bostoen 1994.

47. For thse drawings by Ruisdael (London, British Museum) and Hobbema (Paris, Ville de Paris, Musée du Petit Palais), see Walford 1991, pp. 126–127, figs. 130, 131 respectively.

48. Berlin, Staatliche Museen, Kupferstichkabinett, no. 5380; Gernsheim no. 49165.

49. For these drawings, see Joaneath-Ann Spicer-Durham, "The Drawings of Roelandt Savery," Ph.D. diss., Yale University, 1979, pp. 50–73. Dead and fallen trees and tree stumps were popular motifs among artists of Saverij's generation, including Jan Brueghel the Elder, Abraham Govaerts, and Alexander Keirincx; see Härting 1995, pp. 85–88. Jaromir Síp, "Savery in and around Prague," *Bul-

letin der Musée National des Beaux-Arts (Prague) 14 (1973): 69–75, esp. 71–72, notes that many of Saverij's so-called Tyrolean drawings were actually made in Bohemia in the environs of Prague.

50. See esp. Hollstein 21–22: nos. 221, 225, 234, 236.

51. Paulus van Vianen showed it from a different viewpoint in a drawing formerly in the collection Van Regteren-Altena, which he later used in a painting of a mountain landscape. Peter Stevens introduced the same building and bridge into one of his drawings, *Summer*, for a print series of the Four Seasons published by Aegidius Sadeler in 1620. See Cologne-Utrecht 1985–86, cat. no. 100; An Zwollo, "Pieter Stevens, ein vergessener Maler des Rudolfinischen Kreises," *Jahrbuch der kunsthistorischen Sammlungen in Wien* 64 (1968): 176–177, and figs. 238–240. Two other drawings, one by Van Vianen, the other attributed to Saverij, most likely show different views of the same structures (ibid., figs. 241, 242).

52. Amsterdam, Rijksmuseum, inv. no. A 2211; see Müllenmeister 1988, pp. 191–192, cat. no. 15, color pl. 5.

53. This observation made by Roethlisberger and Bok 1993, 1:137, commentary to cat. no. 89.

54. Roethlisberger and Bok 1993, 1:306, cat. no. 466, discuss this motif and its use elsewhere in Bloemaert's art. For the Berlin drawing, see Elfried Bock and Jacob Rosenberg, *Die niederländischen Meister. Beschreibendes Verzeichnis sämtlicher Zeichnungen*, 2 vols., Staatliche Museen zu Berlin. Die Zeichnungen alter Meister im Kupferstichkabinett (Berlin: Julius Bard, 1930), 1: no. 288; 2: pl. 10. In this respect, Bloemaert's interest in privies anticipates that of Hieronymus Sweerts, who later published a collection of amusing inscriptions that he encountered on walls, in toilets, and the like; see Westermann 1997, p. 108.

55. Hollstein 38–39: no. 327. I am indebted to Sabine Kretzschmar for this information.

56. Roethlisberger and Bok 1993, 1:110, cite a *ruynken* in the death inventory of Hans Brower, Utrecht, 12 October 1603 and 3 July 1607, in a "poor frame" valued at the medium sum of 16 florins; for the *Farmhouse with the Nativity* (Oslo, National Gallery), see ibid., 1: cat. no. 99; 2: fig. 174.

57. Nor is there anything suggesting the contrary in the inscription below, which speaks of the punishment of the Jews for persecuting the Christians; see Roethlisberger and Bok 1993, 1:114, cat. no. 69 for an English translation.

58. Roethlisberger and Bok 1993, 1:195–199, cat. nos. 238–249; 2: figs. 230–249. See also chapter 2 above, pp. 44–45.

59. English translation from Roethlisberger and Bok 1993, 1:196–197.

60. Junius 1588; quoted in Veldman 1977, p. 98. What is described as the man's crutch (Roethlisberger and Bok 1993, p. 197) is more likely the handle and shaft of a spade.

61. Roethlisberger and Bok 1993, 1:196.

62. Gibson 1991, p. 21, with further references.

63. Ill. in John R. Stilgoe, *Borderland: Origins of the American Suburb, 1820–1939* (New Haven and London: Yale University Press, 1988), pp. 72, 77.

64. Friedländer 1967–76, 2: pl. 76, no. 53. For the tradition of the humble life of Christ, particularly

as manifested in Protestant thought, see Robert W. Baldwin, "'On earth we are beggars, as Christ himself was': The Protestant Background of Rembrandt's Imagery of Poverty, Disability, and Begging," *Konsthistorisk tidskrift* 54 (1985): 122–135.

65. John Plummer, *The Hours of Catherine of Cleves* (New York: George Braziller, n.d.), no. 93.

66. Roethlisberger and Bok 1993, 1: cat. no. 493.

67. Hollstein 44–46: no. 923.

68. Rothlisberger and Bok 1993, 1:136–137, cat. no. 89.

69. Petrarch, *De remediis,* 2.8; Petrarch-Rawski 1991, 3:35.

70. Robert Greene, *Greene's Pandosto, or "Dorastus and Fawnia," Being the Original of Shakespeare's Winter's Tale,* ed. P. G. Thomas (New York: Duffield & Company; London: Chatto & Windus, 1907), p. 51.

71. See Rearick 1992, pp. 141–143, and figs. 4, 5. Rearick notes the ultimate influence of Dürer on Titian and suggests that Campagnola's print may represent Menalcas mourning the loss of his farm, taken from Virgil's ninth eclogue.

72. Ovid, *Metamorphose,* trans. Mary M. Innes (Baltimore: Penguin Books, 1955), p. 212 (book 8). See also Wolfgang Stechow, "The Myth of Philemon and Baucis in Art," *Journal of the Warburg and Courtauld Institutes* 4 (1940–41): 103–113.

73. Virgil, *Georgics,* 2.461–463, 500–501; see Virgil 1974, 1:149, 151.

74. Meertens 1942, pp. 48–50. The same song appears in *Kers-nacht ende de naervolgende dagen tot onse Lieve Vrouwe Lichtmis, inhoudende veele schoone kers-liedekens, enz* (Antwerp: Paulus Colpyn, [1766]), pp. 47–48, here titled "Liedeken tot vermaek van de Boeren." Cf. Edmund Spenser's *Faerie Queene* (6, canto 9, lines 16–30), in which the shepherd Meliboee invites the knight Sir Calidore into his simple "cottage clad with lome [loam]" and contrasts the "worlds gay showes" to his own life: "The fields my food, my flocke my rayment breed; / No better doe I weare, no better doe I feed."

75. Huygens 1977, p. 275, line 277; p. 262, line 254.

76. Van Mander–Miedema 1973, 1:212–215 (fols. 36v–37r, chap. 8, verses 31–32).

77. Van Mander–Miedema 1973, 2:554.

78. Emmanuel Le Roy Ladurie, *The Beggar and the Professor: A Sixteenth-Century Family Saga,* trans. Arthur Goldhammer (Chicago and London: University of Chicago Press, 1997), pp. 252–253.

79. Good examples in Hollstein 15: Bartsch 33, 46, 49.

80. Bartsch 50; see Schnackenburg 1984, pp. 35–36.

81. Roethlisberger and Bok 1993, 1:199. Three generations of print publishers named Frederick de Witt (or de Widt) are recorded in Amsterdam between 1648 and 1712 (Waller 1938, p. 495). For Danckertsz, see ibid., p. 74.

82. See chapter 2.

83. *Verscheijden ardige Lanthuijsen nae t'leven Gekonterfeijt. deur Abloemaert;* see Roethlisberger and Bok 1993, 1:199.

84. For the drawing of 1628, see Keyes 1984, cat. no. D144, fig. 146; other examples occur in D122 and D176.

85. Leeflang 1995, p. 278 and n. 19. An etching after Bloemaert shows a group of wastrels in the shadow of a large dovecote, while a man and a woman struggle within the structure; the inscription below speaks of "unstable folk" who wander across the countryside, spending their leisure time sleeping, drinking, and extorting money from the peasants; see Roethlisberger and Bok 1993, 1: no. 393; 2: fig. 554. While Roethlisberger suggests that the dovecote "has no specific meaning in this context," it may well do so in this instance.

86. For other rustic ruins in Van de Velde's landscapes, see Hollstein 33–34: nos. 227, 229, 230, 327. For the inscription, see chapter 2 above.

87. Buijsen 1996, p. 25.

88. Buijsen 1993, p. 51 and fol. 26; Leiden 1996, p. 118, cat. no. 32. Van Goyen's cavalier treatment of an existing monument has parallels elsewhere. As Seymour Slive has shown, the manor Kostverloren, on the Amstel river, was depicted by Hobbema and Jan van Kessel in its previous ruinous state even after it had been restored. See Slive 1988b, esp. p. 137.

89. Now in Los Angeles, The J. Paul Getty Museum; see Walford 1991, p. 89, fig. 80.

90. The Hague–Cambridge 1981–82, pp. 184–185, cat. no. 71. Slive suggests that the painted copies were made after Ruisdael's own painting of this motif and adds that in the eighteenth century Ruisdael's sketch was copied in a drawing by Cornelis Ploos van Amstel, engraved in turn by Cornelis Brouwer.

91. Van Mander–Miedema 1973, 1:212–213 (8:31, fol. 36v). In the margin, Van Mander refers to "*vreemde* peasant houses and shepherds' huts." Miedema translates the two terms into modern Dutch as "bizarre" and "bizarre grilligheiden."

92. Van Mander–Miedema 1994–, p. 298 (fol. 26or).

93. Giorgio Vasari, *The Lives of the Painters, Sculptors, and Architects*, trans. A. B. Hinds, 4 vols. (London and Toronto: J. M. Dent; New York: E. P. Dutton & Co., [1927]), 3:69; idem, *Opere*, ed. Gaetano Milanesi, 9 vols. (Florence: G. C. Sanoni, 1880), 5:399: "il Figliuol prodigo il quale, stando a uso di villano ginocchioni con le mani incrocicchiate, guarda il cielo, mentre certi porci mangiano in un trogolo; ed in questa sona capanne a uso di ville tedesche, bellissime." Dürer's own interest in humble ruins for their own sake appears in such works as his watercolor of a derelict mountain hut (Milan, Biblioteca Ambrosiana), probably done during his first trip to Venice; color ill. in Peter Strieder, *Albrecht Dürer: Paintings, Prints, Drawings*, trans. Nancy M. Gordon and Walter L. Strauss (New York: Abaris Books, 1982), p. 213, fig. 254. In this connection may be cited Dürer's claim that a great artist can "give evidence of his true power and 'art' in coarse and rustic things"; see Panofsky 1955, p. 275.

94. Paolo Pino, *Dialogo di pittura* (Venice: P. Gherardo, 1548; reprint, Milan: Typografia Fratelli Magnani, 1945), fol. 29v; quoted in Pardo 1984, p. 372; see also Gombrich 1971, p. 116.

95. In a dedicatory letter in his *Shepheardes Calender* (London, 1579); quoted from *The Poetical Works*

of *Edmund Spenser,* ed. with critical notes by J. C. Smith and E. de Selincourt and an introduction by E. de Selincourt (London: Oxford University Press, Humphrey Milford, 1926), p. 417.

96. Franciscus Junius, *The Literature of Classical Art, I: The Paintings of the Ancients. De Pictura Veterum According to the English Translation (1638),* 2 vols., ed. and trans. Keith Aldrich, Philipp Fehl, and Raina Fehl (Berkeley and Los Angeles: University of California Press, 1991), 1:279–280; see also Levesque 1994, p. 106.

97. De Klerk 1982, p. 51.

98. De Klerk 1982, p. 51.

99. In the preliminary drawing now in Haarlem (Rijksarchief), the top of the tree has been clearly cut back, or pollarded; this is not so evident in the print. See Peeters and Schmitz 1997, p. 41, figs. 6, 7.

100. Inv. no. 1247; see *Catalogus schilderijen tot 1800* (Rotterdam: Museum Boijmans Van Beuningen, 1962), p. 57; ill. in Beck 1972–87, 2:522, cat. no. 1206.

101. Leiden, Stedelijk Museum de Lakenhal, inv. no. B1306, on loan from the Rijksdienst Beeldende Kunst; ill. in Tokyo-Kasama-Kumamoto-Leiden 1992–93, p. 78, cat. no. 17.

102. For another example, see Walther Bernt, *The Netherlandish Painters of the Seventeenth Century,* 3 vols. (London and New York: Phaidon, 1970), 3: fig. 1448, apparently signed by Wijntrack alone, but possibly with Wijnant's participation. Several of Wijnant's landscapes with prominently placed dead or dying trees are ill. in ibid., figs. 1445, 1446.

103. See the examples in *Adriaen Brouwer, David Teniers the Younger: A Loan Exhibition of Paintings,* introduction and catalogue by Margret Klinge (New York and Maastricht: Noortman & Brod, 1982), cat. nos. 1–9. For *Malle Bobbe,* see Washington-London-Haarlem 1989–90, cat. no. 37. Similar visual considerations, along with possible iconographic significance, may have prompted the occasional inclusion of broken objects in the monochrome still lifes of the earlier seventeenth century, as, for example, in a picture of 1634 by Willem Claesz Heda (Rotterdam, Museum Boijmans Van Beuningen; inv. no. 1286), in which light reflects dramatically along the broken edge of a glass vessel.

104. Heinrich Wölfflin, *Principles of Art History: The Problem of the Development of Style in Later Art* (1915), trans. M. D. Hottinger (New York: Dover Publications, n.d.).

105. See, for example, Hussey 1967, pp. 185–186, who nonetheless admits that "such speculation is at present too conjectural to pursue."

106. Bakker 1994; Bakker 1995.

107. Van Mander–Micdema 1973, 80–81, verses 28, 29 (fol. 3v). See Bakker 1995, 149.

108. Bakker 1995, p. 151.

109. Van Mander–Miedema 1994–, 1:285 (fol. 256v); see also p. 309 (fol. 262v), for a similar characterization of Joris Hoefnagel's book of city views.

110. G. A. Bredero, *Geestigh liedt-boecxken* (1618); quoted in Bakker 1995, p. 152; see also Bostoen 1994 for Bredero and the *Schilderachtig.*

111. G. A. Bredero, *De Spaanschen Brabanter* (1618); quoted in Bakker 1995, p. 152.

112. Constantijn Huygens, *Ooghen-troost*, ed. with commentary by F. L. Zwaan (Groningen: Wolters Noordhoff / Bouma's Boekhuis, 1984), p. 74. See also Schenkveld-van der Dussen 1986, p. 74.

113. Bakker 1995, p. 153.

114. Huygens 1994, pp. 78–79. Bakker plausibly suggests that in the *Ooghentroost* Huygens may have simply been indulging in pious wordplay, appropriate in a poem of consolation written for a woman who was facing increasing blindness.

115. Goeree 1974; see the quotations in Bakker 1995, p. 153 n. 24.

116. *Poësy van Jan Six van Chandlier* (Amsterdam, 1657); quoted in Blommendaal n.d., p. 18. Cf. Johann van Heemskerck, who characterizes Jacob Cats as a *schilderachtigen schrijver* (picturesque or pictorial writer) who has painted folk customs in the most attractive manner (*Bativische Arcadia*, p. 39; quoted in Bakker 1995, p. 152 n. 22).

117. Hoogstraeten 1969, p. 138.

118. Goeree 1974, pp. 21–22; see also Bakker 1995, pp. 153–154, from which the English translation has been taken. This passage, incidentally, follows a discussion of the depiction of "unnatural" things, such as monsters and flying horses.

119. Emmens 1968, pp. 128–129, fig. 14; Bakker 1995, pp. 158–159, fig. 5.

120. Emmens 1968, p. 129.

121. For Anslo, see Schenkveld-van der Dussen 1988, pp. 73–74; and esp. Leeflang 1988, pp. 8–9, who also quotes a similar passage from Vondel; both poets maintain, however, that no artist can compete with God. For Poot's poem, "Mei," see *Gedichten van Hubert Korneliszoon Poot*, 3d ed., 3 vols. (Leiden: C. Van Hoogeveen, Jr., 1766), 3:93–38; quoted in Beening 1963, p. 441. In Jan van Westerhoven's *Schepper verheerlijckt in de schepselen* (1685), another celebration of Haarlem's environs, God is compared to an artist who seeks praise with his creation (Leeflang 1997, p. 100). For other examples, see Freedberg 1980, p. 17.

122. Hoogstraeten 1969, p. 136.

123. Bakker 1995, p. 154.

124. H. M. van den Berg, "Willem Schellinks en Lambert Doomer in Frankrijk," *Oudhiedkundig Jaarboek* 11 (1942): 2, 15, 19 respectively. See also Bakker 1995, p. 154.

125. *Journaal van Constantijn Huygens, den zoon, van 21 October 1688 tot 2 Sept. 1696. Handschrift van de Koninklijke Akademie van Wetenschappen te Amsterdam*, vol. 1, Werken uitgegeven door het Historisch Genootschap gevestigd te Utrecht, Nieuwe Reeks, no. 23 (Utrecht: Keminck & Zoon, 1876). The word *schilderachtig* occurs on pp. 26, 29 (England) and 461, 480 (Belgium); on p. 318, the same term characterizes some *seequabben* (possibly jellyfish). I am greatly indebted to Katharine Fremantle for extracting these entries for me, as well as suggesting the reading for *seequabben*.

126. Huygens 1994, p. 71. For the training of Constantijn the Younger, see Heijbroek 1983, p. 12.

127. Heijbroek 1983.

128. Houbraken 1943–53, 1:57 and 158 respectively, the latter in the life of Lucas van Uden; quoted in

Blommendaal, n.d., p. 34. In his account of Aelbert Cuyp (1:249), Houbraken also speaks of the *schilderagstigste* [*sic*] horses; Blommendaal (p. 25) rightly says that the word here means "most beautiful."

129. William Sewell, *Volkomen Woordenboek der Nederduitsche en Engelsche taalen. A Compleat Dictionary Dutch and English*, 2 vols., rev. Egbert Buys (Amsterdam: Kornelis de Veer, 1766), 2:705. I am grateful to Katharine Fremantle for calling this work to my attention.

130. It is often thought that the English *picturesque* was derived from the Italian *pitoresco*, which refers either to a "painterly" manner of execution or a "picturesque" motif or composition. In his *Essay on the Picturesque as compared with the Sublime and the Beautiful . . .* , 2 vols. (London: Hereford, 1794), 1:54–55, Uvedale Price claimed that the French *pittoresque* had been derived from the Italian term, but not necessarily the English word, although he is not entirely clear on this point. See Sohm 1991, p. 240 n. 1.

131. For a chronological list of citations of *schilderachtig* from 1774 to 1941, see Willem-Jan Pantus, "'In schilderchtige schakeering.' Over de ontwikkeling van de termen 'schilderachtig' en 'pittoresk' in de Nederlandstalige kunstliteratuur sinds de romantiek," in Van Eck, Van den Eynde, and Van Leeuwen 1994, pp. 66–71.

132. For later developments, see Minneapolis-Toledo-Philadelphia 1971–72; Slive 1995, pp. 306–327. Exceptions include the caricatural peasant subjects of Cornelis Bega and esp. Cornelis Dusart, for which, see Hollstein 1:203–232 and 6:45–84, respectively.

133. For Huygens, see p. 147 above.

134. Jan de Brune de Jonge, *Alle Volgeestige Werken*, 2d ed., 3 vols. (Amsterdam: B. Boekholt, 1681), p. 304 (in his *Wetsteen der Vernuften*, 2 pts., first published 1644–59), quoted in Emmens 1968, p. 130; the original Dutch text may be translated roughly as "We listen with an extraordinary enjoyment to a pretended scream, but nonetheless we shrink from real weeping."

Conclusion

Epigraph: In De Lairesse 1817, 2:284.

1. An exception is Pieter de Molijn, who was born in London in 1595 of Flemish parents; however, he was in Haarlem by 1616 (Amsterdam-Boston-Philadelphia 1987–88, p. 374).

2. Norgate 1997, p. 87, see also pp. 168–169 n. 174. Norgate speaks thus of aerial perspective: "of the same temper must the Trees be made (I meane the furthest from sight) and as they grow nearer, darker, and greener, and stronger. The same for *Rocks, Buildings*, or any other as fields, highwayes, &c., Remembring ever that Lanscape is nothing but *Deceptio visus* [deceptive vision], a kind of cousning or cheating your owne Eyes, by your owne consent and assistance, and by a plot of your owne contriving, together with an apt accomodation of Colours, lights, and shadowes, that make grounds seeme neere or farre off, according to those representations you find in your owne fancy."

3. For similar observations, see Adams 1994; Falkenburg 1989, p. 140.

4. John Milton, *L'Allegro,* lines 97–98; see *The Complete Poetry of John Milton,* ed. John Shawcross, rev. ed. (Garden City, N.Y.: Anchor Books, Doubleday & Company, 1971), p. 109.

5. For this series, see chapter 3 n. 74 above. A group of Mirou's drawings for this series, some dated 1615, as well as others in the same format, are now in Budapest; see Gerzi 1971, 1: cat. nos. 192–199. A Flemish artist who seems to have worked for a time in Frankenthal, Mirou deserves further study for his role in the dissemination of the Dutch rustic landscape style elsewhere in Europe.

6. Washington album, nos. 134–138, before the addition of place-names and the address of Peter Isselburg; for the second state, see Wüthrich 1966–96, 1: cat. nos. 22–39, figs. 105–118.

7. The Dutch influence on later landscapists has often been studied; see, for example, Petra Ten-Doesschate Chu, *French Realism and the Dutch Masters* (Utrecht: Haentjes Dekker & Gumbert, 1974), pp. 18–31; *Schok der herkenning. Het Engelse landschap der romantiek en zijn Hollandse inspiratie/"Shock of Recognition": The Landscape of English Romanticism and the Dutch Seventeenth-Century School* (The Hague, Mauritshuis; London, Tate Gallery, 1970). The expression "day in the country" is borrowed from the exhibition catalogue, *A Day in the Country: Impressionism and the French Landscape* (Los Angeles County Museum of Art; The Art Institute of Chicago; Paris, Réunion des Musées Nationaux, 1984), which examines these landscapes in a socio-ideological context.

8. For this work, now in the Toledo Museum of Art, see *François Boucher* (New York: The Metropolitan Museum of Art; The Detroit Institute of Arts; Paris, Réunion des Musées Nationaux, 1986), pp. 280–283, cat. no. 69. For Boucher's familiarity with Bloemaert's work, see Regina Schoolman Slatkin, "Abraham Bloemaert and François Boucher—Affinity and Relationship," *Master Drawings* 14 (1976): 247–260. As early as 1734 Boucher had copied the Bloemaert landscape now in the Centraal Museum, Utrecht (ibid., p. 256). Boucher was not alone in his regard for Bloemaert. For the latter's influence, through a Saenredam print, on a painting by Watteau, see Amsterdam, 1993–94, pp. 645–666.

9. Graham Reynolds, *Constable's England* (New York: The Metropolitan Museum of Art, 1983); William S. Talbot, *Jasper F. Cropsey, 1823–1900* (New York: Garland Publishing, 1977), pp. 209–211, 457–458, cat. no. 195; now in the Chrysler Museum, Norfolk, Virginia, the landscape enjoyed enormous popularity, to judge from its many reproductions, one still available as late as 1967 (Talbot, p. 211 and n. 45). A smaller version, dated 1879, is in the Mead Art Museum, Amherst College.

10. In this connection can be cited the illuminating survey conducted at the National Gallery, London, of reproductions after Constable's *Cornfield;* see Colin Painter, *At Home with Constable's Cornfield,* with photographs by Anne Painter (London: National Gallery Publications, 1996). Aside from postcards and color prints, the painting has been reproduced, sometimes only in part, in many forms, including on jewelry, tin boxes, and wallpaper, as well as in needlepoint.

Select Bibliography

book*Books and Articles*

ography*Books and Articles*

Adams 1994. Adams, Ann Jensen. "Competing Communities in the 'Great Bog of Europe.' Identity and Seventeenth-Century Dutch Landscape Painting." In *Landscape and Power*, edited by W. J. T. Mitchell, pp. 35–76. Chicago and London: Chicago University Press.

Alberti 1988. Alberti, Leon Battista. *On the Art of Building in Ten Books*. Translated by Joseph Rykwert, Neil Leach, and Robert Tavernor. Cambridge, Mass., London: The MIT Press.

Allart 1991–92. Allart, Dominique. "La Peinture de paysage anversoise dans l'orbite de Pieter Bruegel l'Ancien: Contribution à l'étude de la thématique paysagiste au XVIe siècle." 2 vols. Ph.D. dissertation, Université de Liège.

Alpers 1996. Alpers, Paul. *What Is Pastoral?* Chicago and London: The University of Chicago Press.

Ampzing 1974. Ampzing, Samuel. *Beschrijvinge ende lof der stad Haerlem in Holland*. Haarlem: Adriaen Roomen. 1628. Facsimile edition. Introduction by Gerda Kurtz. Amsterdam: N. V. Buijten and Schipperheijn / Repro-Holland.

Amsterdamsche Pegasus 1627. *Amsterdamsche Pegasus*. Amsterdam: Cornelis Willemsz Blaeu-Laken.

Van Anrooij 1993. Van Anrooij, W. "Middeleeuwse sporen van de Haarlemse Damiate-legende." In Grootes 1993, pp. 11–25.

Ashton, Davies, and Slive 1982. Ashton, Peter, Alice B. Davies, and Seymour Slive. "Jacob van Ruisdael's Trees." *Arnoldia* 42: 2–31.

Bakker 1990. Bakker, Boudewijn. "Langhuis and Stolp: Rembrandt's Farm Drawings and Prints." In Washington 1990, pp. 33–59.

Bakker 1993. ———. "Levenspilgrimage of vrome wandeling? Claes Janszoon Visscher en zijn serie *Plaisante Plaetsen*." *Oud Holland* 107: 97–116.

Bakker 1994. ———. "'Schilderachtige': discussies over term en begrip in de zeventiende eeuw." In Van Eck, Van den Eynde, and Van Leeuwen 1994, pp. 11–24.

Bakker 1995. ———. "*Schilderachtig:* Discussions of a Seventeenth-Century Term and Concept." *Simiolus* 23: 147–162.

Bakker and Leeflang 1993. Bakker, Boudewijn, and Huigen Leeflang. *Nederland naar't leven. Landschapsprenten uit de Gouden eeuw.* Zwolle: Waanders Uitgevers; Amsterdam: Museum het Rembrandtshuis.

Bakker et al. 1998–99. Bakker, Boudewijn, Mària van Berge-Gebaud, Erik Schmitz, and Jan Peeters. *Landscapes of Rembrandt: His Favorite Walks.* Bussum: Thoth Publishers; Amsterdam: Gemeentearchief; Paris: Fondation Custodia. Published to coincide with the exhibition *Landscapes of Rembrandt—His Favorite Walks around Amsterdam.*

Van Bastelaer–Gilchrist 1992. Van Bastelaer, René. *The Prints of Pieter Bruegel the Elder. Catalogue Raisonné. New Edition.* Translated and revised by Susan Fargo Gilchrist. San Francisco: Alan Wolfsy Fine Arts. First edition, *Les estampes de Pierre l'Ancien.* Brussels: G. Van Oost & Co., 1908.

Beck 1993. Beck, David. *Spiegel van mijn leven: een Haags dagboek uit 1624.* Edited by Sv. E. Veldhuijzen. Ecodocumenten, 3. Hilversum: Verloren.

Beck 1972–91. Beck, Hans-Ulrich. *Jan van Goyen (1596–1656).* 4 vols. Amsterdam and Doornspijk: Van Gendt et al.

Bedaux 1990. Bedaux, Jean Baptist. "The Reality of Symbols: The Question of Disguised Symbolism in Jan van Eyck's *Arnolfini-portrait*." In *The Reality of Symbols.* The Hague: Gary Schwartz, pp. 21–69. First published in *Simiolus* 16 (1986): 5–28.

Beening 1963. Beening, Theo Jan. *Het landschap in de Nederlandse letterkunde van de Renaissance.* Ph.D. dissertation, Universiteit te Nijmegen, 1963.

Benjamin 1976. Benjamin, Lloyd. "Disguised Symbolism Exposed and the History of Early Netherlandish Painting." *Studies in Iconography* 2: 11–24.

Van den Berg 1986. Van den Berg, J. "De plaats van de kerkgeschiedenis in het geheel van de geschiedsbeoefening." *De zeventiende eeuw* 2: 75–86.

De Bertier de Sauvigny 1991. De Bertier de Sauvigy, Reine. *Jacob et Abel Grimmer: Catalogue raisonné.* N.p.: La Renaissance du livre.

Białostocki 1984. Białostocki, Jan. "Einfache Nachahmung der Natur oder symbolische Weltschau. Zu den Deutungsproblemen der holländischen Malerei des 17. Jhdt." *Zeitschrift für Kunstgeschichte* 47: 421–438. English translation in Białostocki 1988.

Białostocki 1988. ———. "Mere Imitation of Nature or Symbolic Image of the World? Problems in the Interpretation of Dutch Painting of the Seventeenth Century." In *The Message of Images: Studies in the History of Art*, pp. 166–180, 271–273. Vienna: Irsa. English translation of Białostocki 1984.

Bierens de Haan 1948. Bierens de Haan, J. C. *L'œuvre gravé de Cornelis Cort, graveur hollandais, 1533–1578.* The Hague: Martinus Nijhoff.

Biesboer 1996. Biesboer, P. "De Vlaamse immigranten in Haarlem 1578–1630 en hun nakomelingen." In Biesboer et al. 1996, pp. 35–60.

Biesboer et al. 1996. Biesboer, P., G. Th. Kolthof, H. Rau, J. J. Temminck, and J. B. Uttenhout. *Vlamingen in Haarlem.* Serie Haarlemse miniaturen, 37. Haarlem: De Vriesborch.

De Bièvre 1988. De Bièvre, Elisabeth. "Violence and Virtue: History and Art in the City of Haarlem." *Art History* 11: 303–333.

Blankert 1978. Blankert, Albert. *Nederlandse 17e eeuwse Italianiserende landschapschilders.* Soest: Davaco. 2d revised edition of Utrecht 1975.

Blommendaal n.d. Blommendaal, Jan Leopold Peter. "Een scriptie over het gebruik van het word 'schilderachtig' in het Nederlands van 1600–1750." Thesis, Universiteit van Utrecht [c. 1980].

Bok 1994. Bok, Marten Jan. *Vraag en aanbod op de Nederlandse kunstmarkt, 1580–1700. Supply and Demand in the Dutch Art Market, 1580–1700.* Ph.D. dissertation, Universiteit van Utrecht.

Bok 1994–95. ———. "Art-Lovers and Their Paintings: Van Mander's Schilder-boeck as a Source for the History of the Art Market in the Northern Netherlands." In Amsterdam 1993–94, pp. 136–166.

Bostoen 1994. Bostoen, Karel. "Niet met de werf, maar met woorden. Het 'schilderachtige' van de knikkerscene in de *Spaanschen Brabander.*" In Van Eyck, Van den Eynde, and Van Leeuwen 1994, pp. 25–33.

Boxer 1990. Boxer, C. R. *The Dutch Seaborne Empire, 1600–1800.* 1965. London: Penguin Books.

Bredero n.d. Bredero, Gebrandt Adriaensz. *G. A. Bredero's Kluchten.* Edited by C. Kruyskamp. Zutphen: P. J. Thieme and Cie, n.d. First edition, Amsterdam: For Cornelis Lodewijcksz vander Plasse.

Bredero 1982. ———. *The Spanish Brabanter: A Seventeenth-Century Dutch Social Satire in Five Acts.* Translated by H. David Brumble III. Medieval and Renaissance Texts and Studies, 2. Binghamton, N.Y.: Center for Medieval and Renaissance Texts and Studies.

Bredero 1986. ———. *G. A. Bredero's verspreid werk.* Edited by G. Stuiveling and B. C. Damsteegt. Leiden: Martinus Nijhoff.

Briels 1978. Briels, J. *Zuid-Nederlandse immigratie, 1572–1630.* Haarlem: Fibula-Van Dishoeck.

Briels 1985. ———. *Zuid-Nederlanders in de republiek, 1572–1630: Een demografische en cultuurhistorische studie.* Sint-Niklaas: Danthe.

Briels 1987. ———. *Vlaamse schilders in de Noordlijke Nederlanden in het begin van de Gouden Eeuw, 1585–1630.* Antwerp: Mercator Fonds.

Bright 1940. Bright, Timothie. *A Treatise of Melancholie by T. Bright. Reproduced from the 1586 Edition Printed by Thomas Vautrollier.* Introduction by Harden Craig. New York: Columbia University Press for the Facsimile Text Society.

Brown 1984. Brown, Christopher. *Images of a Golden Past: Dutch Genre Painting of the Seventeenth Century*. New York: Abbeville Publishers.

Brown 1988. ————. Review of Amsterdam-Boston-Philadelphia 1987–88. In *Simiolus* 18: 76–81.

Brown 1996. ————. *Rubens's Landscapes: Making and Meaning*. London: National Gallery Publications. Distributed by Yale University Press, New Haven.

Brumble 1979. Brumble, H. David, III. "Pieter Brueghel the Elder: The Allegory of Landscape." *Art Quarterly*, n.s., 2: 125–139.

Brusewicz 1982. Brusewicz, Lech. "On the Perception of Paintings in Seventeenth-Century Holland." *Bulletin du Musée National de Varsovie* 23: 1–24.

Bruyn 1987–88. Bruyn, Josua. "Toward a Scriptural Reading of Seventeenth-Century Dutch Landscape Paintings." In Amsterdam-Boston-Philadelphia 1987–88, pp. 84–120.

Bruyn 1994. ————. "Le paysage hollandais du XVIIe siècle comme métaphor religieuse." In *Le paysage en Europe du XVIe au XVIIIe siècle. Actes du colloque organisé au Musée du Louvre par le Service culturel du 25 au 27 janvier 1990*, edited by Catherine Legrand and Jean-François Méjanès, pp. 67–88. Paris: Éditions de la Réunion des Musées Nationaux, 1994.

Van Bueren 1993. Van Bueren, Truus. *Tot lof van Haarlem. Het beleid van de stad Haarlem ten aanzien van de kunstwerken uit de geconfisqueerde geestelijke instellingen*. Amsterdamse historische reeks, Grote serie, 17. Hilversum: Verloren.

Buijsen 1993. Buijsen, Edwin. *The Sketchbook of Jan van Goyen from the Bredius-Kronig Collection*. The Hague: The Foundation "Bredius Genootschap."

Buijsen 1996. ————. "De schetsboeken van Jan van Goyen." In Leiden 1996, pp. 22–37.

Bunyan 1957. Bunyan, John. *The Pilgrim's Progress*. Introduction by Alexander M. Witherspoon. New York: Pocket Books, Washington Square Press.

Burke 1974. Burke, James D. "Ruisdael and His Haarlempjes." *A Quarterly Review of the Montreal Museum of Fine Arts* 6: 3–11.

Burton 1927. Burton, Robert. *The Anatomy of Melancholy*. Edited by Floyd Dell and Paul Jordan-Smith. New York: Tudor Publishing Company.

Büttner and Unverfehrt. 1993. Büttner, Nils, and Gerd Unverfehrt. *Jacob van Ruisdael in Bentheim. Ein niederländischer Maler und die Burg Bentheim im 17. Jahrhundert*. Herausgegaben vom Landkreis Grafschaft Bentheim und vom Museumsverein für die Grafschaft Bentheim. Bielefeld: Verlag für Regionalgeschichte.

Cafritz 1988a. Cafritz, Robert C. "Netherlandish Reflections of the Venetian Landscape Tradition." In Washington 1988, pp. 112–129.

Cafritz 1988b. ————. "Reverberations of Venetian Graphics in Rembrandt's Pastoral Landscapes." In Washington 1988, pp. 130–147.

Calkins 1995. Calkins, Robert G. "Secular Objects and Their Implications in Early Netherlandish Painting." In *Art into Life: Collected Papers from the Kresge Art Museum Medieval Symposia*. Edited by Carol Garrett Fisher and Kathleen L. Scott, pp. 183–211. East Lansing: Michigan State University Press.

Carasso 1992. Carasso, Dedalo. "Duitse en Franse denkers over de zeventiende-eeuwse Nederlandse schilderkunst." In Grijzenhout and Van Veen 1992, pp. 161–192.

Cervantes 1972. Cervantes Saavedra, Miguel de. *Exemplary Stories*. Translated by C. A. Jones. Harmondsworth: Penguin Books.

Chong 1987. Chong, Alan. "The Market for Landscape Paintings in Seventeenth-Century Holland." In Amsterdam-Boston-Philadelphia 1987–88, pp. 104–120.

Chong 1992. ———. "Aelbert Cuyp and the Meaning of Landscape." Ph.D. dissertation, New York University.

Chong 1997. ———. "Landscape." In *Dutch Art: An Encyclopedia*. Edited by Sheila D. Muller, pp. 213–216. New York and London: Garland Publishing.

Claesz 1609. Claesz, Cornelis. *Constende Caert-Register, In Welcke gheteyckent staen alderhande sorten van Caerten ende Mappen des gantschen Aertbodems groot ende cleyn. Oock een yder Landtschaps ende Coninghrijker ghedeelde besonder . . . Noch zijn hier by-ghevoeght alle de Printen ende Coper-stucken van de beroemste Meesters: Welckers Platen alle by* Cornelis Claesz. *te beccomem ende daghelijcx tot zijne groote costen ghedruckt worden.* Amsterdam: Cornelis Claesz. Unique copy in Wolfenbüttel, Herzog August Bibliothek, Bc Sammelband 10 (2).

Classen 1991. Classen, C. Joachim. "Lodovico Guicciardini's *Descrittione* and the Tradition of the Laudes and Descriptiones Urbum." In *Actes du colloque international: Travaux de l'Institut Interuniversitaire pour l'étude de la Renaissance et de l'Humanisme, Université Libre de Bruxelles*, pp. 99–117. Brussels: Peeters.

Clive 1961. Clive, H. P. "The Calvinists and the Question of Dancing in the Sixteenth Century." *Bibliothèque d'Humanisme et Renaissance, Travaux et Documents* 23: 296–323.

Coelen 1995. Coelen, Peter van der. "Cornelis Bos—Where Did He Go? Some New Discoveries and Hypotheses about a Sixteenth-Century Engraver and Publisher." *Simiolus* 23: 119–146.

Davies 1972. Davies, Alice B. "Allart van Everdingen's Drawings of the Twelve Months." *Register of the Museum of Art, the University of Kansas* 4, no. 9 (Winter): unpaginated.

Davis 1965. Davis, Natalie Zemon. *Society and Culture in Early Modern France: Eight Essays*. Stanford, Calif.: Stanford University Press.

Dekker 1997. Dekker, Rudolf. *Lachen in de Gouden Eeuw: Een geschiedenis van de Nederlandse humor*. Amsterdam: Wereldbibliotheek.

Delen 1930. Delen, A. J. J. *Iconographie van Antwerpen*. Brussels: L. J. Kryn.

Demetz 1963. Demetz, Peter. "Defenses of Dutch Painting and the Theories of Realism." *Comparative Literature* 15: 97–115.

Van Deursen 1991. Van Deursen, A. Th. *Plain Lives in a Golden Age: Popular Culture, Religion, and Society in Seventeenth-Century Holland*. Cambridge: Cambridge University Press.

Dixon 1995. Dixon, Laurinda S. *Perilous Chastity: Women and Illness in Pre-Enlightenment Art and Medicine*. Ithaca and London: Cornell University Press.

Dreher 1978a. Dreher, Faith Paulette. "The Vision of Country Life in the Paintings of David Teniers II." Ph.D. dissertation, Columbia University.

Dreher 1978b. ———. "The Artist as Seigneur: Chateaux and Their Proprietors in the Work of David Teniers II." *Art Bulletin* 60, no. 4 (December): 682–703.

Duke 1990a. Duke, Alistair. "The Reformation of the Backwoods: The Struggle for a Calvinist and Presbyterian Church Order in the Countryside of South Holland and Utrecht before 1620." In *Reformation and Revolt in the Low Countries,* pp. 227–268. London and Ronceverte: The Hambledon Press.

Duke 1990b. ———. "The Ambivalent Face of Calvinism in the Netherlands, 1561–1618." In *Reformation and Revolt in the Low Countries,* pp. 269–293. London and Ronceverte: The Hambledon Press.

Dumas 1991. Dumas, Charles. *Haagse stadsgezichten, 1550–1800: Topografische schilderijen van het Haags Historich Museum.* Zwolle: Waanders.

Duverger 1984. Duverger, Erik. *Antwerpse kunstinventarissen uit de zeventiende eeuw, I: 1600–1617.* Fontes historiae artis neerlandericae, 1. Brussels: Koninklijke Academie voor Wetenschappen, Letteren en Schone Kunsten van België.

Van Eck, Van den Eynde, and Van Leeuwen 1994. Van Eck, Caroline, Jeroen van den Eynde, and Wilifred van Leeuwen, eds. *Het Schilderachtige: Studies over het schilderachtige in de Nedrlandse kunsttheorie en architectuur, 1650–1900.* Amsterdam: Architectura and Natura Pers.

Van Eeghen 1990. Van Eeghen, I. H. "De familie van de plaatsnijder Claes Jansz. Visscher." *Maanblad Amstelodamum* 77: 73–82.

Eisler 1914. Eisler, M. *Die Geschichte eines holländischen Stadtsbildes (Kultur und Kunst).* The Hague: Martinus Nijhoff.

Elias 1903–5. Elias, Johan E. *De vroedschap van Amsterdam, 1578–1795.* 3 vols. Haarlem: Vincent Loosjes.

Emmens 1968. Emmens, J. A. *Rembrandt en de regels van de kunst.* Utrechtse Kunsthistorische Studiën X. Utrecht: Dekker and Gumbert, 1968.

Enkhuizen 1994. *Enkhuizen en het grootslag. Twee schilderijen bekeken.* [Enkhuizen]: Vereniging Oud Enkhuizen.

Ertz 1979. Ertz, Klaus. *Jan Brueghel der Ältere (1568–1625): Die Gemälde mit kritischem Œuvrekatalog.* Cologne: Dumont.

Ertz 1986. ———. *Josse de Momper der Jüngere (1564–1645): Die Gemälde mit kritischem Œuvrekatalog. The Paintings with Critical Catalogue raisonné. With English-Language Summary.* Freren: Luca Verlag.

Evelyn [1907]. *The Diary of John Evelyn.* Edited by George W. E. Russell. 2 vols. New York: E. P. Dutton; London: J. M. Dent.

Falkenburg 1988. Falkenburg, Reindert L. *Joachim Patinir: Landscape as an Image of the Pilgrimage of Life.* Translated by Michael Hoyle. Amsterdam and Philadelphia: John Benjamins Publishing Company. A translation of his "Joachim Patinir: het landschap als beeld van de levenspilgrimage," Ph.D. dissertation, Universiteit van Amsterdam, 1985.

Falkenburg 1989. ———. "De betekenis van de geschilderde Hollandse landschap van de zeventiende eeuw: een beschouwing naaar aanleiding van enkele recente interpretaties." *Theoretische geschiedenis* 16: 131–153.

Falkenburg 1996. ———. "'Schilderachtig weer' bij Jan van Goyen." In Leiden 1996, pp. 60–69.

Falkenburg 1997. ———. "Onweer bij Jan van Goyen. Artistieke wedijver en de markt voor het Hollandse landschap in de 17de eeuw." *Het landschap in de Nederlandse kunst, 1500–1850. Nederlands Kunsthistorisch Jaarboek* 14: 117–161.

Falkenburg 1999. ———. "Calvinism and the Emergence of Dutch Seventeenth-Century Landscape Art—a Critical Evaluation." In *Seeing Beyond the Word: Visual Arts and the Calvinist Tradition,* edited by Paul Corby Fulley, pp. 301–318. Grand Rapids, Mich.: William B. Eerdmans Publishing Co.

Ficino 1989. Ficino, Marsilio. *Three Books on Life.* Translated and edited by Carol V. Kaske and John R. Clark. Medieval and Renaissance Texts and Studies. Binghamton, N.Y.: Medieval and Renaissance Texts and Studies in conjunction with the Renaissance Society of America.

Filedt Kok 1991–92. Filedt Kok, Jan Piet. "Hendrick Goltzius—Engraver, Designer, and Publisher, 1582–1600." In *Goltzius Studies: Hendrick Goltzius (1558–1617). Nederlands Kunsthistorisch Jaarboek* 42–43: 159–218.

Filedt Kok 1994–95. ———. "Jan Harmensz Muller as Printmaker—I–III." *Print Quarterly* 11 (1994): 223–264 (with Erik Hinterding and Jan van der Waals); 11 (1994): 351–378; 12 (1995): 3–29.

Filedt Kok 1996a. Filedt Kok, Jan Piet, with Bart Cornelis and Anneloes Smit. *Lucas van Leyden: The New Hollstein Dutch and Flemish Etchings, Engravings, and Woodcuts, 1450–1700.* Edited by Ger Luijten. Rotterdam and Amsterdam: Sound & Vision Interactive, in cooperation with the Rijksprentenkabinet, Amsterdam.

Filedt Kok 1996b. Filedt Kok, Jan Piet. "Artists Portrayed by Their Friends: Goltzius and His Circle." In *Ten Essays for a Friend: E. De Jongh 65. Simiolus* 24, nos. 2–3: 59–79.

Franits 1983–85. Franits, Wayne. "The Relationship between Emblems and Dutch Paintings of the Seventeenth Century." *Marsyas* 22: 25–32.

Franits 1994. ———. "Between Positivism and Nihilism: Some Thoughts on the Interpretation of Seventeenth-Century Dutch Paintings." *Theoretisch geschiedenis* 21: 123–131.

Franits 1997. ———, ed. *Looking at Seventeenth-Century Dutch Art: Realism Reconsidered.* Cambridge: Cambridge University Press.

Franz 1969a. Franz, Heinrich Gerhard. "Unbekannte Landschaftszeichnungen von Jacob Grimmer." *Pantheon* 27: 213–223.

Franz 1969b. ———. *Niederländische Landschaftsmalerei im Zeitalter des Manierismus.* 2 vols. Graz: Akademische Druck und Verlaganstalt.

Franz 1988. ———. "Hans Bol (1534–1593). Entwurfs-Zeichnungen zur grossen Landschaftsfolge von 1562." *Weltkunst* 58: 101–104.

Freedberg 1980. Freedberg, David. *Dutch Landscape Prints of the Seventeenth Century.* London: Colonnade Books, British Museum Publications.

Freedberg and De Vries 1991. Freedberg, David, and Jan De Vries, eds. *Art in History. History in Art. Stud-*

ies in Seventeenth-Century Dutch Culture: Issues and Debates. Santa Monica, Calif.: The Getty Center for the History of Art and the Humanities.

Friedländer 1967–76. Friedländer, Max J. *Early Netherlandish Painting*. 14 vols. Leiden: A. W. Sijthoff; Brussels: Editions de la Connoissance.

Frugoni 1991. Frugoni, Chiari. *A Distant City: Images of Urban Experience in the Medieval World*. Princeton, N.J.: Princeton University Press.

Van Gelder and Jost 1985. Van Gelder, J. G., and Ingrid Jost. *Jan de Bisschop and His Icones and Paradigmata*. Edited by Keith Andrews. 2 vols. Doornspijk: Davaco.

Gelderblom 1994. Gelderblom, Arie Jan, ed. *'k Wil rijmen wat ik bouw. Twee eeuwen topografische poëzie*. Amsterdam: Griffioen.

Gerzi 1971. Gerzi, Teréz. *Netherlandish Drawings in the Budapest Museum: Sixteenth-Century Drawings*. 2 vols. Amsterdam: Van Gendt and Co.; New York: Abner Schramm.

Geyl 1930. Geyl, Pieter. "De protestantiseering van Noord-Nederland." *Leiding* 1: 113–123.

Gibson 1987. Gibson, Walter S. "Landscape Drawings in the Age of Bruegel: Their Changing Form and Function." *Drawing* 9: 49–54.

Gibson 1989a. ———. *"Mirror of the Earth": The World Landscape in Sixteenth-Century Flemish Painting*. Princeton, N.J.: Princeton University Press.

Gibson 1989b. ———. Review of Falkenburg 1988. *Oud Holland* 103: 249–252.

Gibson 1990. ———. "'Pleasant Places': Some Dutch Drawings in the Cleveland Museum of Art and Their Antecedents." *Drawing* 11: 25–29.

Gibson 1991. ———. "Bruegel and the Peasants: A Problem of Interpretation." In *Pieter Bruegel the Elder: Two Studies*. The Franklin D. Murphy Lectures 11, The University of Kansas, pp. 11–52. Lawrence: Spencer Museum of Art and The University of Kansas.

Goedde 1989. Goedde, Lawrence Otto. *Tempest and Shipwreck in Dutch and Flemish Art: Convention, Rhetoric, and Interpretation*. University Park and London: The Pennsylvania State University Press.

Goedde 1997. ———. "Naturalism as Convention: Subject, Style, and Artistic Self-Consciousness in Dutch Landscape." In Franits 1997, pp. 129–143.

Goeree 1974. Goeree, Willem. *Inleyding tot de pratyck der Algemeene Schilderkonst*. 3d ed. Amsterdam: Daniel van den Dalen. 1697. Reprinted together with *Inleydinge tot de Algemeene Teyken-Konst*. Soest: Davaco.

Gombrich 1971. Gombrich, Ernst. "The Renaissance Theory of Art and the Rise of Landscape." In *Norm and Form: Studies in the Art of the Renaissance*, pp. 107–121. 2d ed. London and New York: Phaidon. First published as "Renaissance Art Theory and the Development of Landscape Painting." *Gazette des Beaux-Arts* 6th ser., 41 (1953): 335–360.

Graham 1994. Graham, W. Fred, ed. *Later Calvinism: International Perspectives*. Sixteenth-Century Essays and Studies, 22. Kirksville, Mo.: Sixteenth-Century Journal Publishers.

Grijzenhout 1992. Grijzenhout, Frans. "Tussen rede en gevoeligheid: De Nederlandse schilderkunst in het oordeel van het buitenland, 1660–1800." In Grijzenhout and Van Veen 1992, pp. 27–54.

Grijzenhout and Van Veen 1992. Grijzenhout, Frans, and Henk van Veen. *De Gouden Eeuw in perspectief. Het beeld van de Nederlandse zeventiende-eeuwse schilderkunst in later tijd.* Heerlen: SUN/OU.

Groeneweg 1995. Groeneweg, I. "Regenten in het zwart: vroom en deftig?" In *Beeld en zelfbeeld in de Nederlandse kunst, 1550–1750 / Image and Self-Image in Netherlandish Art, 1550–1750. Nederlands Kunsthistorisch Jaarboek* 46: 198–251.

Groenveld 1995. Groenveld, S. *Huisgenoten des geloofs. Was de samenleving in de Republiek der Verenigde Nederlanden verzuild?* Zeven Provinciën Reeks, 11. Hilversum: Verloren.

Grootes 1993a. Grootes, E. K. "Het liedboekje van 'Haerlem Soetendal.'" In Grootes, 1993b, pp. 93–109.

Grootes 1993b. ———, ed. *Haarlemse Helicon. Literatuur en toneel te Haarlem vóór 1800.* Hilversum: Verloren.

De Groot 1979. De Groot, Irene. *Landscape Etchings by the Dutch Masters of the Seventeenth Century.* London: Gordon Fraser.

Guicciardini 1567. Guicciardini, Lodovico. *Description de tout le Païs-Bas.* Antwerp: Guillaume Silvius.

Guicciardini 1968. Guicciardini, Lowijs [Lodovico]. *Verschrijvinghe van alle de Nederlanden anderssins gheneomt Neder-Duytslandt . . .* , Amsterdam: Willen Jansz. 1612. Facsimile edition. Amsterdam: Facsimile Uitgaven Nederland, N.V.

Haak 1984. Haak, Bob. *The Golden Age: Dutch Painters of the Seventeenth Century.* Translated from the Dutch and edited by Elizabeth Willems-Treeman. New York: Harry N. Abrams.

Hall 1994. Hall, Edwin. *The Arnolfini Betrothal: Medieval Marriage and the Enigma of Van Eyck's Double Portrait.* Discovery Series, 3. Berkeley and Los Angeles: University of California Press.

Härting 1995. Härting, Ursula. "Bilder der Bibel: Gerard Davids 'Waldlandschaft mit Ochsen und Esel' (um 1509) und Pieter Bruegels 'Landschaft mit wilden Tieren' (1554)." *Niederdeutsche Beiträge zur Kunstgeschichte* 34: 81–105.

Harwood 1988. Harwood, Laurie B. *Adam Pynacker (c. 1620–1673).* Doornspijk: Davaco.

Haverkamp Begemann 1959. Haverkamp Begemann, Egbert. *Willem Buytewech.* Ph.D. dissertation, Rijksuniversiteit Utrecht. Amsterdam: Menno Hertzberger.

Haverkamp Begemann 1979. ———. "Joos van Liere." In *Pieter Bruegel und seine Welt*, edited by Otto von Simson and Matthias Winner, pp. 17–28. Berlin: Gebr. Mann.

Haverkamp Begemann and Chong 1986. Haverkamp Begemann, Egbert, and Alan Chong. "Dutch Landscape and Its Associations." In *The Royal Picture Gallery Mauritshuis*, edited by H. R. Hoetink, pp. 56–67. The Hague: Meulenhoff/Landshoff; New York: Harry N. Abrams.

Hecht 1986. Hecht, Peter. "The Debate on Symbol and Meaning in Dutch Seventeenth-Century Art: An Appeal to Common Sense." *Simiolus* 16: 173–187.

Hecht 1992. ———. "Dutch Seventeenth-Century Genre Painting: A Reassessment of Some Current Hypotheses." *Simiolus* 21: 85–95.

Heijbroek 1983. Heijbroek, J., ed. *Met Huygens op reis: Tekeningen en dagboeknotities van Constantijn Huygens jr. (1628–1697), secretaris van stadhouder-koning Willem III.* Published on the occasion of the ex-

hibition *Met Huygens op reis*, Amsterdam, Rijksprentenkabinet, and Ghent, Museum voor Schone Kunst, 1982–83. Zutphen: Terra Zutphen.

Henkel and Schöne 1967. Henkel, Arthur, and Albrecht Schöne. *Emblemata. Handbuch zur Sinnbildkunst des XVI. und XVII. Jahrhunderts*. Stuttgart: J. B. Metzlersche Verlagsbuchhandlung.

Hoekstra 1947. Hoekstra, Pier. *Bloemendael. Proeve ener streekgeschiedenis*. Wormerveer: Meijer's Boek- en Handelsdrukkerij.

Hollstein. Hollstein, F. W. H. *Dutch and Flemish Etchings, Engravings, and Woodcuts, ca. 1450–1700*. 52 vols. to date. Amsterdam: Menno Hertzberger et al., 1949–.

Hondius 1621. Hondius, Petrus. *Dapes intemptae of de Mouffe-schans, dat is, De soetichheyt des Buytenlevens, Vergeselschapt met de Boucken, Nieuwe editie. T'samen met zyn Hof-wetten*. Leiden: Daniel Goels.

Hoogstraeten 1969. Hoogstraeten, Samuel van. *Inleyding tot de hooge school der schilderkonst*. Rotterdam: François van Hoogstraeten. 1678. Reprint. N.p.: Davaco.

Houbraken 1943–53. Houbraken, Arnold. *De Groote Schouburgh der Nederlantsche konstschilders en schilderessen*. Edited by P. T. A. Swillens. 3 vols. Maastricht: Leiter-Nypels.

Hunt 1992. Hunt, John Dixon, ed. *The Pastoral Landscape*. Center for Advanced Study in the Visual Arts, Symposium Papers XX, Studies in the History of Art, 36. Washington, D.C.: National Gallery of Art.

Hussey 1967. Hussey, Christopher. *The Picturesque: Studies in a Point of View*. 2d ed., with a new preface by the author. London: F. Cass.

Huygens 1892–99. Huygens, Constantijn. *De gedichten van Constantijn Huygens, naar zijn handschrift uitgeven*. Edited by J. A. Worp. 9 vols. Groningen: J. B. Wolters.

Huygens 1977. ———. *Hofwyck*. Edited by F. L. Zwaan. Jerusalem: Chev. Jeruzalem-Israël.

Huygens 1994. ———. *Mijn jeugd*. Translated and edited by C. L. Heesakkers. Amsterdam: Em Querido's Uitgeverij B. V.

Huygens 1996. ———. *A Selection of the Poems of Sir Constantijn Huygens (1596–1687)*. Translated and edited by Peter Davideson and Adriaan van der Weel. Amsterdam: Amsterdam University Press.

Israel 1987. Israel, Jonathan. Review of Schama 1987. *Times Literary Supplement*, 20–26 November, pp. 1267–1268.

Israel 1995. ———. *The Dutch Republic: Its Rise, Greatness, and Fall, 1477–1806*. Oxford: Clarendon Press.

Jacobsen 1972. Jacobsen, Reindert. *Carel van Mander (1548–1606): dichter en prozaschrijver*. Ph.D. diss. Rijksuniversiteit Leiden, 1906. Reprint. Utrecht: HES Publishers.

Jelgersma 1978. Jelgersma, H. J. *Galgebergen en galgevelden in West- en Midden Nederland*. Zutphen: De Walburg Pers.

Jones 1993. Jones, Pamela M. *Federigo Borromeo and the Ambrosiana: Art Patronage and Reform in Seventeenth-Century Milan*. Cambridge: Cambridge University Press.

De Jong 1993. De Jong, Erik. *Natuur en kunst; Nederlandse tuin- en landschapsarchitectuur, 1650–1740*. 2d ed. Bussum: Uitgeverij Thoth.

De Jongh 1967. De Jongh, E. *Sinne- en minnebeelden in de schilderkunst van de zeventiende eeuw.* N.p.: Nederlands Sitchting Openbaar Kunstbezit en Openbaar Kunstbezit in Vlaanderen / Prins Bernhard Fonds.

De Jongh 1971. ———. "Realisme en schijnrealisme in der Hollandse schilderkunst van de zeventiende eeuw." In *Rembrandt en zijn tijd*, exh. cat., pp. 143–184. Brussels: Paleis voor Schone Kunsten.

De Jongh 1991. ———. "Some Notes on Interpretation." In Freedberg and De Vries 1991, pp. 119–136.

DeJongh 1992a. ———. "Seventeenth-Century Dutch Painting: Multifaceted Research." *Historical Research in the Low Countries.* The Hague: Nederlands Historisch Genootschap, pp. 35–46.

De Jongh 1992b. ———. "De iconologische benadering van de zeventiende-eeuwse Nederlandse schilderkunst." In Grijzenhout and Van Veen 1992, pp. 299–329.

De Jongh 1995. ———. "*Van 'vermakelijk bedrog' tot propagandistische 'beelden-leugen.'* Beeldmanipulatie in de zeventiende eeuwe." In *Openbaring en bedrog. De afbeelding als historische bron in de Lage Landen*, edited by B. Kempers, pp. 101–124. Amsterdam: Amsterdam University Press.

De Jongh 1996–97. ———. "Jan Steen, So Near and Yet So Far." In Washington-Amsterdam 1996–97, pp. 39–51.

Joubert 1980. Joubert, Laurent. *Treatise on Laughter.* Trans. and annotated by Gregory David de Rocher. Tuscaloosa: University of Alabama Press.

Judson 1972. Judson, J. Richard. *The Drawings of Jacob de Gheyn II.* New York: Grossman Publishers.

Junius 1588. Junius, Hadrianus. *Batavia: In qua praeter gentis et insulae antiquitatem origem.* Leiden: Ex officina Plantiana, F. Raphalengium.

Van Kampen et al. 1980. Van Kampen, Hinke, Herman Pleij, Bob Stumpel, Annebel Venmans, and Paul Vriesema, eds. *Het zal koud zijn in 't water als 't vriest. Zestiende-eeuwse parodieën op gedrukte jaaarvoorspelingen.* The Hague: Martinus Nijhoff.

Kaplan 1995. Kaplan, Benjamin J. *Calvinists and Libertines: Confession and Community in Utrecht, 1578–1620.* Oxford: Clarendon Press.

Kettering 1983. Kettering, Alison McNeil. *The Dutch Arcadia: Pastoral Art and Its Audience in the Golden Age.* Montclair, N.J.: Allenheld and Schramm.

Keyes 1979. Keyes, George S. "Cornelis Claes van Wieringen." *Oud Holland* 93: 1–46.

Keyes 1984. ———. *Esaias van de Velde, 1587–1630.* With a biographical chapter by J. G. C. A. Briels. Doornspijk: Davaco.

Keyes 1987. ———. "Esaias van de Velde and the Chalk Sketch." In *Was getekend . . . tekenkunst door de eeuwen heen. Liber amicorum prof. Dr. E. K. J. Reznicek. Nederlands Kunsthistorisch Jaarboek* 38: 136–145.

De Klerk 1982. De Klerk, E. A. "*De Teecken-Const:* een 17de eeuws Nederlands traktaatje." With English summary. *Oud Holland* 96: 16–60.

Klessmann 1960. Klessmann, Rüdiger. "Die Anfänge des Bauerninterieurs bei den Brüdern Ostade." *Jahrbuch der Berliner Museen*, n.s., 2:92–115.

De Klijn 1982. De Klijn, M. *De invloed van het Calvinisme op de Noord-Nederlandse landschapkunst, 1570–1630*. Appeldoorn: Willem de Zwijgerstichting.

Knaap 1996. Knaap, Anna C. "From Lowlife to Rustic Idyll: The Peasant Genre in Seventeenth-Century Dutch Drawings and Prints." In *Two Exhibitions. Harvard University Art Museums Bulletin* 4, no. 2 (Spring): 31–54.

Knippenberg 1981. Knippenberg, W. H. Th. "De brede en de smalle weg." *Brabants heem* 33: 106–113.

Knipping 1974. Knipping, John B. *Iconography of the Counter Reformation in the Netherlands: Heaven on Earth*. 2 vols. Nieuwkoop: B. De Graaf; Leiden: A. W. Sijthoff.

Koeman 1985. Koeman, C. *Geschiedenis van de kartographie van Nederland. Zes eeuwen land-en zee kaarten en stadsplattegronden*. 2d ed. Alphen aan den Rijn: Canaletto.

Koppe 1988. Koppe, Konrad. "Zwei Graphikbände des 17. Jahrhunderts aus dem Trierer Jesuitenkolleg." *Kurtrierische Jahrbuch* 28: 223–262.

Kouznetsov 1973. Kouznetsov, Iouryi. "Sur le symbolisme dans les paysages de Jacob van Ruisdael." *Bulletin du Musée National de Varsovie* 14: 31–41.

De la Fontaine Vervey 1976. De la Fontaine Vervey, H. "De geschiedenis van Guicciardini's Beschrijving der Nederland." In *Uit de wereld van het boek. II. Drukkers, liefhebbers en piraten in de zeventiende eeuw*, pp. 9–31. Amsterdam: Nico Israel.

Lagerlöf 1990. Lagerlöf, Margaretha Rossholm. *Ideal Landscape: Annibale Carracci, Nicolas Poussin, and Claude Lorrain*. New Haven and London: Yale University Press.

De Lairesse 1778. De Lairesse, Gerard. *The Art of Painting*. Translated by John Frederick Fritsch. London: Printed for S. Vandenberg et al. First edition 1738.

De Lairesse 1817. ———. *A Treatise on the Art of Painting in All of Its Branches*. Revised, corrected, and accompanied by an essay by W. M. Craig. 2 vols. London: Edward Orme.

De Lairesse 1969. ———. *De Groote Schilderboek*. 2 vols. 1707. 2d ed., enlarged. Amsterdam: J. Marshoorn, 1740. Reprint. Doornspijk: Davaco.

Larsen-Davidson 1979. Larsen, Eric, with the collaboration of Jane P. Davidson. *Calvinist Economy and Seventeenth-Century Dutch Art*. Lawrence: University of Kansas Publications.

Lawrence 1987. Lawrence, Cynthia. "The Parables of the Houses Built on Rock and Sand: A Case for Moralizing Terrains in Seventeenth-Century Dutch Painting." *Studies in Iconography* 11: 185–203.

Leach 1974. Leach, Eleanor Winsor. *Virgil's Eclogues: Landscapes of Experience*. Ithaca and London: Cornell University Press.

Lebeer 1969. Lebeer, Louis. *Catalogue raisonné des estampes de Bruegel l'ancien*. Brussels: Koninklijke Bibliotheek Albert I.

Leeflang 1988. Leeflang, Huigen. "Interpretatie van zeventiende-eeuwse Nederlandse landschappen. Een vergelijking met tekeningen, prenten en poëzie." *Kunstlicht* 9: 2–10.

Leeflang 1993. ———. "Het landschap in boek en prent. Perceptie en interpretatie van vroeg-zeventiende-eeuwse Nederlandse landschapsprenten." In Bakker and Leeflang 1993, pp. 18–32.

Leeflang 1995a. ———. "Het aards paradijs. Het Haarlemse landschap in de 16de en 17de eeuwse literatuur en beeldende kunst." In Haarlem 1995, pp. 115–126.

Leeflang 1995b. ———. Review of Levesque 1994. In *Simiolus* 23: 273–280.

Leeflang 1997. ———. "Dutch Landscape: The Urban View. Haarlem and Its Environs in Literature and Art, Fifteenth–Seventeenth Century." In *Het landschap in de Nederlandse kunst, 1500–1850. Nederlands Kunsthistorisch Jaarboek* 14: 53–115.

Le Petit 1615. Le Petit, Jean François. *Die Nederlantsche Republyck*. Arnhem: Jan Janszen.

Levesque 1994. Levesque, Catherine. *Journey through Landscape in Seventeenth-Century Holland: The Haarlem Print Series and Dutch Identity*. University Park: The Pennsylvania State University Press.

Van Lieberg 1994. Van Lieberg, Fred A. "From Pure Church to Pious Culture: The Further Reformation in the Seventeenth-Century Dutch Republic." In Graham 1994, pp. 409–429.

Liess 1979–82. Liess, Reinhard. "Die Kleinen Landschaften Pieter Bruegels d. Ä im Licht seines Gesamtwerks." *Jahrbuch Graz* 15–16 (1979–80): 1–116; 17 (1981): 35–150; 18 (1982): 79–164.

Van Luttervelt 1970. Van Luttervelt, R. *De buitenplaatsen langs de Vecht*. 2d ed. Lochem: De Tijdstroom.

Mandel 1996. Mandel, Oscar. *The Cheerfulness of Dutch Art: A Rescue Operation*. Doornspijk: Davaco.

Van Mander–Miedema 1973. Van Mander, Karel. *Den grondt der edel vry schilder-const*. Edited and with commentary by Hessel Miedema. 2 vols. Utrecht: Haentjens Dekker & Gumbert.

Van Mander–Miedema 1994–. ———. *The Lives of the Illustrious Netherlandish and German Painters, from the First Edition of the "Schilder-boeck" (1603–1604)*. Translated and edited by Hessel Miedema. 5 vols. to date. Doornspijk: Davaco.

Marrow 1986. Marrow, James. "Symbol and Meaning in Northern European Art of the Late Middle Ages and the Early Renaissance." *Simiolus* 16: 150–69.

Martindale 1981. Martindale, Andrew. "Painting for Pleasure: Some Lost Fifteenth-Century Secular Decorations of Northern Italy." In *The Vanishing Past: Studies of Medieval Art, Liturgy, and Metrology Presented to Christopher Hohler*, edited by Alan Borg and Andrew Martindale, pp. 109–132. Oxford: B. A. R.

Marx 1992. Marx, Leo. "Does *Pastoralism* Have a Future?" In Hunt 1992, pp. 209–224.

Meertens 1942. Meertens, P. J. *De lof van de boer. Deel I. De boer in de Noord- en Zuidnederlandsche letterkunde van de middeleeuwen tot 1880*. Amsterdam: C. V. Allert de Lange.

Meijers 1992. Meijers, Debora. "Twee vorstelijke verzamelingen in Duitsland en het beeld van de Nederlandse zeventiende-eeuwse schilderkunst." In Grijzenhout and Van Veen 1992, pp. 193–208.

Meischke 1978. Meischke, R. "Buitenverblijven van Amsterdammers voor 1625." *Jaarboek van het Genootschap Amstelodamum* 70: 82–106.

Miedema 1977. Miedema, Hessel. "Realism and the Comic Mode: The Peasant." *Simiolus* 9: 205–219.

Van Miegroet and De Marchi 1996. Van Miegroet, Hans J., and Neil De Marchi. "Pricing Invention: 'Originals,' 'Copies' and Their Relative Value in Early Modern Netherlandish Art Markets." In *Studies in the Economics of the Arts*, edited by Victor Ginsburgh and Pierre-Michel Menger, pp. 27–70. Amsterdam: Elsevier.

Mielke 1985–86. Mielke, Hans. Review of *L'époque de Lucas de Leyde et Pierre Bruegel: Dessins des anciens Pays-Bas. Collections Frits Lugt. Master Drawings* 23–24: 76–81.

Mielke 1996. ———. Pieter Bruegel. Die Zeichnungen. [Turnhout, Belg.]: Brepols.

Monballieu 1974. Monballieu, A. "De 'Kermis van Hoboken' bij P. Bruegel, J. Grimmer en G. Mostaert." *Jaarboek Koninklijk Museum voor Schone Kunsten, Antwerpen:* 139–169.

Monballieu 1987. ———. "Nog eens Hoboken bij Bruegel en tijdgenoten." *Jaarboek Koninklijk Museum voor Schone Kunsten, Antwerpen:* 185–206.

Montias 1982. Montias, John Michael. *Artists and Artisans in Delft: A Socio-Economic Study of the Seventeenth Century.* Princeton, N.J.: Princeton University Press.

Montias 1987. ———. "Cost and Value in Seventeenth-Century Dutch Art." *Art History* 10: 455–466.

Moryson 1903. Moryson, Fynes. *Shakespeare's Europe. Unpublished Chapters of Fynes Moryson's Itinerary: Being a Survey of the Conditions at the End of the Sixteenth Century.* Edited and with an introduction by Charles Hughes. London: Sherratt and Hughes.

Moxey 1986. Moxey, Keith P. F. "A New Look at Netherlandish Landscape and Still-Life Painting." *Arts in Virginia* 26, no. 2: 13–33.

Moxey 1989. ———. *Peasants, Warriors, and Wives: Popular Imagery in the Reformation.* Chicago and London: The University of Chicago Press.

Müllenmeister 1988. Müllenmeister, Kurt J. *Roelant Savery. Kortrijk 1576–1639 Utrecht: Hofmaler Kaiser Rudolf II. in Prag. Die Gemälde mit Kritischem Œuvrekatalog.* Freren: Luca Verlag.

Münz 1961. Münz, Ludwig. *Bruegel: The Drawings. Complete Edition.* London: Phaidon.

Nashe 1985. Nashe, Thomas. *The Unfortunate Traveller and Other Works.* Edited with an introduction by J. B. Steane. London: Penguin Books.

Nederduytschen Helicon 1610. *Den Nederduytschen Helicon.* Alkmaar: Printed by Jacob de Meester for Passchier van Westbusch, Haarlem.

Nichols 1991–92. Nichols, Lawrence W. "Hendrick Goltzius—Documents and Printed Literature Concerning His Life." In *Goltzius Studies: Hendrick Goltzius (1558–1617). Nederlands Kunsthistorisch Jaarboek* 42–43: 77–120.

Van Nierop 1993. Van Nierop, H. K. F. *The Nobility of Holland: From Knights to Regents, 1500–1650.* Cambridge: Cambridge University Press.

Nieuw Nederl. biog. woordenboek 1911–37. *Nieuw Nederlandsch biografisch woordenboek.* 10 vols. Leiden.

Noë 1954. Noë, Helen. *Van Mander in Italië.* Utrechtse bijdragen tot de kunstgeschiedenis, 3. The Hague: Martinus Nijhoff.

Norgate 1997. Norgate, Edward. *Miniatura or the Art of Limning.* Edited, introduced, and annotated by Jeffrey M. Muller and Jim Murrell. New Haven and London: Yale University Press.

Nyeuwe clucht boeck 1983. *Een nyeuwe clucht boeck.* Edited by Herman Pleij, Jan van Grinsven, Dick Schouten, and Freddy van Thijn. Populaire Literatuur, no. 4. Muiderberg: Dick Coutinho.

Olson 1982. Olson, Glending. *Literature as Recreation in the Later Middle Ages.* Ithaca and London: Cornell University Press.

Orenstein 1994a. Orenstein, Nadine. *Hendrick Hondius. The New Hollstein Dutch and Flemish Etchings, Engravings, and Woodcuts, 1450–1700.* Edited by Ger Luijten. Roosendaal: Koninklijke van Poll, in cooperation with the Rijkspretenkabinet, Rijksmuseum, Amsterdam.

Orenstein 1994b. ———. "Noordnederlandse landschapsprenten en hun uitgevers in de Gouden eeuw." In Bakker and Leeflang 1994, pp. 33–41.

Orenstein 1995. ———. "Prints and the Politics of the Publisher: The Case of Hendrick Hondius." *Simiolus* 23: 240–250.

Orenstein 1996. ———. *Hendrick Hondius and the Business of Prints in Seventeenth-Century Holland.* Studies in Prints and Printmaking, vol. 1. Rotterdam: Sound and Vision Interactive.

Orenstein 1998. ———. "Marketing Prints to the Dutch Republic: Novelty and the Print Publisher." *Journal of Medieval and Early Modern Studies* 28, no. 1: 141–165.

Orenstein et al. 1993–94. Orenstein, Nadine, Huigen Leeflang, Ger Luijten, and Christiaan Schuckman. "Print Publishers in the Netherlands, 1580–1620." In Amsterdam 1993–94, pp. 167–200.

Orlers, 1614. Orlers, Jan. *Beschrijvinge der Stad Leyden.* Leiden: Henrick Haestens, Jan Orlers, and Jan Maire.

Orlers 1641. ———. *Beschrijvinge der Stadt Leiden.* 2d ed. Delft: Andries Jansz.

Panofsky 1955. Panofsky, Erwin. *The Life and Art of Albrecht Dürer.* 2d ed., 1955. Princeton, N.J.: Princeton University Press.

Pardo 1984. Pardo, Mary. "Paolo Pino's *Diologo di Pittura:* A Translation with Commentary." Ph.D. dissertation, University of Pittsburgh.

De Parival 1697. De Parival, Jean. *Les delices de la Hollande.* Amsterdam: Henri Wetstein.

Parshall 1982. Parshall, Peter. "The Print Collection of Ferdinand, Archduke of Tyrol." *Jahrbuch der Kunsthistorischen Sammlungen in Wien* 78: 139–184.

Parshall 1994. ———. "Art and the Theater of Knowledge: The Origins of Print Collecting in Northern Europe." *Harvard University Art Museums Bulletin* 2, no. 3: 7–36.

Peeters and Schmitz 1997. Peters, Jan, and Erik Schmitz. "Belangrijke aanwinst voor Gemeentearchief: een blad met twee onbekende tekeningen van Claes Jansz Visscher." *Amstelodamum. Maanblad voor de kennis van Amsterdam* 84: 33–44.

Pels 1978. Pels, Andries. *Gebruik én misbruik des tooneels.* Edited by Maria A. Schenkveld-van der Dussen. Culemborg: Tjeenk Willink / Noorduin.

Petrarch-Rawski 1991. *Petrarch's Remedies for Fortune Fair and Foul.* A Modern English Translation of *De remediis utriesque Fortune,* with a commentary by Conrad H. Rawski. 5 vols. Bloomington and Indianapolis: Indiana University Press.

De Pizan 1989. De Pizan, Christine. *A Medieval Woman's Mirror of Honor: Treasury of the City of Ladies.* Translated and with an introduction by Charity Cannon Willard, edited and introduced by Madeleine Pelner Cosman. New York and Tenafly, N.J.: Bard Hall Press.

Pleij 1979. Pleij, Herman. *Het gilde van de Blauwe Schuit. Literatuur, volksfeest en burgermoraal in de late middeleeuwen.* Amsterdam: Meulenhoff.

Pleij 1987. ———. "Dutch Literature and the Printing Press: The First Fifty Years." *Guttenburg-Jahrbuch* 62: 47–58.

Pleij 1990. ———. *Nederlandse literatuur van de late middeleeuwen.* Utrecht: HES Uitgevers.

Pliny 1968. Pliny the Elder. *The Elder Pliny's Chapters on the History of Art.* 1st ed. London and New York: Macmillan, 1896. Translated by E. Jex-Blake, with commentary and introduction by E. Sellers. Chicago: Argonaut Publishers.

Price 1971. Price, Uvedale. *Essays on the Picturesque as Compared with the Sublime and the Beautiful.* 3 vols. London: L. J. Mawman. Facsimile reprint. Weststead, Farnborough: Gregg International, 1971.

Price, Haitsma Mulier, and Van Nierop 1989. Price, J. L., E. O. G. Haitsma Mulier, and H. F. K. van Nierop. "The Dangers of Unscientific History: Schama and the Dutch Seventeenth Century." *Bijdragen en mededelingen betreffende de geschiedenis der Nederlanden (BMGN)* 104, no. 1: 39–55.

Rademaker 1975. Rademaker, Abraham. *Kabinet van Nederlandsche outheden en gezichten.* Amsterdam: Willem Barents. 1725. Reprint. Haarlem: Schuyt and Co.

Rau 1996. Rau, H. "Vlammingen op weg naar Haarlem." In Biesboer et al. 1996, pp. 9–27.

Raupp 1980. Raupp, Hans-Joachim. "Zur Bedeutung von Thema und Symbol für die holländische Landschaftsmalerei des 17. Jahrhunderts." *Jahrbuch der Staatliche Kunstsammlungen in Baden-Württemberg* 17: 85–110.

Rearick 1992. Rearick, W. R. "From Arcady to the Barnyard." In Hunt 1992, pp. 137–159.

Regtdoorzee Greup-Roldanus 1936. Regtdoorzee Greup-Roldanus, Sijbrecht Clasina. *Geschiedenis der Haarlemer bleekerijen.* The Hague: Martinus Nijhoff.

Van Regteren Altena 1954. Van Regteren Altena, I. Q. "Retouches aan ons Rembrandt-beeld II. Het landschap van den Goudweger." *Oud Holland* 69: 1–17.

Van Regteren Altena 1983. ———. *Jacques de Gheyn: Three Generations.* 3 vols. The Hague, Boston, and London: Martinus Nijhoff.

Renger 1970. Renger, Konrad. *Lockere Gesellschaft. Zur Ikonographie des Verlorenen Sohns und von niederländischen Malerei.* Berlin: Gebr. Mann Verlag.

Reznicek 1961. Reznicek, E. K. J. *Die Zeichnungen von Hendrick Goltzius.* Utrechtse Kunsthistorische Studiën 6. 2 vols. Utrecht: Haentjens, Dekker & Gumbert.

Reznicek 1986. ———. "Hendrick Goltzius and His Conception of Landscape." In London 1986, pp. 57–62.

Riggs 1977. Riggs, Timothy A. *Hieronymus Cock (1510–1570): Printmaker and Publisher at the Sign of the Four Winds.* New York and London: Garland Publishing.

Ripa 1971. Ripa, Cesare. *Iconologia, of uytbeeldingen des Verstands.* Amsterdam: D. P. Pers, 1644. Reprint. Introduction by Jochen Becker. Soest: Davaco.

De Rocher 1979. De Rocher, Gregory. *Rabelais's Laughers and Joubert's "Traité du Ris."* University: The University of Alabama Press.

Rodgers 1967. Rodgers, Edith Cooperrider. *Discussion of Holidays in the Later Middle Ages.* Studies in

History, Economics and Public Law, edited by the Faculty of Political Science of Columbia University, no. 474. New York: Columbia University Press, 1940. Reprint. New York: A. M. S. Press.

Roethlisberger and Bok 1993. Roethlisberger, M. G., and M. J. Bok. *Abraham Bloemaert and His Sons: Paintings and Prints*. 2 vols. Doornspijk: Davaco.

De Roever 1885. De Roever, N. "Jan Harmensz. Muller." *Oud Holland* 3: 266–276.

Rosand 1988. Rosand, David. "Giorgione, Venice, and the Pastoral Tradition." In Washington 1988, pp. 20–82.

Rosand 1992. ———. "Pastoral Topoi: On the Construction of Meaning in Landscape." In Hunt 1992, pp. 161–177.

Rugters van der Loeff 1911. Rutgers van der Loeff, J. D. *Drie lofdichten op Haarlem*. Haarlem: De Erven F. Bohn.

Russell 1992. Russell, Margarita. Review of Walford 1991. *Burlington Magazine* 134, no. 1076 (November): 732.

Sadkov 1995. Sadkov, Vadim A. "Unknown Works by Gillis Mostaert in Russia." *Jaarboek Koninklijk Museum voor Schone Kunsten, Antwerpen:* 65–73.

Schama 1987. Schama, Simon. *The Embarrassment of Riches: An Interpretation of Dutch Culture in the Golden Age*. New York: Alfred Knopf.

Schenkveld 1991. Schenkveld, Maria A. *Dutch Literature in the Age of Rembrandt: Themes and Ideas*. Utrecht Publications in General and Comparative Literature, vol. 28. Amsterdam and Philadelphia: John Benjamins Publishing Company.

Schenkveld-van der Dussen 1986. Schenkveld-van der Dussen, M. A. "Nature and Landscape in Dutch Literature of the Golden Age." In London 1986, pp. 72–78.

Schenkveld-van der Dussen 1987. ———. "Otium en *Otia*." In *Veelzijdigheid als levensvorm. Facetten van Constantijn Huygens' leven en werk*. Edited by A. Th. van Deursen, E. K. Grootes, and P. E. L. Verkuyl, pp. 195–204. *Deventer Studiën* 2. Deventer: Uitgeverij Sub Rosa.

Schenkveld-van der Dussen 1988. ———. "Word and Image in Huygens' *Otia:* The Author a Hidden Persuader." In *International Conference on Word and Image. Congrès international de texte et de image*, pp. 238–244. London.

Schmidt 1988. Schmidt, C. "Over buitenplaatsen en de genoegens van weleer." In *Soeticheydt des Buytenlevens. Buitenplaatsen langs de Vecht en omgeving*, edited by Toïta Buitenhuis, pp. 7–27. Delft: Delftse Universitaire Pers.

Schmidt 1978. Schmidt, Kees. "Hollandse buitenleven in de zeventiende eeuw." *Amsterdams sociologisch tijdschrift*, no. 4: 434–449; no. 5: 91–109.

Schmitz 1972. Schmitz, Heinz-Günther. *Physiologie des Scherzes. Bedeutung und Rechtfertigung der Ars Iocandi im 16. Jahrhundert*. Deutsche Volksbücher in Faksimiledrucken, Reihe B. Untersuchungen zu dem deutschen Volksbüchern, vol. 2. Hildesheim and New York: Georg Olms.

Schnackenburg 1984. Schnackenburg, B. "Das Bild des bäuerlichen Lebens bei Adriaen van Ostade." In

Wort und Bild in der Niederländischen Kunst und Literatur des 16. und 17. Jahrhunderts, edited by Herman Vekeman and Justus Müller Hofstede, pp. 30–42. Erfstadt: Lukassen Verlag.

Schneider 1990. Schneider, Cynthia P. *Rembrandt's Landscapes*. New Haven and London: Yale University Press.

Schotel n.d. Schotel, G. D. J. *Het Hollandsch huisgezin der zeventiende eeuwe*. 2d ed. by H. C. Rogge. N.p.: A. J. G. Strenholt's Uitgeverij; Arnhem: Gijsbers and Van Loon. Reprint of 1903 ed.

Schrevelius 1648. Schrevelius, Theodore. *Harlemias, Ofte beter te seggen, De eerste stichtinghe der Stadt Haerlem*. Haarlem: Thomas Fonteyn.

Schulz 1982. Schulz, Wolfgang. *Herman Saftleven, 1609–1685: Leben und Werke. Mit einem kritischen Katalog der Gemälde und Zeichnungen*. Beiträge zur Kunstgeschichte, vol. 18. Berlin and New York: De Gruyter.

Schutte 1988. Schutte, G. J. *Het Calvinistisch Nederland*. Utrecht: Erven J. Bijleveld.

Schwartz 1983. Schwartz, Gary. "Jan van der Heyden and the Huydecopers of Maarsseveen." *The J. Paul Getty Museum Journal* 11: 197–220.

Sellink 1991–92. Sellink, M. "Een teruggevonden Laaste Oordeel van Hendrick Goltzius. Goltzius' relatie met de Antwerpse uitgever Philips Galle." In *Goltzius Studies: Hendrick Goltzius (1558–1617)*. *Nederlands Kunsthistorisch Jaarboek* 42–43: 145–158.

Van Selm 1987. Van Selm, B. *Een menighte treffelijke Boecken. Nederlandse boekhandelscatalogi in het begin van de zeventiende eeuw*. Utrecht: HES.

Seneca 1994. Seneca, Lucius Annaeus. *De tranquillitate animi*. In *Four Dialogues*. Edited by C. D. N. Costa. Warminster: Aris and Philips.

Simon 1958. Simon, Maria. "Claes Jansz Visscher." Ph.D. dissertation, Albert-Ludwig-Universität zu Freiburg i. Br.

Slive 1953. Slive, Seymour. *Rembrandt and His Critics*. The Hague: Martinus Nijhoff.

Slive 1956. ———. "Notes on the Relationship of Protestantism to Seventeenth-Century Dutch Painting." *The Art Quarterly* 19: 3–15.

Slive 1988a. ———. Review of Amsterdam-Boston-Philadelphia 1987–88. *Burlington Magazine* 130, no. 1022 (May): 395–398.

Slive 1988b. ———. "The Manor Kostverloren: Vicissitudes of a Seventeenth-Century Dutch Landscape Motif." In *The Age of Rembrandt: Studies in Seventeenth-Century Dutch Painting*, edited by Roland E. Fleischer and Susan Scott Munshower, pp. 132–168. Papers in Art History from Pennsylvania State University, 3. University Park: Pennsylvania State University Press.

Slive 1995. ———. *Dutch Painting, 1600–1800*. Pelican History of Art. New Haven and London: Yale University Press.

Sluijter 1988. Sluijter, Eric J. "Belering en verhulling? Enkele 17de-eeuwse teksten over de schilderkunst en de iconologische benadering van Noordnederlandse schilderijen uit deze periode." *De zeventiende eeuw* 4, no. 2: 3–28. English version in Sluijter 1991.

Sluijter 1990. ———. "Hoe realistisch is de Noordnederlandse schilderkunst van de zeventiende eeuw? De problemen van een vraagstelling." *Leidschrift* 6, no. 3: 5–39.

Sluijter 1991. ———. "Didactic and Disguised Meanings? Several Seventeenth-Century Texts on Painting and the Iconological Approach to Northern Dutch Paintings of This Period." In Freedberg and De Vries 1991, pp. 175–208. Reprinted with revisions in Franits 1997, pp. 78–87.

Sluijter 1996. ———. "Jan van Goyen als marktleider, virtuoos en vernieuwer." In Leiden 1996, pp. 38–59.

Snoep-Reitsma and Blankert 1967–68. Snoep-Reitsma, Ella, and Albert Blankert. Review of Stechow 1966. *Simiolus* 2: 100–108.

Sohm 1991. Sohm, Philip. *Pittoresco. Marco Boschini, His Critics, and Their Critiques of Painterly Brushwork in Seventeenth- and Eighteenth-Century Italy.* Cambridge: Cambridge University Press.

Spaans 1989. Spaans, Joke. *Haarlem na de Reformatie. Stedelijke cultuur en kerkelijk leven, 1577–1620.* Hollandse Historische Reeks, 11. The Hague: Stichting Hollandse Historische Reeks.

Spickernagel 1972. Spickernagel, Ellen. "Die Descendenz der 'Kleinen Landschaften': Studien zur Entwicklung einer Form des niederländischen Landschaftsbildes vor Pieter Bruegel." Ph.D. dissertation, Westfälischen-Wilhelms-Universität zu Münster.

Spickernagel 1979. ———. "Holländische Dorflandschaften im frühen 17. Jahrhundert." *Städel-Jahrbuch,* n.s., 7: 133–148.

Springer 1896. Springer, Leonard A. *De Haarlemmerhout van 1583–1896.* Haarlem: De Erven Loosjes.

Starn 1994. Starn, Randolph. *Ambrogio Lorenzetti: The Palazzo Pubblico, Siena.* New York: George Braziller.

Stechow 1966. Stechow, Wolfgang. *Dutch Landscape Painting of the Seventeenth Century.* National Gallery of Art, Kress Foundation Studies in the History of Art, no. 1. London: Phaidon.

Van Stipriaan 1996. Van Stipriaan, René. *Leugens en vermaak. Boccaccio's novellen in de kluchtkultuur van de Nederlandse renaissance.* Amsterdam: Amsterdam University Press.

Stoett 1943. Stoett, F. A. *Nederlandsche spreekwoorden, spreekwijzen, uitdrukkingen en gezegden.* 2 vols. 5th ed. Zutphen: W. J. Thieme and Cie.

Stone-Ferrier 1985a. Stone-Ferrier, Linda A. *Images of Textiles: The Weave of Seventeenth-Century Dutch Art and Society.* Studies in the Fine Arts: Art Patronage, no. 4. Ann Arbor, Mich.: UMI Research Press.

Stone-Ferrier 1985b. ———. "Views of Haarlem: A Reconsideration of Ruisdael and Rembrandt." *Art Bulletin* 67, no. 3 (September): 417–436.

Stone-Ferrier 1992. ———. "Rembrandt's Landscape Etchings: Defying Modernity's Enroachment." *Art History* 15: 403–433.

Van Straaten 1977. Van Straaten, Evert. *Koud tot op het bot. De verbeelding van de winter in de zestiende en zeventiende eeuw in de Nederlanden.* The Hague: Staatsuitgeverij.

Strengholt 1977. Strengholt, L. *De dichter van "Bauw-heers wel-leven": Pieter Janssoon Schaghen. Een oud literair vraagstuk opgelost.* Bijdragen tot de Nederlandse taal-en letterkunden, 5. Leiden: E. J. Brill, for the Maatschappij der Nederlands Letterkunde.

Van Strien 1993. Van Strien, C. D. *British Travellers in Holland during the Stuart Period.* British Studies in Intellectual History, 42. Leiden, New York, and Cologne: E. J. Brill.

Van Suchtelen 1993. Van Suchtelen, Ariane. "Hans Bol. Een van de eerste schilders van het Hollandse stadsgezicht." *Antiek* 28: 220–227.

Sullivan 1994. Sullivan, Margaret A. *Bruegel's Peasants: Art and Audience in the Northern Renaissance*. Cambridge: Cambridge University Press.

Sullivan 1984. Sullivan, Scott A. *The Dutch Gamepiece*. Totowa, N.J., and Montclair, N.J.: Bowman and Allenheld.

Sutton 1987–88. Sutton, Peter C. Introduction. In Amsterdam-Boston-Philadelphia 1987–88, pp. 1–63.

Swillens 1946. Swillens, P. T. A. "Roomsch-Katholieke kunstenaars." *Katholiek cultureel tijdschrift* 1: 416–419.

Temple 1972. Temple, Sir William. *Observations upon the United Provinces of the Netherlands*. Edited by Sir George Clark. Oxford: Clarendon Press.

Ter Winkel 1899. Ter Winkel, J. "*Den Nederduytschen Helicon* van 1610." *Tijdschrift voor Nederlandsche taal- en letterkunde* 18: 241–267.

Van Thiel 1990–91. Van Thiel, Pieter J. J. "Catholic Elements in Seventeenth-Century Dutch Painting, apropos of a Children's Portrait by Thomas de Keyser." *Simiolus* 20: 39–62.

Uilenspiegel-Geeraedts 1986. *Het volksboek van Ulenspiegel*. Edited by Loek Geeraedts. Klassik galerij 42. Kapellen: DNB/Uitgeverij Pelckmans; Amsterdam: Wereldbibliotheek.

Van Veen 1985. Van Veen, P. A. F. *De soeticheyt des buytens-levens vergheselschapt met de boucken: Het hofdicht als tak van een georgische literatuur*. Utrecht: HES Publishers.

Veldman 1977. Veldman, Ilja M. *Maarten van Heemskerck and Dutch Humanism in the Sixteenth Century*. Translated by Michael Hoyle. Maarssen: Gary Schwarz.

Veldman 1991. ———. "Philips Galle: een inventieve prentonderwerper." *Oud Holland* 105: 262–290.

Veldman 1992. ———. "Images of Labor and Diligence in Sixteenth-Century Netherlandish Prints: The Work Ethic Rooted in Civic Morality or Protestantism?" *Simiolus* 21: 227–264.

Verberckmoes 1998. Verberckmoes, Johan. *Schertsen, schimpen en schateren: Geschiedenis van het lachen in de Zuidelijke Nederlanden, zestiende en zeventiende eeuw*. Nijmegen: SUN.

Vergara 1982. Vergara, Lisa. *Rubens and the Poetics of Landscape*. New Haven and London: Yale University Press, 1982.

Vergara 1989. ———. "The Printed Landscapes of Pieter Bruegel the Elder." In *The Prints of Pieter Bruegel the Elder*, exh. cat., edited by David Freedberg, pp. 80–89. Ishibashi: Bridgestone Museum of Art.

Vermeer 1993. Vermeer, Wim. "*Den Nederduytsche Helicon*." In Grootes 1993b, pp. 77–92.

Virgil 1974. *Virgil*. Translated by H. Rushton Fairclough. Loeb Classical Library. Rev. ed. 2 vols. Cambridge, Mass.: Harvard University Press; London: William Heinemann.

Visscher 1949. Visscher, Roemer. *Sinnepoppen*. Amsterdam: Willem Iansz, 1614. Reprinted with commentary by L. Brummel. The Hague: Martinus Nijhoff.

Visser 1994. Visser, Derk. "Establishing the Reformed Church: Clergy and Magistrates in the Low Countries, 1572–1620." In Graham 1994, pp. 389–407.

Vitruvius 1960. Vitruvius. *The Ten Books on Architecture*. Translated by M. H. Morgan. Cambridge, Mass.: Harvard University Press. 1914. Reprint. New York: Dover Publications.

Vives 1971. Vives, Juan Luis. *Vives: On Education. A Translation of the De Tradendis disciplinis of Juan Luis Vives.* Introduction by Foster Watson and foreword by Francesco Cordasco. 1913. Reprint. Totowa, N.J.: Rowman and Littlefield.

Vondel 1927–37. Vondel, Joost van den. *De werken van Vondel.* Edited by J. F. M. Sterck et al. 10 vols. Amsterdam: Maatschappij vor Goede en Goedkoope Lectuur.

Vondel 1989. ———. *Lust tot poëzie. Gedichten van Vondel.* Edited by Hans Luijten and Jan Konst. Amsterdam: Em. Querido's Uitgeverij B. V.

De Vries 1974. De Vries, Jan. *The Dutch Rural Economy in the Golden Age, 1500–1700.* New Haven and London: Yale University Press.

De Vries 1978. ———. "Barges and Capitalism: Passenger Transportation in the Dutch Economy, 1632–1839." *A.A.G. Bijdragen* 21. Wageningen: Landbouwhogeschool, Afdeling Agrarische Gescheidenis, pp. 33ff. Reprint. Utrecht: HES, 1981.

De Vries 1986. ———. "The Dutch Rural Economy and the Landscape." In London 1986, pp. 79–86.

L. de Vries 1998. De Vries, Lyckle. *Gerard de Lairesse: An Artist between Stage and Studio.* Amsterdam: Amsterdam University Press.

De Vries 1990. De Vries, Willemien B. "The Country Estate Immortalized: Constantijn Huygens' Hofwijck." In *The Dutch Garden in the Seventeenth Century,* edited by John Dixon Hunt, pp. 81–97. Dumbarton Oaks Colloquium on the History of Landscape Architecture, 12. Washington, D.C.: Dumbarton Oaks Research Library and Collection.

De Vries 1998. ———. *Wandeling en verhandeling. De ontwikkeling van het Nederlandse hofdicht in de zeventiende eeuw (1613–1710).* Hilversum: Verloren.

Walford 1991. Walford, E. John. *Jacob van Ruisdael and the Perception of Landscape.* New Haven and London: Yale University Press.

Waller 1938. Waller, F. G. *Biographisch woordenboek van Noord Nederlandsche graveurs.* Edited by W. R. Juynboll. The Hague: Martinus Nijhoff.

Wederkehr 1991–92. Wederkehr, Léne. "Jacob Matham Goltzij Privignus. Jacob Matham graveur et ses raports avec Hendrick Goltzius." In *Goltzius Studies: Hendrick Goltzius (1558–1617). Nederlandsch Kunsthistorisch Jaarboek* 42–43: 219–260.

Westermann 1996. Westermann, Mariët. Review of Eddy de Jongh, *Kwesties van betekenis: Tema en motief in de Nederlandse schilderkunst van de zeventiende eeuw,* Leiden, 1995. In *Burlington Magazine* 138, no. 1116 (March): 198–200.

Westermann 1997. ———. *The Amusements of Jan Steen: Comic Painting in the Seventeenth Century.* Studies in Netherlandish Art and Cultural History, 1. Zwolle: Waander Publishers.

Wied 1990. Wied, Alexander. *Lucas und Marten van Valckenborch (1535–1597 und 1534–1612): Das Gesamtwerk mit kritischem Œuvrekatalog.* Freren: Luca Verlag.

Wiegand 1971. Wiegand, Wilfried. "Ruisdael-Studien. Ein Versuch zur Ikonologie der Landschaftsmalerei." Ph.D. dissertation, University of Hamburg.

Van der Wijck 1974. Van der Wijck, Henri Wolter Matheus. "De Nederlandse buitenplaats. Aspecten van ontwikkeling, bescherming, en herstel." Ph.D. dissertation, Technische Hogeschool Delft.

Wood 1993. Wood, Christopher S. *Albrecht Altdorfer and the Origins of Landscape*. Chicago and London: The University of Chicago Press.

Woordenboek 1882–. *Woordenboek der Nederlandsche taal*. The Hague: Martinus Nijhoff et al.

Worp 1891. Worp, J. A. "Constantijn Huygens over de schilders van zijn tijd." *Oud Holland* 9: 106–136.

Wüthrich 1966–96. Wüthrich, Lucas Heinrich. *Das druckgraphische Werk von Matthaeus Merian d. AE.* 4 vols. Basel: Bärenreiter-Verlag et al.

Ziemba 1987. Ziemba, Antoni. "Rembrandt's Landschaft als Sinnbild: Versuch einer ikonologischen Deutung." *Artibus et Historiae* 15: 109–134.

Exhibition Catalogues

Amsterdam 1976. Amsterdam, Rijksmuseum. *Tot lering en vermaak*. Catalogue by E. de Jongh et al.

Amsterdam 1993–94. Amsterdam, Rijksmuseum. *Dawn of the Golden Age: Northern Netherlandish Art, 1580–1620*. Edited by Ger Luijten, Ariana van Suchtelen, Reiner Baaren, Wouter Kloek, and Marijn Schapelhouman.

Amsterdam 1997. Amsterdam, Rijksmuseum. *Mirror of Everyday Life: Genre Prints in the Netherlands, 1550–1700*. Catalogue by Eddy de Jongh and Ger Luijten. Translated by Michael Hoyle.

Amsterdam 1998. Amsterdam, Gemeentearchief Amsterdam. *Het landschap van Rembrandt: Wandelingen in en om Amsterdam*. Catalogue edited by Boudewijn Bakker et al.

Amsterdam-Cleveland 1992–93. Amsterdam, Rijksmuseum; The Cleveland Museum of Art. *Hendrick Goltzius (1558–1617) and His Time*. Catalogue by Nancy Bialler.

Amsterdam-Toronto 1977. Amsterdam, Amsterdams Historisch Museum; Toronto, Art Gallery of Ontario. *Opkomst en bloei van het Noordnederlandse stadsgezicht in de 17de eeuw/The Dutch Cityscape in the 17th Century and Its Sources*.

Amsterdam-Boston-Philadelphia 1987–88. Amsterdam, Rijksmuseum; Boston, Museum of Fine Arts; Philadelphia Museum of Art. *Masters of Seventeenth-Century Dutch Landscape Painting*.

Amsterdam-Vienna-New York-Cambridge 1991–92. Amsterdam, Rijksmuseum; Vienna, Albertina; New York, Pierpont Morgan Library; Cambridge, Mass., Fogg Art Museum. *Seventeenth-Century Dutch Drawings: A Selection from the Maida and George Abrams Collection*. Catalogue by William W. Robinson. Introduction by Peter Schatborn.

Berlin 1975. Berlin, Staatliche Museen Preussischer Kulturbesitz, Kupferstichkabinett. *Pieter Bruegel d. Ä. als Zeichner. Herkunft und Nachfolg*.

Cambridge 1992. Cambridge, Mass., Fogg Art Museum. *The Made Landscape: City and Country in Seventeenth-Century Holland*. Catalogue by Kristina Hartzer Nguyen. *Harvard University Art Museums Bulletin* 1, no. 1.

Cambridge-Montreal 1988. Cambridge, Mass., Arthur M. Sackler Museum, Harvard University; Montreal, Museum of Fine Arts. *Landscape in Perspective: Drawings by Rembrandt and His Contemporaries.* Catalogue by Frederik J. Duparc.

Cologne-Utrecht 1985–86. Cologne, Wallraf-Richartz-Museum; Utrecht, Centraal Museum. *Roelant Savery in seiner Zeit (1576–1639).*

Frankfurt-Basel 1993–94. Frankfurt a. M., Museum für Kunsthandwerk; Kunstmuseum Basel. *Mathaeus Merian des Aelteren.* Catalogue by Wilhelm Bingsolm et al.

Haarlem 1986. Haarlem, Frans Halsmuseum. *Portretten van echt en trouw: Houwelijk en gezin in de Nederlandse kunst van de zeventiende eeuw.* Catalogue by E. de Jongh.

Haarlem 1995. Haarlem, Frans Halsmuseum and Teylers Museum. *De trots van Haarlem. Promotie van een stad in kunst en historie.* Edited by Koos Levy-van Halm, Epco Runia, Bert Siggers, and Derk Snoep.

The Hague 1994–95. The Hague, Mauritshuis. *Paulus Potter: Paintings, Drawings, and Etchings.* Catalogue by Amy Walsh, Edwin Buijsen, and Ben Broos.

The Hague-Cambridge 1981–82. The Hague, Mauritshuis; Cambridge, Mass., Fogg Art Museum. *Jacob van Ruisdael.* Catalogue by Seymour Slive and H. R. Hoetinck.

Lawrence 1983. Lawrence, The Spencer Museum of Art, The University of Kansas. *Dutch Prints of Daily Life: Mirrors of Life or Masks of Morals?* Catalogue by Linda A. Stone-Ferrier.

Leiden 1996. Leiden, Stedelijk Museum De Lakenhal. *Jan van Goyen.* Catalogue by Christiaan Vogelaar, with Edwin Buijsen, Eric J. Sluijter, R. L. Falkenburg, and E. Melanie Gifford.

London 1986. London, National Gallery. *Dutch Landscape: The Early Years. Haarlem and Amsterdam, 1590–1650.* Catalogue by Christopher Brown.

Maastricht-Haarlem 1996. Maastricht, Noordbrabants Museum; Haarlem, Frans Halsmuseum. *Aardse paradijzen. De tuin in de Nederlandse kunst 15de tot 18de eeuw.* Catalogue by Erik de Jong and Marleen Dominicus-van Soest, with Willemien B. de Vries and Sara M. Wages.

Minneapolis-Toledo-Philadelphia 1971–72. The Minneapolis Institute of Arts; The Toledo Museum of Art; Philadelphia Museum of Art. *Dutch Masterpieces from the Eighteenth Century: Paintings and Drawings, 1700–1800.* Catalogue by Earl Roger Mandle. Essay by J. W. Niemeijer.

Philadelphia-Berlin-London 1984. Philadelphia Museum of Art; Berlin, Gemäldegalerie, Staatliche Museen; London, Royal Academy of Arts. *Masters of Seventeenth-Century Dutch Genre Painting.* Organized by Peter C. Sutton.

Rotterdam 1988. Rotterdam, Museum Boijmans Van Beuningen. *In de Vier Winden: De prentuitgeverij van Hieronymus Cock 1507/10–1570. Uit de collecties. Tekeningen en prenten.*

Tokyo-Kasama-Kumamoto-Leiden 1992–93. Tokyo, Station Gallery; Kasama, Nichido Museum of Art; Kumamoto, Museum of Art; Leiden, Stedelijk Museum De Lakenhal. *Tussen fantasie en werkelijkheid: 17de eeuwse hollandse landschapschilderkunst / Between Fantasy and Reality: Seventeenth-Century Dutch Landscape Painting.* Catalogue by Edwin Buijsen, with contributions by Bob Haak, Yoriko Kobayashi-Sato, and Irma van Bommel.

Utrecht 1965. Utrecht, Centraal Museum. *Nederlandse 17e eeuwse Italianiserende landschapschilders*. Catalogue by Albert Blankert. For revised 2d edition, see Blankert 1978.

Utrecht-Luxemburg 1993–94. Utrecht, Centraal Museum; Luxemburg, Musée National d'Histoire et d'Art. *Het gedroomde land: Pastorale schilderkunst in de Gouden eeuw*. Catalogue by Peter van den Brink, with contributions by Hans Luijten, Jos de Meyere, Eric Jan Sluijter, and Mieke B. Smits-Veldt. Edited by Peter van den Brink and Jos de Meyere.

Washington 1988. Washington, D.C., Phillips Collection and National Gallery of Art. *Places of Delight: The Pastoral Landscape*.

Washington 1990. Washington, D.C., National Gallery of Art. *Rembrandt's Landscapes: Drawings and Prints*. Catalogue by Cynthia P. Schneider, with contributions by Boudewijn Bakker, Nancy Ash, and Shelley Fletcher.

Washington-Amsterdam 1996–97. Washington, D.C., National Gallery of Art; Amsterdam, Rijksmuseum. *Jan Steen: Painter and Storyteller*. Edited by H. Perry Chapman, Wouter Th. Kloek, and Arthur K. Wheelock, Jr.

Washington-London-Haarlem 1989–90. Washington, D.C., National Gallery of Art; London, Royal Academy of Arts; Haarlem, Frans Halsmuseum. *Frans Hals*. Edited by Seymour Slive.

Index

Calvin, John, 80–81;
 Institutes of the Christian Religion, 64
Calvinism, xxvi, 60, 62, 63–65, 199n.80,
 200n.106
Camera degli Sposi (Mantegna), 209n.118
Campagnola, Giulio, 130, 131;
 Old Man Reclining in a Landscape, 158,
 230n.71
Camphuyzen, Dirck Rafaelsz, 76, 199n.84
Campin, Robert:
 Nativity, 157
canals, 175
Canterbury Tales (Chaucer), 195n.18
Carleton, Sir Dudley, 64, 115
carnivals/festivities, 73
cartography.
 See maps
Casa Davanzati (Florence), 79
Castello del Buonconsiglio (Trento), 79
castle, as Heavenly Jerusalem, 58
Catholicism, 64, 65, 199n.85
Cats, Jacob, 57, 60, 63, 76, 107, 233n.116;
 Galathee, 75, 132
cave dwellings, 161
Caxton, William, 71
Celtis, Conrad, 63
Cervantes Saavedra, Miguel de:
 Exemplary Stories, 72, 208n.98
Charles II, king of Scotland and England, 105
Charron, Pierre, 139–40
Chasses de Maximilian, 25
Chaucer, Geoffrey:
 Canterbury Tales, 195n.18
children, scenes of, 228n.38
Choreide—Autrement Louenge du Bal aus Dames
 (de la Tour d'Albenas), 73
Christ:
 bridge as, 53, 58, 196n.21;

Nativity/Infancy of, 157;
 as not laughing, 74, 205n.59
Christ and the Woman of Samaria (after Vinck-
 boons), 190n.55
Christ Carrying the Cross (Bles workshop), 13
Chrysostom, St. John, 74
church fairs, scenes of (kermis scenes), 14,
 21–22
Church of England, 64
Cicero, 138
city-countryside scenes.
 See town-and-country tradition
city vs. country life, 111, 137, 217n.114
Civitates orbis terrarum (Braun and Hogenberg),
 20
Claesz, Cornelis, 33, 34, 38, 42, 72, 190n.60
Claesz, Pieter, 172
classicism, 147, 149
Clement VIII, pope, 187n.18, 201n.110
De Clerck, Nicolaes, 33
Van Cleve, Hendrick, 81
Cock, Hieronymus, xxiv–xxv, 103, 177;
 architectural prints of, 180n.3;
 Battle of the Money Chests and Saving Pots,
 137;
 career of, 1;
 and Cort, 26;
 print publishing of, 32, 33, 42, 189n.31,
 191n.69;
 Seasons prints of, 125;
 Skating in Front of St. George's Gate, 125;
 Winter, 125.
 See also Small Landscapes
Cock, Matthys, 13, 42, 185n.80
Coecke van Aelst, Pieter:
 Rest on the Flight to Egypt, 13
Collaert, Adriaen, 158;
 By Antwerpen, 23–24, *24*

Huygens, Constantijn the Elder *(continued)*
on ruins, 142, 225n.3;
on skating, 125;
on trees, 167;
Zee-Straet, poem on, 105, 215n.87
Huygens, Constantijn the Younger, 170, 172,
233n.125
Van Huysum, Jan, 148;
Arcadian Landscape with a Sacrificial Feast,
228n.30;
Arcadian Landscape with Fishermen, 228n.30
hysteria, 203n.31

iconography.
See symbolism
Iconologia (Ripa), 71, 137–38
idleness, scenes of, 133–34, *135–36*, 137, 139
Imaginary City View (H. V. De Vries), *9*, 9–10
Imagines (Philostratus), 79
Inferno (Dante), 53
*Inleyding tot de practijck der algemeene schilder-
konst* (Goeree), 169, 233n.118
Inleyding tot der Hooge Schoole der Schilderkunst
(S. Van Hoogstraeten), 70, 77, 169, 202n.21
Innocent VIII, pope, 79
inns, 53, 99, 195n.18
Institutes of the Christian Religion (Calvin), 64
De Ionghe Dochters: Tijt-cortinghe (The young
maid's pastime), 72
intellectual pursuits, 71, 138–39, 176
*Italianate Landscape with Two Crayfishers
by a Waterfall* (Pynacker), *67*, 67–68

Jacoba of Bavaria, 94
James I, king of England, 113, 114
Jansen, Broer, 44
Jansonius, Joannes, 122, 123

Jean, duke of Berry, 121
Jewish Cemetery (Van Ruisdael), 56, *57*, 84,
197n.36
Jews, 64, 229n.57
John 14:6, commentaries on, 53
De Jongh, Eddy, 51, 52, 55, 194n.6, 195n.13
Jonghelinck, Nicolaas, 16, 80
Jordaens, Jacob, 148
Joubert, Laurens, 69, 74, 75
Jubilee Year (1600), 31, 187n.18, 201n.110
Judgment of Paris (Raimondi, after Raphael),
188n.30
June (Goltzius, after G. Mostaert), 23, *23*, 38, 121
June (J. Van de Velde), 122–23, *123*, 132
Junius, Franciscus:
Painting of the Ancients in Three Bookes, 166
Junius, Hadrianus, 118, 134, 137, 157, 229n.60;
Batavia, 98, 212n.21

Kalf, Willem, 172
Van der Keere, Pieter, 34
Keil, Bernhardt, 147
Keirincx, Alexander, 228n.49
kermis (church fair) scenes, 14, 21–22
Van Kessel, Jan, 105, 231n.88
Ketel, Cornelis, 31, 187n.18
Keyes, George S., 33, 220n.17
De Keyser, Thomas:
*Cornelis de Graeff and His Family before
Soestdijk*, 112–13, *113*
De Klijn, M., 63, 199nn.80, 83
Knight of La Tour Landry, 77
Koninck, Philips, xxv, 111;
An Extensive Wooded Landscape, xxv, 120,
121;
't Kopje, 99
Koslow, Susan, 214n.45

on Bloemaert, 31, 44–45;

on H. Bol, 164;

on Bruegel, 76;

on cottages, 160–61, 164, 166, 231n.91;

on Dürer, 28;

on the Dutch countryside, 59–60;

on Dutch farmers vs. Virgil's shepherds, 131;

emigrates to Northern Netherlands, 28;

on figures in landscapes, 118, 120;

Foundation of the Noble Art of Painting (Den Grondt der edel vry schilder-const), 68, 118, 120, 160–161, 164, 166, 168;

on Goltzius, 30;

on Grimmer, 23;

on Haarlem, 115, 218n.137;

Herfstgedicht, 15–16;

on landscapes as relaxing, 68, 82;

on Van Leyden, 28;

on Van Liere, 10;

on C. Molenaer, 168;

on G. Mostaert, 19;

Den Nederduytsche Helicon, 99;

on recreation, 138;

Rustic Landscape, *160*, 161;

on the *schilderachtig* style, 168, 169;

Virgil translated by, 36, 131, 222n.65

Mandyn, Jan, 28

Mantegna, Andrea:

Camera degli Sposi, 209n.118

maps, xxiii, 33–34, 83, 93

Margaret of Navarre:

Heptameron, 206n.76

Martindale, Andrew, 209n.118

Massacre of the Innocents (Raimondi, after Raphael), 188n.30

Massys, Cornelis:

Arrival of Mary and Joseph in Bethlehem, 13–14, *14*

Massys, Jan, 76

Master AP, 125

Master of the Lake Constance Region:

Allegory on the Three Ages of Human Life, 54, *55*

Matham, Jacob, 174;

Abraham Dismissing Hagar, *30*, 31, 155, 229n.57;

Allegory of Human Life, *54*, 54–55, 84;

Bloemaert's influence on, 31, 187n.19;

Brederode Castle print of, 104, 215n.81;

Brewery and Country House of Jan Claesz Loo, 96, *97*, 103;

career of, 32;

Cock's influence on, 30;

Landscape with Daedalus and Icarus, 36;

Months scenes of, 220n.25;

Mountain Landscape, 36;

Parable of the Tares, 31, 45;

secular/religious works by, 65, 201n.109

Matham family, 64

Mathijsz, Dirk, 94, 213n.24

May (J. Van de Velde), 128

May, in poetry, 128

Medicaments against Melancholy, 74

melancholy:

and landscapes, 79, 208n.99, 209n.111;

recreation as a cure for, 71–72, 74, 77, 203n.31, 205n.63

Memling, Hans:

Passion of Christ, 83;

Seven Joys of the Virgin, 83

Mennonites, 64

Merian, Matthaeus, 46, 62, 177

merriment/laughter, 74–75, 205n.64

Metamorphoses (Ovid), 158

Van der Meulen, Andries, 69

De Meyne, David, 43

Nicholas of Clémanges, 224n.88

Nicholson, William, 106

Nieuwe Uitleg (Amsterdam), 112

Nieuwe wereldt vol gecken (Burchoorn), 207n.79

Nil volentibus arduum, 146

Van der Noot, Jan, 59–60

Norgate, Edward, 175, 234n.2;
 Miniatura, 81, 82

novels, pastoral, 131–32

November (J. Van de Velde), 123

nudes, 146

Nude Woman Seated on a Mound (Rembrandt),
 144, 145, 151

Nuremberg Chronicles, 14

October (Van Valckenborch), 122

October (J. Van de Velde), 123–24, *124*

Oestgeest, 107

Ogier, Charles, 143

Van Oldenbarnevelt, Johan, 64

Old Man Reclining in a Landscape (Campagnola,
 after Titian), 158, 230n.71

Old Mill (Cropsey), 177, 235n.9, Plate 16

The Omval (Rembrandt), 166, *167*

"On Viewing a *Schilderachtig* Landscape"
 (F. Van Hoogstraeten), 169–70

Ooghentroost (Consolation of the eyes;
 Huygens), 169, 233n.114

"Op De nieuwe Herengracht, gschildered door
 Gerrit Berckheyde" (Vondel), 217n.116

The Dialogue (St. Catherine of Siena), 53

Orchesographie (Arbeau), 73

Orenstein, Nadine, 189n.31, 190n.58

Orlers, Jan, 107

Ossenmarkt (Amsterdam), 112

Van Ostade, Adriaen, 129, 151, 172;
 Peasant Family in a Cottage Interior, 161, *161*

otium.
 See leisure

Otium (Van Royen), 224n.99

Otium of Ledighe uren (C. Huygens, the Elder),
 138

Otto, Duke, 73

Oudaen, Joachim, 77

Van Ouwater, Albert, 115

Van Overbeke, Aernout, 74, 75

Ovid, 125;
 Metamorphoses, 158

Pagus Nemorosus (after Bruegel), 14, *15*

Painter, William:
 Palace of Pleasure, 72

painting, pleasure of, 81, 83, 211n.135

Painting of the Ancients in Three Bookes (F.
 Junius), 166

paintings:
 of historical subjects, 68;
 vs. prints, 47;
 Catholic vs. Protestant patrons of, 65, 201n.108

Palace of Pleasure (Painter), 72

Palamedes (Vondel), 138

Palazzo del Tè (Mantua), 224n.94

Pandosto (Greene), 158

Panofsky, Erwin, 51

panoramas, 36

Pantagruel (Rabelais), 72

Parable of the Tares (Matham, after Bloemaert),
 31, 45

Parable of the Unfaithful Shepherd (Bruegel), 22,
 22

Paradigmata graphices variorum (De Bisschop),
 145, 147

De Parival, Nicolas, 99, 104;
 Delices de Hollande, 95

Raimondi, Marcantonio:
 Judgment of Paris, 188n.30;
 Massacre of the Innocents, 188n.30
Raphael, 148, 188n.30
Raupp, Hans-Joachim, 55–56, 120
realism, xxiv, xxv, 50–51, 59, 143
Rearick, W. R., 230n.71
recreation, 68–84;
 and bent-bow parable, 68, 70, 73, 76,
 203n.23;
 carnivals/festivities, 73–74;
 for children, 71;
 dancing, 73, 75;
 depictions of, 79;
 drinking, 75, 206nn.70–71;
 Erasmus on, 74, 75, 78, 206n.74;
 and the Feast of Fools, 70, 73, 203n.24;
 gambling, 73;
 human need for, 69–70, 134;
 hunting/hawking, 73, 100, 204n.52;
 intellectual pursuits, 71, 138–39, 176;
 laughter/merriment, 74–75, 205n.64;
 literature, 71–73, 138–39, 204n.39, 225n.105
 (*see also* literature);
 during mealtime, 205n.63;
 and melancholy, cure for, 71–72, 74, 77,
 205n.63;
 for monks/hermits, 70;
 moralizing against, 69, 71, 76;
 and nature, 68, 77–78;
 painting, 81, 83, 211n.135;
 playing with children, 75;
 Seneca on, 70, 71, 73, 75, 76, 202n.21,
 206n.70;
 on Sundays/saints' days, 205n.55;
 as temporary, 71;
 walks in the country, 76–77, 208n.98;

 writing, 211n.135.
 See also leisure
recreative function of landscapes, 68, 80–81,
 83–84
Reformed Church, 64.
 See also Calvinism
relaxation.
 See recreation
religious art, 68–69
religious interpretation.
 See scriptural interpretation
religious practice, Dutch, 64–65, 200n.104.
 See also Calvinism
Rembrandt Harmensz van Rijn, xxiv;
 Cock's influence on, 47;
 criticism of, 146–47, 148, 149, 151;
 Goldweigher's Field, 96, *97*, 99, 111,
 216n.110;
 landscape sketches of, 59;
 Landscape with Cottage and Hay Barn, 141,
 142;
 Landscape with Cottage and Large Tree, 141;
 Landscape with Stone Bridge, 52, 53, *53*, 56,
 58;
 Landscape with Three Gabled Cottages, xxi,
 xxii, 47;
 Nude Woman Seated on a Mound, *144*, 145,
 151;
 The Omval, 166, *167*;
 portrait of Six, 139;
 scavenging by, 146–47;
 as socially ambitious, 114, 217n.125;
 textures in works of, 167;
 tonal style of, xxv;
 Venetian pastoral art's influence on, 131,
 222n.63;
 Windmill, 141

scriptural interpretation *(continued)*

 tavern, as place of sin, 53, 195n.18;

 of tempest scenes, 58;

 Wiegand on, 55, 197n.36;

 Ziemba on, 56

Seasons, depictions of, 125, *126–27,* 128, 130, 220n.29

secular subjects in art, 28, 51, 64

Securitas, 103, 215n.77

Sellink, Manfred, 26

Seneca, 225n.105;

 De tranquillitate animi, 70, 73, 75, 76, 202n.21, 206n.70

La sepmaine (du Bartas), 130

September (Van Valckenborch), 122, 220n.24

September (J. Van de Velde), *122,* 122–23

Serlio, Sebastiano:

 Scena satiryra, 182n.26

Servilius, Joannes:

 Dictionarium triglotton, 61

Seven Joys of the Virgin (Memling), 83

Shed (A. Bloemaert), 31, *154,* 155

Sign of the Fisher, 33, 188n.30

Sign of the Four Winds, 32, 33

Simonides, Simon, 202n.12

Simplicissimus (Grimmelshausen), 57–58

Sinnepoppen (R. Visscher), 62, 69, 119, 125, 222n.59

Síp, Jaromir, 228n.49

Six van Chandelier, Jan, 49, 112, 169

Sixty Landscapes (J. Van de Velde), 43, *43,* 62, 81, 132

Skating in Front of St. George's Gate (H. Cock, after Bruegel), 125

skating scenes, 125, 128

skies, cloudy, 149, 227n.27

slecht en recht, 130, 222n.59

Sleeping Peasant Couple (C. Bloemaert, after A. Bloemaert), 133, 134, *136*

Slive, Seymour, 214n.45, 218n.135, 231nn.88, 90

Small Landscapes (H. Cock), 1–26, 174, 190n.60;

 attribution of prints, 10, 22, 26, 42, 181nn.16, 20;

 castles/manors/gates in, 2, 9, 181n.9;

 composition in prints, *3–4, 7–8,* 10;

 disposition of prints, 25–26;

 J. Galle's editions of, 47, *48,* 49, 193n.107;

 P. Galle's editions of, 26, 27, 29, 38, 42, 185n.77;

 human figures in, *3, 8,* 9;

 inns in, *7–8,* 9, 18, 181n.10;

 vs. *Large Landscapes,* 13;

 novelty of, 173;

 number of prints, 2, 184n.54;

 origins of, 13, 182n.26;

 prints reissued by Visscher, 39–40, *39–41,* 42, 46, 49, 174;

 publication of, 1–2;

 ruins in, 143;

 rural pastimes in, *6,* 9;

 simplicity of, 125;

 success/distribution of, 20, 26, 184n.55;

 title prints of, 2, *2, 5,* 16, 26, 180n.5.

 See also Small Landscapes, influence of

Small Landscapes (H. Cock), influence of, 26, 27, 173;

 on Baltens, 23;

 on Bloemaert, 31;

 on Bruegel, 22;

 on Brueghel, 186n.81;

 Gerzi on, 184n.62;

 on Goltzius, 23, 30–31, 174;

 on Van Goyen, 47;

 on Grimmer, 23;

on Matham, 30;

on Rembrandt, 47;

on Van Ruisdael, 47;

on C. J. Visscher, 39, 174

Smids, Ludovico, 58

Smith, David, 217n.118

Snoep-Reitsma, Ella, 195n.11

Snouckaert, Jacob, 139

Socrates, 75

Soestdijk, 112, *113*

Solomon and Marcolph, 72

Van Sompel, Jan, 96

Songes drolatiques de Pantagruel (Breton), 72

"Sonnet on Amsterdam" (Beck), 93

Spaarne, 107

Spaarwou (E. Van de Velde), *102*, 103

Spain, at war with Holland, 34, 101, 143, 175

The Spanish Brabanter (Bredero), 19, 75, 169, 183n.51

Spenser, Edmund:

Faerie Queene, 230n.74

Spickernagel, Ellen, 182n.26

Spiegel, Hendrick Laurensz, 59–60, 63, 73, 77, 93, 96, 132

Spiegel, Laurens Jansz, 96

Spieghelenburg, 96

Spinoza, Benedict, 141

Springer, Leonard A., 212n.19

Spring (Van de Velde), 95, *126*, 128, 130

staffage, 117.

See also figures, in landscapes

Starter, Jan Jansz, 193n.96;

Friesche lusthof, 75

Stechow, Wolfgang, 51–52, 187n.14, 195n.11, 218nn.134–35

Steen, Jan, 129, 201n.108

Stevens, Karel (Charles Estienne), 157

Stevens, Pieter, 122, 125;

Summer, 229n.51

Van Stipriaan, René, 204nn.39, 41

Stock, Andries, 220n.25

Stone-Ferrier, Linda A., 212n.6, 216n.110

The Story of Noah (C. J. Visscher, after Heemskerck), 212n.4

Strijd tusschen Dood and Natuur (Vos), 146–47, 227n.18

Studius, 78, 118

Summer (P. Stevens), 229n.51

Summer (J. Van de Velde), *126*, 128, 130

Summer Houses and Pavilions along the Spaarne (Van de Vinne), 107–8, *108*, 216n.97

Sunday walks, objections to, 69, 202n.12

Sweerts, Hieronymus, 229n.54

Van Swieten, Gerard:

Maladies des femmes et des enfans, 77

swimming, 105, 215n.85

Syconia, 115

symbolism, xxv–xxvi, 51, 56–57, 194n.6.

See also scriptural interpretation

Synod of Dordrecht, 62

Szabo, George, 223n.78

Tabourot, Jehan.

See Arbeau, Thoinot

Tares Sowed among the Wheat, parable of, 133

tavern, as place of sin, 53, 195n.18

De Teecken-Const (Biens), 66, 166

tekenachtig subjects, 148

telescopes, 120–21, 220n.20

Tempesta, Antonio, 73

tempest scenes, 58

Temple, Sir William, 60

Temple of the Sibyl (Tivoli), 101

Tghevecht van minnen (Van Doesborch), 207n.79

Van de Velde, Jan, 213n.43;
 Amsterdamsche Pegasus etchings, 132–33,
 223n.73;
 audience for works of, 65;
 Autumn, 127, 128, 130;
 Brederode Castle print, 142, 225n.2;
 Four Seasons, 124;
 in Haarlem, 114–15;
 June, 122–23, *123,* 132;
 Landscape with Dilapidated Barn, 163, *163;*
 *Landscape with Two Men Fishing and Dove-
 cote, 162,* 163;
 May, 128;
 Months series of, 122–24, *122–24,* 128,
 130;
 natural scenery in works of, 66;
 November, 123;
 October, 123–24, *124;*
 outhouses in works of, 155;
 Seasons series of, 95, 125, *126–27;*
 September, 122, 122–23;
 Sixty Landscapes, 43, *43,* 62, 81, 132;
 Spring, 95, *126,* 128, 130;
 Summer, 126, 128, 130;
 Winter, 125, *127,* 130
Veldhuijzen, Sv. E., 198n.65
Veldman, Ilja, 201n.110
Velserend, 96
Van de Venne, Adriaen, 220n.20
Verhoek, Pieter, 67–68
Veronese, Paolo, 80
Van Vianen, Paulus, 229n.51
Vida, Marco, 77
View of Bentheim Castle (Van Ruisdael), 52
*View of Bloemendaal with Saxenburgh.
 See Goldweigher's Field*
View of Diemen (C. J. Visscher), 38

View of Egmond on the Sea (Van Ruisdael), 141,
 166, Plate 13
A View of Elser Beeke (H. Collaert, after J.
 Grimmer), 24–25, *25,* 38, 100
View of Goudestein (Van der Heyden), 108, *109*
View of Haarlem (Le Petit), 92, *92,* 212nn.5–6
View of Scheveningen (after Van Ruisdael), 105,
 105
View of Scheveningen (De Vlieger), *104,* 104–5
View of the Dunes near Haarlem (Goltzius), *29,*
 29–30, 99
View of The Hague Forest (Roghman), 106, *106,*
 172
A View of the Kiel near Antwerp (J. Grimmer),
 17, *17,* 20, 23, 24
View of the Schelde near Antwerp (J. Grimmer),
 20, *21,* 23
Villa Barbaro (Maser), 80
Villa Farnesina (Rome), 79
Village in Winter (J. Grimmer), 23, *24*
Village Kermis (Brueghel), *21,* 21–22, 119
Village Landscape (Van Goyen), xxvii, 119, 120,
 128, Plate 10
Village Landscape (Van Liere), 10, *11*
Village Landscape (E. Van de Velde), 44, *44*
Village near Hoboken, 18, *18,* 183n.48
Village with Farmhouses (Antwerp Sketchbook),
 12
Village with Houses and a Wall (De Bisschop),
 171, 171–72
Villa Imperiale (Pesaro), 79–80
villas, decoration of, 79–80, 118
Vinckboons, David, 33, 36, 37, 189n.42, 190n.55;
 Seasons scenes of, 125, 220n.32
Van de Vinne, Laurens:
 *Summer Houses and Pavilions along the
 Spaarne,* 107–8, *108,* 216n.97

DESIGNER Nicole Hayward
COMPOSITOR Integrated Composition Systems
TEXT 11.5/16.5 Fournier
DISPLAY Cochin
PRINTER & BINDER Malloy Lithographing, Inc.